Ferdinand Columbus: Renaissance Collector

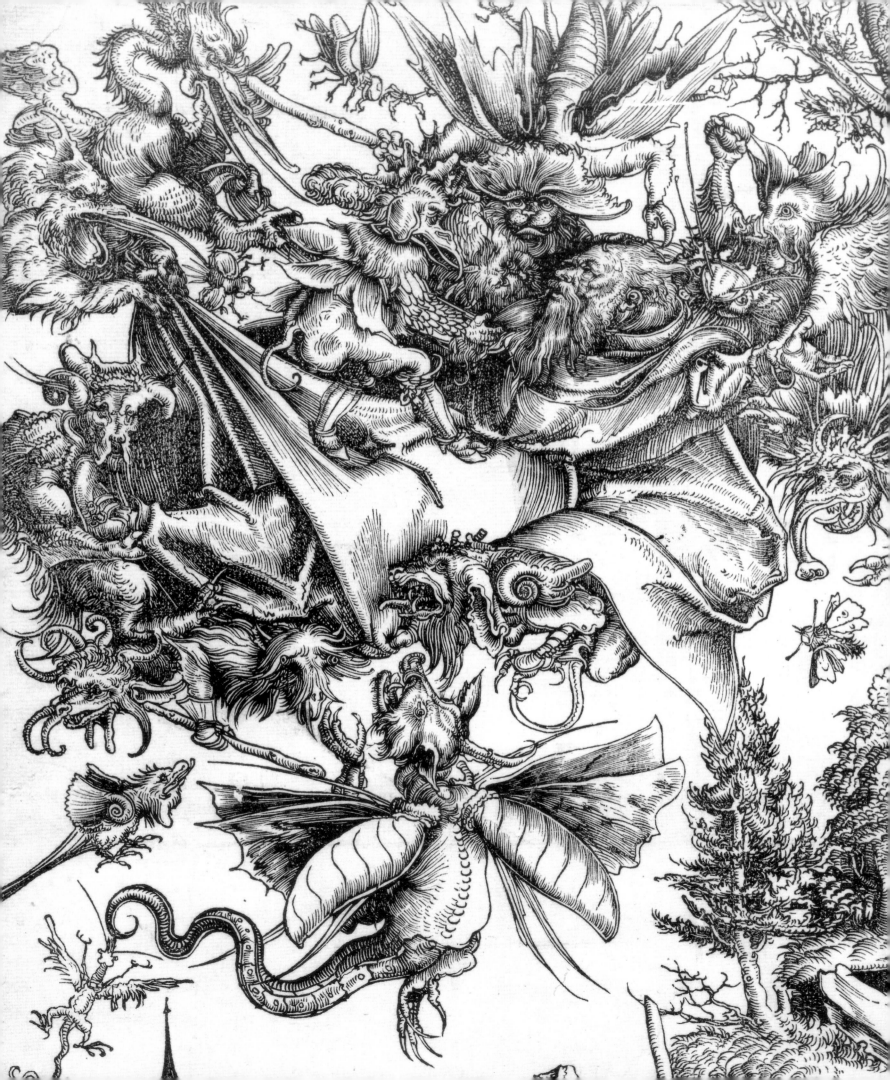

Ferdinand Columbus: Renaissance Collector
(1488–1539)

Mark P. McDonald

THE BRITISH MUSEUM PRESS

First published by Fundación "la Caixa". © 2004
English text © 2005 The Trustees of the British Museum
This edition published in 2005 by The British Museum Press
A division of The British Museum Company Ltd
38 Russell Square, London WC1B 3QQ
www.britishmuseum.co.uk

ISBN-13: 978-0-7141-2644-9

ISBN-10: 0-7141-2644-6

A catalogue reference for this book is available from the British Library

Printed in Spain by Grafos S.A., Barcelona

Cover illustration: Antonio Pollaiuolo (c.1432–98), *Battle of the Nude Men*
(cat. no. 1, detail)

Photographic acknowledgements
The Ashmolean Museum, Oxford; Bibliothèque Nationale de France, Paris; The
British Library; The British Museum; Foto-Commissie Rijksmuseum Amsterdam; Gra-
phische Sammlung der Universität Erlangen-Nürnberg, Erlangen; Herzog Anton
Ulrich-Museum, Brunswick; Institut Amatller d'Art Hispànic; J. Paul Getty Museum,
Los Angeles, California; Kupferstichkabinett der Museen der Stadt Gotha; Kupfers-
tichkabinett, Staatliche Museen zu Berlin–Preussischer Kulturbesitz (Jörg P. Anders);
J. Michel Massing; Museo Correr (Biblioteca), Venice; National Gallery, London;
National Library of the Czech Republic, Prague; Rijksmuseum Amsterdam; Rijks-
museum-Stichting, Amsterdam; Statens Museum for Kunst, Copenhagen (SMK Foto);
Tiroler Landesmuseum Ferdinandeum, Innsbruck; The Victoria & Albert Museum;
Zentralbibliothek, Zürich.

CONTENTS

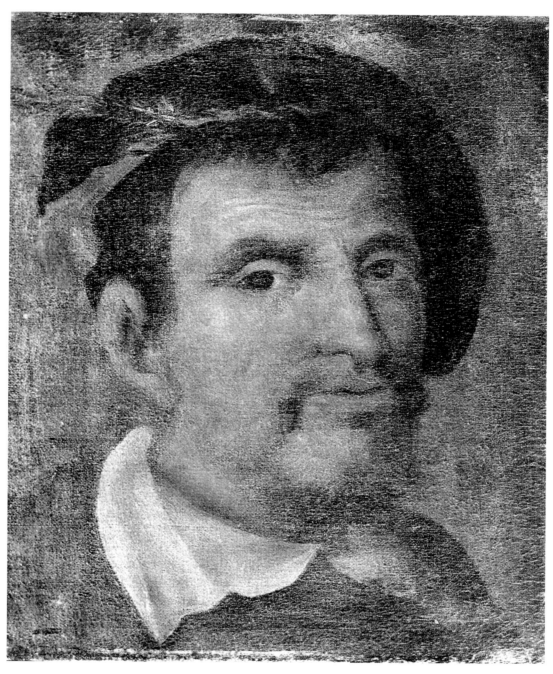

Anonymous, *Portrait of Ferdinand Columbus*. Biblioteca Colombina,
Seville, sixteenth century (photo author).

Christopher Columbus's enterprise of discovery, the first voyage from Spain to the Americas, has become part of our collective consciousness. It is perhaps one of the most potent of all symbols of Europe's exploration of new worlds, which was to transform its economy, its imaginings and above all its intellectual life in the late fifteenth and the sixteenth centuries. As the printing industry revolutionised book publishing, more books than ever before became available. Advances in printmaking were no less dramatic, satisfying the visual aspirations of a growing cultural elite. A new kind of collecting became possible.

In cultural and intellectual overviews of the period, one fascinating figure has been largely overlooked: Christopher Columbus's illegitimate son Ferdinand, who not only travelled on the fourth and final voyage to the New World in 1502, compiled an account of that journey and wrote the first biography of his father, but was without doubt the greatest bibliophile and print collector of his day. At the time of his death, his library contained over 15,000 volumes and more than 3,200 prints. Now vanished and known only through an inventory in Seville, this is the largest Renaissance print collection that we know of.

The significance of the inventory can hardly be overstated, not just because of the number of prints in it by all the major Renaissance artists working in the medium, but because of the survival of Columbus's own catalogue with his extraordinary system for classifying the prints. As a travelling companion and adviser to Emperor Charles V, and a friend of the great humanist Desiderius Erasmus, Ferdinand was at the centre of the great political and intellectual movements of his day, and used his diplomatic travels to assemble his remarkable collections. In contrast to his seafaring father, Ferdinand comes across as a scholar devoted to establishing his library in Seville, a Renaissance man dedicated to gathering knowledge.

David Landau, the editor of *Print Quarterly*, rediscovered the Seville inventory and in 1998 discussed it at a conference organised by the *Burlington Magazine* dedicated to the history of collecting prints and drawings. Caroline Elam recognised its value, and generous funding from the Getty Grant Program was raised to secure its full research. With formidable energy and tenacity, Mark McDonald tracked down prints, and it is possible once again to look at Ferdinand Columbus's print collection. The British Museum Press published the result of that work in 2004. Based on what had been discovered, the Spanish foundation "la Caixa" sponsored an exhibition that was a partial reconstruction of the Columbus collection shown in Madrid and Seville in 2004. This is its third venue and it is presented here thanks to the generous support of the American Friends of the British Museum.

At "la Caixa" we are most grateful to Asunción Cabrera, Imma Casas, Concha Gomez, Carme Guinea, María Lopez-Fanjul, Marta Ponsa, Jana Zamacois and others who have enthusiastically supported this exhibition. At the British Museum, Antony Griffiths, Frances Carey and Janice Reading have guaranteed its seamless realisation. A number of institutions have generously lent key works to this exhibition. At the Kupferstichkabinett in Berlin, we would like to thank Hein-Th. Schulze-Altcappeberg and Michael Roth; at the Ashmolean Museum in Oxford, Christopher Brown and Christian Rümelin; at the British Library, Peter Barber. With its rich and well-researched collection, the British Museum Print Room is probably the only place in which such work could have been undertaken and Columbus's collection recreated, and we are delighted to be able to present this exhibition and catalogue to the public.

Neil MacGregor
Director The British Museum

It is my great pleasure to be able to acknowledge the many colleagues who have contributed to the success of this exhibition. The Columbus Print Collection Project was initially funded by the J. Paul Getty Grant Program and supported by the Department of Prints and Drawings at the British Museum. At the Grant Program, I would like to thank Deborah Marrow and Joan Weinstein, without whose support the research could not have been completed. The research was overseen by a Steering Committee comprising Caroline Elam, Antony Griffiths and David Landau. I am grateful to the Committee for their advice and support.

My colleagues at the British Museum have greatly assisted in all aspects of the exhibition: Giulia Bartrum, Frances Carey, Mercedes Ceron-Peña, Hugo Chapman, Charlie Collinson, Antony Griffiths, Ute Kuhlemann, Sam Moorhead, Sheila O'Connell, David Paisey, Hannah Payne, Janice Reading, David Rhodes, Angela Roche, Martin Royalton-Kisch and Alice Rugheimer. Our Director, Neil MacGregor, has been a most enthusiastic supporter of all things Columbus. At the British Museum Press, Teresa Francis expertly managed the project and Elisabeth Ingles provided invaluable editorial assistance. Ediciones El Viso in Madrid and Andrew Shoolbred are responsible for the elegant design of this catalogue.

One of our happiest collaborations has been with the Fundación "la Caixa" who quickly recognised the exhibiting potential of the subject. This exhibition was first shown in Madrid, then moved to Seville before its showing at the British Museum. It has been an enormous pleasure to work with the Fundación; their commitment to the promotion of culture in Spain is unmatched. I would like to thank Asunción Cabrera, Imma Casas, Elena Celorio, Concha Gomez, Carme Guinea, María López-Fanjul and Jana Zamacois for their continued support. I am most grateful to the presidents of "la Caixa", Sr José Vilarasau Salat and Sr Ricardo Fornesa, who have shown great interest in my work. At the Institución Colombina in Seville I wish to thank the directors, His Excellency Dr D. Juan Guillén Torralba and Nuria Casquete de Prado Sagrera, and all the staff for their help, especially Antonio Lozano Herrera.

Mark McDonald

The Print Collection of Ferdinand Columbus

Like all men of the library, I have travelled in my youth;
I have wandered in search of a book, perhaps the catalogue of catalogues.

JORGE LUIS BORGES, *The Library of Babel*

A manuscript in the Columbus Library in Seville describes 3,204 prints collected by Ferdinand Columbus (1488-1539), the son of Christopher Columbus.[1] Ferdinand Columbus (fig.1) is best known for the biography of his father that he wrote towards the end of his life, the *Historia del Almirante*,[2] and also for his exceptional library, which at his death numbered over 15,000 volumes, and was possibly the largest private collection in Europe; it was accumulated during Ferdinand's diplomatic missions for the Spanish royal family and Habsburg emperors. The print collection once formed part of that library. All the prints and most of the books have vanished but what remains is a series of carefully devised and painstakingly executed inventories that represent the first such systematic classification of books and prints. The manuscript describing the prints is the only known surviving inventory for a print collection from the first half of the sixteenth century at a time when print production and collecting were in their infancy.

A significant feature of Ferdinand's acquisitive impulse is that his print collection existed outside what is traditionally considered the mainstream of European culture and beyond the main centres of print production. In the early sixteenth century, Seville was a powerful centre on the periphery. She was the most important trading port and point of departure for the New World. Seville during the period has been called the 'new Rome', a cultural melting pot that absorbed and reflected a multitude of artistic and ethnic influences.[3] Set within this dynamic context, Ferdinand's collections can be better understood as part of a 'New World' on European soil. The peripheral nature of Seville possibly compelled Ferdinand to create his print inventory, motivated by the fact that he had to travel in order to buy prints which would not easily have been available beyond their point of origin. We know from

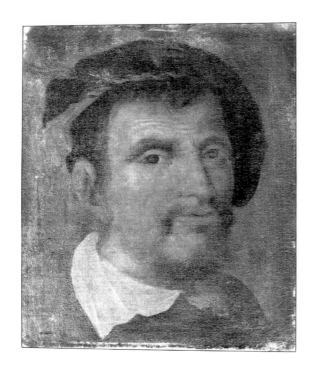

FIG. 1 Anonymous, *Portrait of Ferdinand Columbus*, sixteenth century. Biblioteca Colombina, Institución Colombina, Seville (photo author).

classification is entirely based on the size of a print, its broad subject and the number of figures or features in the image.

The aim of this exhibition is to reconstruct part of Ferdinand's print collection and to present a profile of Renaissance printmaking. The prints shown here are not those that Ferdinand himself owned, but because prints are made in multiples other impressions can be identified in print rooms around the world. In order to better appreciate the reconstructed collection it needs to be seen in relation to the printmaking industry in Europe and also Ferdinand's library. Ferdinand considered his library an enterprise for the 'greater benefit of mankind'. His library aspired to universality, a utopian space to which one could turn when 'any doubts presented themselves'. These were his objectives. The physical properties of prints make them the ideal companion for a library but the information they contain is very different from that provided by books. The print collection played an important role in his library and it is the earliest evidence for prints interacting within such a space.

Within the collecting context, Ferdinand's books have been the focus of considerable interest, which has never extended to the print collection. This is because of the difficulty of understanding what the print inventory represents and its system of classification. The classification is, however, only complex if the prints themselves are not taken into account. When considered together with the prints it is an effective method for classifying printed images. Whereas the inventory might well be the first such articulation of a classification system of its kind, it owes its existence to contemporary codification of images and it is anchored in those social institutions that gave rise to collecting practices. Read within a context that made possible its production, the true significance of this unique document becomes apparent.

documents that Ferdinand carried the inventory with him on his journeys as a sort of checklist. The classification systems that Ferdinand devised to catalogue and access his collections are unique and predate any other systematic attempt to organise a collection with the same degree of thoroughness. The thread that binds all of Ferdinand's inventories is his intention to order his collections and to make their contents accessible. In the case of the book inventories, ascertaining what Ferdinand owned is relatively straightforward because an author and title are given and other examples exist in libraries around the world. But in the print inventory the names of printmakers are rarely provided and their

1 The inventory is kept in the Institución Colombina, Biblioteca Colombina, Seville, signatura 10-id-5. For a complete analysis of the Columbus print collection see McDonald, 2004.

2 Colón, 1984.
3 See Lleó Cañal, 1979.

1 | *Printmaking and Print Collecting in the Renaissance*

Printmaking during the Renaissance

Printmaking relies on techniques of replication. As a method of producing images it had its origins in antiquity and was later widely used in Asia and found extraordinary new expression in Europe in the first decades of the fifteenth century. From that time woodblock and intaglio printmaking developed into an art creating highly complex images with sophisticated pictorial schemes and extraordinary levels of detail. The rise of printmaking coincided with preoccupations in other branches of the visual arts: the concern with technical virtuosity and new and effective ways of representing the world. As part of the broader European phenomenon of artistic renaissance during the fifteenth century, nearly all the leading artists became involved in printmaking.[1] That their designs could be multiplied was one of the main reasons for its popularity.

The notion of multiplication underlies any discussion of Renaissance printmaking but it needs explaining. The fifteenth century witnessed the unparalleled rise of the 'multiple'. The development of the printing press and the ascendancy of book publishing had an enormous impact on what could be read and seen simultaneously across Europe, and the sheer volume of books and images produced was staggering, transforming visual and literary culture.[2] No longer were words and images the preserve of wealthy individuals, particularly in the case of devotional prints, which were commonplace and cheap. We live in a society where multiplication is synonymous with mass production, low quality and the ordinary. How then can a print by Albrecht Dürer or Lucas van Leyden be an original work when there are other impressions exactly similar to it? Multiplication has led to the distorting attitude that a print is a secondary object as compared to a painting or more particularly a drawing. But through

examining a fine impression of a print and considering the intentions of the artist who produced it and its function, the false hierarchy soon collapses. The great prints are not reproduced drawings but works of art purposefully created through the printing medium. Bearing this in mind we can, for example, better appreciate the prints of Lucas van Leyden, which were created specifically as engravings, a medium expressly designed for multiple replication. It is important, however, to understand that multiple does not mean infinite and artists always knew that the edition of prints was limited because of the wearing of the plate [see cat. no. 24].

Understanding the function of the Renaissance print goes a long way to explaining its forms. Broadly speaking, the prints can be divided into two groups, first, rudimentary prints intended for devotion, as book illustration and other ephemeral purposes such as wall decoration, and secondly, the artist's print. Most fifteenth-century woodcuts belong to the first group and were discarded once they had served their purpose. But within the first group, there are levels of difference. The *Battle of Zonchio* [cat. no. 5] is fundamentally a news-sheet reporting on a contemporary battle but it was carefully coloured to increase its appeal and possibly was meant to outlast interest in its subject. A small, quickly produced woodcut depicting the Virgin and Child, on the other hand, had a limited lifespan. In the second category, prints such as Antonio Pollaiuolo's *Battle of the Nude Men* [cat. no. 1] was conceived and produced as a work of art and no doubt kept as such. These broad divisions of function provide one way of understanding the wide variation in prints produced during the Renaissance.

Printmaking processes

Relief printing

There are a number of different relief processes used in printmaking. What unites them is that the actual lines from which the printing is done stand in relief above the rest of the block, which has been cut away. The type of relief print used during the Renaissance was the woodcut. The material used for the wood-cut is a wooden block from a softwood tree, sawn along the grain and planed smooth. The block is then seasoned so that it will not warp or crack. Woodblocks are normally small [cat. nos 41a–d, 71a–h etc.); and for large prints, several blocks are used [cat. nos 15, 18, and 19]. After the block has been prepared, the design is either drawn directly on to it or a drawing is stuck to the surface. A professional cutter – not normally the artist – then uses a knife to cut away sections of the block, carefully following the design. The lines that are needed to produce the print then stand in relief to provide the image. The skill required to cut a block successfully should not be underestimated. Cross-hatching, for example, required laborious work and if a mistake was made it had to be replaced with a new section. The complex lines in Giovanni Battista Palumba's *The Calydonian Boar Hunt*, for example [cat. no. 13], reveal the highly intricate carving. The block was then inked, put in a press, pressure applied evenly over the surface of the entire block and the image printed.

The majority of woodcuts produced during the fifteenth century were not ambitious (see above). Hardly any were signed or dated. It is almost impossible to locate the origin of their production, but the German-speaking lands seem the main area. This is possibly because of the predominance of wood sculptors in the north, in contrast to the marble sculptors in Italy. Today extremely few of these prints survive and most are known in only one or two impressions. There is some evidence for the early production of more ambitious woodcuts. The German coloured woodcut of the *Relics, Vestments and Insignia of the Holy Roman Empire* is one example [cat. no. 21]. Around 1460–80, were it not for the rapid rise of book production, which required illustration, woodcuts might have been condemned to remain a minor art. The real turning point came with Albrecht Dürer, who transformed the then relatively crude woodcut practices into a high art form [cat. nos 36–45].

Dürer's achievement was critical, and the first thirty years of the sixteenth century witnessed the transformation of the medium. His students and others working in Germany, including Hans Baldung [cat. nos 48–50], Lucas Cranach [cat. nos 78–82], Albrecht Altdorfer [cat. nos 68–75], and Hans Wechtlin [cat. nos 51–2] established the woodcut as a major art form. From the early

sixteenth century, printing colour woodcuts became common. Normally as many blocks are used as there are colours. A key-block is made with the design in outline; the artist then colours impressions from this by hand, each with one of the colours required in the final design. These sheets are pasted on to other blocks and all the non-printing areas are cut away. Each block can then be inked in its colour and printed on the one sheet. These prints are called *chiaroscuro* from the Italian word for 'light and shade'. Lucas Cranach and Hans Burgkmair made the first single-sheet colour woodcuts in Germany. Burgkmair developed the technique by 1507 and it flourished by 1510 [see cat. nos 51–2]. The technique also found great popularity in Italy, where Ugo da Carpi seems first to have used it to translate Raphael's drawings [cat. no. 14].

The rate at which the woodcut developed during the early sixteenth century was phenomenal, and similar activities inspired by Dürer's example were occurring in the Netherlands. Foremost amongst the practitioners were Lucas van Leyden [cat. nos 97, 100], Jacob Cornelisz. van Oostsanen [cat. no. 105] and Jost de Negker [cat. no. 104], but their true achievement is hard to gauge because so little of their work remains. Although Germany dominated the development of the woodcut, Italy and France had their own traditions. Italian fifteenth-century woodcuts are exceedingly rare but this is probably due to their low rate of survival. There is every indication that the industry there was significant, a fact borne out by the Columbus print inventory. Venice in particular came to dominate Italian woodcut production in the early to mid-sixteenth century, where Jacopo de' Barbari was among the most talented [cat. no. 3]. One aspect of woodcut production that is often overlooked through lack of evidence is the remarkable production of large-format prints. In Italy, Jacob of Strasbourg, Titian and Domenico Campagnola led the way in producing grand designs of extraordinary power and scale [see cat. nos 17, 18, 19]. In Germany, Hans Burgkmair produced at least one long frieze [cat. no. 56]; in the Netherlands, Lucas van Leyden made several [cat. no. 100] and Robert Peril produced one of the most impressive multi-sheet prints of the period, measuring over seven metres long [cat. no. 109]. Maps and views also often comprised several sheets [cat. nos 20, 89, 108].

Intaglio printing

The term intaglio refers to a process in which a design is produced by lines cut into the surface of a metal plate – usually copper, sometimes iron or steel – which is then inked and printed under great pressure so that the paper is forced into the sunken areas and draws out the ink. The two most common intaglio processes are engraving and etching. The design is engraved in the metal plate normally using a burin – a straight steel rod. The plate is then covered with ink, which needs to penetrate the engraved lines. Unlike woodcuts, which are inked so that the ink lies on the uppermost surface, intaglio plates are wiped clean so that ink is left only in the incisions. This is a difficult process requiring great skill; the printer must be careful not to wipe too hard so as to drag the ink out of the lines and it must be done fairly rapidly so that the ink does not dry. Once the plate is ready, it is placed face upwards on the press and a dampened sheet of paper placed on it. The plate and sheet are run through the roller and the impression that is taken is hung up to dry. The pressure quickly flattens the metal and the quality deteriorates. The number of impressions a plate is capable of yielding varies greatly between processes. The skill of the printer is critical in prolonging the lifespan of a plate.

Engraving is the oldest and most widespread of the intaglio techniques. The practice of incising images into metal long predates engraved surfaces as printing surfaces. The Greeks, Etruscans and Romans all engraved metal surfaces – goblets, plates, mirrors and so on – for decorative effect. The practice was widespread in the Islamic world and spread to Europe during the middle ages as a method of embellishing gold and silver. The practice of impressing paper on engraved plates probably originated in the workshops of metalworkers and goldsmiths in southern Germany in the second quarter of the fifteenth century as a means of keeping records of their designs. In the early days, these prints were tied to the style of goldsmiths. Most of the early engravings were of religious subjects sold for devotional purposes. It was not long before artists identified the commercial potential of prints and Martin Schongauer, for example, began producing monogrammed prints of exceptional delicacy [cat. no. 31]. By the last quarter of the fifteenth century, in German-speaking lands engraving was flour-

ishing and among the most important practitioners who developed prints with independent subjects were Israhel van Meckenem [cat. no. 24] and the Master ES [cat. no. 30]. In the Netherlands as well, masters such as the Master IAM of Zwolle and the Monogrammist FvB were producing fine engravings [cat. nos 93 and 95].

Fifteenth-century engraving was not a phenomenon restricted to countries north of the Alps. In Italy as well – albeit a little later – engraving evolved independently from the northern tradition.[3] Florence was the centre of fifteenth-century engraving and the earliest surviving prints from there probably date from the late 1440s. Italian engravings are far 'lighter' in tone than those produced in Germany and they are closely connected to pen drawings. They have traditionally been grouped in two categories, 'fine manner' and 'broad manner', describing the type of working.[4] Their subject matter was also different from that of northern engravings, and incorporated mythological, astrological, classical and

other secular themes. The outstanding engraving produced in the fifteenth century is Antonio Pollaiuolo's *Battle of the Nude Men* [cat. no. 1] made around 1460–75. An example of an engraving with a secular theme is the *Carnival Dance* by the Monogrammist SE, also impressive for its size and delicacy of line [cat. no. 4]. Outside Florence, one of the greatest figures was Andrea Mantegna (c.1431–1506) who spent most of his career at the court in Mantua and produced some of the most inventive prints from the period, which greatly influenced his followers (fig. 2), amongst them Jacopo de' Barbari in Venice in the 1490s [see cat. no. 3].

Engraving in the early sixteenth century was dominated by two figures: Albrecht Dürer in the north [cat. nos 34, 35a and 35b] and Marcantonio Raimondi in Italy [cat. nos 6 and 7]. Dürer not only perfected the engraving technique and greatly expanded its subject matter, but also made it a fully independent art form. His early work reflects the influence of Martin Schongauer [cat. no. 31], and by 1500 he was exploring classical themes and the nude. Marcantonio's career began in Bologna before he moved to Venice in 1506, where he made engraved copies of Dürer's woodcut series *The Life of the Virgin* [see cat. nos 40a and 40b]. The piracy so enraged Dürer that he is said to have complained to the magistrates in Venice, and this had some effect because Marcantonio stopped copying his AD monogram. Marcantonio moved to Rome in 1510 where he began to work with Raphael, making prints after his drawings, frescos and paintings (fig. 3). Raphael's style therefore became widely disseminated and imitated. Their collaboration changed the course of printmaking and its great contribution was to make engraving the pre-eminent means of pictorial transmission.

Etching is the most important intaglio technique after engraving. The fundamental difference is that the metal of the plate is removed by eating into it with acid rather than by cutting it with a tool, as in engraving. The usual material for the etching plate is copper, but sometimes zinc is used. The plate is first highly polished and then coated with an acid-resistant ground – gums, resins and waxes. The act of drawing on the ground is similar to pen on paper and, because the plate can be drawn on easily, the etched line exhibits much greater freedom.

FIG. 2 | Andrea Mantegna, *Christ's descent into Hell*. Engraving, 446 × 347 mm, 1470–1500 (The British Museum, 1895-9-15-70).

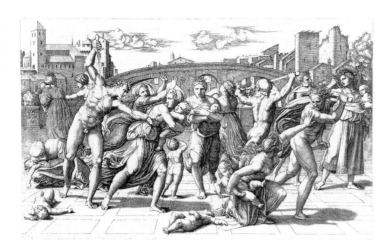

FIG. 3 | Marcantonio Raimondi, *The Massacre of the Innocents* (after Raphael). Engraving, 276 × 425 mm, 1510–14 (The British Museum, H.1-19).

It seems that etching was invented as a method of decorating armour in the fifteenth century in northern Europe. Albrecht Dürer was the first artist to concentrate on the medium; he produced six etchings between 1515 and 1518. Altdorfer followed him, and in the Netherlands, Lucas van Leyden and Dirk Vellert used etching mainly as a more expedient way of achieving the effect of engraving. In Italy, Marcantonio Raimondi made occasional use of etching.

Print markets – buying and collecting prints

The brief survey of the early history of European printmaking provided above establishes a context for better understanding the print collection of Ferdinand Columbus. His collecting practices were in direct response to the tenacious development of the printmaking industry.

Ferdinand's collection is the earliest and largest recorded during the Renaissance and, as such, it was located within his library in Seville, although independent of it. The print collection visually and physically complemented his books and, by virtue

of the fact that both were printed on paper, drew the viewer into the one experience. Many of Ferdinand's books were themselves richly illustrated, and the relationship between those illustrations and his single-leaf prints is close. The title-page of *La Conqueste de Grece* (Jacques Galliot, Paris, 1527), depicting a horseman brandishing a sword (fig. 4), is very similar to a number of woodcuts in Ferdinand's print collection such as Hans Wechtlin's *A Knight and a Lansquenet* [cat. no. 52].

The relationship and the crossover between book illustrations and loose-leaf impressions and their comparative status within collections has been given little attention, mainly because of the lack of any meaningful evidence. But the presence of many prints in Ferdinand's collection occurring as both book illustration and single leaf suggests that conceptually they were virtually one and the same. The single-leaf print industry really comes into its own at the moment when prints come to be regarded as being objects of artistic merit and, in addition, the physical dimensions of the print preclude it from being used as a book illustration.

Ferdinand's collecting practices suggest that he was following an Italian humanist model. During his early years in Rome from 1512 (see chapter 2), humanism was firmly established and the publishing industry turning out hundreds of new titles on many subjects every year. Ferdinand responded to humanist aspirations by purchasing large numbers of manuscripts and books by classical authors.[5] The ascendancy of the printmaking industry in Italy during the first decades of the sixteenth century was unparalleled. From its inauspicious beginnings in the late fifteenth century, the establishment of a highly competitive industry founded on the commitment of a number of printmakers developed engraving into a highly marketable enterprise. Within a matter of years, printmaking evolved into a highly regarded profession. The collaboration between Marcantonio Raimondi and Raphael, and the way in which artists such as Titian became involved in printmaking, indicate the regard in which the profession was held.[6] There is every indication that little distinction was perceived between a beautifully executed painting and an equally proficient print.[7] The prestige enjoyed by printmakers in Italy during the time Ferdinand was there, and the fact that it was a prominent, diverse and expand-

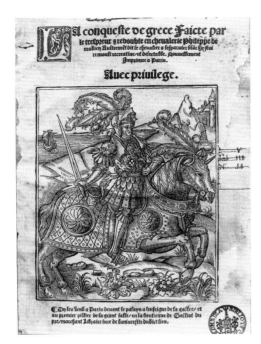

FIG. 4 | Title page of *La Conqueste de Grece*, Paris, 1527. Biblioteca Colombina, Institución Colombina, Seville, sig. 1-6-20 (photo author).

ing industry, would surely have provided ample stimulus for him to establish his own print collection.

The chronology of Ferdinand's travels provides a secure framework for his movements throughout Europe. His schedule has been determined from the inscriptions he wrote on the books that he bought (figs 19 and 20).[8] Tying his travels to his book purchases has provided information regarding what was available, for example in London, when he was there in 1522.[9] Because of the durable nature of books and the way they were collected, their production and networks of sale are much better understood than the distribution and marketing of prints. Our understanding of how prints were sold during the period is negligible. But evidence from Ferdinand's book indexes (see chapter 4) and his print inventory supports earlier research suggesting that prints were sold alongside books, and that book publishers/printers often produced prints themselves, presumably to supplement their principal trade.

In a number of cases, Ferdinand owned books and single-leaf prints published by the same person. Marcello Silver (Silber) for example was a prominent Roman publisher of books between 1510 and 1530.[10] Ferdinand bought a number of books from his press when he was in Rome in 1512 and 1515.[11] He also owned at least one large-format single-leaf impression of a *Music Sheet* from the Silver press [inv. no. 3096]. These prints would certainly have had the same point of sale as the books. A different form of this marketing procedure is the sale of prints that were used as both book illustrations and single-leaf impressions. Examples include the sixty-three prints from the *Salus Animae* produced in the Dürer workshop [see inv. no. 46] and the many prints by Erhard Schön and Hans Springinklee in Ferdinand's collection. In addition to being used to illustrate their respective texts, these prints were also sold independently.

Several entries in the print inventory provide tantalising information about the possible operations of a bookseller. Inv. nos 3075 and 3076 describe a pair of prints that list the titles of books.

[3075] Eleven titles of books, the first reads *Valerius Maximus ad comento*, the second *vita plutari* and the last of all *aug ses de diebus* [?].

[3076] Eleven titles of books, the first one reads *Boetius de Consolatione*, the second reads *Burleus super arte Betari* and the last of all *egidius super posteriora*.

These prints do not survive in any known impression, but were possibly a sort of advertisement that listed the stocks of a particular bookseller.[12] The titles listed on the prints refer to Plutarch, *Parallelae, sive Vitae illustrium vivorum*,[13] Boetius, *De consolatione philosophiae*,[14] Valerius Maximus, *Facta et dicta memorabilia*,[15] Walter Burley, *Super octo libros Phisicorum*,[16] and one of a possible three works by Egidius Romanus.[17] It cannot be coincidental that Ferdinand owned copies of all these books. It is fascinating that these sorts of prints were being produced and found their way into Ferdinand's print collection, strengthening the idea that books and prints had the same point of sale.

Precedents for the Columbus print collection

The evidence for print collecting during the late fifteenth and into the early sixteenth century is only fragmentary; however, there are reasons to think that the activity was widespread. During his lifetime the Nuremberg medical doctor, humanist and bibliophile Hartmann Schedel (1440–1514) acquired several hundred prints, some of which today survive in the Bayerische Staatsbibliothek in Munich.[18] Schedel mainly pasted them into his books to illustrate their text. Schedel's acquisition of prints lacked the system he applied to organising and accumulating his library.[19] The prints he owned were mainly local productions, including engravings, metalcuts and woodcuts, many of which he coloured himself.

Another fifteenth-century collector, the Parma notary Jacopo Rubieri (Jacobus de Ruberiis), pasted prints into juridical notes but was less attentive to the relationship between the text and image than Schedel. Evidence of comparable print-collecting practices in Spain has not yet been discovered but, given the large number of libraries there, it seems likely that prints were collected along the same lines as discussed above, pasted into books, on to papers and so on. The significant feature of the early collections is that prints were supplementary to an existing format. The relationship between form and function was clearly circumscribed, which is hardly surprising given that one of the main purposes of the fifteenth-century print was to provide cheap book illustrations.

The practice of pasting prints into books occurred on different levels during the fifteenth century.[20] In the case of Schedel, the relationship between text and image was loose, but there are other cases where the prints and the text were interdependent. A rare example is a fifteenth-century Latin prayer book in the British Museum that is written on vellum, illuminated and containing a number of engravings by Israhel van Meckenem depicting the Passion of Christ (fig. 5).[21] This book is a valuable indication of the shift in the use of prints. The engravings exist on separate

FIG. 6 | Michael Wolgemut and Wilhelm Pleydenwurff, *Samson Razing the House at Gaza*. Woodcut, 256 × 172 mm, *c*.1491 (The British Museum, 1973 U. 1173 [24]).

FIG. 5 | Israhel van Meckenem, *Christ before Pilate*. Engraving pasted into a Latin prayer book, second half of fifteenth century (The British Museum, 1897-1-3-7, fol.28v & 29r).

pages facing the text and have a gold inner border and a marbled surround. Their function was not to emulate an illuminated manuscript but, rather, to complement the conception of the book by providing ready-made illustrations.

Towards the end of the fifteenth century, there were growing signs of prints transcending their bindings precisely because of their technical achievements and the subsequent appreciation of them. The crossover was the production of images that functioned as both book illustrations and single-leaf impressions. For example, both Schedel and Columbus owned an impression of a woodcut depicting *Samson Razing the House at Gaza* (fig. 6) that is framed by a decorative border. The same print without the border illustrated the *Schrein oder Schatzbehalter* (Anton Koberger, Nuremberg, 1491).[22] The border embellishment implies a conscious attempt to differentiate the print from the text, even to elevate its status, perhaps for a more discerning clientele.

Sixteenth-century print collections

Ferdinand Columbus's print collection can be recognised as the first we know of in which prints existed as a separate entity within his library, and as such it represents the beginning of a 'second phase' of Renaissance print collecting. The remains of later sixteenth-century collections also reflect upon Ferdinand's enterprise (see chapter 4). This is because the same concerns of classification and storage confronted later collectors, and there is continuity in the systems of ordering directed by the physical nature of the object that continue to this day.

The available evidence, although fragmentary, confirms that collecting prints as independent items in the first half of the sixteenth century in Italy and northern Europe was widespread, especially in the main centres of printmaking.[23] The collection of Konrad Peutinger (1465–1547) is roughly contemporary with Ferdinand's and, although a detailed inventory of his prints has not survived, the inventory of his entire collection mentions prints stuck into books and others kept loose.[24] In 1530, Marcantonio Michiel records seeing in the house of Antonio Foscarini in Venice

a 'book of prints by several hands'.[25] The Venetian collector Gabriele Vendramin (d. 1552) amassed an enormous collection that included books, manuscripts, sculptures, drawings and a large number of prints, all of which were housed in the 'Camerino delle Antigaglie' in the Palazzo Vendramin at San Fosca in Venice.[26] The inventory compiled in 1567 and 1569 after his death frequently mentions woodcuts and engravings in various contexts. The collection assembled in the 1560s by Cardinal Scipione Gonzaga comprised prints arranged in great books.[27] Late sixteenth-century collections include that of Philip II at the Escorial, which consists of almost 7,000 prints, mostly engravings, but also a small number of etchings and woodcuts, contained in thirty-six albums and organised topically.[28] Philip's collection at the Escorial and that of his cousin Ferdinand, Archduke of Tyrol, at Schloss Ambras, containing around 5,000 prints also in albums with drawings, are the only two aristocratic print collections from the sixteenth century to have survived relatively intact.[29]

The librarian to Albrecht V of Bavaria, Samuel Quiccheberg, published in 1561 the only treatise from the sixteenth century that discusses the principles for organising a print collection.[30] It was the first detailed scheme for arranging an encyclopaedic collection and takes the form of inscriptions for ordering knowledge by topics. Prints come under the last of five classes, 'Pictures', and the text recommends that engravings and maps be located in the library by themselves. The diversity of the pictorial categories demonstrated by Quiccheberg's taxonomy was the outcome of the rapid development of the print and the wealth of subject matter it incorporated by the time he devised it.[31] Throughout his treatise, Quiccheberg advises on practical matters of storage. For the loose-leaf prints he notes the importance of keeping them together between covers that have distinctive titles. The folders seem to be conceived as a temporary measure and the prints would eventually have been bound into 'individual books separately compiled'. Quiccheberg's method provides something of a context for Ferdinand's collection because the systems he employed must have derived from then current or earlier practices. There is no suggestion that later sixteenth-century collectors knew of Ferdinand's print collection or his classifica-

tions, but the physical nature of the object, the desire to collect it and the subsequent necessity to house and organise it were the common ground.

Ferdinand's motivation for buying prints

Ferdinand probably began collecting prints in earnest on his 1520 trip through Europe (see chapter 2). What might have been the prime motivator? His time in Rome certainly exposed him to the world of prints, but there is no evidence that he bought in large numbers at that time. In fact, the smattering of prints by important Italian printmakers such as Marcantonio, Campagnola, de' Barbari and so on in his collection would suggest that he was not buying when presumably they were available in great numbers. The reason for Ferdinand's increased interest in prints possibly lies in his direct contact with Albrecht Dürer and the latter's lasting influence.

On 12 July 1520, Dürer and his wife Agnes left Nuremberg for the Netherlands, where they spent a little under a year. He recorded his experiences in great detail in his diary.[32] The main purpose of the trip was to meet Charles V who, he hoped, would confirm the annual pension awarded to him by Emperor Maximilian. He also wanted to sell his woodcuts and engravings, and for this reason carried many sets. As Dürer's diary reveals, his time in Antwerp was largely taken up with this task. On one occasion he sold sixteen sets of the *Small Passion* engravings.[33] During his journey, Dürer mixed with noblemen, royalty and various dignitaries from the court of Charles V. In Antwerp he entrusted to Gilles von Apfennauwe – a Gentleman at the imperial court – a number of his prints to present as a gift to the sculptor Konrad Meit.[34] Dürer also socialised with Jean de Metenye, the Grand Marshal of the Emperor,[35] dined with the Count of Nassau and was on good terms with the Archduchess Margaret of Austria.[36] Dürer was in Aachen when Charles V was crowned emperor on 23 October 1520.

From July to late October 1520, there were regular opportunities for Ferdinand's and Dürer's paths to cross. Ferdinand

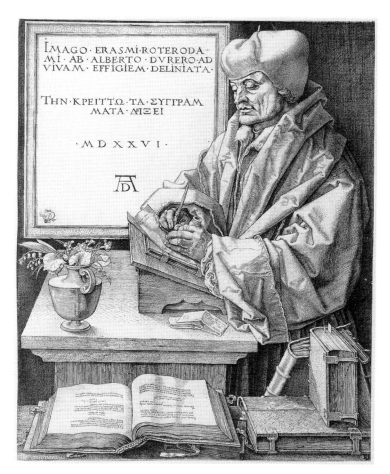

FIG. 7 | Albrecht Dürer, *Desiderius Erasmus*. Engraving, 250 × 190 mm, 1526 (The British Museum, E.3-30).

was attached to the court of Charles V and accompanied him on his travels leading up to the Diet of Worms in early 1521. His first point of contact with Dürer might have been in Brussels where Dürer arrived on 27 August and remained until 2 September. Ferdinand was there for periods in June, July and in August from the 26th. Ferdinand's and Dürer's itineraries corresponded at several points after that; they were both in Aachen in late October and in Cologne in November, where Dürer was granted his imperial pension of 100 florins a year on 13 November. Dürer had given Erasmus an engraved *Passion* in early September;[37] Ferdinand met the latter soon after on 7 October, receiving from him a copy of his *Antibarbarorum liber unus* which he proudly

inscribed several times.[38] Because of Dürer's networks and because he was the most highly regarded artist of his age,[39] Ferdinand must have at least known of his reputation. Furthermore, the frequent annotations in his print inventory, 'this print is truly by Albrecht [Dürer]', express Ferdinand's admiration for his work [e.g. cat. nos 35a, 42a]. It is not impossible that Ferdinand was one of those to whom Dürer sold his prints.

Erasmus was very aware of the efficacy of the multiple image and used it to great effect to promote his own likeness.[40] There are a number of instances in his letters where Erasmus mentions sending prints to various correspondents.[41] In 1526, Dürer engraved the memorable portrait of Erasmus in which he is shown working at his desk with his books displayed to the viewer (fig. 7).[42] Erasmus greatly admired Dürer, and in *De pronuntiatione* observed: 'What cannot Dürer express in monochromes, that is, by black lines only (even though other techniques of his deserve admiration also)?' Ferdinand's meeting with Erasmus in early October 1520 had an enormous impact on him, but if Erasmus's recognition of Dürer's printmaking ability was not enough, then his clear appreciation of the printmaking medium would surely have reinforced any burgeoning interest Ferdinand had in prints and print collecting.

The movement of Ferdinand's prints

No documents relating to how the prints reached Seville have survived, but Ferdinand's book purchases provide a framework for their movement. Because Ferdinand bought the prints at the time he was buying books, many presumably from the same sources, they must have been sent to Spain together.

In 1521, when he arrived in Venice, Ferdinand secured a loan from the Genoese banker Grimaldi to pay for book purchases.[43] From Venice, he despatched a large shipment of books and prints to Seville, but that shipment never reached its destination, being lost in a storm at sea. Where the ship sank is not recorded, but the route to Seville was through the port of Cádiz, and followed the Guadalquivir River upstream. Sea transport was around four times cheaper than land transport but ran the con-

stant risk of piracy and storms, a lesson hard-learnt by Ferdinand.[44] In the *memoria* – the document regarding the organisation of Ferdinand's library – Juan Pérez writes that 'the books, together with many excellent prints, were sent in the boat that sank' (*pero esto libros con mucho debuxos y pinturas muy eçeleentes se perdieron en una carraca que se anego*).[45] This confirms that prints and books were sent together. There is every indication that, given the large numbers of objects Ferdinand bought, there was more than one shipment. In the short period between Worms in mid-December 1520 and Venice in early May 1521, he bought around 1,600 volumes. It would have been difficult to travel very far with such a large load, and before reaching Venice he probably sent a shipment from Genoa.[46] He no doubt also sent prints with that shipment which he had bought in the Low Countries and Germany.

Ferdinand was very concerned with establishing a procedure to augment his library in perpetuity and to set up standing orders with a network of booksellers throughout Europe for that purpose. The booksellers he targeted were those with whom he had regular dealings. They are referred to in Ferdinand's final Testament as being located in Rome, Venice, Nuremberg, Antwerp, Lyons and Paris. The proposed augmentation of his collection after he died depended on the co-operation of the corresponding merchants. In April of each year, a representative in Seville was to make contact with a bank or major merchant in Lyons and deposit 100 gold ducats. The agent in Lyons would write to his contacts in the other five cities who then entrusted the required books to a known bookseller. The booksellers in each city sent the books to Lyons with their bill 'following their conscience and good credit' (*segun su conciencia y su buen credito*). The Lyons merchant settled the account and sent the books on to Medina del Campo in time for the fair in May where the Seville representative collected them.[47] Additionally, the Testament recommends that, every six years, an employee of the library should travel abroad with the following procedures and itinerary for buying:

> With respect to the comfort of leaving the books that
> he has bought in different places so that they can
> be sent to Seville from each place, if that is not pos-
> sible all the books bought in Naples and Rome, Siena

and Pisa, Lucca and Florence can be sent to Rome packed in bundles by means of the Genoese merchants who live in each of these towns. … With respect to the shipping of the books they will be sent from Naples to Florence and shipped in Rome where the correspondent will send them to Cádiz and from Florence the abridger will send them to Bologna and there he will follow the same procedure thus looking for bookshops as already explained. From Bologna he will go to Modena and to Parma to Piacenza and Pavia and to Milan which are just half a journey from each other. In each of the towns where there are booksellers he must undertake the same arrangements to look for books. From Milan he will go to Lodi and from Lodi to Cremona, from Cremona to Mantua, from Mantua to Venice, from Venice to Padua, from Padua to Treviso and books bought in all these towns will be gathered in Venice since it is easier to ship those which are marked and to send them along the river and the channels that link most of these towns to Venice where they can be delivered either to the correspondent or to one of the Genoese merchants who will ship them to Cádiz.[48]

This passage is fascinating for its careful programme of book-buying based on Ferdinand's own experiences of where the main booksellers were. Venice and Genoa are identified as the principal ports from which the books could be sent, because it was easy from those places.

It seems that Ferdinand did not rely much on books being sent to him through standing orders, and that he preferred to buy directly is suggested by his regular travels and comments in the Testament referring to the efficacy of buying from the major publishing centres. The same patterns emerge with Ferdinand's print purchases; they were all bought when he was travelling throughout Europe, but there is no indication that he intended the print collection to be added to after he died. It is unlikely that Ferdinand bought many of his prints in Spain. Only two, one of the *Virgin of Monserrat* [inv. no. 1035] and a *Cross made from Saints*

[inv. no. 2452], both of which carried Castilian verse, were possibly produced there.

It is critical to keep in mind the concentrated time-frame of Ferdinand's travels. For example, between 26 June 1520 and 13 December of the same year he travelled to Brussels, Ghent, Louvain, Cologne and Worms and all the towns in between. His print purchases were dictated by what was available then. His collection would have been very different if he had lived permanently in a great centre of printmaking activity such as Venice or Antwerp. The logical conclusion, that Ferdinand collected 3,200 images while on the move between important centres of print production, indicates the sheer size of the print industry during the first decades of the sixteenth century.

What type of collector was Ferdinand?

To gauge what sort of collector Ferdinand was, his travels must be set against the prints that were available for purchase at the time he was buying. Whereas he began to buy books seriously around 1512, his print collecting seems to have begun in earnest only around 1520, motivated perhaps by his putative contact with Dürer. This is not to undermine his earlier interest in visual representations, evident from early in his life. Ferdinand sent 238 books in four chests from Santo Domingo when he returned to Spain in 1509. Among this treasure were a quantity of 'charts or maps, various documents and papers, three sheets of my paintings, colours for painting …' (*cartas o mapas y diversos documentos y papeles, tres pliegos de pinturas mías, colores para pintar*).[49] The 'cartas' and 'mapas' refer to nautical maps and charts but the 'tres pliegos de pinturas mías, colores para pintar' probably refers to pictures he himself had made.[50]

Broadly speaking, the print collection seems to have comprised whatever Ferdinand could lay his hands on. For example, there are twenty-two prints by Lucas van Leyden, six engravings and sixteen woodcuts. *Joseph Interpreting his Dreams to Jacob* [inv. no. 295, fig. 8] is the only engraving from the series of five prints depicting the story of Joseph. Ferdinand owned an impression of

David, Solomon and Rehoboam [inv. no. 2541, fig. 9] but not the other four sheets as single-leaf impressions that make up the series. He did, however, own the entire frieze as a roll [inv. no. 2712]. There is no obvious reason why Ferdinand would have wanted only one print from a series. The only explanation can be that he bought what he could, when he could, and sometimes only part-sets were available.

Ferdinand evidently regarded prints separated from a series, or sections of composite images, as acceptable. The fact that he sometimes bought two impressions of a print that occurred in different formats also indicates his voraciousness. Cornelisz. van Oostsanen's series *Saints on Horseback* comprises at least six woodcuts [cat. no. 105]. From the series, Sts Adrian, George, Quirinus of Neuss and Sebastian each occur in three different impressions: as single leaves with text beneath the image, as single leaves with no text beneath the image, and finally in a roll format.

To say that Ferdinand was a collector who bought every-thing he could lay his hands on should not imply that he bought indiscriminately, with no eye for quality. It suggests rather his enthusiasm for prints and his desire to collect them at a critical point in their history when they were first being collected in their own right. Ferdinand's fastidious inventory is evidence of his serious intentions. Availability was a determining factor, but his collection contained many prints that were produced for the upper end of the market. There are sufficient indications in the inventory to suggest that the quality of a print was also an issue for Ferdinand. Their condition and quality is sometimes commented upon in the entries. Some entries indicate that a print was of outstanding quality. The entry for an unidentified print of *Justice and Nero* [inv. no. 1641] mentions 'y en torno ay un lazo muy bien pintado'. The sixteen-sheet-long *Triumph of Christ* was 'colorido de colores finas' [inv. no. 2823]. Other prints are singled out for their poor quality. A large print depicting a boat is described as being badly coloured 'es a colores maldadas' [inv. no. 2639].

The inventory also indicates what was available when Ferdinand was buying. For example, there is a striking absence of small fifteenth-century woodcuts.[51] The woodcuts of this period that Ferdinand owned are all relatively large. It is difficult to know exactly why there are so few small fifteenth-century woodcuts, given his affinity with small works, but it was probably because the majority of them were coarsely cut devotional images that he would not have wanted in his collection. Furthermore, because of their devotional function, many thousands were produced and they were highly disposable. Unless there was an active second-hand trade in such images, it is unlikely that the places where Ferdinand bought his prints also sold such rudimentary images. The predominance of larger fifteenth-century prints is also significant insofar as it indicates that there might have been a residual trade in these more eye-catching compositions [cat. nos 1, 4, 21].

As for the origin of the prints in Ferdinand's collection, a percentile breakdown provides a startling contrast. Prints of the German school (including Swiss) comprise *c.* 70 per cent, Italian prints *c.* 20 per cent, Netherlandish *c.* 10 per cent. In addition to the German majority, what is striking about Ferdinand's collection is the overwhelming preponderance of woodcuts. Of the identified prints, woodcuts outnumber engravings five to one. This might be because prints of religious subject matter dominated Ferdinand's collection and religious prints in the late fifteenth and early sixteenth centuries fuelled the woodcut industry. By far the majority of engravings are German and mainly by Israhel van Meckenem and Albrecht Dürer. Because of Ferdinand's strong financial position it is highly unlikely that he would have avoided buying engravings simply because they were generally more expensive. With the exception of Marcantonio Raimondi's *Portrait of Raphael* [cat. no. 7] from around 1518, all of the Italian engravings were produced earlier. Those by Nicoletto da Modena are dated around 1510–15 [cat. nos 8, 9] and there are a few fifteenth-century engravings such as Antonio Pollaiuolo's *Battle of the Nude Men* [cat. no. 1].

It is not easy to discern any clear patterns in Ferdinand's engraving purchases. They include works of all sizes and subjects from all the countries through which he travelled. What is striking is that given the amount of time Ferdinand spent in Italy as a young adult, he owned extremely few engravings by signifi-

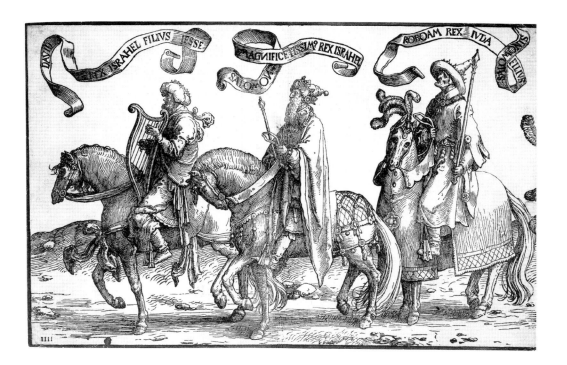

FIG. 9 | Lucas van Leyden,
David, Solomon, and Rehoboam.
Woodcut, 320 × 498 mm, *c.*1520
(Rijksprentenkabinet, Rijksmuseum,
Amsterdam, RP-P-B.J.6236-A).

cant Italian masters such as Marcantonio. This could mean either that such prints were not available at the time he was buying, or that he did not particularly care for Marcantonio's prints. The prints he owned are small: *St Jerome* [cat. no. 6] and the *Portrait of Raphael* [cat. no. 7]. Ferdinand did not own any of the large ambitious engravings Marcantonio produced together with Raphael. One reason that might explain the absence of highly regarded works by masters like Marcantonio is that they were no longer available for purchase by the time Ferdinand was in Italy, after his acquisition of prints really took off. But another possible reason is that Ferdinand did in fact buy large numbers of Italian engravings and they were amongst those lost at sea in 1521 (see above). If this was the case, the absence of more striking Italian works in the inventory means that on subsequent trips he was not able to replace them, leading to a secondary hypothesis: that from around 1530 on, they were in fact very hard to come by. There is no way of knowing if this is the case but it must be offered as conjectural.

The subjects of Ferdinand's prints

Seventy per cent of the prints described in the inventory are of religious subjects. It is not possible to say if this religious majority absolutely reflects what was produced during the period, but it would appear to be a relatively accurate proportion.

The rise of the print medium provided the means for an expanded repertoire of imagery that had not before been the subject of independent representation. That prints could be produced in multiples was an added impetus for new representational genres to emerge, because there was more of a return on selling multiples than on single impressions. Quiccheberg's subject categories, discussed earlier, which reflect what was available around 1560, include many subjects not to be found in the prints Ferdinand owned by 1539. They were just emerging (for example, numismatics), and were not categorically defined. The contrast is revealing, and demonstrates that as the printmaking industry evolved, the subject canon expanded.

FIG. 10 | Jacob of Strasbourg (Jacobus Argentoratensis), scene from *The Passion of Christ* pasted on choir-stalls in the Chapel of Santa Chiara in the church of San Damiano in Assisi. Woodcut, *c*.1500–25 (photo J. Michel Massing).

To use Ferdinand's inventory as if it were a guide to the complete range of subject matter available in print during his lifetime as a collector would be wrong. It must again be emphasised that his travels and his limited exposure to markets constricted his buying. We know that there were categories of subject being produced that he did not own. Given his voracious appetite, it is likely that he would have bought them had he had the opportunity. A number of emerging subject categories are only marginally represented in Ferdinand's collection. Prints depicting costume are one example. The need for depictions of costume (and customs) was motivated in part by the discovery of the New World, the interest in exotic subjects, and also a greater awareness of ethnic groups, for example the Turks, whose attempts to conquer Christian Europe meant that they were often depicted. Although not strictly representative of costume, Hans Burgkmair's woodcuts of *The Peoples of Africa and India* [cat. no. 56] reveal a fascination for the dress of the people he depicts. Prints of astronomical subjects are represented by Dürer's *Map of the Northern Sky* [cat. no. 45]. Astronomical imagery had long been represented in manuscripts and, from the mid-fifteenth century, in printed books. It began to appear more frequently in prints when the need for nautical maps coincided with increased travel.

Painted portraits certainly existed in the fifteenth century, but printed portraiture developed only in the first decades of the

sixteenth, at a time when the ruling classes became increasingly aware of the value of reproducing and distributing images of themselves. Most of the portraits in Ferdinand's collection are of royal or noble persons. Examples include Hans Weiditz's *Emperor Charles V* [cat. no. 60] and the striking twin portraits of the *Duke* and *Duchess of Gelders* [cat. nos 102 and 103]. One of the rare non-noble portraits Ferdinand owned was Hans Burgkmair's *Jacob Fugger the Rich* [cat. no. 58]. The sitter's wealth made him one of the most powerful figures during the period and thus worthy of portraying.

Considering the large number of prints depicting classical subjects that were produced in the early years of the sixteenth century, it is surprising that so few are described in the inventory. Giovanni Battista Palumba's *Mars, Venus and Vulcan* [cat. no. 12] is a notable example. There are no prints depicting antique statuary, classical architecture or motifs, or any other subjects associated with the humanist interest in antiquity.

There is an almost total absence of broadsides. This area of print production was gathering momentum around the time Ferdinand was collecting, but it seems that he was interested only in buying prints where the image was principal and not subservient to the text. The roll by Lucas van Leyden, *The Nine Worthies* [cat. no. 100], for example, had a text panel running along the bottom of the image and the same occurred in Hans Burgkmair's woodcut of *Peoples of Africa and India* [cat. no. 56]. In both prints, the image provides the principal focus of interest and the text serves as an explanatory key.

Large-format prints

By virtue of their size and subject, small prints could be handled with ease, pasted into books to illustrate a text, gathered into albums, made into a small altar or pinned on to walls. This is not the case with very large prints, the majority of which have not survived. The following discussion of the rolls considers their subject and format as indicators of their function, which, until the analysis of the Columbus inventory, is a field of Renaissance printmaking

that has been poorly understood through lack of evidence.[52]

The rolls described in the inventory can be divided into two broad groups, those that are larger versions of subjects represented in small sizes, for example Christ Crucified or St Sebastian, and multi-figure compositions that were rarely if ever represented in smaller sizes. These large religious compositions must have been pinned to walls as temporary decoration for events of religious significance or in place of more permanent images. Saints' days, festivals, sites of devotional focus called for such decoration. Rolls of religious prints were also used for more permanent decoration. For example, sections of Jacob of Strasbourg's *The Passion of Christ* were pasted on to the ends of stalls in the chapel of St Clare in the Church of San Damiano in Assisi (fig. 10).[53] This

FIG. 11 | Donat Hübschmann, *St Stephen's Cathedral.* Woodcut, 582 × 390 mm, *c.*1566 (The British Museum, 1867-7-13-97).

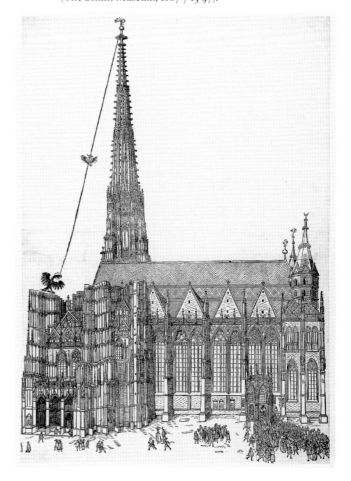

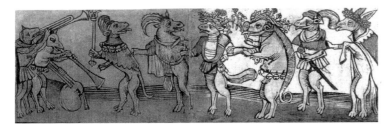

FIG. 12 | Anonymous German, *Animals Cooking, Dancing and Playing Instruments*. Woodcut, *c*.240 × 365 mm, *c*.1460–80 (Herzog Anton Ulrich-Museum, Brunswick. One of two sections).

FIG. 13 | Dürer Workshop, *Decorative Panel with Four Pomegranates*. Woodcut, 392 × 281 mm, *c*.1520 (Graphische Sammlung der Universität Erlangen-Nürnberg, Erlangen, AH 409).

example is significant insofar as it indicates that some prints originally conceived as a roll could be cut up to fit small spaces, differentiating them from the large-format frieze that could not be subdivided because of the continuous subject.

All the large prints of religious subjects (a standing saint, the Virgin and Christ Child and so on) apart from those comprising images relating a narrative convey unambiguous messages that could be read easily. The most complex of these – the lives of the Virgin and Christ, or the Mass of St Gregory – were part of an established iconography that was widely understood. The Mass of St Gregory, for example, would have directly engaged the viewer in its readable message as a form of sacramental seeing.[54] Understanding the image did not involve complex interpretation or explanation, but relied on the immediate absorption of its content. None of the rolls of religious images described in the Columbus inventory represented difficult biblical narratives or the lives of obscure saints. Just as large printed images were no doubt hung in the interiors of churches, the same subjects were sometimes hung or painted on the outside. One example is St Christopher, shown in a large print hung to the right of the entrance to St Stephen's Cathedral in Vienna in a woodcut by Donat Hübschmann (fig. 11). The purpose of this practice was that, from a distance, a person approaching the church could easily assimilate Christopher's significance as the patron saint of travellers and the bearer of Christ. The same devotional intention applied to large images of St Roch, as the protector against plague.

The second group of large-format prints consists of those depicting secular subjects, almost all of which have vanished. Many of these rolls depict popular and humorous subjects, including a huge ten-sheet *Fat Man at a Table* [inv. no. 2743] and *Animals Cooking, Dancing and Playing Instruments* [inv. no. 2966, fig. 12]. Others of social subjects include *Lines of Lovers* [inv. no. 2796], *Men and Women Dancing* [inv. nos 2695, 2709] and so on. It is not difficult to imagine the prints that depict animals (or people) dancing and cooking pinned to walls for peasant festivals and weddings.

Some entries describe chivalrous subjects that were also very popular during the early sixteenth century. The most often repre-

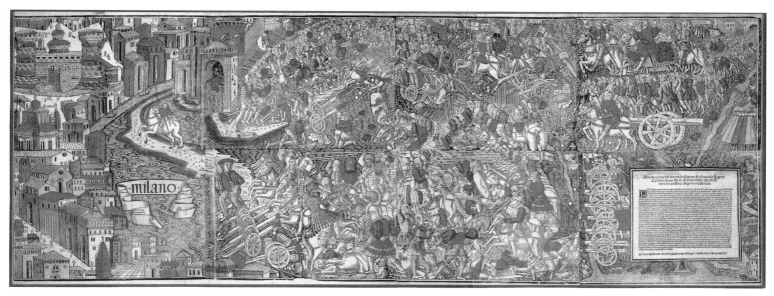

FIG. 14 | Giovan Andrea Vavassore, *The Battle of Marignano*. Colour woodcut, 555 × 1525 mm, *c*.1515 (Zentralbibliothek, Zürich, 307).

sented are the Nine Worthies [cat. no. 100], heroes on horseback [inv. nos 2693, 2694] and various triumphs and noble processions [inv. nos 2736, 2740, 2751, 2758]. Another function of print rolls about which little is known is their use as wallpaper. The Dürer Workshop *Decorative Panel with Four Pomegranates* (fig. 13) was meant to be part of a repeated pattern.[55]

Very few multi-sheet rolls depicting battles have come down to us. An example is the unique *Battle of Marignano* [inv. no. 2815, fig. 14], which was perhaps carefully guarded because it was so beautifully coloured. Several coloured impressions of Robert Peril's *Genealogical Tree of the House of Hapsburg* [cat. no. 109; the spelling for the Spanish branch] have survived, no doubt because of its topical interest. In a combination of text and images in

roundels, each member of the Hapsburg lineage is depicted and described. Indeed, a later impression of the print had a section depicting Philip II added after he ascended the throne, further reinforcing its relevance as a lasting document.[56]

This brief overview of the rolls of prints Ferdinand owned reveals a facet of the Renaissance printmaking industry that, although it cannot be precisely defined, can be better understood. Their large numbers in the inventory, together with the fact that Ferdinand made his print purchases during brief periods of time, point to an industry that must have been enormously productive, satisfying a market that needed both instant, relatively cheap images for specific functions and others carefully embellished as lasting and impressive documents of historical significance.

1 See Landau and Parshall, 1994.
2 Eisenstein, 1979.
3 See especially Levenson *et al.*, 1973.
4 Hind, 1938–48. Also *The Illustrated Bartsch*, commentary volumes 24 and 25 (all parts).
5 For the books see Segura Morena, Vallejo Orellana *et al.*, 1999; also Marín Martínez, Ruiz Asencio *et al.*, 1993.
6 For Titian see Rosand and Muraro, 1976.
7 Landau and Parshall, 1994, p. 284.
8 Wagner, 1984; also Beaujouan, 1960, pp. 152–8.
9 Rhodes, 1958, pp. 231–48.
10 British Museum, 1958, pp. 953–4.
11 Segura Morena, Vallejo Orellana *et al.*, 1999, p. 950 and corresponding entries.
12 See Richardson, 1999, p. 37.
13 Segura Morena, Vallejo Orellana *et al.*, 1999, no. 1011, p. 526.
14 Segura Morena, Vallejo Orellana *et al.*, 1999, no. 208, p. 143.
15 Segura Morena, Vallejo Orellana *et al.*, 1999, no. 1222, p. 634.
16 Segura Morena and Vallejo Orellana, 2001, no. 726. The reference to ' Burleus super arte Betari' is not entirely clear: 'arte Betari' might be a mistranscription of the publisher Andree Torresani de Asula. The entry might refer to Walter Burley's *Burleus super Libros Ethicorum* (Segura Morena and Vallejo Orellana, 2001, no. 725, p. 349).
17 The description of the title is not sufficiently transparent in the inventory entry, but it could be his commentary on Aristotle's *Analytica Posteriora*. Segura Morena, Vallejo Orellana *et al.*, 1999, nos 419, 420 or 421, pp. 246–49.
18 See Hernad, 1990.
19 Landau and Parshall, 1994, p. 64.
20 Schuppisser, 1989, pp. 389–97.
21 British Museum, 1897-1-3-1…12. Shelfmark 158 b.1*. Hollstein, 1954–, xxiv, 142–53.
22 Hernad, 1990, cat. no. 65, pp. 232–3.
23 Bury, 1985; Landau and Parshall, 1994, pp. 64 ff.
24 See Künast, 2001.
25 Landau and Parshall, 1994, p. 289.

26 Ravà, 1920, pp. 155–81.
27 Bury, 1985, p. 16.
28 McDonald, 1998, pp. 15–35.
29 Parshall, 1982, pp. 139–84.
30 Hajós, 1958, pp. 151–6; also Roth, 2000.
31 Hajós, 1958, p. 153.
32 See Goris and Marlier, 1971; also Conway, 1889.
33 Goris and Marlier, 1971, p. 58.
34 Goris and Marlier, 1971, p. 62.
35 Goris and Marlier, 1971, p. 65.
36 Goris and Marlier, 1971, p. 68. For other people Dürer gave prints to see Grigg, 1986.
37 Goris and Marlier, 1971, p. 65.
38 Gil, 1989, no. 37.
39 See Bartrum, 2002.
40 See Jardine, 1993.
41 Jardine, 1993, p. 49 and no. 80, p. 222.
42 B.vii.107 [114].
43 Wagner, 1990, p. 53.
44 Richardson, 1999, pp. 37–8.
45 For the *memoria* see Chapter 4.
46 Wagner, 2000, p. 6.
47 For an explanation of the system see Wagner, 1992, p. 488.
48 McDonald, 2004, I, p. 289.
49 Marín Martínez, Ruiz Asencio *et al.*, 1993, p. 252.
50 See Jos, 1941, p. 525.
51 For a cross-section of the small prints see the volumes in the Heitz series: Heitz, 1899–1942.
52 See Appuhn and Heusinger, 1976.
53 Massing, 1977, pp. 42–4.
54 See van Os, 1994.
55 For a composite illustration see Appuhn and Heusinger, 1976, fig. 10, p. 18.
56 Hollstein, 1949–, xvii.2/IIIb. The British Museum, 1904-7-23-1.

2 | *The Life and Work of Ferdinand Columbus*

Family history and birth

Ferdinand Columbus was born in Córdoba on 15 August 1488, the natural son of Christopher Columbus (1451–1506) and Beatriz Enríquez de (H)Arana (c.1465–1522). Beatriz was the only daughter of Pedro de Torquemada and Ana Núñez de Harana, both from the mountain village of Santa María de Trassierra near Córdoba.[1] After Beatriz's father died, the family moved to Córdoba and when her mother died in 1471, Beatriz and her brother Pedro were placed under the guardianship of their grandmother, Eleonora Núñez, and their maternal aunt, Mayor Enríquez de Arana.[2]

Christopher Columbus's background is much better understood.[3] The eldest of five children, Christopher was born in Genoa to Domenico Colombo, a master weaver, and Susanna Fontanarossa.[4] During the fifteenth century, Genoa was a centre of international commerce and its port was amongst the busiest in Europe.[5] At the time the family moved to Savona on the coast northwest of Genoa around 1470 Christopher was almost twenty and old enough to launch his own career as a merchant. His early years in that capacity involved extensive travel around the Mediterranean.[6] In 1478, Columbus was in Lisbon – the capital of the Atlantic – as an agent for the Genoese merchant Paolo di Negro, who was shipping sugar from Madeira to Genoa. A year later Columbus married a Portuguese woman, Felipa Perestrelo y Moniz, and in doing so gained Portuguese citizenship and the right to trade in Portuguese territories. His wife was the daughter of Isabel Moniz and Bartolomeu Perestrelo, the first governor of the island of Porto Santo in the Madeiras.[7] Columbus's marriage was clearly advantageous, providing him with improved social and no doubt economic opportunities. The Perestrelo and Moniz lineage was one of the most noble, and the marriage introduced him to the world of wealth and power that trained him for his later dealings with the Spanish royal family. Christopher's first son, Diego, was born around 1480, probably in Porto Santo, soon after the marriage.[8]

Felipa Moniz died around 1484 in Porto Santo, before Columbus returned to Portugal in 1485. During that time, he was planning nautical expeditions, amongst them his idea of finding the Indies by sailing west into the Atlantic, rather than following the established practice of circumnavigating Africa. In early 1484, Columbus presented his scheme to King João II of Portugal. His petition was unsuccessful. The thought of travelling on the open sea for days on end to the shores of an unknown continent was met with incredulity and dismissed.

Christopher Columbus in Spain

Columbus realised quickly that there was little point in pursuing patronage in Portugal and in 1485 moved to Spain, no doubt attracted by the possibility of support from the Spanish monarchy, which was, at that time, the most powerful in Europe. Shortly thereafter, Columbus petitioned the monarchs to sponsor an exploratory commercial voyage west to Asia but, despite the promising circumstances, his proposal fell on deaf ears.

Columbus met Beatriz Harana in 1486 when he was in Córdoba trailing the court. They never married, but he considered his son from that union as his own, naming him after King Ferdinand. The reason Columbus did not formalise the union with Beatriz is possibly because of his subsequent fame, his ambition to achieve the trappings of the nobility, and the regard in which he came to be held by the Spanish court.[9] There were strict rules that forbade illustrious persons marrying women of an inferior social position.[10] Columbus did, however, provide some financial support, which appears to have been short-lived.[11] His interest declined as his fame ascended. Shortly after Columbus's death in 1506, Beatriz complained to Ferdinand that his brother Diego was slow in administering the allowance left to her by the Admiral.[12]

When Columbus and Diego returned to Spain after a brief trip to Portugal in 1488 they arrived in Huelva and continued to the Franciscan monastery of Santa Maria de la Rábida where Diego remained in the monks' care. At the monastery Columbus met Juan Pérez, who had trained in King Ferdinand and Queen Isabella's treasury office. During the years Columbus spent in Portugal, he had learnt of the successful explorations of Bartolomeu Dias who had discovered the route around the Cape of Good Hope. It is possible that Pérez apprised the Spanish monarchs of these developments which he heard from Columbus, thus re-igniting their interest in commercial exploration.

Columbus was relentless in his pursuit of royal patronage and lobbied members of noble Spanish families who had connections with the court. Powerful amongst them was the Duke of Medinaceli who, convinced by the strength of his proposals, supported Columbus financially and urged the monarchs to do the same. They finally took an interest in his plan and, in the summer of 1489, invited Columbus to the court, at the time resident in Jaén. Again his proposals were rejected; but through his insistence and his success in marshalling powerful support among members of the court, in early 1492 the sovereigns finally promised support in tandem with the financial backing of various bankers and noble families. The conditions agreed to by the monarchs are known as the 'Granada capitulations'. They decreed that once Columbus took possession of any island or continent he would become their hereditary Admiral of the Ocean Sea, Viceroy and Governor of what he discovered, and from then on, he and his descendants would be addressed as 'Sir'. Capitalising on the royal favour, in May 1492 Christopher secured for his sons Diego and Ferdinand the position of pages in the house of the heir to the throne, Prince Juan. They did not, however, arrive at the court until two years later, in 1494.

Columbus set sail on the famed first voyage from Palos (de la Frontera) on 3 August 1492. The voyage was momentous; he sailed to the West Indies across the Atlantic Ocean as he had predicted. He returned triumphant on 15 March 1493, and was immediately summoned to the court in Barcelona. At the court he was received as 'Admiral of the Ocean Sea' and duly referred to as 'Sir'. News of the discovery quickly spread and created much excitement as it promised endless opportunities for territorial expansion and increased wealth. Eager to capitalise on the promise of the first voyage, Isabella and Ferdinand quickly agreed to support a second, more ambitious voyage, which departed during

September 1493. Ferdinand and his brother Diego travelled from Córdoba to Seville and Cádiz to see their father off.[13] Shortly afterwards, the brothers entered the royal court as pages.

Ferdinand's early years in Córdoba and arrival at the court

Until 1494, Ferdinand lived in Córdoba with his mother. In 1488 – the year Ferdinand was born – Columbus sent his son Diego to Córdoba so that Beatriz and her family too could care for him. During their childhood, Columbus did not permanently reside in Córdoba, although he often visited the city to seek financial support for the Indies enterprise. Ferdinand was too young to have been fully aware of his father's success and the fame that grew especially after he returned triumphant from the first voyage in March 1493. But Christopher would have been an important figure at home. To be regarded as an explorer and moving in courtly circles carried considerable prestige, especially given the number of wealthy families in Córdoba who were associated with the court.

In March 1494 Ferdinand and his brother, accompanied by their uncle Bartolomé, left Córdoba and travelled to Valladolid to be presented at court. They arrived at a time when their family name was held in the highest regard. The office of page was normally reserved for the sons of the aristocracy. Details about how they arrived at the court are scarce but Bartolomé Las Casas recounts their arrival in the following passage:

> He [Bartolomé] left Seville to join the Court, which was in Valladolid, at the beginning of 1494, and he carried with him the Admiral's two children: D. Diego Colón, who was the eldest and the successor to his estate, as well as second Admiral of the Indies, and D. Hernando Colón, who was the youngest, so that they would serve prince don Juan as his pages, since the Queen had thus favoured the Admiral. When Bartolomé Colón and his nephews went and paid homage to the King and

Queen, the Catholic Monarchs welcomed them with joy and benevolence.[14]

Ferdinand's entry into the service of Prince Juan as a page marked the end of his life in Córdoba and his introduction into a completely new and fascinating world. The contrast between his home and the splendour of the court must have been remarkable; and its impact on Ferdinand was long-lasting.

The court of Isabella and Ferdinand

The marriage of Isabella I of Castile (1451–1504) to Ferdinand II of Aragón (1452–1516) in 1469 initiated an alliance of kingdoms that provided the basis for modern-day Spain.[15] Their initial programme was to expel the Moors from Spain and unite five kingdoms into one dominated by Castile. The kingdom of Granada was freed from the Moors' control in January 1492 and gave the monarchs the confidence to implement further radical changes in all other areas of their administration.[16] The reforms to the government were sweeping and left no institution untouched; standardised political instruments were developed to maintain order in their kingdoms. By 1500, the shape and character of Spain as a political and cultural unit was completely different from what it had been just twenty years before and Spain was becoming increasingly dominant as a European power.

The court was dominated by the personality of Isabella, who maintained a high public profile, controlled the treasury, named all the court officials and was effectively the decision-maker. Her peripatetic court travelled constantly throughout the Spanish kingdom. A key feature of Isabella's court was her patronage of artists and her love of culture, and she was the driving force behind artistic policy. A number of painters made their living almost exclusively from court patronage, such as Juan de Flandes, Melchior Aleman and Michael Sittow, who was appointed court painter by Isabella in 1492.[17] Isabella's conspicuous patronage of the arts established a fashion that was followed by the noble families in Spain. Her collections showed a distinct preference for Flemish

artists, almost to the total exclusion of Italian. Her cultural reforms extended to her direct intervention in the regulation of trade, such as the abolition of duties on books in 1480, which had an enormously positive effect on the printing industry in Spain.[18]

Isabella's lack of interest in Italian art has never been fully understood because she enthusiastically patronised Italian scholars. During the mid-fifteenth century Italy was the centre of humanism, and Spanish scholars – including Juan de Lucena and Alonso de Palencia – went there and brought back new understanding of Latin literature and Renaissance thought. Humanists from Italy also came to Spain. The most renowned was Peter Martyr d'Anghiera, who arrived at the court in 1488 to establish a school of humanistic studies.[19] Isabella gave Peter Martyr the momentous title 'professor of the nobility in the court', apparently with the intention of trying to keep the young men of the court occupied by educating their minds, rather than allowing them to indulge in amorous activities. In addition to Peter Martyr, the court supported other distinguished scholars, including the Castilian grammarian Antonio de Nebrija who had returned to Spain in 1476 after twelve years in Italy. In 1492, Nebrija published the first book of Castilian grammar, the preface of which carried the famous phrase 'language is the instrument of empire' that reflected the aspirations of the new regime.

Renaissance humanism was in the service of the state, and both Ferdinand and Isabella were strong supporters of the new learning. Latin had to be learnt as an essential prerequisite of service in diplomacy, administration and the church. In order to sustain these changes, renovating the education system was one of Isabella's and Ferdinand's most important objectives. When they first assumed control of Spain, the only distinguished university was that of Salamanca. During their reign, academies were established in Alcalá de Henares, Granada, Seville and Toledo.

Uppermost in the minds of Isabella and Ferdinand was the need to maintain the new order they had created. To achieve this, they educated their children (Isabel, Juan, Juana, Maria and Catherine) not only in statecraft but also in the importance of maintaining political control through symbols of refinement, the most potent of which was artistic patronage. Prince Juan

(b.1476) was the eldest son and his well-being and education were critical for perpetuating that which the monarchs had instigated. Juan had his own court and was attended by some of the most learned and distinguished men in Castile, as well as a household staff most of whom were from the lesser nobility. The pages formed an important part of the prince's court. Fernández de Oviedo writes how 'all the sons of grandees and of the heads of the main families of the kingdom were engaged as pages to the Prince, as well as many other sons of illustrious gentlemen without title', listing their names but not describing their duties.[20]

Ferdinand's education in the court

Apart from intellectually embellishing the court, one of the principal responsibilities of the resident scholars was to instruct the prince and other young men who were part of his retinue. Each scholar had different teaching responsibilities. The prince's principal tutor was the Dominican Fray Diego de Deza who had been called from his theological position at the University of Salamanca in 1486 to take charge of Don Juan's education.[21] Deza's main responsibility was to teach the prince to read and write. His methods were no doubt complemented by those of Peter Martyr, who concentrated on the Liberal Arts. The prince's education followed an established humanist programme. The subjects were catechism, Latin and Castilian grammar, sacred and profane history, philosophy, heraldry, drawing, music and singing.[22] The pages were taught the same subjects. Some details about how the classes were conducted can be gleaned from various contemporary accounts and the occasional image (fig. 15).[23] The German scholar Hieronymus Münzer describes a Latin class given by Peter Martyr: 'his students were the duke of Villahermosa, the duke of Cardona, don Juan Carillo, don Pedro de Mendoza and many others from noble families, whom I saw reciting Juvenal and Horace. ... All these are awakening in Spain the taste for letters'.[24] The 'many others' no doubt included the Columbus brothers.

Fernández de Navarrete writes of Ferdinand's involvement in the classes and his insatiable appetite for education:

FIG. 15 | *Antonio Nebrija Teaching a Class of Pupils from Noble Spanish Families.* Illumination from Antonio de Nebrija, *Institutiones Latinae*, late fifteenth century (photo Institut Amatller d'Art Hispànic).

Pedro Mártir de Anglería, who did not leave Don Juan from 1492 until his death, remained in charge of the education of the pages … until 1501, when he was rewarded with the post of ambassador in Venice. Columbus's children were of an age when they were most willing to profit from his useful lessons. Don Hernando [Ferdinand] listened to them since he was six years old and until he was twelve. Hence, he acquired not only the basic principles of sciences and letters, but also such a strong inclination to learn that it became an insatiable thirst.[25]

There is every indication that Ferdinand was a star pupil and even became something of an apprentice to Peter Martyr.

During Ferdinand's years as a page, the court travelled continuously and spent periods in Valladolid, Madrid, Burgos and elsewhere. After the wedding of Prince Juan on 3 April 1497 to Margaret of Austria, the daughter of Maximilian I, the court moved to Medina del Campo where Columbus was present and no doubt saw his sons. Ferdinand writes how 'at Medina del Campo, in 1498, the Catholic Sovereigns granted him many favours and privileges in what related both to the Admiral's affairs and estate and to the better government and administration of the Indies'.[26] The monarchs approved a third voyage and granted some personal favours, but made no effort to expedite the administration to effect the voyage.

On 6 October 1497, the nineteen-year-old crown prince of Spain, the heir to the throne, died in Salamanca. His death came only six months after his marriage and dashed the hopes of succession and of further consolidating the alliance of Castile and Aragón with the Austrian Habsburgs. It also marked the end of Ferdinand's first phase within the court. One of the consequences of the prince's death was the collapse of his household and the dispersal of his court. This must have been a most trying time for Ferdinand, who had to cope with grief at the loss of the prince with whom he had effectively grown up.

Ferdinand in the service of Queen Isabella

On 18 February 1498, four months after the death of Prince Juan, Ferdinand and Diego were appointed pages to Queen Isabella. When they entered the queen's service, Diego was twenty years old and Ferdinand ten. Diego had reached adulthood and his courtly duties were probably very different from those of Ferdinand, who was still a child. Diego had become involved in defending his paternal interests presumably because he was the immediate heir to his father's titles and privileges. Ferdinand, in addition to his duties as a page, was absorbed in his education with Peter Martyr. By that time, their father's reputation had diminished.

Marín observes that the anti-Columbus feelings descended to the lowest levels of the court.[27] Ferdinand's academic ability possibly gave him sufficient kudos and enough of an independent identity to offset the negative associations of the family name. A characteristic of Ferdinand's *Historia* is its constant defence of his father and, although it was written towards the end of his life, it shows how his years at the court were affected by anti-Columbus feelings.

Columbus returned to Spain under arrest for mismanaging his duties as Governor of La Española. According to Ferdinand, as soon as the monarchs realised he was in chains they ordered his release.[28] Columbus presented himself at court in December 1500, at a time when the monarchs were reconsidering their support for the Indies enterprise. Columbus had not landed at the Spice Islands and he was wrong about the extent of the sea. The Crown had committed considerable resources for exploratory projects that had resulted in negligible financial return. They did authorise a fourth voyage and continued to recognise his title as Admiral but they denied him any governing powers over the islands he came upon. His administration was reduced almost to nothing and the voyage they authorised was a joint venture with substantial private sponsorship.[29]

After Columbus returned from the third voyage in November 1500, the promise of great riches seemed slight. The royal treasury was empty but Columbus desperately wanted to continue with his exploration. Around this time, while in Seville awaiting a royal audience, he began to collect materials for his *Book of Prophecies (libro de las profecías)*.[30] The book was Columbus's attempt to reveal his vision to Isabella and Ferdinand and he hoped the biblical prophecies it contained would inspire the monarchs to fund a fourth voyage, allowing them to become the monarchs of the new Jerusalem. The book was compiled and written in 1501–2 by his son Ferdinand and Fray Gaspar Gorricio under Columbus's direction.[31] What is remarkable about the *libro* for the present discussion is Ferdinand's proficiency in Latin. By the time he was thirteen, he had a complete command of the language and a steady hand that betrays a highly developed orthographic style, a clear testimony to the quality of his humanist education. The wide-ranging sources used in the *libro* have been well analysed and reveal a considerable grasp of cosmology, hermeneutics, scripture, theology, astronomy and humanist texts.[32] Columbus explained his facility: that God had given him a special gift of understanding (*spiritualis intellectus*).[33]

Columbus's reasons for writing the *libro* and the correspondence surrounding it disclose a belief system that must have influenced Ferdinand and framed his experiences on the fourth voyage, discussed below. From the early stages of planning his enterprise, Columbus was utterly convinced of his role as a missionary and a crusader. The *libro* leaves no doubt that he believed his discoveries were divinely ordained and were part of a greater spiritual destiny revealed by visions of meaning that would have lasting impact and benefits for the Spanish realm. Columbus's unshakeable faith in his purpose must have rubbed off on his sons.

Ferdinand and the fourth voyage

In 1502, at the age of fourteen, Ferdinand was taken from his studies to accompany his father and uncle on the fourth and final voyage to the New World. This was to be the most difficult and disastrous voyage of all. The reasons why Ferdinand was involved in the voyage must have had something to do with the skills he had acquired at the court. Ferdinand left Seville on 3 April with a daily allowance of 164 *maravedís*, which was an enormous amount for a page, and reflects the trust the monarchs placed in him.

The aim of the voyage was to discover a more direct route to the Indian Ocean than going around Africa. The fleet, comprising four ships, set sail on 9 May 1502, heading for the Portuguese fortress of Arzila on the Moroccan coast (figs 16 and 17). The most detailed account of the voyage appears in the *Historia* in which Ferdinand recounts in great detail the experiences and the hardships they endured.[34] But his specific duties on board the ship remain a mystery.

The monarchs banned Columbus from dropping anchor in the port of La Española on account of the fact that a new governor of the Indies and trusted ally of the queen, Nicolás de

FIG. 16 | Columbus's fourth voyage, 1502–4.

FIG. 17 | Columbus's fourth voyage, Caribbean explorations, 1502–4.

Ovando, had been installed, in a position Columbus had earlier occupied. Upon arrival, the fleet anchored as near to the port as they could. Columbus's fleet left La Española on 15 July, sailing downwind into the Western Caribbean, past Jamaica, towards Cuba and the island of Bonacca off the Honduran coast. There, Columbus sent his brother Bartolomé ashore to assess the prospects of finding gold. Ferdinand records his own fascination with aspects of this area, describing a vessel carrying native people, 'a canoe as long as a galley and eight feet wide … it had a palm-leaf awning like that which the Venetian gondolas carry'. The fleet continued towards the mainland, anchoring at the Cape of Honduras, and on to the Río de la Posesión. Ferdinand describes the natives:

'When they adorn themselves for some festivity, some paint their faces black or red like an ostrich, and still others blacken their eyes. They do this to appear beautiful, but they really look like devils.' After a further twenty-eight days of sailing in adverse weather they rounded the Cape Gracias a Dios, named by Columbus because thereafter the conditions became favourable. They continued along the coast of Nicaragua to Costa Rica. In late September, they dropped anchor in what is now Puerto Limón where they encountered the Talamanca Indians. Ferdinand describes them as being superstitious, because when they caught sight of a pen and paper they were so terrified they ran away; 'the reason was that they were afraid of being bewitched by words or signs'.

The fleet continued southeast in search of the strait that provided a shortcut between the Caribbean Sea and the Pacific Ocean. They rested and traded gold with the Indians around the Chiriqui Lagoon before moving past Veragua to Puerto Bello, but were forced back to Veragua because of storms. Among the treasures of this region were gold mirrors that the natives wore around their necks. Ferdinand describes the various attempts to trade these mirrors; his father considered them a clear indicator that the area was rich in gold. Beginning on 5 December and continuing for a month the fleet was besieged by inclement weather. By the time the storms passed in early January the men were exhausted and sick, and anchored off Belén River in Veragua, where Columbus decided to explore. There they found large quantities of gold, more than Columbus found in all the years on La Española, and founded a settlement that was the beginning of Santa María de Belén. The building programme made the Indians uneasy and they plotted against the Spanish. As a pre-emptive strike the Spanish arrested the Indian king along with a large number of his retinue and kept them captive on one of the ships. The native hostility again flared when part of the fleet set sail for Spain. The Spanish who remained were attacked, suffering several casualties. Some of the captive Indians were able to escape and the others hanged themselves. In a particularly insensitive passage, Ferdinand describes how 'their death was no great loss to us of the fleet but seriously worsened the plight of the men ashore; the Quibían would gladly have made peace for the return of his chil-

dren, but now that we no longer had hostages, there was reason to fear he would wage even crueller war on the town'.

The return journey was fraught with difficulties. The ships leaked, the voyagers were ravaged by storms and eventually marooned in Saint Ann's Bay in Jamaica (Santa Gloria). Christopher sent a party to La Española for help. As he waited, a number of his men plotted a mutiny. Ferdinand relates in detail the reasons for their actions – they were motivated mainly by their desire to return to Castile. They commandeered ten canoes that were tied to the ships, and waited for the first calm day to sail. In the interim they raped and pillaged the Indians and told them to collect their pay from the Admiral and authorised them to kill him if he would not pay. They also told the Indians he was hated by the Christians and was the cause of all the misery of the Indians on Española and would inflict suffering on them if they did not kill him, for it was his intention to stay and settle the island. The mutineers' escape was unsuccessful because of inclement weather and also because they were overloaded. To lighten the load they threw the Indians overboard and hacked off their hands if they tried to clamber back.

After being stalled by the Ovando administration, a caravel finally returned to Jamaica to collect the survivors. They departed on 29 June and after an arduous journey landed in Santo Domingo on 13 August. Ferdinand writes that the 'governor received the Admiral very hospitably and lodged him in his own house; but it was a scorpion's kiss, for at the same time he released Captain Porras, the ringleader of the mutiny'. On 12 September 1504, Columbus and his few remaining crew set out for Spain and reached Sanlúcar de Barrameda on 7 November. Columbus was suffering from gout and retired to Seville to recover and await the call to the court. Queen Isabella died on 26 November and Columbus lost his most faithful ally in the court. He was finally granted an audience in May 1505. Crushed by ultimate defeat and failing health, Columbus died in the company of several of his seamen and his son Ferdinand in Valladolid on 20 May 1506.

Despite Ferdinand's careful account of the fourth voyage in the *Historia*, his overriding motive of glorifying his father leaves no room for any discussion of his own activities. His behaviour and

contribution must have been exemplary, because Ferdinand returned to Spain high in his father's estimation. In a series of letters written to his son Diego during the first weeks of December 1504, Columbus refers to Ferdinand's valour and maturity despite his youth.[35] Columbus's estimation of his younger son had risen so greatly that he dramatically revised his inheritance.[36]

The pleitos colombinos

Shortly after Columbus died, Ferdinand became very involved in what have come to be known as the *pleitos colombinos*, which aimed to re-establish the privileges that had been stripped from his father. The first litigation stretched from 1508 to 1536, and was continued by the family until 1790. The *pleitos* are briefly summarised here.[37]

In Granada on 17 and 30 April 1492 the monarchs Isabella and Ferdinand signed a two-part agreement (Capitulations) to give Christopher Columbus the following:

1. The position of Viceroy and Governor of the lands he discovered and the right to propose three names for every governmental post on those territories;

2. The position of Admiral over those territories and the right to decide controversies regarding merchandise and commerce;

3. One-tenth of the net profits of the Crown from discoveries and trade from the territories he governed;

4. The right to contribute and enjoy a participation of one-eighth in every expedition.[38]

The formulae for profits devised by Columbus were unsustainable because they were unrealistic. They meant effectively that from the exploration and settlement of the Indies Columbus would gain a financial amount greater than that of the Spanish crown. That the monarchs agreed to the initial conditions was evidently an over-enthusiastic response to the prospect of the great riches to be gained after Columbus returned from the first voyage of 1492. Columbus was clearly very aware of the potential benefits to himself, and after returning from the voyage wasted

no time in securing confirmation of the Capitulations. This was achieved on 28 May 1493. Reconfirmation was obtained a second time, four years later in April 1497. Throughout his life Columbus saw his privileges whittled away, especially after returning from La Española in chains in October 1500, but never during his life did he institute legal action to have them reinstated. The litigation was entirely the work of his descendants. After Columbus died, his first-born son Diego inherited his titles and other privileges, but their extent and their application were unclear. Diego was determined to assert his rights according to the original 1492 agreement, and in 1508 instigated the first lawsuit.

Ferdinand did not return to the court after his father's death, but devoted his time to elaborating petitions to uphold the original Capitulations. In July 1509, Ferdinand set sail with his brother on his second voyage to the New World. The reasons why Ferdinand accompanied his brother are not made explicit. The nautical expertise he had gained from his father's fourth voyage was no doubt valuable, but he probably spent much of his time with his brother devising how best to defend their privileges. Ferdinand spent only two months and nine days on La Española before returning to Spain in September. The brevity of the trip further suggests that its purpose was to clarify the substance of their claims. Because Diego remained in La Española as Governor, Ferdinand was the only person able to prosecute the case in Spain. The *pleitos* stood a much better chance of being successful if Ferdinand was doing the negotiating.

Ferdinand's return to Spain

Ferdinand returned from La Española in early November 1509. His first task was to present himself at court in Valladolid; he arrived there in January 1510. At that time, Ferdinand was twenty-one years old, in receipt of an excellent education, and had considerable financial resources. From early in 1510 and throughout 1511 he accompanied the court, carefully monitoring his brother's claims. Little else is known of his other activities during this period. On 5 May 1511, the first judgement was passed

down in Seville. The decision confirmed Diego's perpetual position as Viceroy and Governor of the islands discovered by his father, but his actual powers were severely curtailed. The sovereign remained supreme and implemented measures to protect the rights of the settlers by diminishing the power of the Viceregal office.[39] The outcome pleased neither Diego nor Ferdinand and Diego announced a further challenge from Santo Domingo in December 1512.

Ferdinand's acuity in legal matters is demonstrated by two documents he wrote during 1510–11, the *Forma de descubrir y poblar las Indias* and the *Colón de Concordia*.[40] Because it no longer exists, little is known about the *Forma*, other than that it addressed matters relating to the discovery and settlement of the New World. The *Concordia* however is better understood. It was written in three parts and resembled a legal document addressing matters of settlement, the evangelisation of the natives and the rights of the crown, all of which was endorsed by the 'reason and authority of experts' and corroborated 'by the prophecies and authority of the holy scriptures'.[41] The *Concordia* was sent both to the king and the powerful prelate and statesman Cardinal Francisco Jiménez de

Cisneros for examination and revision. Both wrote Ferdinand a letter approving what he had written, but these have not survived. Ferdinand, however, refers to their sanction:

> The examination took place and, once it was seen by the Cardinal of Toledo, as representative to the Catholic King, who has gone to glory, it was graciously accepted, according to the letters that His Highness and the Cardinal wrote to me about it.[42]

Cisneros was known for his apathy and inhumanity towards the Indians. He organised evangelical missions to the New World, attempting to resolve the problems regarding their settlement and coercing the native peoples into being baptised. Both the *Forma* and the *Concordia*, while specific in their content, appear to have a clear subtext. They validated the attitudes and actions of Ferdinand's father and brought him closer to the court and its powerful associates. The respect Ferdinand gained through the documents could only have embellished his reputation within the court and added weight to his defence of his family's litigation.

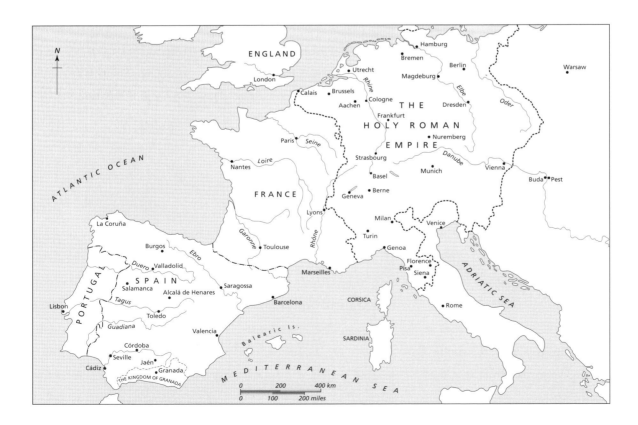

FIG. 18 | Europe around 1520.

The beginnings of Ferdinand's collecting

During the time Ferdinand was involved in maintaining his paternal inheritance and writing various legal-historical papers, he continued to develop his scholarly interests, central to which was building a library. It is not possible to determine exactly when Ferdinand's modest book collecting took on grander dimensions, because the passion for learning that underscored his love of books had begun early in his life. But the earnest formulation of a systematic programme of book collecting probably began some time between 1505 and 1510: that is, after his return from the fourth voyage, when a *Memorial* records that he owned 238 volumes,[43] and before the first notice of his buying books in Valladolid, Calatayud and Lérida in 1510.

Acknowledging the background to Ferdinand's collecting ambitions is crucial to understanding his vocation as a bibliophile and print collector. His education within the court and his family's involvement in the book trade provided the initial footing. Christopher Columbus is recorded as buying and selling books during his early years in Spain.[44] His activity as a book dealer appears to have peaked at around the time he was petitioning the monarchy to support his seafaring projects, evidently when he needed money. From all accounts, Columbus was very interested in reading and spent long periods in institutions that had extensive libraries. When he first arrived in Spain, for example, he stayed at the Franciscan monastery Santa Maria de la Rábida, which was a well-known centre of learning. And in Seville he frequently visited the monastery of Nuestra Señora Santa Maria de la Cuevas, which in the late fifteenth century had an enormous library containing around 10,000 volumes.[45] When Columbus died in 1506, Ferdinand inherited his library. By 1510, Ferdinand had firmly established the foundations of his collecting. He owned a modest number of titles and the information he inscribed in them indicates the seriousness of his intentions. If he wanted to build only a small library he could have done so buying from booksellers in Spain – especially Seville – but he clearly had tremendous ambitions and the augmentation of his library could only be achieved through widening his buying circles.

FIGS 19 & 20. Purchase information written by Ferdinand Columbus on his books. Biblioteca Colombina, Institución Colombina, Seville, sig. 1-2-16 (photo author).

Ferdinand's first travels through Europe

In September 1512 Ferdinand embarked upon his first journey through Europe, travelling first to Rome (fig. 18). One of his main tasks there was to act on behalf of his brother as defendant in a lawsuit laid by Isabel Samba (Gamboa), who was trying have legitimised a son she had borne to Diego out of wedlock in 1508.[46]

In Rome, Ferdinand attended to business matters, but his trip was largely a cultural visit. During his time there, he bought large numbers of books. By that time, Ferdinand was twenty-four years old, financially secure – thanks to his paternal inheritance and the various allowances he had received from the Crown – and possessed of a burning desire for knowledge. Nothing in Spain could have prepared him for what he encountered in Rome. He found himself in a vibrant centre of art and learning. The city was a magnet for artists and many of the most important of the time including Bramante, Pinturicchio, Raphael and Michelangelo worked there. Michelangelo had just finished the Sistine chapel and Raphael the Stanza della Segnatura. Pope Julius II (1503–13) had undertaken one of the most ambitious building campaigns ever, and the city was enjoying great prosperity.

In Rome, Ferdinand stayed with Spanish-speaking Franciscans who encouraged his scholarly interests.[47] Rosa y López writes of his contacts there: 'he remained in the monastery of St Francis or of *the Spaniards*, with short intermissions, for five years, thus getting his education under the supervision of masters Castro, Sebastian, Pedro de Salamanca and other equally learned scholars'.[48] The inscriptions on his books provide further details about his interaction with Roman humanists. On his copy of Juvenal's *Satires* he wrote that in December he listened to a 'maestro' lecture on Britannicus' commentary on the *Satires*. In 1513, Ferdinand's friend Father Dionisio Vázquez gave him a copy of a sermon he had written[49] that Ferdinand had heard the year before: 'Hunc sermonem audivi viva voce auctoris Rome mesis Martis 1513'.[50]

The decades from 1500 to 1520 saw the unparalleled rise and dominance of humanism in Rome. Having been educated by humanists within the Spanish court, Ferdinand would have found that the atmosphere in Rome reinforced and augmented what he had learnt earlier. Indicative of Ferdinand's humanist credentials are his practice of inscribing many of his books in Latin and the type of Roman lettering he used (figs 19 and 20). Ferdinand remained in Rome until June 1513, and was back in Spain for all of August, before returning to Rome in November of the same year. During the years 1513–15 he travelled constantly.[51]

Ferdinand's second major Italian sojourn began in Genoa in January 1515, from where he returned to Rome by way of Lucca and Viterbo. Although he was buying large numbers of books throughout 1515, he did not leave for Spain again until October of the following year. The long periods of time he spent in Rome indicate his deep involvement in literary and cultural matters and his desire to maintain the relationships he established there. Like his earlier book purchases in Rome, those he made during 1515–16 carry inscriptions that reveal his activities. On his copy of the *Historia de Alejandro y las cartas de Quinto Curcio* he wrote, 'I listened to Master Castro in Rome when he expounded this history of Alexander and the above-mentioned Quinto Curcio's letters, from 29 March to 4 April 1516'.[52] Ferdinand returned to Spain in October 1516, and spent the next year between Valladolid, Alcalá de Henares and Medina del Campo. Up until that time, he led an ambulatory existence, but from 1519 Seville became his base.

In the service of Charles V

On 23 January 1516 King Ferdinand died and the throne passed to his grandson Charles (1500–58), son of his deranged daughter Juana (La Loca). Charles V was the first king to succeed to a united Spain, which, in addition to the kingdoms of Castile and Aragón, incorporated Naples, Sicily and the New World territories. From his father, Philip the Handsome, Charles inherited the Burgundian Netherlands, and upon his investiture as Holy Roman Emperor in 1519 following the death of his paternal grandfather Maximilian I, he acquired the Habsburg estates in Germany and Austria.

Charles's ascent to the throne marks a new and important phase in Ferdinand's life. Ferdinand's involvement in the *pleitos colombinos* kept him close to the court's machinery and he was often consulted on questions of territorial and native administration. Charles had a great interest in the fate of the Indies, mainly from an economical point of view, and because of Ferdinand's expertise in the subject the king turned to him for advice.[53] Charles V, born in Ghent, had spent all his life in the Low Countries, and arrived in Spain for the first time in September 1517. At that

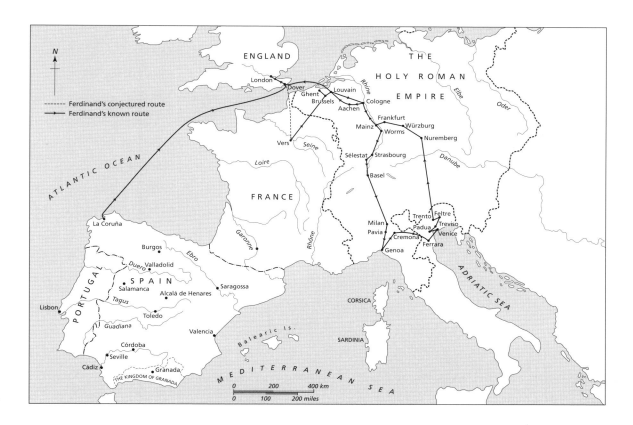

FIG. 21 | Ferdinand Columbus's
travels through Europe
with Charles V, 1520–22.

time Ferdinand was travelling throughout Spain writing a geo-graphical summary of all her villages and towns, a work known as the *Cosmografía*.[54] Whereas Charles knew nothing about the peninsula, Ferdinand, through his book-buying peregrinations, knew it intimately.

It is not possible to determine exactly when Ferdinand and Charles first met, but it was probably early in 1518. In 1519, Charles conscripted Ferdinand to form part of his retinue on his progress through the Low Countries and Germany for his coronation as Holy Roman Emperor. In early 1520, Ferdinand left Seville for La Coruña and is recorded there by 12 May, a week before the royal party embarked. His brother Diego, who was pursuing his claims relating to his hereditary rights, accompanied him. Earlier, on 22 March, Charles V signed the 'Declaración de La Coruña' in which he accorded Diego most of the political and economic rights raised in litigation with the crown. At the same time, Ferdinand renounced his claim to any paternal legacy and in compensa-tion received the annuity of 'doscientos mil maravedís' to be paid in June and December in Seville every year for life.[55] After being

so closely involved with the *pleitos* his settlement represents a significant change in attitude. Although he never abandoned the claims completely, Ferdinand was perhaps tired of the work involved in maintaining them and wanted the guaranteed income so that he could step up his book-buying programme. But the fact that his brother had received a favourable outcome and had confirmed a large part of the hereditary rights was possibly vindi-cation enough.

The royal party left La Coruña on 16 June 1520 (fig. 21). Fer-dinand's exact position is not entirely clear; Wagner plausibly sug-gests he was a geographer and adviser to Charles.[56] Ferdinand was the only person in his retinue to have participated in the explo-ration of the New World and his experience in territorial matters would have been valuable to Charles, given that such matters were on his political itinerary. Charles's itinerary is well documented.[57] From Spain they travelled first to England, landing in Dover, then via the Low Countries to Germany, passing through Brussels, Bruges, Louvain, Antwerp, Aachen for his coronation, and Bonn, reaching Worms for the Imperial Diet on 12 December. Charles's

itinerary was politically motivated, and he used the journey to meet King Henry VIII of England and King Francis I of France to discuss matters of military co-operation. At the same time he attended to domestic matters regarding the administration of Spanish territories and on 8 May 1521 ratified the Bull 'Exurge Domine' excommunicating Martin Luther.

Ferdinand closely followed the court, but made numerous diversions to buy books and probably prints as well. On 16 June, for example, Charles was in Brussels staying at the monastery of Groenendael. Taking advantage of the momentary respite, Ferdinand went to Vers where he bought various books. Whereas little is known of his actual work with the court during that period, we can learn a lot about whom he met from the inscriptions on his books. In Louvain on 7 October, Ferdinand met Desiderius Erasmus and the meeting had an enormous impact on him.[58] Erasmus gave Ferdinand a first-edition copy of his *Antibarbarorum liber unus* which, proudly recognising it as a gift, Ferdinand inscribed three times. Ferdinand was clearly a great admirer of Erasmus, for his library contained many of his works, and it is highly likely that the great humanist was very important for the development of Ferdinand's own library. Ferdinand's book-collecting activities would have been enough to cause him to seek Erasmus out, but strangely none of Erasmus's copious correspondence makes any mention of Ferdinand.[59]

On 22 October, the court arrived in Aachen where Ferdinand was a witness at the coronation of Charles as emperor, an event at which Erasmus was also present. The investiture made Charles the most powerful European emperor, giving rise to his image as the Christian Hercules, the ruler of an empire upon which the sun never set. After the coronation, Ferdinand continued with the court to Cologne, arriving in Worms on 12 December. Four days later the emperor awarded Ferdinand 2,000 ducats as remuneration for his services. In Worms, the Imperial Diet had been convoked to hear the claims of Martin Luther; as a result of the process, he was proscribed. The politics of the court did not, however, stop Ferdinand buying copies of the most contentious books published during the period. Ferdinand permanently lived on the fringes of political and religious debate, which was typical of many educated individuals of the period, whose intellectual interests overrode restrictions of religious or political dogma.[60]

The time Ferdinand spent with the court was clearly profitable. The financial rewards outlined above enabled him to buy enormous quantities of books. Taking advantage of the emperor's favour, Ferdinand wrote an important document directed to his patron known as the *memorial*. In it Ferdinand laid out a plan for the creation of a universal library in Seville, for which he requested financial support.[61] The *memorial* judiciously reflects Charles's political and religious aspirations and is most significant because it demonstrates that, relatively early in his book-buying days, Ferdinand was committed to the idea of a universal library; he had conceived its intellectual contours and had initiated the basis of its cataloguing procedures. From the evidence of his book-buying and his petition to the emperor, there can be no doubt that whatever advisory or administrative duties Ferdinand had were incidental to his aim of forming his collections. While he had first begun buying books in large quantities in Rome in 1512, the 1520 trip provided an opportunity to expand greatly the scale of his purchasing; being so close to the emperor he was in the perfect position to lobby for royal support. The picture we get of Ferdinand is that of a clever operator, using his extensive experience in the Spanish court, and his learning, to bolster his bibliographic ambitions.

Charles left Worms on 30 May for Mainz and then on to Cologne. Ferdinand had earlier taken his leave and he is recorded in Strasbourg on 18 February and Basel on 25 February, before travelling to Milan in March. It is not known why Ferdinand left the emperor's entourage before the Diet, but having secured his payment he possibly wanted to continue with building his collections and wished to waste no time. His early departure reinforces how single-minded he was during this journey. He reached Venice, the largest publishing centre in Europe, on 9 May by way of Pavia, Genoa, Cremona and Ferrara. He remained in Venice until 20 December. Nothing is known of his time there other than that he bought around 1,600 books and a large number of prints.[62]

The books and prints Ferdinand bought in Venice were shipped to Seville but the cargo was lost in a storm, as we saw in

chapter 1. Their details were carefully recorded in the *Memorial de los libros naufragos*, where their sad fate is recorded under entry 2562: 'Note that all the books from number 925 until here are those left in Venice to Mister Octaviano de Grimaldo that were sent and drowned in the sea' (*Nota que todos los libros contenidos desde el num. 925 hasta aquí son los yo dexé en Venecia a miser Octaviano de Grimaldo que los enviase y se anegaron en el mar*). The *memoria* – the document regarding the organisation of Ferdinand's library – written by his friend and librarian Juan Pérez records that along with the lost books there were also 'mucho debuxos y pinturas muy eçeleentes', referring to prints he bought at the same time.

Having sent off the ill-fated shipment Ferdinand continued on his travels, reaching Nuremberg by 2 January 1522. In the few weeks he spent there, Ferdinand bought 700 books before returning to Würzburg by 18 January; he went on to Frankfurt, where he bought 200 books, and then to Cologne, where he bought almost 1,000 more. He rejoined the court in Brussels in mid-March and continued to Louvain, Bruges and London. During the two months between Brussels and Louvain, he wrote the *Forma de navegación para el alto y felicísimo viaje del Emperador, desde Flandes a España*, an account of the journey undertaken by the emperor that he probably presented to him in May.[63] The *Forma* supports the earlier contention that Ferdinand's role in the court was principally as an adviser on geographical matters. The court left Southampton bound for Spain on 7 July, arriving in Santander nine days later, and by 20 July Ferdinand is recorded as being back in Valladolid.

Ferdinand's 1520–22 journey was paramount in his book- and print-buying programme, because he bought on an unprecedented scale. It was also the period during which he fully developed his cataloguing procedures, and realised the importance of carefully recording all the purchase details. The inscriptions in some books also convey information regarding his relationship and reaction to their contents. The inscription he wrote on Seneca's *Tragedies* for example defines his reading programme:

> Saturday, the sixth of March 1518, I started to read
> this book and to make notes from it in the index in

Valladolid; and, because I was distracted by so much work and travelling, I could not finish it until Sunday, the eighth of July 1520 in Brussels, Flanders; in the meantime, the notes that can be found from number 1559 onwards have not been copied in the index, since it remained in Spain.[64]

On Cato's *Opera Agricolationum* the inscription relates how: 'this book I read while I ate my supper in Seville during February of 1538' (*este libro se leyo myentra yo comia y cenava en Sevilla por hebrero de 1538*).[65] These various inscriptions indicate how his books were an integral part of his world and cannot be separated from his daily existence. Here, he was following a well-established humanist tradition.

Ferdinand's return to Spain

The two years Ferdinand spent abroad in Europe were his longest period outside Spain. He became well known to dealers and established standing orders with some of them. Back in Spain, Ferdinand continued his book-buying activity. He remained with the court in Valladolid until late September 1523 when he set off, spending around two months in Piedrahíta from November; he was in Medina del Campo by the middle of November 1524 – where he was probably buying at the fairs. From there he returned to Valladolid in early December and thence to Madrid and Salamanca from February until April 1525. Medina del Campo held a major fair twice yearly in May and November where books, prints, paintings and other art objects were sold in great numbers.[66]

At the beginning of 1524, alongside the celebrated pilots Sebastián Cabot, Américo Vespucci and Juan Sebastián Elcano, Ferdinand represented the Spanish crown on the Council of Badajoz and Elvas, which had been established as a result of a dispute with the Portuguese over the ownership of the Molucca islands.[67] The aim of the council was to determine the correct legal extent of ownership. Ferdinand was a significant force in the proceedings, his voice the most persuasive, and he provided scientific

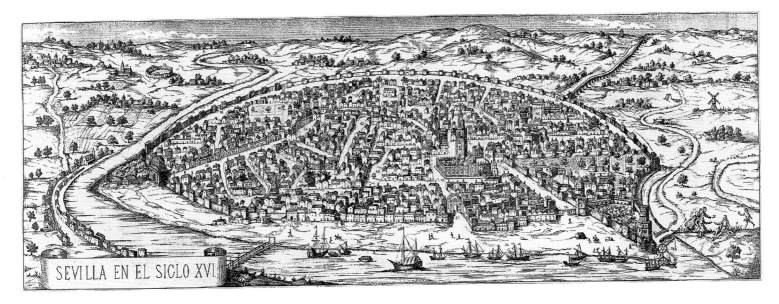

SEVILLA EN EL SIGLO XVI

FIG. 22 | *View of Seville in the Sixteenth Century* (photo author).

points of apportionment. Ferdinand's contribution was crucial to the outcome in favour of the Spanish Crown.[68]

In the same year Ferdinand wrote a paper declaring the rights of the Spanish relative to those of the Portuguese over the provinces of Persia, Arabia and the Indies (*Declaración del derecho que la Real corona de Castilla...*).[69] The document again reveals Ferdinand's extensive geographical knowledge and also the depth of his legal understanding. Ferdinand's geographical knowledge remained valuable to the court, and in 1526 Charles commissioned him, together with other experienced pilots associated with the *Casa de Contratación* in Seville, to produce a navigational map that would serve as a model to be used for journeys to the Indies. The map never materialised, for reasons that remain unknown.

Settling in Seville

From 1519 Ferdinand considered Seville his permanent base, but because of his travelling schedule he had not been able to spend more than six months there at a time. In 1526, at the age of thirty-eight, after years of travelling and collecting, Ferdinand decided to build his own house in Seville. On 12 February and 18 April 1526, the council transferred to Ferdinand a parcel of land by the Puerta de Goles for the purpose of building his house. 'Goles' was a popular local term for Hercules (*er-Goles*) and refers to the old entry gate to the city called the gate of Hercules.[70] In choosing a parcel of land outside the city walls, Ferdinand was imitating the practice of Italian humanists who wanted gardens where they could enjoy peace for their work.

Ferdinand's house has vanished but sufficient documentation survives to give a good impression of its appearance. Its form was in the style of the suburban villas lived in by humanists of Renaissance Florence.[71] From 1526 until 1528 Ferdinand remained in Seville where he supervised construction. From all accounts, the house was magnificent. The gardens were ample, adding to the effect of an elegant suburban residence, an aspect described by Juan de Mal Lara in his *Recibimiento ... muy noble y muy leal ciudad de Sevilla* of 1570: 'next to the gate is the house of Columbus and a garden with thousands of trees'.[72] The garden contained a mixture of native plants and those discovered in the New World. When Ferdinand was in Genoa on 10 September 1529 he contracted the sculptors Antonio María de Carona and Antonio de Lanzio to execute the villa's façade (*un portada y quatro ventanas*)

FIG. 23 *View of Seville in the Sixteenth Century*: detail showing the house and gardens of Ferdinand Columbus in the centre (no. 21) (photo author).

in Carrara marble.[73] The *portada* was in the form of a Roman arch supported by two Corinthian pilasters, imitating the precedent set by the Casa de Pilatos made also by the same sculptors.[74] The Columbus coat of arms surmounted the arch and at both sides were groups of dolphins. Ferdinand's property can be seen in an engraved view of Seville (figs 22 and 23). A wall enclosed the gardens and the villa complex comprising three buildings was oriented towards them. The most important feature of the house was the library, which Juan de Mal Lara describes as the 'new Mount Parnassus'.[75] Ferdinand had achieved what he most wanted, a conducive environment where he could study the treasures in his collection.

Seville in the early sixteenth century

From 1492, when Columbus first attempted to find a westward route to the Indies, Seville developed as the commercial capital of the Spanish Hapsburg empire. In 1503 the Crown decreed that every ship travelling between Spain and the New World should pass through the port so that its cargo and passage could be carefully monitored. The *Casa de Contratación* was established to supervise commercial activities – as a clearing-house for trade – and also to appraise the processes of colonisation and so on. It was responsible for teaching all aspects of nautical navigation and was an important academic centre, attracting pilots of international repute.

From the time Seville became a commercial capital, it experienced a vast growth in population and an urban spread that continued unabated into the seventeenth century. When Ferdinand settled there in 1526, Seville had a total population of around 55,000. A number of contemporary accounts mostly written by foreigners describe life in Seville and how the city appeared in the first half of the sixteenth century. In 1525, the Venetian ambassador Andrés Navagero arrived in Seville to present himself before Charles V. He describes Seville as not unlike Italian cities: the streets were wide and pretty, the houses were somewhat lacking but the city was abundant in wine and good food, an assessment that occurs in many accounts.[76] Domestic architecture in Seville was transformed during the following fifty years, as noted by Juan de Mal Lara, who in 1570 observed: 'Ferdinand Columbus's house was one of the earliest to effect the transformation and soon after there were many residences with patios, balconies, internal gardens, and beautiful grille work.'[77]

In his important study of Seville during the sixteenth century, Lléo Cañal traces the transformation of the city from its provincial beginnings into a splendid centre of Renaissance culture.[78] The establishment of educational institutions, the intellectual and cultural aspirations of the noble families manifest in their collecting practices and support of Renaissance forms of culture, defined the city as the 'new Rome'. For the beginning of the heightened process of transformation, 1526 – the year Charles V celebrated his marriage to Isabel of Portugal – is the key date. The city was decorated with triumphal arches in the Roman style and filled with foreign dignitaries.[79] Public buildings such as the Ayuntamiento were renovated to reflect the new architectural style, in this case transforming its *mudéjar* appearance to a Renaissance façade.

At the forefront of the Sevillian revival were Rodrigo Fernández de Santaella, who founded a humanist academy in Seville

in 1503, and Don Fadrique Enríquez de Ribera, the first Marquis of Tarifa, who established the first collection of Renaissance art in Seville.[80] Whereas the royal presence in Seville was crucial for the city's cultural status, members of the nobility – the most important were the Dukes of Medina Sidonia and Enríquez de Ribera – empowered their taste through their habit of establishing collections. A further reflection of the developing aristocratic aspirations was the foundation of religious institutions. Between the years 1520 and 1525, no fewer than five new convents endowed by the nobility were established in Seville.[81]

Ferdinand's final years

After seeing his villa and library to a successful completion, at the beginning of September 1529 Ferdinand once again set out travelling, first to Genoa, then Piacenza and Modena, ending up in Bologna in December where he remained until the end of January 1530 (fig. 24). Emperor Charles was in Bologna to meet Pope Clement VII and to be crowned King of Lombardy and Emperor of the Romans. Repeating the pattern of his 1520–22 trip, Ferdinand did not remain in Bologna for the coronation (24 February) but went instead to Venice. In Venice he bought a number of books from the library of the Venetian humanist Marin Sanudo, whose extensive collection was dispersed because of economic hardship.[82] After Venice, Ferdinand spent September and October in Rome.

After leaving Rome, Ferdinand zigzagged through the north of Italy, buying in Ferrara, Modena, Parma, Piacenza, Turin, Milan, Modena and Treviso before crossing the Alps and arriving in Innsbruck by the middle of May 1531. From there, he travelled to Augsburg, Basel, Strasbourg, Cologne, Brussels and Louvain, arriving in Antwerp by 9 October, after which he returned to Spain. In Louvain, he contracted the services of the Burgundian doctor of law Juan Hammonius, and the humanist scholar Nicolas Cleynard and Jan Vasaeus, to help in organising his library in Seville. The party set out from Louvain at the beginning of October 1531 and headed towards Salamanca. Ferdinand's book purchases dur-

ing this trip were significantly fewer than those from ten years earlier and were restricted mainly to works published after 1522. The same can be said for the print purchases, suggesting that at that time he was consolidating his collections and filling in gaps.

Ferdinand arrived back in Seville by April 1533, where he remained for most of the year until early 1534 when, once again, he set off travelling throughout Spain, buying more books. In 1535 Ferdinand undertook a new journey, this time to France. From late June until the end of July he stayed in Montpellier and then went on to Lyons, where he spent six months, followed by three in Avignon, before returning to Spain by June of 1536. Lyons was a major publishing centre where Ferdinand bought a considerable quantity of books.[83] There he mixed with writers and publishers, amongst them the celebrated historian, philosopher and poet Symphorien Champier. Ferdinand was back in Seville by July 1536, and made no further trips outside Spain. He settled down to integrate his many new purchases into his existing collection and to organise his library. But, having established so many contacts throughout Europe, he continued to receive new books.

In 1536, Ferdinand's nephew Luis was recognised as the inheritor of his father's titles: Admiral, the Duke of Veragua and the Marquis of Jamaica. María de Toledo, Diego's widow (he had died ten years earlier), launched another claim in the *pleitos colombinos* and Ferdinand was once again involved as the consultant. It seems that Ferdinand intended to return to the New World to assist in the litigation.[84] Luis was also the sole heir to Ferdinand's collection, and he probably wanted to discuss with him the plans he had for its maintenance and continued expansion, but due to ill health he did not undertake the voyage. In his final will and testament Ferdinand left his library to his nephew, but it is not known if he was fully aware of Luis's lack of interest. At the time Ferdinand died, Luis was still embroiled in legal battles trying to sustain his claims to the privileges. Whatever interest Luis might have had in Ferdinand's collection would have been reduced because of the pressures of protecting his legacy. The conditions imposed by Ferdinand in his Testament for the maintenance of the collection would surely have been even less of an incentive for him to take an active interest.

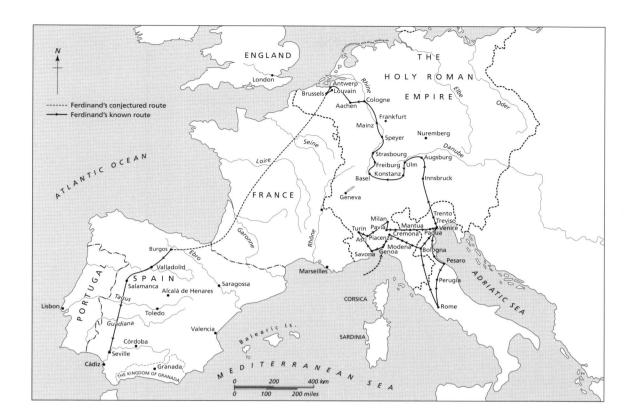

FIG. 24 | Ferdinand Columbus's travels through Europe, 1529–33.

Ferdinand died in Seville on 12 July 1539 at the age of fifty. From various sources we know a lot about the circumstances surrounding his death but not its actual cause. A letter from Ferdinand's trusted assistant Juan Pérez to Luis describes his last days:

Sir: your lordship may know that on Saturday, the ninth of July at eight in the morning blessed Don Hernando Colón, your uncle, died: your lordship must not be grieved because of his death, though this is not pleasant, since his end was that of an apostle. Fifty days earlier, he knew he was going to die, by means of his great wisdom. Hence he summoned his servants and told them that he would not remain with them on earth much longer. He made the inventory of all his property, even the pewter crockery, and he drew an estimation of its worth. He named your lordship as his heir, both to his furniture and to his silver, as well as to his tapestries and everything else … Your lordship is also heir to 15,370 books, provided you give 100,000 *maravedís* per year to keep them and to appoint a keeper in charge of them and of tidying them… and two hours before his death, he asked for a plate with earth, and so it was brought, though nobody knew what for, and he asked them to throw it over his face; as they thought this did not make any sense, they pretended they were doing so, yet they did not; he got angry and put his hand on the plate, took some earth in his fist and threw it on his face and on his eyes, while saying in Latin: *Recognosce homo quia pulvis es, et in cinerem reverteris* ['recognise man that you are dust, and that you will become ashes again'], and raising his hands to the sky while saying *Te Deum laudamus* ['Glory be to God'], he gave his spirit to God.[85]

The letter is partly a commemoration to Ferdinand's memory but also a plea to Luis to assume the mantle of responsibility for his library.

1 Obregon, 1992, pp. 41–43.

2 For the (H)Arana of Córdoba see Torre y del Cerro, 1933, pp. 32–50.

3 See Provost, 1991; also Bedini, 1998.

4 See Taviani, 1985, pp. 23–6.

5 See Airaldi, 1985.

6 See Taviani, 1985, pp. 47–58.

7 See Treen, 1989; also Harrisse, 1884, pp. 267–300.

8 For Diego Columbus see Floyd, 1973.

9 Jos, 1944, p. 616.

10 Manzano Manzano, 1964, pp. 131–4.

11 See Guillén Torralba, 1992, pp. 193–5.

12 See summary and documents cited by Torre Revello, 1945, no.4, p. 4.

13 Marín Martínez, Ruiz Asencio et al., 1993, p. 65.

14 Quoted by Marín Martínez, Ruiz Asencio et al., 1993, p. 74.

15 For an overview of the period, see Kamen, 1991, pp. 1–61.

16 Fernández Armesto, 1975, pp. 89–105.

17 See Yarza, 1993, pp. 87–121; also Domínguez Casas, 1993, pp. 116ff.

18 For which see Vega, 1992, pp. 199–232.

19 For Peter Martyr (Pedro Mártir de Anglería or Anghiera) see Aldea Vaquero, Marín Martínez et al., 1972–5, I, pp. 66–8.

20 Fernández de Oviedo, 1870, pp. 18–21.

21 For Diego de Deza see Cotarelo y Valledor, 1905; also Torre, 1956, pp. 257–8.

22 Duque de Maura, 1944, p. 42.

23 The illumination is late fifteenth-century and shows a fellow student of Ferdinand, Juan de Zúñiga, maestre of Alcántara (1478–94), attending a lecture given by Antonio de Nebrija.

24 Cited in Kamen, 1991, p. 58.

25 Fernández de Navarrete, 1850, pp. 296–7.

26 The correct year is 1497. Columbus, 1992, p. 174.

27 Marín Martínez, Ruiz Asencio et al., 1993, p. 99; Jos, 1941, p. 515.

28 Columbus, 1992, p. 224.

29 Columbus, 1992, p. 226.

30 For which see Columbus, 1992a.

31 Columbus, 1992a, pp. 81–86; Jos, 1944, pp. 581–3.

32 See table compiled by West and Kling on p.23 of Columbus, 1992a.

33 West and Kling in Columbus, 1992a, p. 22.

34 See Columbus, 1992.

35 Guillén Torralba, 1992, pp. 201–2.

36 Jos, 1944, no.12, p. 19.

37 For the pleitos see Schoenrich, 1949–50; also Muro Orejón, 1964–84.

38 These four points are taken from Ursula Lamb in Bedini, 1998, pp. 413–14.

39 Guillén Toralba, 1992, p. 204.

40 See Jos, 1944, pp. 71–6; also Marín Martínez, Ruiz Asencio et al., 1993, pp. 187–93.

41 Marín Martínez, Ruiz Asencio et al., 1993, p. 190.

42 Jos, 1944, p. 72.

43 Guillén Torralba, 1990, p. 15.

44 Manzano Manzano, 1964, pp. 135ff; Marín Martínez, Ruiz Asencio et al., 1993, p. 203.

45 See Cuartero Huerta, 1950–54.

46 Arranz, 1991, pp.190–98; Marín Martínez, Ruiz Asencio et al., 1993, pp. 194–5.

47 Guillen Toralba, 1992, p. 206.

48 Rosa y López, 1906, p. 107.

49 Sermo Fr. Dyonisii Vazquez hispani, Rome, 1513. Listed in the Abecedarium B, column 484.

50 See Guillén Torralba, 1992, p. 207.

51 See Wagner, 1984.

52 Guillén Torralba, 1992, p. 207.

53 See Marín Martínez, Ruiz Asencio et al., 1993, pp. 261–2.

54 Mora Mérida, 1988.

55 Hernández Díaz and Muro Orejón, 1941, p. xiv.

56 Wagner, 1966, p. 101.

57 See Cadenas y Vicent, 1992.

58 It is possible that Ferdinand had met Erasmus earlier in Calais, when both were at the famous meeting between Charles V, Henry VIII and Francis I. See Huizinga, 1952, p. 145.

59 See Allen, 1933, iv, p. 353.

60 Guillén Torralba, 1992, p. 210.

61 Marín Martínez, Ruiz Asencio et al., 1993, pp. 315ff.

62 Guillén Torralba, 1992, p. 211.

63 See Wagner, 1966, p. 107; Marín Martínez, Ruiz Asencio et al., 1993, pp. 265–6.

64 'Sabado seis de março de 1518, commençe a leer este libro y a pasar las notas del en el yndiçe en Valladolit; y distraydo por muchas ocupaciones y caminos no lo pude acabar hasta el domingo ocho de julio de 1520 en Bruselas de Flandes; en el qual tiempo las notaciones que ay desde el número 1559 en adelante aun no estan pasadas en el indiçe porque quedo en España.'

65 Segura Morera, Vallejo Orellana et al., 1999, no.1117.

66 Yarza, 1993; Alvarez, 1998.

67 See Mora Mérida, 1988, pp. xxxvi–xxxviii.

68 Fernández de Navarrete, 1850, pp. 321–2.

69 Fernández de Navarrete, 1850, document 3, pp. 382–420.

70 Guillén Torralba, 1990, p. 215.

71 Bernales Ballesteros quoted by Wagner, 1990, p. 57.

72 Mal Lara, 1992, p. 93.

73 Hernández Díaz and Muro Orejón, 1941, no.1, p. xx; also Alizeri, 1870, v, p. 103.

74 See Lléo Cañal, 1998; also Recio Mir, 2001, pp. 59–60.

75 Mal Lara, 1992, p. 93.

76 Morales Padrón, 1989, p. 55; also Lleo Cañal, 1979, p. 11.

77 Mal Lara, 1992, pp. 59ff, esp.92–5; Oliva Alonso, 1982; and extensive discussion in Lléo Cañal, 1979, esp. Chapter 1, pp. 27ff.

78 Lléo Cañal, 1979; also Mora Mérida, 1988, pp. xxxix-lii.

79 See Moreno Mendoza, 2001.

80 Lléo Cañal, 1979, pp. 20ff.

81 Aranda Bernal and Quiles, 2001, p. 50.

82 See Wagner, 1971; Wagner, 1972b; Wagner, 1991, p. 59.

83 Beaujouan, 1987; also Babelon, 1913.

84 Guillén Torralba, 1992, p. 218.

85 Fernández de Navarrete, 1850, pp. 420–24.

86 Marín Martínez, Ruiz Asencio et al., pp. 254–9.

3 | *The Print Inventory, its Systems of Classification and Rebuilding the Collection*

The critical fortunes of the print collection

Since it was first mentioned in print, the inventory of Ferdinand Columbus's print collection has proved an enigma for scholars who, although they have recognised its existence and potential importance, have been reluctant to explore its significance fully. This is because the print collection vanished soon after Ferdinand died in 1539. Separated from the print collection it documents, the inventory exists as a record of diminished use. Nonetheless, unlike most inventories of collections, the descriptions of the prints are remarkably detailed, and make it possible to get a very clear understanding of what Ferdinand's collection originally comprised.

The print collection has also been overshadowed by Ferdinand's extraordinary library. Book collecting was Ferdinand's first passion and he amassed a collection of singular richness. The contents of Ferdinand's library, like his prints, were carefully catalogued. It is difficult to believe that Ferdinand's collection of prints was unique during the early sixteenth century, especially considering the tremendous rise in the printmaking industry and the proliferation of private libraries in Spain from around the late fifteenth century. What does seem to be unique about Ferdinand's collections is the attention he paid to cataloguing them.

Notwithstanding the critical concentration on his book collection, the print inventory has often been mentioned.[1] The earliest record of the inventory is the *memoria* written by Ferdinand's principal collaborator Juan Pérez as a record of the systems and procedures employed in organising his library.[2] For the print collection, the *memoria* is the most significant document because it relates to the collection as it once existed and records how the prints were to be organised. The *memoria* reads:

My master don Hernando also intended to collect all the drawings, pictures and images he could find, as he did with a large amount of them. Hence, it was necessary to establish an order to keep the records of those that were purchased, so that the same picture would not be bought twice. With this aim, he used three books, quarto, written by hand, bound in white vellum, that are tied together in the library in the place I have already mentioned. They are the report of all the drawings or pictures that are in the library and in the chests, organised as follows: if the picture is small, that is, it is made of a sheet of sixteen parts it is called *sezavo*, and if it is medium size, that is a page in eight parts, it is *octavo*; and if larger, of a sheet made of four parts, it is called *cuarto*; if it is big like a sheet, it is called a *pliego* [folio]; and if it is very big, like *marca real*, it is called *marca*; images are thus distinguished by using these terms.

These books can be useful to know how many pictures are in the library and to avoid buying the same picture twice, as has been said. The way of doing so was to take the picture he wanted to record, and if it was a quarto, he said quarto, and if there were one or more figures in it, he said quarto with two figures. If they were dressed, he said dressed, and if naked, he said so, and this was the title. In another line, he wrote all the signs [features] that the picture and the figures had; hence, if the picture was quarto and there were four naked men, he said as its title: quarto, with four naked men, and he added all the important signs [features] of the figures below, thus saying: a man and a woman, they are naked and seated, he has his right on his thigh, cannot see his thumb, his left is folded and he leans his left cheek on it, his feet are crossed, and next to his left knee he touches the shaft of the axe; she holds two children with her right hand and a distaff; and so he did with all the other signs [features]. Therefore, when a pic-

ture was brought to be sold, and he wanted to buy it, as he had so many, he did not know whether it was in the library or not. By seeing the number of figures or the people represented in it, as well as other signs, he could search the books and, by checking the size of the picture, he could know whether it was there. If not, he would buy it, but if it was in the book, it would not be bought twice.[3]

The fundamental problem was that, although its significance had been recognised, little else could be achieved until the prints described had been identified to show precisely what the collection comprised. Only once that was done could the importance of the collection be fully understood and its value for the study of printmaking and markets during the period be revealed.[4]

The Seville inventory

Today the Seville inventory consists of quires that form one volume. Each inventory page is consistent in the way it is structured. At the top of the page is the category under which the prints are described (fig. 25). Each block of text describes one print and is separated from the next description by a space. Throughout the inventory, there are different hands of around twelve scribes. The role of the scribes in cataloguing Ferdinand's collection has long been recognised, and the implications this has for the organisation of his workforce will be considered later. The identification of independent hands in the inventory is part of the archaeological process that provides an understanding of how the collection was formed. The scribes recorded the prints according to a system of classification devised by Ferdinand.

Classification of the prints

Ferdinand's system of print classification was determined by the sorts of prints that were available to him at the time he began

Size classification

The seven size categories should more accurately be regarded as six sizes – *sezavo* to *marca* – and one *rótulo* format that could comprise prints of any size that were in a roll. Generally, those in a roll format were categorised as such because they were so big; however, they could be formed from sheets of smaller prints. Size therefore is the first assessment criterion for prints in the inventory. In the *memoria*, the imperative of size is carefully defined (see above). The *memoria* indicates that a *sezavo* size print is one that is made from a 16° format sheet; an *octavo*-size print from an 8° format sheet; a *quarto*-size print from a 4° sheet; a *pliego* print is a folio sheet and a *marca* print is from a royal sheet. The classification *medio* is not mentioned; this category was devised as an intermediate size between *quarto* and *pliego*.

From the prints identified in the collection, it is possible to ascertain the size parameters for each category. These are as follows:

Sezavo	h. 55–80 mm × w. 40–60 mm	>	Very small
Octavo	h. 110–130 mm × w. 75–100 mm	>	Small
Quarto	h. 160–200 mm × w. 110–140 mm	>	Medium
Medio	h. 230–260 mm × w. 160–180 mm	>	Large
Pliego	h. 300–380 mm × w. 200–300 mm	>	Very large
Marca	h. 450+ × w. 450+ mm	>	Extremely large
Rótulo	Length c.600+ mm	>	Roll format

The *sezavo* prints form a tight group that are all around the same size. Extremely few prints from this category exceed the limits defined in the table above and, when they do, the increment is closer to the *sezavo* category than *octavo*, the next size up. In contrast, the *marca*-size category was used for any huge print that was not in a roll, many of which greatly varied in size. The differentiation between a *marca*-size print and a roll (*rótulo*) was determined by its length and also how the print was to be stored. The three woodcuts comprising Lucas van Leyden's *The Nine Worthies* [cat. no. 100], joined together to form a roll as Ferdinand bought it, measured around 317 × 1522 mm. Its length would have made it more or less impossible to store if it was not rolled up.

FIG. 25 | Page from the *Seville Inventory*. Biblioteca Colombina, Institución Colombina, Seville (photo author).

collecting. In the inventory, the prints are described pragmatically, categorised first by one of seven sizes (*sezavo, octavo, quarto, medio, pliego, marca* and *rótulo*), then subject (male and female saints; men and women; animals; inanimate objects; decorative knots; topography; ornament and vegetation). The third category is the number of any one of these in the image, for example, '6 male saints' or '3 dogs'. After fifteen, the designation 'muchos' is used. The fourth criterion is whether they are dressed or undressed. A complete heading from the inventory runs, for example, '*pliego* size print of 8 clothed male saints' (*Pliego de 8 de santos vestidos*). The prints that agreed with the criteria were then described under that heading.

Although the *rótulo* category did not by definition refer to size, most of the prints identified are very large. Amongst the smallest rolls identified are the *Battle of Zonchio* [548 × 800 mm, cat. no. 5] and Domenico Campagnola's *Massacre of the Innocents* [cat. no. 18].

Ferdinand's systems allowed a degree of flexibility in deciding where was the best place in the inventory to describe a print. One scribe might consider an *octavo*-size print as falling between a height of 95–120 mm by a width of 70–80 mm, whereas for another *octavo* might be slightly larger. Such cases crop up throughout the inventory. Hans Wechtlin's *A Knight and a Lansquenet* [cat. no. 52] measures 271 × 182 mm and is classified as *pliego*-size but could also have been placed as *medio*. Despite these occasional misjudgements, there is a remarkable consistency in size classification throughout the inventory, testifying to the efficacy of Ferdinand's system.

The basis for the Columbus system of size classification

Ferdinand devised his system for the classification of his prints before he began to record his print purchases. As discussed earlier, his great passion was book collecting, and by the time he began buying prints – possibly around 1520 – he owned a substantial library. It is clear that Ferdinand based his size classification on book sizes and the descriptors (*sezavo, octavo, quarto* etc.) were adapted from standard book/paper formats. Their broad correspondence of *sezavo, octavo* etc. to books Ferdinand owned provided him with a basis for his print classification. These divisions were discussed in the *memoria* and provided him with the initial systematic key for print classification.

Was there a precedent for Ferdinand's system of size classification other than his exposure to books, and how did the system precisely relate to paper sizes produced during the period? There is very little clarity about the subject of print sizes and classification. When Albrecht Dürer was travelling through the Netherlands in 1520, he sold his prints according to subject matter and size: quarter, half and whole sheets.[5] It is unlikely that the size terms used by Dürer designated precise parameters; they broadly reflected the dimensions of the sheets he used to differentiate between small, medium and large prints. In the inventory from the shop contents of a Florentine merchant, Alessandro di Francesco Rosselli (d.1525), many of the prints are referred to by size (*foglio comune, foglio reale, quarto foglio, octavo foglio*), presumably as a means of assessing their value.[6] From what little remaining evidence there is, it seems that prints were referred to by conventional paper sizes. But in the case of Ferdinand's system there is a palpable shift from format approximations as expressed by Dürer, to devising quite precise measurements based on paper formats that were transformed into a rigorous independent system of print classification.

There seems to be a currency of scale relevant to prints that has little to do with aggregate sizes for paper formats. Their scale, although based on paper formats and terminology, responded to the self-determined patterns of printed images. Put simply, a print such as Israhel van Meckenem's *Samson Slaying the Lion* [cat. no. 24] was classified as *quarto* because it was comparable in size to books of that format in Ferdinand's library. Albrecht Altdorfer's *The Large Crucifixion* [cat. no. 70] was classified as *octavo* because its size was similar to an *octavo*-size book. A sample of books from his collection reinforces the broad correlation. Ferdinand's size classification was a conscious attempt to bring order to his huge collection. He wanted to move beyond the simple approximations of small, medium and large that appear to be the basis of print sizes during the Renaissance.

The terms in Ferdinand's size classification that require further explanation are *pliego* and *rótulo*. *Pliego* can be used in two ways. It can mean a sheet of any size, and in the context of the print inventory the print dimensions given above for the classification *pliego*. In one of Ferdinand's book catalogues, the Registrum A, many of the entries refer to the number of pages in a book as *pliegos*. In the print inventory descriptions, *pliego* is never used to refer to a print size but rather a sheet of paper. There are many examples where this occurs. For example in Hans Burgkmair's woodcut *The Peoples of Africa and India* [cat. no. 56], the text

describes 'the people of India in eleven sheets each with a text box below' (*La gente de India en onze pliegos cada qual con su letrero abaxo*).

In a number of entries the term *pliego* is married to a size category, making it possible to work out the approximate size of a *rótulo*-format print. Ugo da Carpi's *The Sacrifice of Abraham* [cat. no. 15] is described as 'four sheets of *marca* size' (*quatro pliegos de marca*). The four *marca* sheets making up the *Sacrifice* measure h. 790 × w. 1076 mm. This size agrees with the expected size (2 × 400 mm × 2 × 500 mm = 800 × 1000 mm).

Subject classification

Like size classification, the predominant subjects depicted in prints during the period determined the subject categories in the inventory. The hundreds of variations within subject categories had to be distilled into a structured system of unambiguous meanings. Religious subjects were the ones most commonly represented. They included everything from single standing saints to complex multi-figure compositions. By definition, religious subjects contained at least one figure (divine or mortal or a mixture of both), so using figures as criteria for classification was straightforward. The figure as criterion for classification was also used for prints depicting secular subjects. The criterion of clothed and unclothed also theoretically provided unambiguous benchmarks for classification but, as discussed later, it proved problematic in its application. There are other areas of print subject that did not contain figures and these are covered by the categories *animalias*, *tierras*, *inanimados*, *lazos* and *follajes*.

Taken together, the subject categories represent a sort of global subject index of printmaking capable of absorbing any subject. The classification categories are not inviolate and operate within complex matrices of hierarchies and individual interpretation. Individual prints might present real problems of classification, for example a print showing half-human figures intertwined in foliage. Should it be classified as an ornament print or a figure print? Are there a fixed number of figures that would deter-

mine if a print should belong in a human category or a non-human category, or is it the size of the figures that determines the classification? These matters were generally resolved by Ferdinand's secondary rules of classification.

Secondary rules of classification

Ferdinand's classification of figure prints in the first instance is numeric and then based on opposed conditions: male/female, religious/secular, clothed/unclothed. But within this straightforward and eminently workable system, there existed other rules that further refine the processes of classification. These evolved as a response to problems Ferdinand encountered in the initial stages of devising his system, resulting in the need to establish a hierarchy of standards for his scribes. The secondary rules are not mentioned in the *memoria* but become evident when the inventory is analysed.

The secondary rules can be summarised thus:
- saints take precedence over mortals
- male saints take precedence over female saints
- males take precedence over females
- clothed figures take precedence over naked
- people take precedence over animals and inanimate objects
- animals take precedence over inanimate objects

An example of each demonstrates the rule of precedence.

Thomas Anshelm's *Martyrdom of St Sebastian* [cat. no. 86] is classified as '*pliego*-size sheet of five dressed male saints' (*pliego de 5 de santos vestidos*). The print contains five male figures, only one of which is a saint. The figure of Sebastian determines the categorisation. In all cases – discounting the occasional error – saints take precedence over mortals, so one saint in the company of ten soldiers would be classified as 'eleven saints'. An even more striking example is the Lucas Cranach print depicting the *Beheading of St John the Baptist* [cat. no. 82]. St John is the only holy personage amongst many secular figures, but because of his presence, the print is classified as a '*pliego*-size sheet of many dressed male saints' (*pliego de muchos de santos vestidos*).

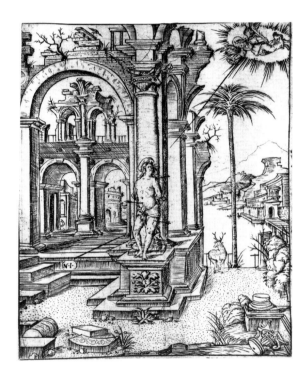

In the majority of cases, male saints take precedence over female saints. Wolf Traut's *An Angel Seated on the Empty Tomb and the Three Maries* (fig. 26) depicts three female figures and one male.[7] Because of the male angel, the print is classified as a '*sezavo*-size sheet of 4 dressed male saints' (*sezavo de 4 de santos vestidos*). This entry is particularly revealing because the scribe originally entered it under the category of a '*sezavo*-size sheet of 4 dressed

female saints' (*sezavo de 4 santas vestidas*) then crossed it out and re-entered it where it occurs now, a clear indicator of how the rules of precedence operated.

The hierarchy of male dominance generally applies to secular subjects. In equal pairings, where there is one man and one woman, the male always determines the precedence. Wolf Huber's *Pyramus and Thisbe* [cat. no. 76] is classified as an '*octavo*-size sheet of two dressed men' (*otavo de 2 de hombres vestidos*). Occasionally women who outnumber men determine the precedence. It is amusing to read that the two unidentified prints depicting Judith with the head of Holofernes are classified as 'clothed women'.[8] The decapitation clearly emasculated Holofernes' status and dominance, but in this case, it is not clear if Judith's exemplary virtue or the fact that the only visible male part was the decapitated head determined the classification. Counting heads without bodies seemed to cause problems.

The hierarchy of saints, males and females is consistent but there is less consistency in the categories of clothed and unclothed. Does a scantily clad St Sebastian or a naked Christ count as clothed or unclothed? Scribe A considers St Sebastian with a loincloth a 'naked male saint' and as such he classified Nicoletto da Modena's treatment of the subject (fig. 27).[9] In other descriptions, Sebastian in the same state of undress is classified as a 'clothed male saint', as in Hans Baldung's woodcut (fig. 28).[10] Another difficult subject is Christ as the man of sorrows, who despite his restrictive loincloth is sometimes classified as a naked male saint. There seems to be no general consensus about how best to classify the subject; seventeen prints of Christ as the man of sorrows are classified as a 'naked male saint' and fourteen as a 'clothed male saint'. In some cases, the nudity of a subject leads to a more bizarre classification. The unidentified print depicting *An Ancient Roman Head composed of Penises* is considered 'one naked male'.[11]

Generally speaking, if naked women numerically overwhelm a male figure then the category is female. For example, in Giovanni Battista Palumba's *Diana and Actaeon* (fig. 29) there is a total of seven figures: five naked women, a huntsman in the background, and the partially transformed Actaeon in the foreground.[12] The print is classified as a '*pliego*-size sheet of seven

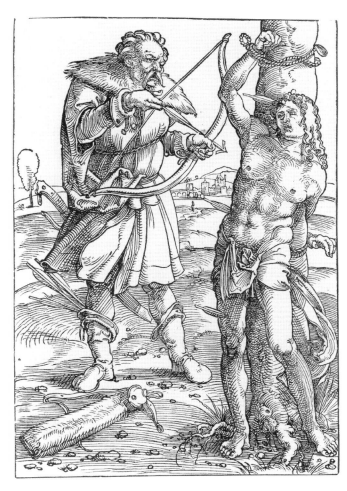

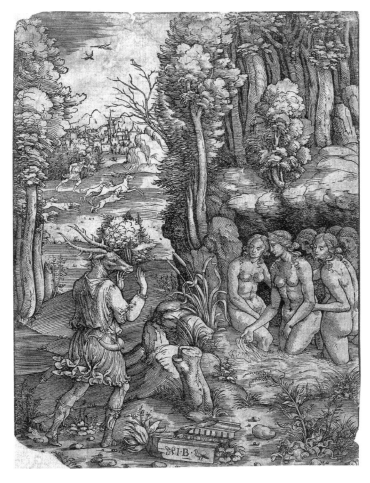

FIG. 28 | Hans Baldung, *St Sebastian*. Woodcut, 236 × 161 mm, *c*.1505–7 (The British Museum, E.2-301).

FIG. 29 | Giovanni Battista Palumba, *Diana and Actaeon*. Woodcut, 301 × 217 mm, *c*.1505–12 (The British Museum, 1845-8-25-627).

naked women' (*pliego de 7 de mugeres desnudas*). In all cases, humans take precedence over animals and inanimate objects. *The Pedlar Robbed by Apes* (fig. 30), depicting one man among twenty-three apes and one bear, is classified as a '*pliego*-size sheet of 1 dressed man' (*pliego de 1 de hombres vestidos*).[13]

Ambiguous classification

The secondary rules of classification can be understood as standards that, if rigorously applied, would provide a framework for assessing different levels of subject, but the ambiguous nature of many subjects and the mixture of figures often make a conclu-sive classification difficult. Ferdinand probably devised or at least had a very clear notion of hierarchies that were even more com-plex than the secondary rules outlined above, but getting the scribes to understand and implement them in a consistent manner with so many prints would have been impossible. The secondary rules for classification, however well intentioned, proved too much for some scribes and there are inconsistencies throughout the inventory. Several examples of different misunderstandings illus-trate the vagaries of the system and the difficulty in maintaining overall consistency. In an unidentified print classified as a '*quarto*-size sheet of 12 naked male saints' (*quarto de 12 de santos desnudos*) depicting the *Mass of St Gregory*, Christ is shown in the tomb naked – save a loincloth – appearing to Gregory and his entourage.[14]

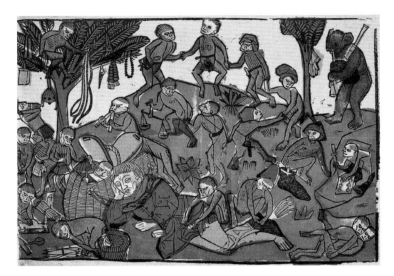

FIG. 30 | Anonymous German, *The Pedlar Robbed by Apes*. Colour woodcut, 266 × 370 mm, *c.*1480–90 (Kupferstichkabinett der Museen der Stadt Gotha, 1,3).

FIG. 31 | Jost de Negker, *The Temptation of St Antony*. Woodcut, 338 × 268 mm, 1505–8 (The British Museum, 1875-7-10-182).

That the print is classified as '12 naked saints', despite the fact that eleven of them were dressed, indicates that for the scribe the figure of Christ took precedence over the other figures, clearly an overly literal interpretation of a protocol. The classification of Jost de Negker's *The Temptation of St Antony* as a '*pliego*-size sheet of 4 dressed male saints' (*pliego de 4 de santos vestidos*) illustrates an especially difficult feat for the scribe (fig. 31). The print depicts two naked females, one male saint and a kneeling demon. The scribe had to assign an overall category; although it is absurd, the classification under '4 dressed male saints' is correct according to Ferdinand's logic.

In the case of prints which to our eyes are not figured, the presence of any human form can result in an interpretation which seems to offend common sense. The woodcut depicting the *City of Nineveh* (fig. 32) that occurs in Hartmann Schedel's *Nuremberg Chronicle* is fundamentally a topographical view (*tierra*), but it is classified as a '*medio* size sheet of 1 dressed man' (*medio de 1 de hombres vestidos*).[15]

For some of the scribes the subject classification proved too much of a struggle. Dürer's *Map of the Southern Sky* is a case in point (fig. 33).[16] The woodcut depicts a celestial map with stellar configurations realised by figurative representations. Ceres is a fish, Canis Minor is a dog and Orion is an armed man. Because of the figure representing Orion, the print is classified as a '*marca*-size sheet of 1 dressed man' (*marca de 1 de hombres vestidos*).[17] How should Dürer's print ideally be classified? It incorporates the categories of Animals, Maps, and Clothed Men. Classifying it as a 'dressed man' is absurd, but by working though the hierarchies of subject dominance there is logic to the classification.

If there are inconsistencies in the inventory, they are not the result of imperfections but rather the hesitation of those describing the image and their inability to decide the best classification. Although the categories may seem strange to us, there is remarkable consistency on all levels, pointing to the efficacy of the primary and secondary protocols devised by Ferdinand. Given his love of system, it is notable that he did not develop an independent set of sub-descriptors to deal with disparate subject matter. Ferdinand's lack of attention to sub-hierarchies for his print

FIG. 32 | Michael Wolgemut and Wilhelm Pleydenwurff, *The City of Nineveh with a King*. Woodcut, 141 × 225 mm, c.1493 (The British Museum, 1870-10-8-1938).

FIG. 33 | Albrecht Dürer, *Map of the Southern Sky*. Woodcut, 427 × 432 mm, 1515 (The British Museum, 1895-1-22-735).

classification beyond the secondary rules of precedence contrasts sharply with the multi-level classifications he developed for his books. But this might be expecting too much of him. One suspects that the system he devised was so completely original that, unlike the long and distinguished history of book classification, there was no precedent for it, and like all systems it needed to be applied and refined before it became efficient and workable.

Interpreting the inventory text

In the last section, the system devised by Ferdinand for classifying his prints was examined. Married to that taxonomy are descriptions of each print. The relatively straightforward taxonomy enabled a scribe to catalogue a print correctly and allowed anyone consulting the inventory later to determine the item's physical properties and subject. The interdependency between the taxonomy and the descriptions is made very clear in the *memoria*. Because today the actual prints Ferdinand owned have not survived (many do not exist in any known impression), half the equation is missing, which undermines the strategies implicit in the entries. In the absence of the object, the inventory cannot operate as originally intended.

Each inventory entry describes some utterly unique feature within a print, thereby coding the image in such a way that it was impossible to confuse one print with another of the same subject. In the *memoria* Juan Pérez gives an example of the form of description that occurs in the inventory (see above). The model he describes is fascinating for the sort of details he considers important: how the right hand is placed on the thigh, which thumbs are hidden, which body parts touch other figures and objects, and so on. The consistency of this sort of description throughout the inventory clearly indicates the efficacy of the model.

The unique features can be divided into two broad groups: (1) macro, an object or figure in a print and (2) micro, a detail within an object or figure in a print. This simple division, which probably evolved as a practical response to the experience of applying the system of classification, resolved the descriptive needs posed

by different types of print subject. In most entries, there is a mix of macro and micro descriptions. The necessity of isolating peculiar features in a print resulted from the presence in Ferdinand's collection of so many versions of the same subject. He owned eighteen prints of Christ being crowned with thorns, twenty-eight prints depicting the Last Judgement, forty prints of St Sebastian and around the same number of the Virgin holding the Christ Child. Many of these were the same size, often remarkably similar to one another, and in some cases they were copies. Moreover, what he bought was a fraction of an enormous industry. In Ferdinand's collection there were a number of such prints that would be impossible to differentiate were it not for their careful descriptions, which can allow copies or close variations on the same print to be distinguished.

Israhel van Meckenem's engraving *Christ Being Crowned with Thorns* [cat. no. 27] well illustrates the type of macro classification. The entry reads:

> Christ seated on a pillar with a cane in his right hand
> being passed to him by a Jew in his left hand, his right
> raised a little like a greeting, the other three are above
> fixing the crown of thorns on his head with sticks,
> one of them has his back turned, below are two dogs,
> one is hairy and the other, a greyhound, is lying down.

In this entry, the main figures and their actions are described as well as other details to mark the print as unique.

Identifying unique features resolved the problem of differentiating between prints of the same subject that were structurally identical but totally different in appearance. The subject of the Last Supper illustrates this proposition. The subject was one of the most depicted in religious art. All representations contained basic features: Christ, the apostles, a table, and normally things on the table to do with eating. By isolating small details and deploying them in the description, the means of differentiation then increases exponentially. The Monogrammist S and Wenzel von Olmütz both produced prints of the Last Supper that are the same size, contain the same features but are very different [cats 101a and 32].[18]

By identifying the unique arrangements of figures and relationships between objects, the inventory descriptions make it perfectly clear which is which. The description of the print by Wenzel von Olmütz reads:

> The Last Supper of Christ with his disciples, on the
> table are two chalices, the plate touches the head
> of a disciple of whom we cannot see the left, the other
> who is to our right touches bread with the middle
> finger, with the left index finger a knife, at the upper
> left of Christ is a dog and a man who has the right
> foot on the left and a sword, he holds a plate in his
> hands with which he touches his face.

The description of the same subject in a print by Monogrammist S reads:

> The Last Supper of Christ with his disciples, Christ
> has a chalice in his left hand, we can see only that
> index finger and thumb which touches St John's face,
> the disciple below to our left has a plate in his hands
> in which is a lamb, below a knife, Judas has a bag
> in the right that touches bread, below is a jug that
> almost touches the right foot of a man and the right
> foot of Judas.

By providing a certain threshold of detail, it becomes entirely possible to differentiate between the two otherwise indistinguishable prints. The simpler the subject, the greater the need for descriptions that remove any possible ambiguity.

A sufficient level of detail in a description is critical to the process of identifying prints in the collection. On a few occasions, the required threshold is not reached and even where the print survives it cannot be matched with absolute certainty to the entry. *St Jerome in the Desert* [cat. no. 6] is an example where the description is very general. The print corresponds to Marcantonio Raimondi's treatment of the subject, but were it not for the mention of the clips on the book it would be impossible to be certain of the

match. The fact that there are so few entries where the required threshold of detail is not reached indicates that Ferdinand was clearly aware of the imperative to describe in detail and impressed this upon his scribes.

Generally, if a print contained a sufficient number of tangible objects one of them was singled out and described as an anchoring detail. An example is the *Siege of Aden* [cat. no. 108]. After describing the castle and the boat, the scribe writes, 'at the extreme right by the border is an elephant carrying two barrels' (*junto a la Raya viene un alefante cargado con dos bariles*). Describing a whole element of this sort would not have been adequate for a print depicting Adam and Eve, where the objects rarely vary (Adam, Eve, serpent, apple, tree).

One recurrent feature in the inventory descriptions is a focus on details that occur in multiples that could be counted. This belongs with the second type of assessment, micro description. Very common details that are highlighted in the descriptions are slashes or slits ('cuchilladas') in the garments worn by figures. The description of the piper in Amico Aspertini's *Three Musician Soldiers* [cat. no. 10] has 'four slashes on the right thigh' (*quatro cuchilladas en el muslo diestro*).

Another often-used identifier is beading and jewellery, presumably because the beads or stones could be counted. The child from Guinea depicted in the first sheet of Hans Burgkmair's *The Peoples of Africa and India* [cat. no. 56] is described as wearing 'five bracelets on each arm' (*en cada braço 5 manillas*). Plumes worn as headgear were another favourite, because they too could be counted. In Jan Wellens de Cock's *Six Musician Footsoldiers* [cat. no. 107] a soldier is described as wearing 'a hat on his head with six plumes' (*una gora puesta en la cabeça con seys penachos*). Holes and buttons are also singled out as identifiers. The reins held by Hector in Lucas van Leyden's woodcut *The Nine Worthies* [cat. no. 100] are described as being 'punctured by four holes' (*en la falsa rienda cuatro agugeros*). In many entries, the countable details are described in profusion. Part of the description of Lucas van Leyden's engraving *A Young Man Holding a Skull* [cat. no. 99] reads: 'the right sleeve has four slashes and a button, in the left three, in the opening of the vest are five slashes, he has an embroi-

dered shirt with a button, the bonnet has three slashes with six plumes and a jewel with four pearls'.

Because of the homogeneity of countable details, it is highly likely that Ferdinand provided his scribes with examples of the sort of detail that could effectively be deployed to describe a print uniquely. The macro and micro descriptions in the inventory operate in tandem as a structured hierarchy that was probably as effective for Ferdinand's purposes as any diagnostic system could be.

FIG. 34 | Hans Baldung, *St Barbara*. Woodcut, 238 × 161 mm, *c*.1505–7 (The British Museum, E.3-162).

Problems of interpreting the descriptions

The first difficulty is understanding in a description which anatomical feature is being referred to. For example, when referring to a person in a print, many scribes adopt the abbreviated formula 'the man at the left of Christ touches the tree with his right, whose left touches the door of a house'. It is not clear what the 'right' or the 'left' refer to. For example, the entry describing Jost de Negker's *St Christopher* [cat. no. 104] reads:

> St Christopher with Christ on his shoulder, his right is on St Christopher's shoulder, we can see only three digits, he has his right foot outside the water, it touches the crags, his robes wind around his staff and his right arm, there are four ducks in pairs at either side of the staff.

FIG. 35 | Anonymous Italian, *A Round Knot*, after Leonardo da Vinci. Woodcut, 292 × 207 mm, 1490–1500 (Bibliothèque Nationale de France, Paris, 71050146).

Once the print has been matched to the description, it is clear that the first line means 'the right *foot* is upon the shoulder of which only three toes are showing'.

Another idiosyncrasy is the way spatial relationships within an image are described, resulting in a compression of objects across perspectival planes. Part of the description for Hans Baldung's woodcut *St Barbara* (fig. 34) reads 'the tips of her hair touch a boat' (*las puntas de los cabellos tocan a un navio*). Even after reading the complete entry, it is not at all clear what this means. But upon seeing the print, it becomes perfectly evident. This sort of object/space compression crops up throughout the inventory, making it difficult to visualise how objects exist in space.

For many prints, the descriptions are almost impenetrable because the scribe struggles to isolate unique features and becomes disconcerted in the process. Often a minor detail is isolated, a convoluted description is given, or one so general that it undermines the protocols of classification. Lucas Cranach's multi-figure *The First Tournament* depicts a subject that is difficult to describe because of its busy composition [cat. no. 79]. The scribe records the subject as a tournament, and then tries to isolate something in the composition: 'to our right is a little dog that has its feet on a step, touching the nose of a horse, whose left foot we cannot see'. Having the image in front of him provided the scribe with the mechanisms for abbreviating the description, knowing that the consequent act of seeing the print would 'fill in the gaps'.

The most difficult descriptions to make sense of are those describing ornament prints. Inv. no. 3112 for example reads:

> A white knot made as if from two chain links with two squares, in the centre one is a rose-like shape of five leaves, in the centre a small white circle, in the other centre are another four leaves, in the middle another circle, and each square has a different style, there is a rose of five petals and the two tips are like knots of cherries.

The generic forms of ornament make it difficult to isolate a unique feature because in most cases there is no one feature upon which

subject statement to an objective approximation of the actions taking place. Hans Burgkmair's *Aristotle and Phyllis* (fig. 37)[22] is described as 'a woman astride a man' (*Una muger que ahorca a un onbre*) and Giovanni Battista Palumba's *David with the Head of Goliath* (fig. 38) is described as 'a young naked man ... a large knife in his right is thrust into a head' (*Un mançebo desnudo ... un cuchillo en la diestra hincado en una cabeca*).[23] Sometimes, the need for objective description overrides elucidation of the subject. The description of Marcantonio Raimondi's *Marcus Curtius* (fig. 39) begins 'a man on a horse, he wears a helmet on his head' (*Un honbre ençima de un caballo en la cabeça un yelmo*) even though the banderole that reads 'curtius' is transcribed in the entry.[24] Scribe A might not have known who Marcus Curtius was, but the prominence of the banderole makes his identity obvious. This example reinforces the point that there was an overriding need for a scientific structure to the descriptions. More striking is where a scribe does not name a sitter as prominent as Charles V. In inv.no. 1730 Charles V is described as 'a gentleman in half-length' (*Un gentil honbre hasta el honbligo*), followed by a descrip-

FIG. 36 | Lucas van Leyden, *Herod and Herodias* (*The Large Power of Women*). Woodcut, 390 × 284 mm, *c*.1514 (The British Museum, 1845-8-9-1015).

FIG. 37 | Hans Burgkmair, *Aristotle and Phyllis*. Woodcut, 117 × 94 mm, 1513 (The British Museum, 1895-1-22-372).

to hang the description. They are part of a greater ornament device that is repeated. Even in the few cases where an ornament print is matched, it is difficult to align with confidence the description with the image. Were it not for the words 'academia leonardi' transcribed in the entry, it would have been impossible to match the *Round Knot* after Leonardo da Vinci (fig. 35).[19]

In a number of entries, the subject is altogether misunderstood. Albrecht Altdorfer's *Joachim's Offering being Refused* is described as 'the Circumcision of Christ'[20] and Lucas van Leyden's *Herod and Herodias* is described as the 'Decapitation of St John the Baptist' (fig. 36).[21] More commonly, the scribe has little or no idea of the subject of a print, which results in a shift from a

tion of all his attributes, making his identity obvious even though the print no longer survives. What can be concluded from these examples is that iconography as a conveyor of meaning had minimal value in the process of classification. Attributes were relegated to the abstract realm of impartial associations solely in the service of identifying something unique in an image, thereby supporting the taxonomical system.

A broader context for Ferdinand's classification system

The rules of classification devised by Ferdinand suited his specific cataloguing needs. They emerged, however, from cultural and intellectual systems for ordering and measuring the universe that permeated the society in which he lived.

Ferdinand's humanist background is the key to understanding the strategies reflected by his print catalogue. The education, which began in the court of Ferdinand and Isabella, was reinforced by his subsequent years in Rome and the Low Countries. When Ferdinand lived in Rome, humanist scholarship was at its peak. Because humanists looked to the past to make sense of the present, their approach was to systematise the information ancient sources contained in order to find new methods of doing things. One manifestation of this mentality was the tabulation and annotation of texts – a practice followed by Ferdinand – which provided a sort of index to the contents of a book and also a way of analysing its contents. The literary criticism of the humanists relied on models for analysing textual structures. Texts were broken down into components according to their arguments and divided into parts: sentence→clause→phrase→word.[25] The imple-

FIG. 38 | Giovanni Battista Palumba, *David with the Head of Goliath*. Woodcut, 378 × 263 mm, c.1505–12 (Bibliothèque Nationale de France, Paris).

FIG. 39 | Marcantonio Raimondi, *Marcus Curtius*. Engraving, 177 × 117 mm, c.1510 (The British Museum, 1972 U.1293).

ıods provided pathways to meaning. The
and content was similarly applied to the
This was a conspicuous feature of the art
y. The rationalisation of pictorial space
ometry distinguishes it from the art pro-
d in other parts of Europe. In his treatise
ing, 1435/6) Leon Battista Alberti writes:

e who begin to learn the art of paint-
practised by teachers of writing.
all the signs of the alphabet sepa-
ow to put syllables together, then
students should follow this method
st they should learn the outlines of
way in which surfaces are joined
r that the forms of all the members
hey should commit to memory all
at can exist in those members, for
w nor insignificant.[26]

ext and image was constant during the
fifteenth and sixteenth centuries, and was a principal force behind
intellectual life.

The development of merchant capitalism, too, needed
accounting methods to keep track of increasing trade transactions,
especially with the rise of conglomerate empires comprising
different peoples, languages and customs that had to be dealt with
in order for understanding to be achieved. Michael Baxandall
discusses how important mathematical skills were to daily life,
especially in the market place, and how the experience of quan-
tification was pervasive, not just the preserve of individual spe-
cialists.[27] He cites treatises such as Filippo Calandri's *De arimethrica*
(Florence, 1491), illustrating measuring exercises; how to ascertain
the height of a column, the circumference of a globe and the *Libro
di mercatantie et usanze de Paesi* (Florence, 1481), which provided
comparative information regarding the difference between Flo-
rentine measures and those of other Italian towns.[28] Mathemati-
cal analyses carried through to understanding nature and the

human form. The analyses of perspective theorised by Alberti,
Viator's *De artificiale perspectiva* (1505) and Leonardo's studies
of the forces of nature are part of the same objective: to understand
the static and dynamic operations of elements, the effect space has
on the perception of objects and their representation. Early in
his career, Albrecht Dürer began devising formulae for determining
the proportions of the human figure. At the expense of anatomi-
cal exactitude, Dürer's methods were part of a broader project to
understand the motor functions of the human body and the math-
ematical relationship between each of its components. The mat-
erial in Dürer's *Vier Bücher von Menschlicher Proportion*, published
in 1528, demonstrates how mathematically derived proportion
provided a legitimate means for measuring human form.[29]

The interest in what can broadly be termed quantifica-
tion continued unabated from the early Renaissance. In the late
fifteenth century, texts regarding the measurable world represented
by the works of the ancients – for example Philo of Alexandria –

FIG. 40 | The Spitz Master, *Christ Carrying the Cross.*
Manuscript, *c.*1420 (The J. Paul Getty Museum,
Los Angeles).

were being translated and published, sometimes in several editions. In 1493, Hartmann Schedel's *Nuremberg Chronicle*, containing the 'history of the world' from creation onwards, was published in Nuremberg [see cat. no. 23]. Although the *Chronicle* belongs more to a medieval world and did not pretend to be scientific in its method, it appealed to the same need for ordering the known universe. The discovery of the New World in the late fifteenth century vastly expanded the frame of reference with a concomitant effect on interpretative methods and the development of the sciences. Many written accounts of the New World, its inhabitants, flora and fauna began to appear. Ferdinand's *Historia* is one example that carefully describes his own voyage with his father, the people he encountered, their customs and how they lived.

FIG. 41 | Lucas Cranach the Elder, *Portrait of a Woman*. Oil on beech, *c*.1520 (National Gallery, London).

Whereas the above brief discussion does not directly bear upon Ferdinand's system of print classification, it provides signposts suggesting broad preoccupations with ways of ordering and explaining the world. From the time Ferdinand began collecting, it was obvious to him that were he to maintain his acquisitive programme, he would have to implement cataloguing procedures to manage his vast numbers of objects. It would make no sense for a collector to buy on such a scale without establishing order. Chapter 4 of this catalogue discusses Ferdinand's library in Seville, and how it was structured with the explicit purpose of ordering the contents so that they could easily be accessed.

But what of the particulars of Ferdinand's system for classifying his prints beyond the general context, and how do they relate to images produced around the same time or earlier? Ferdinand's method of describing prints is unique for the period. There are no other cases where images are described in quite the same way. The way of describing objects as touching other objects with no differentiation between their perspectival relation is an isocephalic reading, like describing a frieze from left to right and picking out details only to anchor the description. What is also striking about the inventory descriptions is the absence of terms to indicate perspective, background or foreground. The word 'campo' and the clause 'no hay lexos' are used to indicate the presence or absence of a background but these are edited translations and should not be taken to imply a view of perspective. This method of description – different from classification – is intriguing; ranking surface tension before space is revealing for ways of seeing and reading images.

In the name of objective description, the system Ferdinand devised played down any subjective relationship so that the fundamental signifiers of an image could be listed. The latter precluded any account of its perspective or an examination that a figure standing in the far background is not really touching the tree in the foreground. The compression of space and reading the image on a single plane finds a parallel with the decoration of many medieval manuscripts, where border details are compressed to occupy the same plane, thereby facilitating an axial reading. The border decoration often incorporated scenes enclosed in a

frame that surrounds text or a principal image. An example is a page from the book of hours by the Spitz Master depicting *Christ Carrying the Cross* surrounded by a border of angels holding instruments of the Passion and foliage (fig. 40).[30] The border decoration is compressed on a single plane with no indication of perspective. The flat, even background forces the figures and the action to the foreground, and the defined lateral and horizontal axes emphasise the central scene, which is deeply perspectival. If we were to describe the border decoration in Ferdinand's language, the description would entirely depend on the surface tensions.

The details Ferdinand distinguished in a composition as defining its uniqueness also find many parallels in paintings from the period. Lucas Cranach's *Portrait of a Woman*, painted around 1520 (fig. 41), is replete with countable details.[31] The slits on her sleeves, the chain around her throat and the repeated letter 'M' on her chemise are precisely the sort of details that a scribe would have recorded if it were a print. More than being just a convenient comparison, this sort of painstaking attention to visual detail is largely typical of northern art from the period. The details in the Cranach painting are immediately engaging; they betray the richness of the woman's dress and the elegance of her demeanour. The high level of detail transcends a purely decorative function and is intrinsic to the meaning of the portrait, and for Ferdinand's system, these details were a significant – albeit abstracted – aspect of an image to be put in the service of classification.

Ferdinand's rules of precedence, discussed earlier, were based on hierarchies; saints take precedence over mortals, clothed figures take precedence over unclothed figures, and so on. Hierarchies, understood according to the pre-eminence of those depicted, were the common substance of images during the period. Depictions of the heavenly and terrestrial realms, for example, were structured from top to bottom, with the spiritual realm above and the terrestrial below. Those in the heavenly sphere were further subdivided and located according to their liturgical eminence. Ferdinand did not have to go far to find examples of visual hierarchies; his prints provided a rich source. In the *Assumption and Coronation of the Virgin* by Lucas Cranach (fig. 42) clusters of angels and saints at the sides watching the Virgin being drawn

FIG. 42 | Lucas Cranach the Elder, *The Assumption and Coronation of the Virgin*. Woodcut, 397 × 281 mm, *c*.1515 (The Ashmolean Museum, Oxford).

up in a vortex and crowned at the top assist the lateral structure of the image.[32] The hierarchical structure of these examples had its basis in liturgy and underpinned the relative importance of those depicted.

The humanist concern with systems of classification, the need to order and understand the expanding world, and the ways of representing religious subjects during the period provide intersecting contexts for the methods employed in Ferdinand's print inventory: its taxonomy, rules of precedence and how things are described. The consistency and rigour of its application are mathematical, which is what Ferdinand required because such accuracy qualified the effectiveness of his system. The same uniformity

can be discerned in all his indices, but only the print inventory is unique in its conception. To devise a means of reducing such a huge variety of visual subject matter could not have been achieved without Ferdinand's education, his comprehension and participation in the intellectual and cultural world in which he lived and his particular facility at taking from that world the necessary components to effect his aims of ordering and classifying his collection.

Rebuilding the lost collection

Important information about the way the print collection was formed can be gained from analysing writing in the inventory. The most important scribe, Scribe A, was responsible for 944 entries, the largest number in the inventory. His descriptions are always the first following the print classification category at the head of the page. Fig. 25 illustrates a typical page from the inventory with the category written at the top and the entries underneath. As the prints that are described by Scribe A were entered first, this may mean they were the first to be bought. Under the same category heading there often appeared entries written by a number of different scribes. Analysis of these features can be used to reunite series of prints that were bought together as a group but because of the different classification criteria ended up scattered through the inventory. Albrecht Dürer's *Apocalypse* was bought when Ferdinand was first forming his collection. Because of the classification system, the prints are spread across seven categories but Scribe

Table 1 | Inventory location of the *Apocalypse* woodcuts by Albrecht Dürer

INV. NO	TITLE	TAXONOMY	PAGE
1798	St John's Vision of the Seven Candlesticks	Pliego de 2 de santos vestidos	296
1916	The Virgin Appearing to St John	Pliego de 3 de santos vestidos	308v
1983	The Angel Showing St John the New Jerusalem	Pliego de 4 de santos vestidos	319
1987	St Michael Fighting the Dragon	Pliego de 4 de santos vestidos	319v
2086	St John Devouring the Book	Pliego de 6 de santos vestidos	335
2154	The Apocalyptic Woman	Pliego de 8 de santos vestidos	350
2217	The Seven Trumpets	Pliego de 11 de santos vestidos	363
2218	The Four Horsemen of the Apocalypse	Pliego de 11 de santos vestidos	363v
2318	The Torture of St John the Evangelist	Pliego de muchos de santos vestidos	386
2320	The Four Avenging Angels of the Euphrates	Pliego de muchos de santos vestidos	386
2325	The Opening of the Fifth and Sixth Seals	Pliego de muchos de santos vestidos	386v
2326	The Beast with Two Horns like a Lamb	Pliego de muchos de santos vestidos	386v
2327	The Adoration of the Lamb	Pliego de muchos de santos vestidos	386v
2328	Four Angels Staying the Winds	Pliego de muchos de santos vestidos	387
2330	St John before God and the Elders	Pliego de muchos de santos vestidos	387
2331	The Whore of Babylon	Pliego de muchos de santos vestidos	387

A at the top of the relevant pages records them all. Table 1 shows the *Apocalypse* prints regrouped as a series that has been separated.

In some instances, it is possible to differentiate between two sets of the same series that were probably bought at different times. Ferdinand owned a complete set of Dürer's *Small Passion* woodcut series. He also owned a number of duplicate impressions from the same series. A complete set of the *Small Passion* is recorded by Scribe A and the descriptions occur at the top of the page under the appropriate category. The duplicate impressions are recorded by other scribes and occur under the same category but much further down the page. For example, Dürer's *Sts Veronica, Peter and Paul with the Sudarium* [inv. nos 998 and 1005] and *Christ Carrying the Cross* [inv. nos 1216 and 1128] were first recorded by Scribe A [inv. nos 998 and 1216]. Another scribe records further impressions [inv. nos 1005 and 1028] under the same categories below the entries by Scribe A. This reveals that in the case of Dürer, Ferdinand bought impressions of the same print at different times. Most series of prints appear to have been bought complete, such as Albrecht Altdorfer's *The Fall and Redemption of Man* comprising forty woodcuts all recorded by the one scribe.[33]

FIG. 43 | Lucas Cranach the Elder, *St George on Horseback.* Woodcut, 232 × 160 mm, *c.*1507 (The British Museum, E.77-165).

The recovery of lost prints

In reconstructing Ferdinand's collection it is also possible to attribute new works to artists. A number of the print descriptions carry monograms, making it relatively easy to match a print. Some monograms identify a printmaker but no known impression of the print described survives. The description of *Venus with a King and a Woman* has the unmistakable monogram of Urs Graf but no impression is known.[34] The meaning of the print is not entirely clear, but Graf is known for his inventive subjects, often charged with erotic overtones, and the print described would fit that genre. Other similar prints by Graf that Ferdinand owned include the *Young Woman with an Old Man and a Youth (Mercenary Love)* [cat. no. 91].

The distinctive monogram of the Netherlandish printmaker Jacob Cornelisz. van Oostsanen makes it possible to attribute 'new'

prints to him. *St Gandolfo on Horseback* has not survived,[35] but it carries the Oostsanen monogram and was evidently part of his series of saints on horseback [cat. no. 105]. A roll of prints, also lost, depicts *Death taking People from all Professions*.[36] It carries the Oostsanen monogram and is dated 1509, the period during which he was most active.

In many cases the transcriptions are difficult to fathom. In Jacopo de' Barbari's *Battle Between Nude Men and Satyrs* [cat. no. 3] the transcribed letters 'Q.R.F.E.V.' referring to a Roman festival appear in a tablet in the middle of the composition. In the inventory entry there is no indication that these letters are anything other than a monogram, especially as they appear at the end of the entry. Letters that initially appear to be some monogrammatic device are actually part of a decorative pattern, and in Lucas Cranach's woodcut of *St George on Horseback* (fig. 43) the text

FIG. 44 | Hans Weiditz, *Brooding Dominican.* Woodcut, 260 × 225 mm, *c.*1521 (Kupferstichkabinett, Staatliche Museen zu Berlin, 2-6).

FIG. 45 | Hans Weiditz, *The Cheese-maker and His Wife.* Woodcut, 293 × 213 mm, 1521 (Kupferstichkabinett der Museen der Stadt Gotha).

states how 'in the horse-covers are many A's' (*en las cubiertas del caballo ay muchas* A), a letter that closely resembles the monogram of Albrecht Altdorfer.[37]

Whereas individual inscriptions can indicate previously unknown works by artists, they can also open on to a completely new *oeuvre*. Lucantonio degli Uberti's activity as a producer of maps is indicated by a map of Florence that survives in a unique impression in Berlin and another of Lombardy, also unique, in Rome. Ferdinand, however, owned no less than four maps by Lucantonio all identified by his name, none of which are known to have survived. They include *The Province of Granada* by 'Lucha Antonis Florentino', *Constantinople*, 'opera e Lucha Antonis Florentino ympresum Venecie', *Italy*, 'opus Lucha Antho de Uberti floren. ympressum Venetis', and *Rome*, 'ympressa en Florencia per Lucha Antonio'.[38]

Running from inv. nos 1557 to 1563 is a series of personifi-

Table 2 | Sequence of prints described on folios 303 and 303v

INV. NO	ARTIST	TITLE	TAXONOMY	PAGE
1863	Hans Weiditz	*Brooding Dominican*	Pliego de 2 de hombres vestidos	303
1864	Hans Weiditz	*Cheesemaker and His Wife*	Pliego de 2 de hombres vestidos	303
1865	Hans Weiditz?	*A Woman Raising a Vase and a Man with a Sausage*	Pliego de 2 de hombres vestidos	303
1866	Hans Weiditz?	*A Woman with a Barrel and a Man with a Halberd*	Pliego de 2 de hombres vestidos	303 and 303v
1867	Hans Weiditz	*Dance Partners*	Pliego de 2 de hombres vestidos	303v
1868	Hans Weiditz	*A Drunkard and his Wife*	Pliego de 2 de hombres vestidos	303v

cations of female virtues (*Virtue, Hope, Faith, Prudence, Justice, Temperance* and *Fortitude*). All the prints are *medio*-size and are recorded by Scribe A on fol. 269 of the inventory. Only in the description of *Hope* is the printmaker named: 'lucen flor', which is a contraction of Lucantonio Florentino, known as Lucantonio degli Uberti. The prints are clearly part of the same series and all by him.

These examples lead to one of the most important archae-ological procedures for rebuilding the Columbus print collection. By assessing the hand of the scribe, the physical characteristics of a print – as revealed by the taxonomy – and its location on the inventory page, it is possible to attribute new prints where nei-ther name nor monograms are recorded. Of the thirty prints from the inventory ascribed to Hans Weiditz, twenty-one survive and the other nine can be attributed to him using the logic described above. Inv. no. 1863 (fig. 44) describes Weiditz's *Brooding Domini-can*, a '*pliego*-size sheet of 2 dressed men' (*pliego de 2 de hombres vestidos*), on page 303 of the inventory. The same scribe also records the following print, Weiditz's *Cheesemaker and his Wife* [inv. no. 1864, fig. 45]. The next two prints [inv. nos 1865 and 1866], also recorded by the scribe under the same category, depict *A Woman Raising a Vase and a Man with a Sausage* and *A Woman with a Barrel and a Man with a Halberd*. The following two entries [inv. nos 1867 and 1868] describe surviving woodcuts by Weiditz, *Dance Partners* and *A Drunkard and his Wife*. Table 2 clarifies the sequence. Given the confluence of physical characteristics and the 'popular' subject matter of 1865 and 1866, they too are surely by Weiditz and can be attributed to him.

Borders

The description of borders in the inventory can help also to attrib-ute lost prints to artists. One example is the print of *St Barbara?* described at inv. no. 2454, which can be attributed to Georg Erlinger/Hans Springinklee. This is because the same border dec-oration: 'below outside the composition is a man riding a don-key, in both hands he holds a full sack, not showing either hand,

FIG. 46 | Georg Erlinger, *St Ursula*. Woodcut, 332 × 230 mm, 1519–20 (Kupferstichkabinett, Staatliche Museen zu Berlin, 453-1895).

above to the left is Christ standing naked with the right hand point-ing, in the left he has the world' (*abaxo fuera del quadro esta un onbre que cabalga en un asno y tiene con ambas manos un costal lieno no muestra ninguna mano y ariba a la siniestra esta Nue-stro Señor en pie desnudo con la diestra santignando y en la sinies-tra tiene el mundo*) occurs in Erlinger's woodcut of *St Ursula* (fig. 46).[39]

Copies of prints

Sometimes the inventory descriptions provide sufficient detail to identify copies. The roll of prints described at inv. no. 2750 is a copy after Hans Burgkmair's *Seven Planets*.[40] The description of Venus, Mercury, the Moon and the border of naked children described in 2750 match those in the Burgkmair prints. Two sets

FIG. 47 | Monogrammist IFM, after Hans Burgkmair, *The Seven Planets.* Woodcuts, each 175 × 78 mm, *c.*1510–20 (The British Museum, 1972, U.1107-U.1112).

FIG. 48 | *Washing the Ass's Head.* Majolica plate (Italian–Deruta), 1556 (Victoria and Albert Museum, 6665-1860).

of copies after Burgkmair's prints are known, one set with the signature 'ANDL' and the other set 'IFM'. It is possible that the planets described at 2750 are those by IFM because the scribe who made the entry notes two small holes on the right knee of the figure of the Moon and three small slashes on her left foot (*la luna tiene dos agugeros so la rodilla diestra y tres cuchilladitas sobre el pie siniestro*) (fig. 47). In Burgkmair's print, there are three distinct holes on the knee, and the same with the figure cut by ANDL. These sets were copied from one another and not the originals, which would account for the diminishing and more generalised details.

In several instances the subjects of prints that no longer survive are represented in other media. The scene of a man washing a donkey's head is represented on a majolica dish dated 1556 (fig. 48). The inscription recorded in the inventory is the same and the print probably directly provided the subject for the plate.[41]

Variations on prints

A little-explored phenomenon of Renaissance printmaking is the production of prints that were altered through the substitution (or subtraction or addition) of extra blocks, thus producing variations on a subject. The motivation for substitution was presumably to maximise the print's financial return, in much the same way as prints were produced in different colours to make them more attractive, perhaps for particular clients.

The inventory describes a large print depicting *St George and the Dragon* by Lucantonio degli Uberti [inv. no. 2656]. No impression of this print is known but it is remarkably similar to another print of the same subject by the same Uberti, which survives in a unique impression in Copenhagen (fig. 49). In both, there are bones in the lower left corner and a city above; between the city and St George there is an inscribed tablet. The Copenhagen print is unusual in that it seems to comprise disparate sections that could be swapped about. The sheet depicting the city of Alexandria in the upper right corner might have been a substitute for some other block. This is suggested in the way the foliage

FIG. 49 | Lucantonio degli Uberti, *St George and the Dragon*.
Woodcut, 850 × 1170 mm, *c.*1510–20 (Statens Museum for Kunst,
Copenhagen).

FIG. 50 | Girolamo da Treviso, *Susanna and the Elders*.
Woodcut, 427 × 1072 mm, *c.*1514 (Statens Museum for Kunst,
Copenhagen).

at the bottom of the sheet does not continue on to the one beneath it. In fact, the entire top section of the print could have been issued as a separate roll, indicated by its distinctive isocephalic layout. Inv. no. 2825 describes another roll depicting St George. This print comprises four sheets in which there is a city and palace upon which are two men, the one to our right holding a stick in his right hand. The same passage exactly appears in the Copenhagen *St George* (fig. 49). Could the term 'sileria' in 2825 be a mistranscription of Alexandria? And could 2656 and 2825 be the same print with different block configurations?

In Girolamo da Treviso's *Susanna and the Elders* (fig. 50) the visual differences between the four blocks are immediately striking. Each quarter is nearly a self-sufficient design.[42] Although the details that cross the plate borders – such as Susanna's wrap and the tree trunks – match, there are as many details that do not, or sit awkwardly. The canopy over the gate to the left of Susanna does not fit the print alignment and was surely designed to crown some other feature. What seems to be occurring is block substitution, where a number of blocks were interchangeable and presumably had the features that corresponded to the crossover details. It would not have been impossible, for example, to use the lower right block depicting the two old men for a print of the Adoration of the Magi; the fragment of cloth might then serve as the Virgin's mantle.

Fragments

Around half of Ferdinand's collection does not appear to have survived in any impression, but a number of prints in fragments have, where the inventory entry provides more complete details of their original form. Inv. no. 2589 describes *The Madonna and Child in a Rosary with Dominicans* (fig. 51), which today survives in a very badly damaged impression in Berlin with large sections missing. The inventory entry records other details that can be used to gauge its original appearance.

States and editions of prints

Because the collection has vanished, it is impossible in the major-ity of cases to determine the states of the prints Ferdinand owned and only occasionally is there sufficient detail to convey this infor-mation. In the entries for Israhel van Meckenem's engraved series of the *Large Passion*, the letters after the Meckenem monogram provide evidence for assembling the entire series from several different states.[43]

In many entries the presence of text is noted, indicating dif-ferent editions of prints. In the inventory, Hans Weiditz's *Winebag and Wheelbarrow* [cat. no. 62] is described as having text below the image. No impression is known to have text below the image but one survives with text above. Similarly, Lucas van Leyden's roll of *The Nine Worthies* [cat. no. 100] is not known to have text below the image as it is described in the inventory. In some entries, the little-understood practice of substituting text in different lan-guages is made evident. Hans Burgkmair's woodcut roll of the *Peo-ples of Africa and India* was based on images and text provided by Balthasar Springer, describing his journey to Africa and India in 1505 [cat. no. 56]. The text on the few surviving fragmented impressions is in German. The inventory describes an edition pos-sibly with French text running along the bottom in text boxes.[44] Robert Peril's *Genealogical Tree of the House of Hapsburg* [cat. no. 109] was printed in editions with Latin, French and Spanish text.

FIG. 51 | Anonymous German, *The Madonna and Child in a Rosary with Dominicans*. Woodcut, 565 × 385 mm, *c*.1515 (Kupferstichkabinett, Staatliche Museen zu Berlin, 977-301).

FIG. 52 | Jacobus Argentoratensis (Jacob of Strasbourg), *Fragment of a Map of Venice*. Woodcut, 306 × 444 mm (sheet), 273 × 397 mm (image), 1515 (Museo Correr [Biblioteca], Venice, Stampe A15/82).

Sizes of prints that no longer survive

The combination of the *pliego* with *marca*-size categories described earlier provides a basis for ascertaining the approximate size of rolls of prints that no longer survive. The rolls represent the great-est area of loss from the inventory. The *View of Venice* by Jacob of Strasbourg, which now survives in a fragment (fig. 52), is described as '12 sheets of *marca*-size, 6 long by 2 wide' (12 *pliegos de marca mayor los 6 anchos en largo y dos largos en ancho*).[45] This indicates that the print must have measured somewhere around h. 800 mm × w. 3000 mm. The surviving fragment supports the

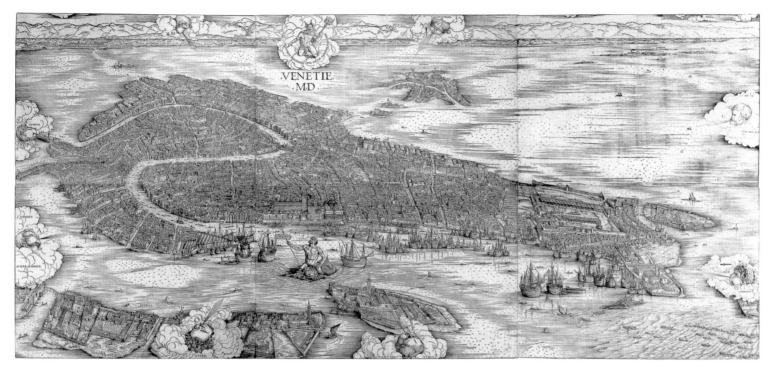

FIG. 53 | Jacopo de' Barbari, *Map of Venice*. Woodcut, 1330 × 2815 mm, 1500 (The British Museum, 1895-1-22-1192...7).

size estimation, which is not too far from Jacopo de' Barbari's *View of Venice* (h. 1300 mm × w. 2840 mm, fig. 53). Some entries describe prints that appear to have irrational sheet configurations. Lucantonio degli Uberti's map or view of Rome is described as comprising 'twelve and a half sheets, five wide by three high and a half

lengthwise, in the middle sheet that is lengthwise are added to Rome two lines of paintings' (*Roma en 12 pliegos y medio los 5 anchos en largo y los 3 largos y medio en ancho en los medios pliegos que en el anchos estan añadidos a la Roma ay dos reucles de pinturas*).[46] Figure 54 illustrates a possible solution for the sheet configuration.

The principal image is 5 × 2 sheets; the two lines of images depicting Roman emperors and the history of Constantine would probably have come underneath and do not count as part of the main image. The 'añadidos a la Roma' may have been two or two and a half extra sheets pasted on the end (possibly some sort of key) making the total of twelve and a half.

By adopting an archaeological approach to the inventory, the inventory documenting a collection that has vanished can be better understood. The different methodologies open on to specific information that, read together, not only allows a reconstruction of the collection as far as is possible, but tells us how the prints were collected and stored.

FIG. 54 | Proposed reconstruction of Lucantonio degli Uberti's *Map or View of Rome*.

1 The literature up to the 1960s has been outlined by Marín Martínez, 1970, pp. 255–68. For later literature see Landau, 2003, pp. 29–36 and McDonald, 2004, pp. 58–63. After Marín Martínez's (1970) study of the inventory David Landau was the first person connected with this project to examine the manuscript in Seville.

2 For Pérez see Marín Martínez, 1970, pp. 10–20; the *memoria* has been published by Marín Martínez, 1970, pp. 47–76. See Domínguez Bordona, 1935, no. 254, pp. 34–5. It has also been transcribed and translated by McDonald, 2004, pp. 269–85.

3 McDonald, 2004, I, pp. 269–70.

4 See McDonald, 2004.

5 Conway, 1889, p. 97; Landau and Parshall, 1994, p. 16.

6 Hind, 1938–48, i, pp. 304–9.

7 Inv. no. 685. CD.I.513.2[4].

8 Inv. nos 1556 and 2533.

9 Inv. nos 242 and 244. TIB comment.2508.072 & 2508.045.

10 Inv. no. 1600. H.ii.130.

11 Inv. no. 1755.

12 Inv. no. 2150. B.xiii.2[249].

13 Inv. no.1749. Schreiber, 1985.

14 Inv. no. 1483.

15 Inv. no. 1540.

16 Inv. no. 2509. B.vii.152[161].

17 The portrait of Dürer in the ornamental frame was added posthumously.

18 Inv. nos 316 and 293. H.xiii.125, B.vi.16[324].

19 Inv. no. 456. Hind.v.22[94].

20 Inv. no. 726. B.viii.3[73].

21 Inv. no. 2236. B.viii.12[441].

22 Inv. no. 983. B.vii.73[221].

23 Inv. no. 1751.

24 Inv. no. 259. B.xiv.191[155].

25 Baxandall, 1988, p. 135.

26 Alberti, 1972, p. 97.

27 Baxandall, 1988.

28 Baxandall, 1988, p. 89.

29 Panofsky, 1955, pp. 99–104.

30 J. Paul Getty Museum, MS 57 [94.ML.26] Fol.31r.

31 London, National Gallery, NG291.

32 Inv. no. 2432. H.vi.73b.

33 Inv. no. 504. B.viii.7[1–40].

34 Inv. no. 2469.

35 Inv. no. 1682.

36 Inv. no. 2761.

37 Inv. no. 1519. B.vii.65[284].

38 Inv. nos 3151, 3159, 3162, 3170.

39 Inv. no. 2402. G.1341 (as Springinklee).

40 Inv. no. 2797. B.vii.41–47[215].

41 Inv. no. 1533.

42 Rosand and Muraro, 1976, p. 88.

43 See McDonald, 2004, p. 110.

44 Inv. no. 2752. See McDonald, 2003a.

45 Inv. no. 3171.

46 Inv. no. 3170.

4 The Physical Life of the Print Collection and Ferdinand's Universal Library

The function of the Seville inventory

The Columbus print inventory is the earliest known example of a fully descriptive catalogue that grew alongside the collection, the physical form of which was inextricably tied to its function. As a catalogue of Ferdinand's collection, the Columbus inventory could have operated as a working index to the location of the prints. That the inventory had a practical function is critical to the understanding of its value and indeed its uniqueness.

The description of the inventory's function in the *memoria* is important to understand how it existed physically and was handled. The reason for its system is made explicit: 'hence, it was necessary to establish an order to keep the records of those that were purchased, so that the same picture would not be bought twice'. The implications of this statement for the inventory's practical use are complex. At face value, because the prints were all bought in Germany, Italy and the Low Countries, the inventory would have had to accompany Ferdinand as he travelled, a function that is suggested by its format. Its small and manageable size would have made it easy to carry. How would the inventory have operated on-site? If, for example, Ferdinand came across an impression of Hans Wechtlin's *A Knight and a Lansquenet* [cat. no. 52] he would assess the print according to the taxonomical system he had established, and after determining that it was a *pliego*-size sheet of 'two dressed men', go to the corresponding section of the inventory and see if he already owned an impression by reading the detailed description of prints there provided.

The inventory was indeed systematised so that no print could be bought twice, but going by the multiple hands in it the entries seem to have been made in Seville after the prints had been bought. It

is possible that Ferdinand did have one scribe with him on his first journey, during which he bought so many books and prints. But it is just as likely that, at the outset of his collecting, Ferdinand could more or less remember what he had bought, and when he returned to Spain Scribe A (his main scribe) entered the backlog. The sequence of events is also suggested by the fact that the inventory does not seem to list the prints Ferdinand had lost in a shipment at sea in 1521 (see page 47). If Scribe A had been recording them during Ferdinand's 1520–22 trip, they would have appeared in the inventory in the same way as the lost books from the same shipment were recorded in book Register A, unless he was able to replace successfully all he lost, in which case the entries made during the 1520–22 trip might have been left as they were as a guide to acquiring replacements. This matter cannot satisfactorily be resolved, but the following scenario is feasible: when Ferdinand resumed his travels outside Spain in 1529, he took the inventory as an up-to-date guide of what he already owned. Based on what he did not own, he bought, and sent his acquisitions back to Seville where they were catalogued after he returned with the inventory.

Collection maintenance

Forming the basis of Ferdinand's collection were the headings he wrote in the inventory in his own hand (fig. 55). In all cases, under the original headings, Scribe A recorded the first prints. As Ferdinand bought more prints, later scribes either added to the existing categories or created new ones following the principles laid down by the original system. No prints fitted the category '*quarto* sheet of 5 dressed women' (*quarto de 5 de mujeres vestidas*) and the page is left blank (fig. 56). But because there were many 'pliego size sheets of many dressed saints' (*pliego de muchos de santos vestidos*), that heading is copied and repeated seven times by his scribes. Ferdinand evidently devised the taxonomical foundation of the collection in anticipation of what he would be buying. This is indicated by the headings in his hand under which no prints are described.

It has always been assumed that Ferdinand constructed the inventory, wrote the classification categories and recorded many of the prints. Marín Martínez observes: 'it is evident that Ferdinand, from the outset, arranged a considerable number of quires for recording the descriptions of prints he had acquired or hoped to acquire'[1] and that 'the titles are written in Columbus' hand – a humanist script, cursive and clear'.[2] Ferdinand indeed devised the system and wrote many of the headings, but he recorded none of the entries. Ferdinand's hand is very different from that of his scribes.

Although Ferdinand entrusted to his scribes the task of recording the prints, he closely monitored their work. Throughout the inventory there are numerous corrections, almost all of which were made by Ferdinand (fig. 57). The corrections appear in three ways: (1) corrections or additions to entries when a scribe either inadequately or incorrectly described some part of an image; (2) the addition of an identifying monogram or name of an artist; and (3) the mention of an additional impression or version of a print. What the three types of annotations indicate is that Ferdinand was comparing the prints side by side with the descriptions written by his scribes and carefully monitoring the development of the inventory. The changes that he made were intended to make an entry conform to the rules of classification and the descriptive structure described earlier.

Throughout the inventory, Ferdinand corrects directional signifiers: 'right' is changed to 'left' and vice versa. In the description of Israhel van Meckenem's *St Bartholomew* the scribe mixed up the left foot with the right.[3] Ferdinand crossed out 'syniestra' and substituted 'dyestra'. In many entries, Ferdinand adds to the description so that the unique feature or aggregate features can be identified. In Marcantonio Raimondi's *Portrait of Raphael* [cat. no. 7] Ferdinand added 'and the left foot is upon the right' (*y el pie syniestro encima el dyestra*), thus refining what would otherwise be an entry too generic to be unique. At the end of the entry describing Master IAM of Zwolle's *Large Calvary with Horsemen* [cat. no. 93] Ferdinand added 'below runs a dog whose tail almost touches a horse with the right foot' (*abaxo corre un perro cuya cola casi toca a uno caballo con el pie diestro*). Evidently,

FIG. 55 | Page from the *Seville Inventory* written by Scribe A (photo author).

FIG. 56 | Blank page from the *Seville Inventory* (photo author).

FIG. 57 | Page from the *Seville Inventory* with corrections made by Ferdinand Columbus (photo author).

the basic description was inadequate. In Marcantonio's *St Jerome in the Desert* [cat. no. 6] Ferdinand adds to the generic description of the figure as 'un viejo sentado', 'es San Geronimo'.

One of the best ways to identify something unique in a print was to record a monogram, and, judging by the number of monograms Ferdinand added, he favoured this method of verification. To a number of the entries describing prints by Israhel van Meckenem he add the IVM monogram, and in several cases such as *St Peter* he also added further description 'and a piece of the cape doubled on the right shoulder' (*y un pedaço de al capa tiene doblado sobre el onbro diestro I.V.M.*).[4] In the entries where Ferdinand added monograms, he was not concerned with naming the artist – it was a device to point out a unique feature – except that, only in the case of the prints by Albrecht Dürer, he was most insistent in recognising authorship. At the end of many entries describing Dürer's prints he added, 'es vere de alberto'. What is critical about Ferdinand's procedure of adding to descriptions is that each print, no matter how small, was being carefully checked. There can be no clearer indication that Ferdinand was concerned with the uniqueness of his prints, and with making the classification system rigorous in its application for practical use in his library.

Ferdinand occasionally bought more than one version of a print. Because they were the same they did not require separate entries, but equally, because of their differences (coloured/uncoloured), they had to be recorded in some way. At the end of entry 2656, which describes a variation of a now unique and very large impression of *St George and the Dragon* by Luca Antonio degli Uberti, Ferdinand described a coloured impression: 'I have another time another well coloured that is by Fioro de Bavasori' (*tengo esta otra vez otra hecha y colorida bien que es di Fiorio de Bavasori*).[5] Ferdinand apparently owned three impressions of a twelve-sheet *Battle of Salvore* dated 20 April 1527 which no longer survives.[6] He adds to the entry that, in addition to the one described, 'I have one coloured finely and another still to colour' (*tengo una colorida de finas colores y otra por coloriz*).

The inventory provides ample evidence for collection maintenance beyond the annotation of entries. The anonymous fifteenth-century German woodcut *The Pedlar Robbed by Apes* (fig. 30) was first recorded as a '*pliego*-size sheet of 1 naked man' (*pliego de 1 de hombre desnudo*).[7] Another scribe deleted the entry and correctly re-described it as a '*pliego*-size sheet of 1 dressed man' (*pliego de 1 de hombre vestido*). Many of the crossed-out entries seem to be Ferdinand's handiwork.

The process of maintaining the inventory carried over to the taxonomical headings, no doubt driven by the sorts of prints being bought and the need to tailor subject classifications. In

one case, an entire category was revised. The original basis for classifying animal prints was by size and subject alone. A typical category was a 'sezavo-size print of animals'. Presumably because of the sort of animal prints Ferdinand bought after he devised the classification, he realised that animals also should be counted. As a result the categories were appended with numbers, so 'sezavo-size print of animals' became 'sezavo-size print of 1 animal' then 2/3/4 and so on. But perhaps the original system for classifying animal prints was the best, because a later scribe changed the category 'marca-size sheet of 2 animals' (marca de animales 2) to a 'marca-size sheet of 1 to 15 animals' (marca de animales 1 hasta 15). There were no marca-size animal prints other than the one recorded by Scribe A [inv. no. 2970] and the classification was condensed.

The revisions, additions and deletions in the inventory all indicate that it was a 'living' document. Because the collection has vanished, the greatest value of the inventory today is to identify what prints it originally comprised. With the collection in its original form, the inventory would have been used as a finding guide to locate series of prints that had been split up into different sections because of their taxonomy. An important matter is how the prints were stored and how the inventory was used to access the collection.

Print storage

The only document to mention print storage is the *memoria*. It describes 'three books, quarto, written by hand, bound in white vellum, that are tied together in the library … they are the report of all the drawings or pictures that are in the library and in the chests, organised as follows [*las arcas divididas*]: if the picture is small, that is, it is made of a sheet of sixteen parts, it is called *sezavo*…'. The phrase 'las arcas divididas' refers to the prints that are divided and sorted by size into a number of *arcas*.

The term *arcas* describes the type of the storage unit. An *arca* is a large box or a chest used for storing books, clothes, fabrics or similar objects that opens at the top (fig. 58). The word

arca appears at an earlier moment in Ferdinand's life, making its purpose indisputable. A document dated 1509 records that Ferdinand had 238 books sent from Santo Domingo to Seville in *arcas*.[8] That the chests were kept in the library is also made clear in the *memoria* and supported by the fact that the print inventory was stored with the book indices. It would be wrong to think that the prints were separated from the inventory that documented their existence and arrangement.

The problem remains to determine how the prints were kept within the chests and how the system of classification was manifest in their physical storage. Having around 3,200 prints meant that a system of organisation would have needed to be implemented to manage them. The most likely scenario is that the prints were organised in the chests according to the hierarchy of the classification taxonomy: by size and then subject. But after their basic size allotment how were the prints divided by subject? The categories of male saints/female saints and so on provide practical divisions, but this would have meant that the small-format prints that comprise the majority of the collection (*sezavo, octavo, quarto*) must have been cut up from the sheet into their smaller component images. Originally the images would have been printed several to a large sheet and this is how Ferdinand would have bought them. About the method of print storage within the chests, little more can confidently be said. They might have been kept in

FIG. 58 | A sixteenth-century Spanish chest (photo author).

folders, or the chest might have contained partitions or removable trays. Most probably the chests were subdivided, but in the absence of documentation, their internal configuration is impossible to determine. But rolls of maps would surely have been kept together separate from the rolls of saints.

It is probable that the inventory's original configuration 'in three books', as it is described in the *memoria*, meant there was one section for each chest. That the inventory quires originally ran in size order further supports this conclusion. Three chests of the type illustrated in fig. 58 would have been quite adequate to store 3,200 prints. The first chest possibly contained all the prints that were *sezavo* to *medio* (1,889), the second chest *pliego* and *marca* (1,083) and the third chest the rolls (230).

Symbols in the inventory

Among the most perplexing details of the print inventory are the symbols drawn alongside many of the entries (fig. 59). The symbols have elicited nothing from any of the commentators except Marín Martínez who, after identifying and describing their form (a cross, a circle) observes that they remain an enigma.[9] The groups of symbols in the inventory, however, are not accidental scribbles. This is because each principal symbol occurs repeatedly, and symbolic repetition signifies coded meaning.

Ferdinand used complex systems of symbols throughout his book indices, which are carefully explained in the *memoria*.[10] These symbols demonstrate Ferdinand's dependence on the network they form in order to convey very specific meanings. The *memoria* states that because there are so many symbols used, a key is necessary so that their meaning will not be lost: 'but since these notes contain many signs that are commonly needed, it can be useful saying something else about them, so that they are not forgotten'.[11] They were symbols that refer to the size of his books, to the number of pages they contained, to whether the text was in columns, to how many prologues there were etc.[12] Letters of the alphabet followed by a number indicate where a book was published, for example P1532 indicates that a book was published in Paris in 1532,

L = León, Al = Alcalá. It is striking, given the comprehensive explanations of the symbols used for book classification, that in the section regarding the print inventory no mention is made of its symbols.

The symbols in the print inventory can be broken down into three basic forms: (1) a spade, (2) a circle, (3) a rectangle with letters (fig. 60). From these dominant forms derive a number of sub-categories identified through the addition of details such as a tear, a cross, dots and so on.[13] There is no consistent relation between the two main symbols – spade and circle – and any of the categories of meaning outlined above (size, subject etc). This is because they are placed alongside entries describing all types and sizes of prints from different times and countries.

Scribe A neatly draws the carefully formed spade symbol in black ink alongside the first line of 255 entries, all of which were written by him (fig. 59). These entries describe prints from all countries of all subjects and sizes but their common ground is that all these prints were bought first and formed the basis of the collection. The shape of the spade is perhaps better understood as a key. The implication is that the spade/key symbol means that those prints were categorical exemplars (by marking their pre-eminence).

It is likely that the entries annotated with the spade were chosen because they best illustrated the principle of a taxonomical category. The prints by Scribe A with a spade that have been identified are unambiguous examples of their classification. For example Marcantonio Raimondi's *Marcus Curtius* (fig. 39) can be nothing other than a *quarto*-size print of one dressed man.[14]

The twenty-three entries marked with 'B in a rectangle' are all prints by Albrecht Dürer, and include fifteen out of the sixteen woodcuts of the *Apocalypse* and eight from the *Large Passion of Christ*. These symbols were drawn by Ferdinand with the same ink he used to add the words 'es vere de alberto' to entries and other annotations throughout the inventory. The letter 'B' is clearly an abbreviation of 'Biblioteca' and meant that the prints with that annotation were bound and kept in the library – on shelves – as distinct from being stored with the other prints in the chests. Dürer issued the prints from the *Large Passion* and the *Apocalypse* together as a bound set in 1511, confirming that they remained in

FIG. 59 | Margin symbols on pages in the inventory (photo author).

FIG. 60 | The main symbols that occur in the print inventory.

why only 1,267 (under half) of the entries are annotated. In the broadest sense, the objective of a stock-take is to account for the presence of objects. There is no indication that the entries not annotated were no longer part of the collection. The circle symbols point to a process of selection.

No one explanation can underpin the meaning of all the symbols in the inventory. However, it seems that the spade denoted exemplars of the different categories, and also perhaps the storage system that, once established, was followed by later scribes.

Ferdinand's universal library and academy in Seville

It order to appreciate the full significance of Ferdinand's library, its aims and how it operated need to be considered. From the time Ferdinand began collecting in earnest, probably between 1512 and 1520, it is clear he wanted to create a universal library. This aspect of Ferdinand's ambitions was appreciated by his peers during his lifetime. The Flemish humanist Nicolas Cleynard recognised his ambitions in the dedication to Ferdinand of his edition of Livy's *Historiæ Romanæ decades* (Salamanca, 1533):

this format in Ferdinand's library. The B symbol is most significant, because it demonstrates beyond all doubt that the print collection proper existed completely separately from the book collection, and on the occasion that the two merged this had to be clearly indicated.

The tear drops, dots and crosses that are added to the circle symbol indicate the engraving medium but there is no indicator of the woodcut medium. This is because there were only two types of prints in the collection (woodcuts and intaglio). The system needed only to indicate one (intaglio) and, by default, those not so indicated were woodcuts.

The circle symbol in brown ink is often drawn over the spade symbol and thus was added later. It seems that the circle refers to some sort of stock-take of the prints when, after the collection had been fully formed, they were dispersed. This hypothesis seems to resolve the meaning of the circle symbols, but does not answer

As your illustrious father has planted in the New World Spanish might and civilisation, out of a surprising prodigy, so you, as a fair compensation for the benefits provided by your father, gather *the wisdom of the whole universe* in Spain. What can I say about the celebrated library that for a few years you have gathered with such great, persistent efforts? Your house in Seville is certainly worthy of remark because of its luxury and magnificence, yet it is even more remarkable for the treasures kept in your library. There everything that has been published to the present day can be found. In order to discover all these riches and to bring them from all the world, even from the remotest places, you left your country twice and you have travelled almost everywhere in Europe, allowing neither expenses nor dangers to detain you.[15]

An important document regarding Ferdinand's intention to create a universal library is the petition *memorial* (as distinct from the *memoria*) he wrote to Emperor Charles V requesting financial support for his plan.[16] In this document, the aim of establishing a universal library is made explicit. Ferdinand writes: 'In order to let your Majesty know the benefits that must be derived from it, he says that the first one will be the existence of a specific place in your kingdom where *all the books will be gathered, in every language, and concerning all the sciences and the arts* that can be found both in Christian and in non-Christian nations'.[17] Ferdinand's Testament refers to the petition:

> The already mentioned master D. Hernando begs your Majesty that, considering the good purpose at which they are aimed and that he who may obtain it is your Majesty's servant, and that he does not wish to retain any memory or family estate because of his services and of everything that his father left him but that everything has been done by means of your Majesty's mercy and favour, *may his request be accepted as the perpetuity of the five hundred* pesos *that he has been granted while alive as a help for the above mentioned* [library].[18]

The Emperor then partially accepted the invitation without assuming total financial responsibility. On 20 November 1536 in Valladolid, he conceded 500 gold pesos 'for the help and subvention of the library that is in the city of Seville'.[19] Ferdinand also requested that the annuity was not to terminate upon his death, so that the maintenance of the library would continue. The Emperor's response is not known, but the act of conceding the original sum is most significant, because it represents the first ever state-sponsored library. Ferdinand's petition has a complex history and no contemporary evidence bears upon it. When the money was granted towards the end of his life the library contained over 15,000 volumes, but the original petition must have been conceived around 1520–21 when Ferdinand was beginning to build his collection while travelling with the Emperor.[20] This date is signifi-

cant because it was during this trip that he first met Erasmus (October 1520) and was deeply marked by that encounter. Erasmus, the foremost humanist scholar in the Low Countries, had a substantial library of his own, and was part of an extensive network of scholars who had similar aspirations. Ferdinand's conception of his library and its systems of organisation must have been influenced by this contact with his peers but there is no record of their interaction.

Erasmian ideology permeated the court of Charles V, and Ferdinand's petition reflects these beliefs and skilfully appeals to the Emperor's political and moral motives. Framing, early in the text of the *memorial*, the library as being of potential benefit to Christianity coincides with Charles's grand design to bring a new concept of order to Europe.[21] By the time he ascended to the throne, Europe had become politically fragmented, and the role of emperor had lost its universal potency. Charles wanted to align the separate states in a coherent political framework and his investiture as Holy Roman Emperor in 1519 gave him tremendous unilateral powers over the most far-reaching territories, from Jamaica to Rome. The vast dynastic inheritance brought with it obligations and traditions that he had to respect and uphold. Unity and harmony were his principal aspirations from his early years as emperor. In his appeal for a universal library Ferdinand tapped directly into these aspirations, exploiting the concept of omnipotent greatness and the idea that such an institution would complement and even assist in the process of achieving political hegemony. The increasing threat presented by the Turks undermined the stability of the state and the popularity of Martin Luther threatened its Christian foundations. The denunciation and excommunication of Luther (1521), the repulsion of the eastern threat and the shoring up of the Empire were all part of Charles's obsession with saving his dominions from heresy.

The arguments in the petition are carefully designed to cultivate the Emperor's favour through their effective programme. They begin by appealing to his Christianity, referring to his realm before turning to the specifics of the grand design, that religion and government would be well served by those in positions of influence who could draw on its resources, and that the information

the library contained would be perfectly accessible through a carefully devised series of indices. Ferdinand emphasises the Christian authors and the place they would have in the library, clearly playing to the Emperor's greatest concerns. The petition also exploits the concept of centralised knowledge as power, 'in a place within your majesty's realm'. For its containment of knowledge, Ferdinand conceived the library as a potent symbol that the Emperor might come to draw upon for his own imperial edifice. This is significant because Seville was on the periphery of the European Empire, and was not a place Charles had visited.[22] Locating the library in Seville, Ferdinand made the city more accessible by roping it into Charles's sphere of influence. It offered a method by which the Emperor could indirectly control a place he did not know.

From around at least 1520, Ferdinand's buying expeditions were aimed at fulfilling his desire to create the universal library. His ambitions were matched by his determination to make his collection accessible, a point that is made amply clear throughout the *memorial*: [the catalogues] 'as I have said, contain the names of the authors, the names of the works whose authors are not known, and the beginnings of all the authors and their works, everything in a very careful alphabetical order'. That his library was to be accessible no doubt had an impact on the success of the petition mentioned above. By devising indices and framing it as a library of universal intellectual benefit he dissociated it from a purely private ambition. The upper part of the epitaph for his tombstone, which is discussed and illustrated in Ferdinand's Testament, also reinforces what his aims were during his life: 'He spent all his life and his fortune in promoting the Arts, and in gathering and establishing in this town *all the books of all those sciences that he could find in his times*, and in summarising them within four books, according to what is pointed out here.'[23] Flanking the Columbus coat of arms on the stone are four open books inscribed *Librorum authores*, *Compendium scientiarum*, *Materiarum epithome*, and *Index Materiarum*. These are the cornerstones of his classification system discussed below (fig. 61).[24]

In addition to the indices, another important component of Ferdinand's aim to make his collection accessible and of

FIG. 61 | The Columbus coat of arms from Ferdinand's Testament (photo author).

universal value is the *Vocabulario* which he began to write but did not complete before he died.[25] What survives from the project is the first volume, comprising 737 folios covering the letters 'A-' to 'Bi-'. The *Vocabulario* was a sort of dictionary of universal knowledge useful for those who wanted to know the meaning of words and concepts and the identity of writers, but it went beyond simple definitions to provide subject contexts. In this way, it was like a Renaissance dictionary, meant to be read like a book. But it is an unusual compilation because it adopts the alphabetical order of a dictionary with a partial keyword index, but is not divided thematically like earlier dictionaries.[26] Its hybrid form suggests that the *Vocabulario* was intended as a resource specifically to be used in the library by those consulting the books.

The universal library aimed at owning a copy of every book published so that in the one place the entire memory of the world could be contained. Such a response provided for the possibility of acquiring knowledge on any subject, and to know about all things was a Renaissance ideal. The notion of housing all knowledge in one location, which had begun in ancient times with

Ptolemy Soter's famed library of Alexandria,[27] was characteristic of the aspirations of Renaissance book collectors and developed to a phenomenal level during the seventeenth and eighteenth centuries.[28] Through the rediscovery of ancient Graeco-Roman texts, the Renaissance humanists aspired to fathom the inner secrets of past civilisations and apply that knowledge to contemporary life. Book collectors sought out texts that lay hidden in monasteries across Europe and developed networks of contacts who collaborated in their interest. One collector was the Florentine Poggio (Poggius) Bracciolini (1380–1459) who, not unlike Ferdinand, used his peripatetic civil career as a pretext for hunting out books.[29] Bracciolini and his friend Nicolaus de Niccolis devoted their time to collecting as many manuscripts as they could lay their hands on. Implicit in their collecting practices was the notion of gathering within their realm all past knowledge, and from their correspondence they considered this an achievable objective.

The possibilities of universal book collecting diminished, however, as the printing press became firmly established from the late fifteenth century. It became impossible to own a copy of every work published because of their sheer number. A distinction must, therefore, be drawn between the aspirations of early fifteenth-century Renaissance collectors such as Bracciolini and de Niccolis, who moved in a more circumscribed intellectual world and could reasonably aspire to establishing a collection that was representative of what was available, and a collector like Ferdinand who might valiantly try to buy a copy of everything published, but could effectively never do so. The ground shared by the earlier collectors and Ferdinand is the attention they paid to the contents of their books. They were not buying through uncontrolled acquisitive ambition, but rather from a profound interest in the knowledge their books contained. The evidence for this is the enthusiastic discussions and copious correspondence between book collectors. In Ferdinand's case his engagement with his books is demonstrated by the different information he recorded in them regarding how he read them, when and where. Throughout the *memoria* and Ferdinand's Testament, his collecting objective never implies owning everything, but rather that all branches of knowl-

edge could conceivably be contained in his library. Ferdinand's aspirations are amongst the first signs of a more practical large-scale collecting activity, which concentrated on a representative collection rather than being numerically vast.

Because Ferdinand's print collection is the first one we know of, how it complemented his library is not entirely clear, but some conclusions can be reached. The taxonomical categories for classifying the prints described earlier were designed to absorb any subject represented in print form and thus they fit the criterion of universality. As images, they represented the visual world and transmitted types of information that could not be conveyed in words. Establishing such a collection distinguished the prints as an independent body of objects, but they were part of the same intellectual aspirations that governed his library. In this way, the prints were counterpart to the books and form part of an allied experience.

Ferdinand's energies went into creating his library as an intellectual centre, but it was not in any sense a public institution, which explains the lack of any mention of it by those not associated with learning in Seville.[30] That it was accessible only to scholars was a characteristic of private libraries from ancient times. Nonetheless, many scholars are known to have visited the library and some commented on its breadth and quality. Amongst them were erudite Sevillians including members from the Chapter of Seville Cathedral and cosmographers from the Casa de la Contratación – Alonso de Chaves and Diego Ribeiro.[31] His early teachers Peter Martyr d'Anghiera and Fernandez de Oviedo are known to have visited and also the writers Juan de Mal Lara, Garibay, and Bartolomé de Las Casas.

The academy

Within Ferdinand's universal library, he wanted also to create 'an academy and college of the mathematical sciences important to navigation'.[32] In this context, the Seville cathedral archivist and librarian Loaisa (Loaysa) writes of the 'college or university' planned by Ferdinand:

Besides all this, he intended to build a College or a University next to his Houses, where public lectures on Mathematics would be given for the public benefit, and that of God and of the King, especially for the understanding of seamanship and navigation. However, he died in this Town at the time he was thinking of starting this foundation which would have been so useful to the Republic, hence he did not even see the beginning of this work.[33]

The library can be understood as the umbrella structure providing for related academic activities. Ferdinand's objectives laid out in the Testament coincide with the notion of an academy; the library was to conserve in Spain the treasures of universal science and to make books that were otherwise rare and costly accessible to those who would benefit from their knowledge. The details regarding the proposed form of the academy are few; it did not materialise during Ferdinand's lifetime, or at least there was no rigorous programme of instruction.

Ferdinand's earliest experience with the form of an academy came from the court of Isabella and Ferdinand, where he took part in the academic programme conducted by Peter Martyr. His subsequent contact with humanist circles in Rome and his communication with scholars throughout Europe no doubt exposed him to similar academic notions. The academy had grown with the rise of humanism as a forum where its members could develop new ideas outside the confines of the universities, which were sometimes hostile to innovation.[34] Specialist academies sanctioned by the church and court were a feature of the intellectual landscape of the fifteenth and sixteenth centuries, and were established in Seville from the early 1500s. In 1503, the Casa de Contratación was established as a training school for pilots and a centre for knowledge about the New World. In the same year, the Queen's Canon Maese Rodrigo Fernández de Santaella bought a house in Seville in which he wanted to establish a college for the general education of clerics and poor scholars.[35] A papal Bull issued by Julius II in 1505 recognised the lack of such an academy (*Studium*) in Seville, and ratified the application allowing for instruction in

Logic, Philosophy, Theology, Canon and Civil Law.[36] Several years later, in 1508, another Bull was issued that allowed a chair of Medicine to be established carrying the same titular privileges as the University of Salamanca. By the time Ferdinand settled in Seville, the number of academies that had been established provided the context for him to establish his own. But what is unique about Ferdinand's proposed academy was that it was based on his existing collections, rather than the library being gradually established to suit the needs of an educational programme.

The library and its operations

Ferdinand's residence and gardens by the Puerta de Goles have not survived, so it is difficult to get a sense of how the library existed in relation to the villa discussed earlier (figs 22 and 23). There is, however, sufficient documentation to suggest how the library operated.

It was noted that Ferdinand's systems of bibliographic classification were the first of their kind, but there is evidence that other scholars assisted him in realising their ultimate form. His four principal collaborators were the Flemish humanists Nicolas Cleynard and Jan Vasaeus, the Burgundian doctor of law Juan Hammonius and the author of the *memoria*, Juan Pérez.[37] The Portuguese archaeologist André de Resende, resident in Louvain, introduced Cleynard and Vasaeus to Ferdinand when he was there in September 1531.[38] Ferdinand evidently befriended them, and offered a contract to help organise his collections in Seville. Cleynard, who was embroiled in legal problems in Louvain, saw the offer as an opportunity to free himself from a tedious lawsuit and other professional problems at the university, and to learn Arabic. The resources in Ferdinand's library were also an additional enticement. Cleynard writes of Ferdinand's great book collecting and the time they met: 'As it is generally known [Ferdinand] travelled throughout Europe with the aim of dedicating all his fortune to the creation of a celebrated library … he came to Louvain to buy works destined to enrich his library.'[39]

All four set out on their journey to Spain at the beginning of October 1531.[40] Upon reaching Salamanca, Cleynard decided

to remain there on account of gaining employment as a tutor to the son of the Viceroy of Naples.[41] Vasaeus, however, arrived in Seville and in November 1532 began working in the capacity of librarian. Hammonius died in Seville after contracting a fever. At the expiration of his contract, Vasaeus considered abandoning Spain and returning home, but Cleynard encouraged him to stay with the enticement of the professional rewards that awaited in Salamanca. He wrote, 'It is our happiness that we came to Spain. We will together combine all our assets. Already, I see you dressed in the toga of the University of Salamanca.'[42] Evidently persuaded, Vasaeus moved to Salamanca from where he continued to send Ferdinand various books for his library.

There is no exact record of the work Vasaeus or Hammonius did for Ferdinand other than help 'organise his library'. By the time they were in Seville the collection numbered in the thousands, catalogued in the four principal indices that Ferdinand had devised. These were the indices of Authors, Sciences, Epitomes and Themes. There also existed a number of subsidiary indices and it is likely that Vasaeus and Hammonius assisted Ferdinand in devising these.[43] On 14 May 1533 Cleynard wrote to Ferdinand from Salamanca urging him to continue building the collections in his famous library.[44] In the same letter he refers to the truly remarkable nature of his collection and to the magnificence of the villa:

> For what else shall I say about that library, over which you have toiled for several years, with so many and such exhausting labours? Having achieved old age and magnificence in a marvellous way, Seville that abode of yours is to be admired.[45]

Ferdinand's most faithful collaborator, however, was Juan Pérez, about whom we know little other than that he seems to have been his principal assistant and first librarian.[46] Pérez also appears to have been in charge of the various scribes who worked cataloguing the books and prints, and he was devoted to the library's maintenance after Ferdinand died.[47]

To organise his library, Ferdinand established a series of primary and secondary book indices that are described in great detail in the *memoria* written by Juan Pérez. Their practical use is obvious because, as Pérez explains, 'one does not have to search the entire library looking for the books and reading all the titles'. When Ferdinand died, around 10,000 books from his library had been catalogued with a complete bibliographic description. Much of the information was conveyed by symbols explained by the *memoria* (see above). The indices that today survive in the library in Seville include the following:

- The *Abecedarium B* is an analytical index done alphabetically by author, title, incipits, tied to a registry number and complemented by a *Supplementum* (*Índice General Alfabético*).[48]

- The *Regestrum B* (Register B) is incomplete but is a chronological list of the books in the order of the registry number. The first part provided full bibliographic details of the books numbered 1–4231[49] and the second portion gives the remainder up to 15,556 but only the column numbers of the *Abecedarium B* where information on those books can be found. A third part provides a correspondence between the registry numbers of the *Abecedarium B* and the *Regestrum B* and another new series for a planned, but never fully implemented, reordering of the collection based on subject matter and format.

- The *Abecedarium A* was antecedent to the *Abecedarium B* and provides the names of authors and works (*Índice Alfabético Antiguo*).

- The *Regestrum A* (Register A) is an index of a large number of books that were lost in transit from Venice in 1521 (*Memorial de los Libros Naufragados*).

- The *Alphabetical Index of Authors and Works* gives the name of the author or the title of the work only when the author is not known.

- The *Index of Authors and Sciences* provides not only the authors and the works but also the sciences and themes that correspond.

- The *Book of Epitomes* contains summaries of the books (*Libro de Epítomes*).

- The *Book of Themes* provides a summary of the principal ideas of a book (*Libro de Materias*).
- The *Book of Propositions* is like a second book of themes in which ideas are ordered alphabetically (*Libro de las Proposiciones*).

According to the *Memoria*, there originally existed sixteen repertories. Three of these, the *Vocabulario*, the print inventory and the *Cosmografía*, do not catalogue the books and two, the *Annotations* (*Anotaciones*) and the *General Index of all written* (*Índice Generale de todo lo escrito*), have not survived.[50] The book repertories can be divided into three types, the alphabetical indices (e.g. the *Abecedarium* A), the numerical indices (e.g. *Regestrum* B), and the summaries (the *Book of Epítomes*). A card index (*manojos de papeles cortados y ensartados*), which would have contained precise bibliographic details of all the books, was also planned.

To compile the indices that Ferdinand devised, a number of graduate students with excellent stipends were employed ('docena de colegiales, que el llamaba sumistas, con muy buenos salarios'). Their names are not known, but the *sumistas* are the scribes we encounter recording the prints in the print inventory. They worked under the supervision of Juan Pérez. One of the terms of employment was that the graduates had to pass an examination held in Salamanca. Once accepted, they were contracted to work in the library for three years. The first year was spent in training, presumably getting to know the library and understanding the classification systems. The second and third years were for dedicated application to work in the library as stated in the Testament. The extent of Ferdinand's workforce cannot be determined exactly, but the names of several people that worked for him in some capacity are recorded.

The duties of the librarian and the employees were carefully laid out in a document known as the *Regla* written by Ferdinand that was to be carefully kept by Marcos Felipe and Juan Pérez in the library.[51] The work hours for the librarian, who had to lead by example, were timed for summer and winter. Five hours daily were to be worked: in the summer (April to September), 8–11 am and 2–4 pm, in the winter (October to March), 9am–12 noon and 3–5 pm. Penalties were imposed for non-compliance. The lost days or hours had to be made up and there were also provisions for payment by the job. Controls were implemented to ensure that the work was done to an acceptable standard and a level of productivity was expected.[52] Twenty-five 'anotaciones' had to be completed every day, and all errors were to be recorded in a book for that purpose.[53]

In addition to handsome remuneration, the graduates enjoyed other benefits including lodging, linen and study facilities:

> The person in charge of this work will be provided with a room near the library, with a desk and with one of my couches, and with my bed linen, with a straw bed, two mattresses, four white sheets and pillows, a cover, a blanket, a chest, a chair and a wooden bench and a big cupboard for his books and writings.[54]

The image we get from the Testament (and the *Regla*) is that Ferdinand's institute operated as something between an academy and a library. The numbers of the graduates are not known, but if the print inventory can be used as a guide there were around twelve to sixteen over a period of possibly thirteen years; that is, from the establishment of the library in 1526 to Ferdinand's death in 1539. The description of their lodgings – fitted with a bench, bookshelves, a bed and a place to write – recalls the set-up depicted in Vittore Carpaccio's *Scholar in his Study*: a confined, yet organised space with adequate room to read and write (fig. 62). The description of the rooms by Francisco Maldonado de Saavedra as 'cuadradas' indicates their confined nature.[55]

Sixteen pages in the Testament deal exclusively with the library and how it was to be maintained after Ferdinand died.[56] It represents the earliest coherent treatise on the formation and maintenance of a library, which astonishingly has been almost entirely overlooked except by Spanish scholars working on Ferdinand Columbus. Determined though Ferdinand was to develop his library as an intellectual resource, he was equally concerned with matters of maintenance and security. In the Testament, there is extensive discussion of how the books should be consulted, handled and managed. The Testament states, 'it would be impos-

sible to guard the books even with chains' (*es imposible guardar los libros aunque están atados con cadenas*). An imaginative solution recommends that the reader sits on a bench. In front of him would be a metal grille, not very thick, but with sufficient clearance to pass the hand under and turn the pages of the book, which would rest on a lectern.[57] The passage describing the system is worth quoting in full:

> Everything will be encircled with an iron grille, so that whosoever goes to this room cannot touch the books. In the space between the grate and the books, there will be a lectern close to the grate, as tall as those in libraries usually are, and as many books as possible will be placed there, arranged according to their subject. On the right and in the outer side of the grate, facing the room and reaching the middle of it, there will be a bench for those entering the library. There will be a distance of one foot between the bar and the bench, so that those sitting there can read the books placed behind the grate, and that they can turn the pages among the bars. However, such grille cannot have vertical bars, but a net which leaves space just for the hands.[58]

It is difficult to know if this system was implemented, for it seems hopelessly impractical and could only have accommodated books up to a certain size. It would certainly not have been suitable for viewing prints, many of which, by virtue of their size, had to be spread on a flat surface. The significant point to the rules is that, like a modern library, access was to be monitored and the users were presumably not able to help themselves to the collections. On no account could a book be borrowed, and fines were imposed if an item was lost.[59]

Inside the library, the books were arranged on wooden shelves.[60] Today around 3,000 books from the original collection survive. They are housed in fifteen cupboards, each with seven shelves, on the top floor of the cathedral library. Beyond recognising that the books were stored vertically on them, nothing else

FIG. 62 | Vittore Carpaccio, *A Scholar in his Study*. Pen and brown ink, 190 × 275 mm, *c*.1520 (The British Museum, 1895-9-15-806).

can be said about the alignment of the shelves. They may have lined the perimeter of the library or projected out in parallel lines like the university library of Leyden (fig. 63). Because of the numbers working in the library, the floor space would have had to be quite large. There were apparently two floors and all the books were on the lower floor, presumably along with the chests of prints. The lodging facilities were on the top floor.

An ancient model for Ferdinand's library

The lower part of the inscription for the design of Ferdinand's sepulchral stone, described earlier, reflects his intellectual aspirations while encapsulating the fundamentals of Renaissance humanism (fig. 61). The inscription reads:

> Behold what one brings forth having sweated through all
> the globe
> And three times travelled through the New World of his
> father:

What one had only imagined upon the lovely banks of
 peaceful Baetis,
Riches, after I had had my inspiration,
So that I might engender for you the approving nods of
 the fountain of Castali
And offer treasures together with those which Ptolemy
 did,
If only I had heard, in running past, the stone to murmur
[but] you say neither farewell to my father, nor hail to me.[61]

The reference to divinities of the Castalean Spring is to the Muses – the keepers of knowledge – and the reference to Ptolemy indicates Ptolemy I Soter (d. 230 BC) who is credited with founding the great library of Alexandria.[62] Lléo Cañal observes that the inscription combines the two classic ideals of humanism, the refuge or the life devoted to quiet study and the symbols of universal knowledge, but it signifies much more than this.[63] The reference to Ptolemy Soter was most significant for Ferdinand. In the inscription, he directly aligns his own endeavours with those of Ptolemy. During the Renaissance, the memory of the great library of Alexandria was the most potent, more than any other lost library. It represented the revered knowledge of the lost classical world gathered together in one place.

The circumstances under which Ferdinand conceived of his library mirror those of ancient Alexandria. In 331 BC Alexander the Great (d.323 BC) settled upon the site on which he would build the city of Alexandria to perpetuate his name so that 'midmost of the civilised world, should be the veritable mistress of the trade of the East and the West and the centre of the arts and intellectual endeavours of mankind'.[64] The port on the promontory Alexander chose was little more than a village, and what is striking about its foundation was the rapidity with which it achieved prominence.[65] When Ptolemy Soter assumed control after Alexander died, he decided to make his kingdom the intellectual and cultural centre and to implement his predecessor's wish to create a world library. He also instituted a policy of attracting the most prominent scholars and artists. Seville, like Alexandria, was an outpost before it became the principal departure point for the New

World, after which it developed rapidly. When Ferdinand settled in Seville in 1526, it was a growing commercial and artistic centre. Because of the implantation of Renaissance humanism in Seville, it became known as the 'new Rome'. The conditions for the establishment of Ferdinand's library on the periphery of Europe and the departure point for the New World were ideal.

There are many points of correspondence between the aims and programme of the Alexandrian library and Ferdinand's library in Seville. The fact that Ferdinand names Ptolemy in his tombstone inscription forges an immediate connection. In addition to existing in the memory of Renaissance intellectuals, there were numerous references in the surviving classical literature to Ptolemy and his achievements. Written accounts of the library itself are, however, almost non-existent. The library and museum was also a learning institute where there lived a community of scholars provided with food and lodging. They were given decent salaries and substantial grants that produced a deal of comment at the time. Their work, directed by specialist librarians, aimed at organising the collections and cataloguing their contents in a series of carefully devised indices known as the *Pinakes*. The purpose of the catalogues was to provide easy access to the books and to find what one was looking for without too much difficulty. The cataloguing system was devised largely by Callimachus of Cyrene, an epigrammatist and scholar who can be credited with implementing the method of alphabetic ordering. The cataloguing of the library of Alexandria became the model for the first libraries of Imperial Rome, the Byzantine East and later Christian Europe.[66] The library was accessible only to those who were invited, and it was in no sense a public institution.

The operations of the library of Alexandria and Ferdinand's library are conceptually almost identical. The similarities might be coincidental and reflect a broad operational basis for Renaissance libraries, but at the very least, they point to a bibliographic continuity, which, inspired by the most famous library of them all, found perfect expression in Renaissance Seville.

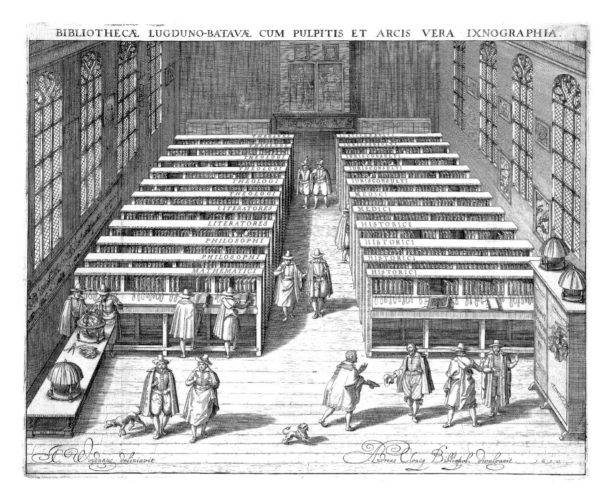

BIBLIOTHECÆ LUGDUNO-BATAVÆ CUM PULPITIS ET ARCIS VERA IXNOGRAPHIA.

FIG. 63 | Willem van Swanenburg(h), *The Library of the University of Leyden*. Engraving, 327 × 402 mm, 1610 (Rijksmuseum, Amsterdam).

The fate of Ferdinand's collections

After Ferdinand died, the books began to be dispersed.[67] The print collection on the other hand seems to have been dispersed not gradually, but all at once, a conclusion supported by the stock-taking symbols in the inventory discussed earlier, and the fact that the collection is never mentioned in the later literature. What seems most likely is that the collection was sold off shortly after Ferdinand died.

In the Testament, there are specific instructions for the increase and maintenance of the library. Half of the income was to be spent on adding to the collection and the other half for its maintenance: binding, cupboards and chains. Ferdinand's nephew Luis Colón was the sole heir to the collections. In case he did not accept the legacy, Ferdinand made provision for alternative

inheritors; the collection would then pass to the library of Seville Cathedral.[68] If they did not accept, the Monasterio de San Pablo was next in line.[69] The last in the line of inheritance was the Monasterio de las Cuevas outside Seville. The alternatives reveal Ferdinand's overriding concern for the fate of his collections. They also perhaps signal that he was worried about who would get them, possibly because the conditions for their maintenance might deter the inheritors.

For almost a year, his nephew did not make a decision as to whether he wanted the library. In addition to being something of a playboy, his prevarication was probably compounded by the rigid conditions set forth in the Testament for maintaining the collections. The cathedral Chapter knew of the conditions, were determined to receive the collections, and on 14 June 1540 named a commission to contact the executor of the Testament, Marcos

Felipe, to press for a decision.[70] The document empowered delegates to find out from Ferdinand's nephew if he wanted the collections. Two months later, on 2 August, the cathedral authorities commissioned a legal expert, Rodrigo de Solís, to examine the Testament carefully to understand the exact terms of the inheritance. The situation remained at stalemate for four years until the beginning of 1544. Possibly acting on the advice of a Dominican priest, Fray Antonio de Toledo,[71] Luis's mother, the Virreina María de Toledo, had the books deposited in the library of the Monasterio de San Pablo, where they arrived on 13 June 1544. The cathedral Chapter was swift to react: they banned the Dominicans from preaching in the cathedral until the books were sent to them and laid claim to their ownership using the Testament as evidence for their rightful inheritance. There ensued a protracted legal dispute, which eventually came down in favour of the cathedral. Distrustful of the Dominicans, the cathedral Canons ordered that they prepare an inventory of the books so that it could be determined if any were missing. Not until March 1552 did the cathedral receive the inventory. Twelve years after Ferdinand's death, on 27 April, the books were finally deposited in their present location.

The documents refer only to books because they had the greatest value, were the principal focus of Ferdinand's interest and also that of the inheritors. They also refer to the 'cerraduras' or 'almarios' that were purpose-built to house the collection.[72] Because the Testament does not mention the print collection, it did not fall under the same legally binding conditions that applied to the books. It is certain that Ferdinand meant the prints to be included with the inheritance as part of the library, but he did not identify them as a separate category. That the prints were stored in chests also means that, unlike books, they would not need new units to be built for their storage and could have easily been placed *in situ*. The singular lack of reference to the print collection in the Testament possibly provided a loophole for them to be sold. The only mention of the fate of the prints comes from Gestoso, who in 1910 suggested that they were sold to cover debts to the Genoese banker Francisco (Franco) Leardo, resident in Seville.[73] But there is no suggestion that upon his death Ferdinand was in any sort of financial trouble.

Ferdinand's universal library was unique for the time, and the many sources indicate its extraordinary organisational programme. Even though they have been rarely acknowledged, his systems of classification and cataloguing provide the basis for modern libraries. Ferdinand's print classification is also unique, and it was so effective that its principles and methods of categorisation have filtered through to the present century.

1 Marín Martínez, 1970, p. 278.

2 Marín Martínez, 1970, p. 274.

3 Inv. no. 229. B.vi.71[227].

4 Inv. no. 227. B.vi.66[226].

5 Fiorio de Bavasori is Florio Vavassore, a woodcutter who worked in Venice around 1505–44. See Hind, 1935, II, p. 430.

6 Inv. no. 2818.

7 Inv. no. 1749. Schreiber, 1985.

8 Marín Martínez, Ruiz Asencio *et al.*, 1993, p. 252.

9 Marín Martínez, 1970, p. 280.

10 See also table in Beaujouan, 1987, p. 59.

11 See McDonald, 2004, I, p. 272.

12 See Marín Martínez, 1970, pp. 57–72; Wagner, 1972, pp. 41–9.

13 A complete explanation of these symbols with reproductions can be found in McDonald, 2004, pp. 121–6.

14 Inv. no. 259. B.xiv.191[155].

15 The Latin dedication is seven pages long and occurs before Livy's text. Wagner has translated a small section of the dedication, which is in Spanish. See Wagner, 1995, note 5, pp. 96–7. Italics mine.

16 Marín Martínez, 1970, pp. 84–9, suggests that the text may be partial, p. 84; also Hernández Díaz and Muro Orejón, 1941, pp. 241–3.

17 Hernández Díaz and Muro Orejón, 1941, p. 241.

18 McDonald, 2004, I, p. 296.

19 Guillén Torralba, 1990, p. 20; also Hernández Díaz and Muro Orejón, 1941, p. xxxvi.

20 Marín Martínez, 1970, p. 87, who points out that there must have existed an earlier petition than that in the Testament.

21 See Schilling, 1999, pp. 285ff.

22 Charles first went to Seville in March of 1526. Cadenas y Vicent, 1992, p. 173.

23 See Marín Martínez, 1970, p. 95.

24 Marín Martínez, 1970, pp. 95–7.

25 Marín Martínez, 1970, pp. 663–84.

26 See Burke, 2000, pp. 93–4.

27 Jacob, 1996, pp. 47ff; Staikos, 2000, pp. 58ff.

28 Chartier, 1994.

29 Goodhart Gordon, 1974.

30 Wagner, 1990, pp. 61–2.

31 Marín Martínez, Ruiz Asencio *et al.*, 1993, p. 331.

32 Ortiz y Zúñiga quoted by Guillén Toralba, 1992, p. 214.

33 Quoted by Guillén Toralba, 1992, p. 214 (J. de Loaysa, *Abecedario de la librería de la Santa Iglesia Catedral de Sevilla*, manuscript, folio 4).

34 Burke, 2000, pp. 35–8.

35 See Lleó Cañal, 1979, pp. 18ff; also Hazañas y la Rúa, 1909.

36 See Morales Padrón, 1989, p. 287.

37 For Vasaeus see Roersch, 1933, pp. 79–96; Huarte y Echenique, 1919, pp. 519–35; also Wagner, 1995, pp. 97ff.

38 Roersch, 1933, p. 6; for Cleynard's work see Bakelants and Hoven, 1981.

39 Cited in Wagner, 1995, p. 96.

40 Vocht, 1934, p. 419.

41 Roersch, 1933, p. 83.

42 Quoted by Roersch, 1933, p. 84.

43 Marín Martínez, 1970, note 76, p. 551.

44 Roersch, 1933, p. 146.

45 Roersch, 1933, p. 144.

46 For Pérez see Marín Martínez, 1970, pp. 10–20.

47 Marín Martínez, 1970, pp. 15–16, 18.

48 This has been published in facsimile. See Colón, 1992.

49 Reproduced by Huntington, 1905.

50 Marín Martínez provides the clearest summary of the repertories. See Marín Martínez, Ruiz Asencio *et al.*, 1993, pp. 343–7; also Marín Martínez, 1970, pp. 805ff; Sáez Guillén, 2002, nos 617–27, pp. 714–26.

51 Wagner, 1992, p. 493; also Marín Martínez, 1970, pp. 14–16.

52 Guillén Torralba, 1990, pp. 28–30; also Wagner, 1992, pp. 492–5.

53 Hernández Díaz and Muro Orejón, 1941, p. 147–8; also Torre Revello, 1945, pp. 31–2.

54 McDonald, 2004, I, p. 286.

55 Maldonado de Saavedra quoted in Sebastián y Bandarán, 1940, p. 17.

56 The Testament has been published by Hernández Díaz and Muro Orejón, 1941. Sections of it relating to the library have been transcribed and translated into English in McDonald, 2004, pp. 285–95.

57 Guillén Torralba, 1990, p. 25.

58 McDonald, 2004, I, p. 286.

59 Wagner, 1992, p. 494.

60 Guillén Torralba, 1992, p. 216.

61 *Aspice quid prodest totum sudasse per orbem*
Atque orbem patris ter peragrasse novum:
Quid placidi Baetis ripam finxisse decoram
Divitias, genium post habuisse meum
Ut tibi Castalii serarem numina fontis
Offerremque simul quas Ptolemeus opes
Si tenui saltem transcurrens murmure saxum
Nec patri salve nec mihi dicis ave.
That Ferdinand travelled three times to the New World is incorrect; only twice did he go. The verse might have been written anticipating the third voyage he did not undertake because of illness. Harrisse, 1871, p. 126.

62 Lléo Cañal, 1979, p. 68. For the library of Alexandria see Staikos, 2000, pp. 57–89.

63 Lléo Cañal, 1979, p. 66.

64 Parsons, 1952, p. 54.

65 See Parsons, 1952, pp. 53–72.

66 Manguel, 1997, p. 192.

67 For the history of the library after it arrived at the cathedral, see Álvarez Márquez, 1992. Also Ruiz Asencio, 1995, pp. 73–6.

68 For which see Álvarez Márquez, 1992, pp. 28–42.

69 Harrisse, 1871, pp. 94, 101, 104; also Marín Martínez, Ruiz Asencio *et al.*, 1993, pp. 333–4.

70 Guillén Torralba, 1990, p. 30.

71 Álvarez Márquez, 1992, p. 31; Harrisse, 1871, p. 109.

72 Álvarez Márquez, 1992, p. 32.

73 Gestoso y Pérez, 1910, p. 237, also n.1, p. 43.

Catalogue

Note to the Reader

Only the prints that are illustrated in this catalogue have the full description from the Seville Inventory entry. A complete transcription of the inventory can be found in McDonald, 2004. The inventory number and classification category are, however, given for each print. For prints that are part of a series (e.g. Albrecht Altdorfer's *Fall and Redemption of Man*, cat. nos 72a–72h) details of size, medium and date are given only in the first entry. A standard bibliographic reference is provided for each print.

The following abbreviations have been used in this catalogue.

B A. Bartsch, Le Peintre-graveur, 21 vols, Vienna, 1803–21.

CD C. Dodgson, *Catalogue of Early German and Flemish Woodcuts Preserved in the Department of Prints and Drawings in the British Museum*, 2 vols, London, 1903 (reprinted 1980).

G M. Geisberg, *The German Single-Leaf Woodcut: 1500–1550*, ed. and rev. Walter L. Strauss, 4 vols, New York, 1974.

H F.W.H. Hollstein, *Dutch and Flemish Etchings, Engravings and Wood-cuts, ca. 1450–1700*, Amsterdam, 1949–; F.W.H. Hollstein, *German Engravings, Etchings and Woodcuts 1400–1700*, Amsterdam/Rotterdam, 1954–.

Heitz P. Heitz (ed.), *Einblattdrucke des Fünfzehnten Jahrhunderts*, 100 vols, Strasbourg, 1899–1942.

Hind A.M. Hind, *Early Italian Engraving. A Critical Catalogue with Complete Reproduction of all the Prints Described*, 7 vols, London, 1938–48.

NH *The New Hollstein, Dutch and Flemish Etchings, Engravings and Wood-cuts, ca. 1450–1700*, Rotterdam, 1993–.

Lehrs M. Lehrs, *Geschichte und kritischer Katalog des deutschen, niederländis-chen und französischen Kupferstichs im XV. Jahrhundert*, 16 vols, Vienna, 1908–34.

Meder Meder, J., *Dürer-Katalog: Ein Handbuch über Albrecht Dürers Stiche, Radierungen, Holzschnitte, deren Zustände, Ausgaben und Wasser-zeichen*, Vienna, 1932.

Pass. J.D. Passavant, Le Peintre-graveur, 6 vols, Leipzig, 1860–4.

Schreiber W.L. Schreiber, *Handbuch der Holz- und Metallschnitte des XV. Jahrhunderts*, 8 vols, Stuttgart, 1969.

TIB A. Bartsch, *The Illustrated Bartsch*, ed. W.L. Strauss, University Park, PA, and New York, 1971– (and commentary volumes).

For further references on Ferdinand Columbus and Renaissance printmaking, see the Bibliography.

1 Antonio Pollaiuolo (*c.*1432–98)
*Battle of the Nude Men, c.*1460–75

Engraving
398 × 594 mm
B.xiii.2[202]; Levenson *et al.*, 1973, pp. 66–80
The British Museum, V.1-33

This engraving is one of the most important and best-known works made in Florence during the Renaissance. Produced on one plate, it is also the most ambitious print from the fifteenth century and the first Italian engraving to carry the artist's full name, seen on a tablet in the upper left. The interpretation of its subject remains problematic despite various episodes from mythology, medieval and Roman history having been proposed as its source. One of the most plausi-

ble interpretations is that its broad subject of gladiators engaged in battle provided Pollaiuolo with the perfect opportunity to display his skill in depicting the nude in action. As such, it is aligned more to imaginative allegory than to specific history. Indeed, the various pairings of the figures seen from all angles and the aimless battle – like actors on a stage – support this contention.

The impression exhibited here has been tinted pink, probably in the eighteenth or early nineteenth century, to simulate the colour of prepared papers used for drawing in the Renaissance.

> This print is described in the Seville inventory at no. 2576 under the classification '*marca*-size sheet of 10 naked men': *Ten nude men who fight with sticks, bows, hatchets and knives, the two men in the middle have seized a chain, there are two trees, in the corner to the left of one it reads opus* Antonii Pollayolo Florentin, *there is foliage against a black ground.*

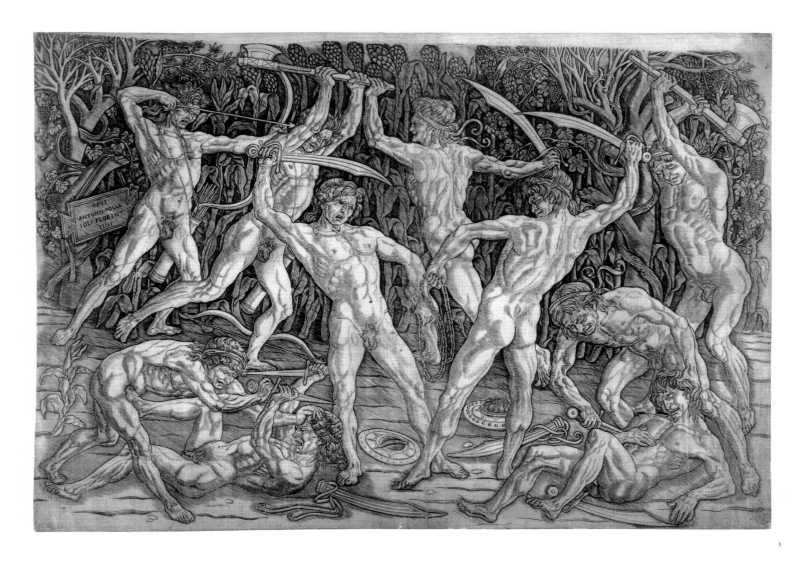

1

2

2 | Anonymous Italian
Allegory of Pope Paul II and Emperor Frederick III, c.1495

Engraving
215 × 145 mm
TIB comment.24-III.008; Levenson *et al.*, 1973, pp. 162–4
The British Museum, 1845-8-25-264

As a sort of political cartoon, this print must have enjoyed enormous popularity in its day because it exists in numerous other versions (engravings and woodcuts). The print shown here is a variant in reverse of the impression Ferdinand owned. The subject presents a complex allegory of European politics that probably alludes to the contest for power between Pope Paul II and Emperor Frederick III who had met in Rome at the end of 1468.

In the print the Pope has climbed to the top of the mast and seems to threaten the Emperor's authority; the inscriptions on the rungs of the ladder refer to the events connected with his rise to power. The Emperor holds a snapped spindle, referring to the King of Bohemia who had been excommunicated by Pope Paul in

1466. It is attached to the wheel of the Roman patriarchy that powers the Pope. The print is filled with references to other European powers. The Duke of Milan is symbolised by a viper biting the Pope's neck and the King of France by the shield supported by the Pope. The ship itself represents the Holy Roman Empire.

> This print is described in the Seville inventory at no. 1895 under the classification '*pliego*-size sheet of 2 naked men': *The emperor of Rome and the pope who are above a mast of a boat, the pope in the right has a balance, in which is a banderole that reads Roma, around his neck is a big snake, in the middle of a star it reads Cometaria, its stem touches the banderole on the 'y', there are three oars, two touch the ground, a line goes from one of them to the neck of a lion.*

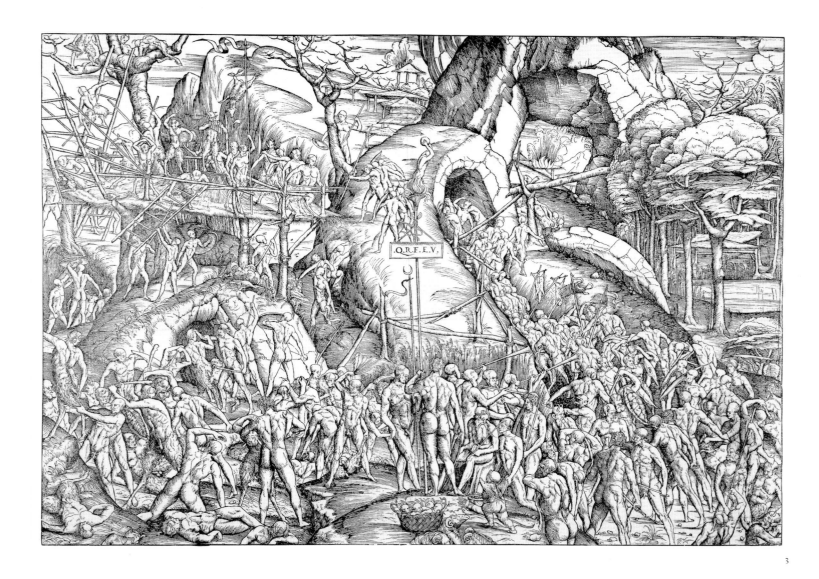

3 | Jacopo de' Barbari (*c.*1460/70–*c.*1516)
Battle Between Nude Men and Satyrs, 1490s

Woodcut
384 × 538 mm
Kristeller, 1896, n.31
The British Museum, 1849-9-10-600

Jacopo de' Barbari probably learnt printmaking in Venice in the early 1490s and this is one of the first prints he produced. His woodcuts appear all to have been made during the early years of his career, whereas he produced engravings throughout his life.

This print attests to Jacopo's interest in mythological subjects, which was typical of artists of his day. The scenes were often deliberately obscure to appeal to an inquisitive educated audience; they sometimes provided a riddle for the viewer. The letters on the banner held by the naked man in the centre, 'Q.R.F.E.V.', have been interpreted as 'Quemadmodum recte factum esse videte' ('see how all has been well done'), the meaning of which is not entirely clear but possibly refers to the efficacy of the battle. As a printmaker, Jacopo was strongly influenced by Andrea Mantegna, whose influence in this print is particularly evident in the rocky outcrop and the layers of tree foliage at the right.

> This print is described in the Seville inventory at no. 2649 under the classification '*marca*-size sheet of many naked men': *A battle of nude men against satyrs who are in a high crag to our left surrounded by a stockade, one has his nose in the stockade and pulls a ladder, below is a man with his back turned, he does not show the right foot, in the lower right corner is a man who with the right has two horns of a satyr, below this satyr is another who shows neither feet nor hands, in the middle of the men is a basket with four children, below the basket is a ram Q.R.F.E.V.*

4 | Monogrammist SE
after Botticelli?, *Carnival Dance: The Sausage Woman*,
1475–90

Engraving
382 × 565 mm
Hind.i.B.III.12[142]; Kwakkelstein, 1998.
Kupferstichkabinett, Staatliche Museen zu Berlin, 102-1908

The authorship of this rare and beautiful engraving has been much debated. Most recently, Sandro Botticelli (1444/5–1510) has convincingly been proposed as the person responsible for its design. The subject is a Morris dance, which is indicated by the bells around the ankles and wrists of the dancers. The origins and purpose of the dance are not entirely clear but seem to relate to fertility and rites of agrarian societies. The bells were worn possibly to attract benevolent Spring and Summer spirits. The peasant theme is given further emphasis by the pig's trotter carried by the woman.

This print is described in the Seville inventory at no. 2570 under the classification '*marca*-size sheet of 9 dressed men': *A dance of people, amongst them a woman like a villager, in the right she has a spit with meat, in the left between the thumb and index finger she holds the foot of a pig, in the corners two old men in stockings and tunics play hornpipes, one has no bonnet except for a garland of leaves, we cannot see the thumbs, or the other's left thumb, with the middle left finger he touches a dancer, at the end of the hornpipe are five buttons.*

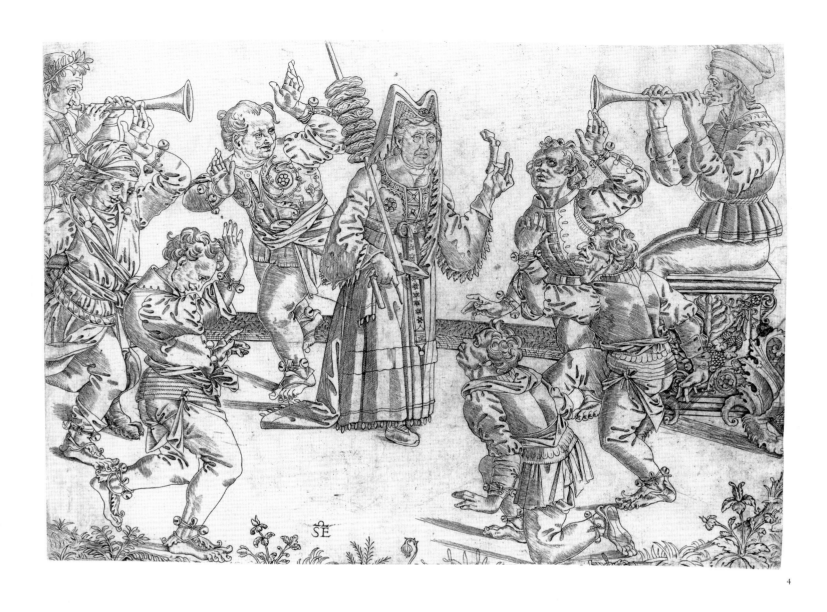

4

5 | Anonymous Italian
The Battle of Zonchio (Navarino), *c.*1499

Woodcut coloured using stencils
548 × 800 mm
Dodgson, 1934, II, no.247, p. 24; Hind, 1932, p. 34
The British Museum, 1932-7-9-1

The battle shown here was fought in August 1499 off Zonchio, north of Navarino (Peloponnese). The combatants were a Turkish vessel commanded by Kemal Ali (shown standing on the deck of his ship), and two Venetian vessels commanded by Antonio Loredan and Albano d'Armer. The Turks were victorious; Loredan was killed when his ship was burnt, and Armer was taken prisoner to Istanbul, where he was sawn into pieces on the order of Bajazet II. This is possibly the first print of an actual naval battle.

The woodcut became the most important medium for producing images of topical interest and they were coloured using stencils so that many impressions could be produced quickly. Many impressions of this print must have been produced but this is the only one that survives. It comes from a famous album of early woodcuts that once belonged to Rudolph II in Prague.

This print is described in the Seville inventory at no. 2735 under the classification 'roll of many figures': *A roll of four sheets two-by-two in which are three galleons, and the top of the topsail in the middle boat in the centre of the sheet has five shields with stars and a banner with a moon fighting the eight ships, each of which has its name, the ship Jordan is to our right, it has a sail furled and burns less than the others.*

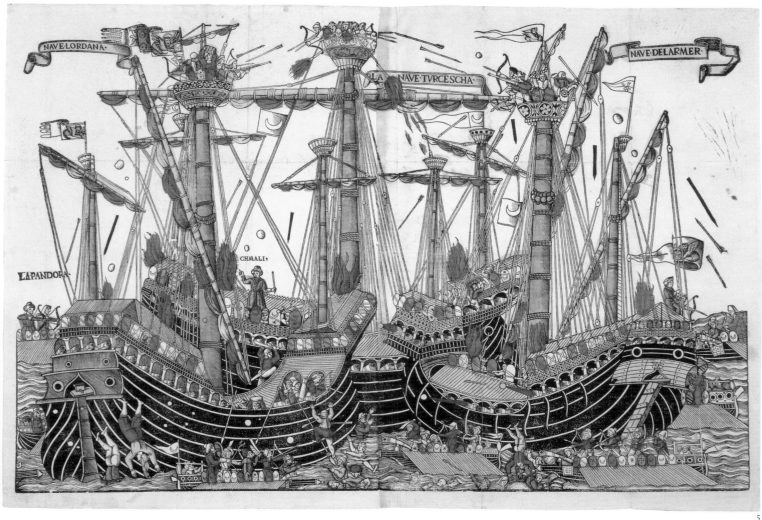

6 Marcantonio Raimondi (*c.*1470/82–1527/34)
 after Titian (*c.*1485/90–1576)
 *St Jerome in the Desert, c.*1510

Engraving
144 × 189 mm
B.xiv.102[88]
The British Museum, 1867-10-12-644

Marcantonio was an engraver from Bologna who worked in Venice before settling in Rome, probably around 1510. There he met Raphael (1483–1520) with whom he collaborated, engraving a large number of prints after his designs. Their collaboration was a landmark in the history of printmaking and established a precedent that was quickly followed by other artists. Reproductive engraving provided the perfect means to disseminate the ideas of an important artist. Marcantonio made over 300 engravings, almost all of which were reproductive.

This print has long been thought to be after Raphael but in fact was made after a drawing by Titian now in the Uffizi in Florence. It shows Marcantonio's remarkable skill in evoking texture and atmosphere with the burin, a talent based on his extensive study (and forgery) of Dürer's work.

This print is described in the Seville inventory at no. 201 under the classification '*quarto*–size sheet of 1 dressed male saint': *An old man seated poorly covered around the buttocks and abdomen otherwise naked, there is a book with two clasps, the left fingers rest upon the book with the others half inside, he is next to an edifice, further on is a large old tree and further still a lion [this is St Jerome].*

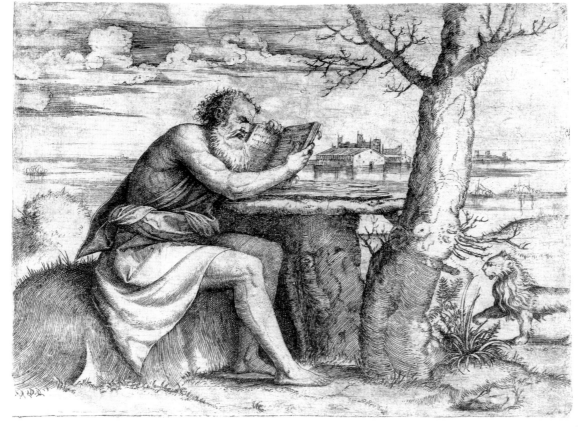

6

7 | Marcantonio Raimondi (*c*.1470/82–1527/34)
Portrait of Raphael, c.1518

Engraving
139 × 106 mm
B.xiv.496[369]
The British Museum, 1973 U.82

Although the sitter's name is not included on the print, this delicate and intimate portrait is thought to depict Raphael, shown here in a reflective moment wrapped in a cloak and seated near his paint pots and mixing palette. By the time Marcantonio made this print he had known Raphael for at least five years and was producing monumental prints of classical subjects after the painter's designs. The unaffected structure and plain background underscore Raphael's humanity and even their friendship. This print might have been a sort of personal tribute to Raphael.

> This print is described in the Seville inventory at no. 263 under the classification 'quarto-size sheet of 1 dressed man': *A dishevelled man with his cape as if he is cold seated on a bench [with his left foot over the right], to his right are two paint pots, no background.*

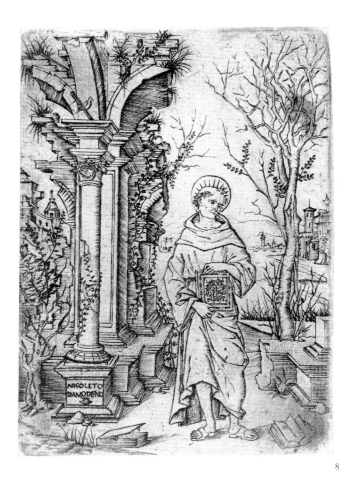

8

9

| 8 | Nicoletto da Modena (*fl. c.*1500–*c.*1520)
*St Bernardino of Siena, c.*1510–15

Engraving
146 × 103 mm
B.xiii.26[270]; Hind.v.57[126]
The British Museum, 1853-6-11-245

Nicoletto was a prolific engraver; around 78 signed engravings are known and over 120 can be attributed to him in total. Those dated before 1500 are connected with Andrea Mantegna (*c.*1431–1506) and his circle. They exhibit fine, densely applied cross-hatching and a feeling for richness of surface typical of fifteenth-century Ferrarese engravings.

This engraving is one of a group of fourteen prints that constitute the 'third period' of Nicoletto's activity after he had been to Rome and was possibly working in Venice. They are all around the same size and the figure is often placed centrally before an elaborate architectural setting. Each element of the composition seems to exist independently, providing separate points of interest.

> This print is described in the Seville inventory at no. 208 under the classification '*quarto*-size sheet of 1 dressed male saint': *St Antony of Siena has a sun in front of his belt, with the right he raises a bit of his habit, the left is above the sun, to the right appears a broken edifice upon which grows foliage and a bird, there are many trees, to the left is a big tree, next to it many small ones, in front of the edifice at the foot of the pillar reads Nicoleto di Modena, there is a boat with a sail.*

| 9 | Nicoletto da Modena (*fl. c.*1500–*c.*1520)
*St George and the Dragon, c.*1510–15

Engraving
149 × 103 mm
Hind.v.49[125]; TIB comment.2508.044; Levenson *et al.*, 1973, no.176
The British Museum, 1846-5-9-16

The delicate engraving, the use of stipple on the ground and the soft light suggests that this print was produced in Venice and reflects the work of Vittore Carpaccio (1460/6–1525/6). The dragon, tethered with the princess's girdle, is subdued in contrast with St George, who stands confident after his victory. The imaginative architecture provides the perfect background for the decorative armour and headgear worn by St George. See also cat. no. 8.

> This print is described in the Seville inventory at no. 252 under the classification '*quarto*-size sheet of 1 dressed man': *A man armed, not lacking the banner, he has plumes on his helmet, a lance in the right with a pretty banner from which go two strips, it furls three times around the lance, two tassels, in the left is a chain that is tied to the neck of a very big serpent and next to the end of the tail grow two trees, above in the verge of the edifice reads nicoleto da Modena.*

10 | Amico Aspertini (1474/5–1552)
*Three Musician Soldiers, c.*1510–20

Engraving (drypoint)
142 × 143 mm
Hind.v.1[244]; Faietti and Scaglietti Kelescian, 1995, no.1, pp. 325–6
The British Museum, 1870-6-25-1062

The activity of the eccentric Bolognese painter Aspertini as a printmaker is known only through this unique impression and one other print of a different subject. This print is executed in drypoint, imparting to the composition a diffuse quality. The subject represents three musician soldiers in the costume of Swiss or German *lansquenet*, a theme that was very popular, especially in northern Europe, during the early years of the sixteenth century [see cat. nos 52, 66]. Here, the figures are set against a Venetian lagoon. The radial penumbra emanating from the sun suggests the influence of the engravings by Jacopo de' Barbari [see cat. no. 3], where the same device appears. Aspertini's monogram is inscribed on the stone at the bottom but the meaning of the numbers 147 that appear on the other stone is not known.

This print is described in the Seville inventory at no. 1963 under the classification '*pliego*-size sheet of 3 dressed men': *Three soldiers, one has a kettledrum, his hands and the left half of the face are hidden, he has a cap and a hat with a plume, the one in the middle plays a pipe, he has another in his bonnet, four slashes on the right thigh, the fringe of his stockings hangs to the legs, the other man to our left has a banner in the right hand, that thumb hidden.*

10

11

11 | Giovanni Antonio da Brescia (*c*.1460–*c*.1520)
after Giovanni Pietro da Birago
*A Nereid and Two Children Playing Musical
Instruments, c.1500*

Engraving
536 × 78 mm
B.xiii.22 [307]; Hind, v.10(2)[80]
The British Museum, 1845-8-25-678

This engraving is the only one that survives from a series that Ferdinand owned
of twelve ornament panels engraved by da Brescia after drawings by Giovanni
Pietro da Birago (*fl. c*.1471–1513). It depicts an elaborate candelabrum with a female
triton at the bottom playing a violin, and naked children. These types of prints
were often stuck on to surfaces as decoration. The elongated shape and size of
this print suggests that it might have been intended as border decoration. Because
of their practical function, relatively few ornament prints have survived but the
description of so many in the Columbus print inventory indicates how many were
made during the Renaissance.

> This print is described in the Seville inventory at no. 2035 under the classifica-
> tion '*pliego*-size sheet of 4 naked men': *A* strip, *in the upper part are two naked*
> *children, they have a stick between them, the one to our left has a shield in the*
> *right, the other in the right, below them are another two kneeling between them hold-*
> *ing a shield-like object in which reads D.M.aR.v, the one at the right holds a chain*
> *in the left, the other one in the right from which many urns are hanging, below are*
> *two serpents, their tails upwards.*

12 | Giovanni Battista Palumba (active first quarter of
16th century)
*Mars, Venus and Vulcan (Vulcan Forging the Arms of
Achilles), c.1505*

Woodcut
298 × 213 mm
Shaw, 1932, pp. 294–5, and 1933, nos 24a and b, pp. 177–8
The British Museum, 1854-11-13-167

For a long time the identity of this printmaker was unknown and on account of
his monogram he was simply called 'Master IB with the Bird'. His prints are
now accepted as the work of Giovanni Battista Palumba, and his woodcuts are
amongst the most important produced in Italy (Rome) during the early years of
the sixteenth century. His grand pictorial compositions, many with mythologi-
cal narrative subject matter, were an attempt to emulate the rich values of Dür-
er's woodcuts of the later 1490s [see cat. nos 36–39]. They are remarkable per-
formances, in the finest of which the quality of the cutting is high and the figures
are effectively integrated into the landscape.

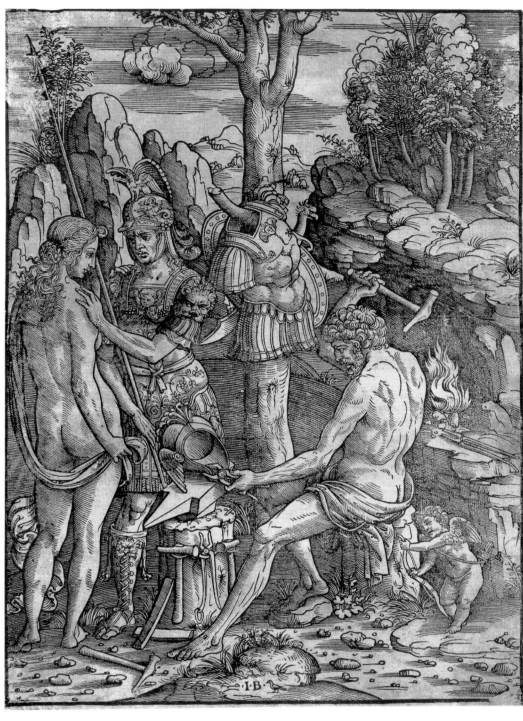

12

Palumba alludes to several classical stories in this print. In the *Odyssey* it is related that Venus, the wife of Vulcan (the blacksmith to the gods), fell in love with Mars, the god of war, and slept with him. Their intimacy is implied here; his hand rests on her shoulder. Vulcan, however, is shown here making a set of armour for Achilles, who is not depicted.

This print is described in the Seville inventory at no. 2032 under the classification '*pliego*-size sheet of 4 naked men': *Vulcan who is working a helmet in a forge, behind is an armed cupid with a bow, an armed man touches the left of a naked woman, there is a huge tree in the middle from which hangs a cuirass, a guard, a knife, author IB* 🐦 *, Vulcan has the right foot higher than the left upon a round stone, the hammer is in his right.*

13 | Giovanni Battista Palumba (active first quarter of 16th century)
*The Calydonian Boar Hunt, c.*1505–12

Woodcut
270 × 445 mm
Shaw, 1932, p. 290, and 1933, no.21, pp. 176–7
The British Museum, 1895-1-22-1215

The scene depicts the savage boar sent by Artemis to wreak havoc on Calydon after she had been ignored during the annual sacrifice. The bravest warriors were sent to hunt the boar; at the left the great huntress Atalanta was the first to draw blood with one of her arrows. Of all Palumba's prints, this is one of the most successful because of its pictorial unity. In various states of dress the figures encircle the wild beast. The subject also allows for a dramatic exploration of the body in motion.

The naked man at the far right recalls the same figure in Pollaiuolo's engraving [cat. no. 1]. Because the figures are presented to the viewer like a sculptural frieze, other sources such as Trajan's column in Rome and a fresco in the Villa Farnesina in the same city have been proposed.

This print is described in the Seville inventory at no. 2033 under the classification '*pliego*-size sheet of 4 naked men': *A Roman on horseback, two men standing go to hunt a boar, one has a lance in his right hand, the tip touches the left eye of a dog which is on the pig and seizes its left ear, the horse is covered with the skin of a lion, its right hoof touches the left eye of the pig, next is a naked man wearing a garland on his head, in his hands a stake, in the other part a woman fires an arrow at the pig, we cannot see the right thumb, there are twelve birds flying and in the background a city, IB* 🐦 .

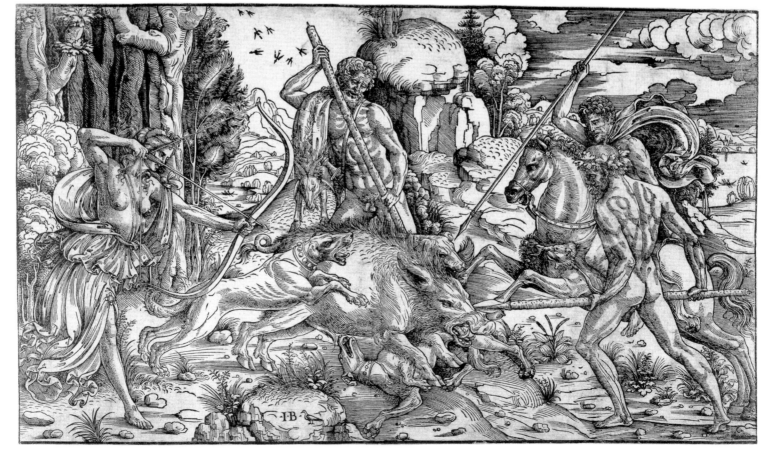

13

14 | Ugo da Carpi (*c*.1502–32)
 | *A Sibyl Reading, c.*1515

Chiaroscuro woodcut
287 × 240 mm
B.xii.6[89]; Johnson, 1982, no.4
The British Museum, W.4-18

Carpi claimed to have invented the chiaroscuro technique in which several blocks are used to produce an image in different colours, allowing for pictorial effects closer to drawing. It had, in fact, been developed earlier in Germany by Burgk-mair and Cranach [see cat. nos 55–59, 78–82] and Carpi probably encountered examples of their work when he was in Venice from around 1509. The present print is made from two blocks: the first defined the black lines and the second laid the colour. At the right of the present print is the letter 'R' which refers to the painter Raphael. It is not known if Carpi collaborated with Raphael or simply used his name on his woodcuts to increase their appeal.

> This print is described in the Seville inventory at no. 1896 under the classifica-tion '*pliego*-size sheet of 2 dressed women': *A seated woman bareheaded reading a book held in her left hand, her right foot is hidden, the scene is illuminated by a candle held by a standing child, his left fingers and right foot are hidden, he has raised the hem, no background.*

15 | Ugo da Carpi, (*c*.1502–32)
after Titian? (*c*.1485/90–1576)
The Sacrifice of Abraham, 1515

Woodcut
790 × 1076 mm
Rosand and Muraro, 1976, 3A-II
Kupferstichkabinett, Staatliche Museen zu Berlin, 44-1967

The degree to which Titian was responsible for designing this composition has been much debated, but he probably provided drawings for its major elements. The story is depicted as it is told in the Bible (Genesis 22: 1–19). In the foreground, Isaac's pathos is fully expressed as he stoops under the weight of the wood for his sacrifice. The two men seem to understand the profundity of his fate, while Abraham at the left conveys a sense of urgency. The only anomaly in the narrative depicted is in the upper right where, instead of a ram caught in the thicket, there is a goat.

The print borrows a number of motifs from Dürer. The angel in the upper right seems based on the angel in the *Four Horsemen of the Apocalypse* [see cat. no. 43a] and the distant mountain landscape at the upper left is taken from the *Visitation* from Dürer's *Life of the Virgin* series. There are at least five editions of this print. The inscription recorded in the inventory tells us that Ferdinand owned an impression from the first edition (illustrated here, Berlin 868–100), whereas that in the exhibition is from the second state.

This print is described in the Seville inventory at no. 2686 under the classification 'roll of 9 figures': *A roll of four sheets of marca-size two-by-two lengthways, it is the sacrifice of Abraham that is in the upper right sheet, a child is on an empty altar of sticks, in the middle half a goat pokes out, which he touches with his left foot, the other is suspended, in the lower left sheet are three people, printed in Venice by Hugo de Carpi and Bernardino Benalio, in the background is a high tower of a city that is round and abandoned.*

16 | Jacobus Argentoratensis (Jacob of Strasbourg)
(*fl. c.*1500–*c.*1520)
designed by Benedetto Bordon (*fl.* 1488–1530)
*Istoria Romana, c.*1500–20

Woodcut
291 × 397 mm
H.xvA.17
The British Museum, 1862-7-12-118

The meaning of this print is not clear. It presents an amalgamation of seemingly disparate figures and objects that was possibly designed as a sort of 'classical puzzle' to delight and possibly challenge the viewer with its arcane juxtapositions. The prominent inscription 'Istoria Romana' at the right suggests that the overarching theme relates to Rome. The female personification of Rome, holding the head of Janus in one hand and the victory standard in the other, stands on a pedestal inscribed SPQR, the abbreviation of SENATVS POPVLVS QVE ROMANVS (the Roman senate and people). To her right is the Roman hero Marcus Curtius (see fig. 39) on horseback followed by a line-up of gods: Neptune, Mercury, Pan, Venus and Cupid, Mars.

This print is described in the Seville inventory at no. 2256 under the classification '*pliego*-size sheet of 12 naked men': *A Roman history in which is an armed man upon two horses, the horses are wild, in the right he has something like a pronged lance, in the tip a thorn, we cannot see that thumb or the left one, above the helmet is an angel who has a scourge in his hands to guide the horses, in front is a standing barefoot woman who in the right has two male heads, thumb hidden, in the left a sceptre, in the other part is a man who thrusts his right hand into the mouth of a horse, in the left he has a jaw, below is a serpent, in the background a tree in which is a nymph and a child, the work of Jacobi.*

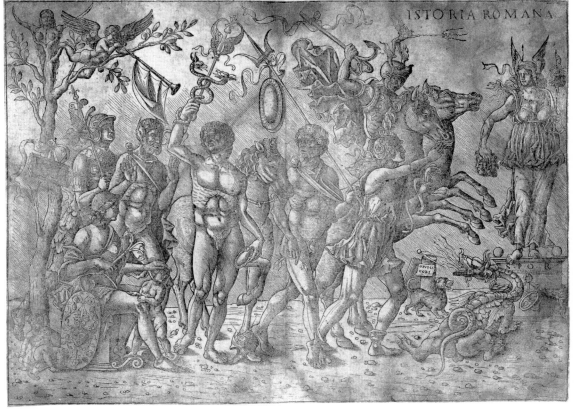

16

17 | Jacob of Strasbourg (Jacobus Argentoratensis)
(*fl. c.*1500–*c.*1520)
after Benedetto Bordon (*fl.* 1488–1530)
Madonna Enthroned between Sts Roch and Sebastian,
*c.*1500–20

Woodcut
542 × 292 mm
H.xvA.2; Massing, 1977
The British Museum, 1919-6-16-14

Jacob of Strasbourg was a block-cutter from northern Europe and Benedetto Bordon was a miniaturist from Padua. Their collaboration in Venice during the early years of the sixteenth century produced some extraordinary large prints of which this is a fine example. The two plaques in the upper corners record that

Bordon designed the print and Strasbourg cut it. The print elegantly combines northern and Italian conventions. Bordon based the position of the Virgin and her drapery on a print by Martin Schongauer and the small scenes of the Passion of Christ reveal knowledge of the same artist [see cat. no. 31]. The ornate altar and niche in which the Virgin and Child sit flanked by Sts Sebastian and Roch are completely Italian in their inspiration.

This print is described in the Seville inventory at no. 2592 under the classification '*marca*-size sheet of many dressed male saints': *The Virgin in a chapel, below in the border are small squares of the acts of the Passion, to the sides are St Roch and St Sebastian, in the corners are ten children with instruments of the Passion, above them it reads Benedictus pinxit, to the right Jacobus fecit, the Virgin and the Child have the world with the right, upon the Virgin's hem to the left sticks out a harpy and its right arm.*

17

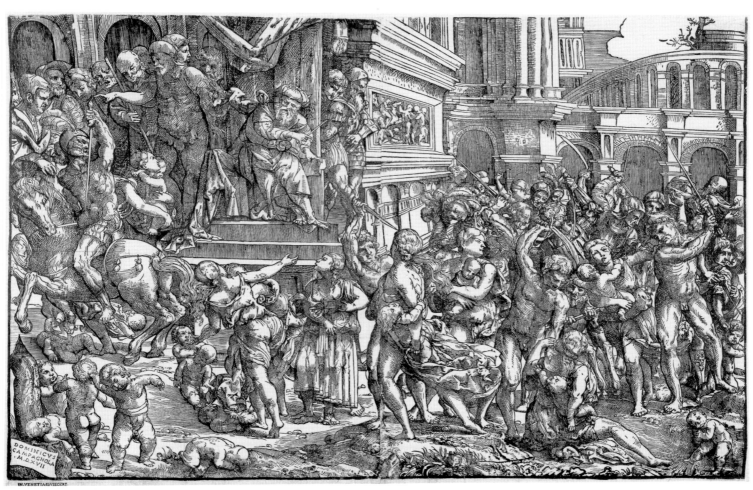

18 | Domenico Campagnola (1500–64)
The Massacre of the Innocents, 1517

Woodcut

532 × 822 mm

B.xiii.1[384]; Rosand and Muraro, 1976, no.20

The British Museum, 1860-4-14-120

Despite Campagnola's success and prominence as a printmaker in Padua and Venice during the first half of the sixteenth century, almost nothing is known about him. He was greatly inspired by the expressive power of the prints by Titian [see cat. nos 6, 15 19], as is evident in the present work, one of Campagnola's most ambitious prints, made early in his career. It is striking for the dynamic composition and the energy of the figures, which are entirely appropriate for the subject. Set before sombre architecture, the figures, led by the women trying to save their infants, surge in waves while in the upper left Herod and those responsible for delivering the orders act as witness to the bloodshed.

All surviving impressions of this print are late. In the lower left corner is the inscription 'Il Vieceri', a late seventeenth-century publisher who somehow acquired these blocks and added his name.

> This print is described in the Seville inventory at no. 2811 under the classification 'roll of many figures': *The innocents, in the corner to our lower left is a tablet which is inscribed Domynicus Campañea mdxiii, above is King Herod seated, he has a sceptre in the right, the index finger is outstretched, to our right are two men, their cheeks together, the one in the left hand has a child by the hair, whose hands are hidden.*

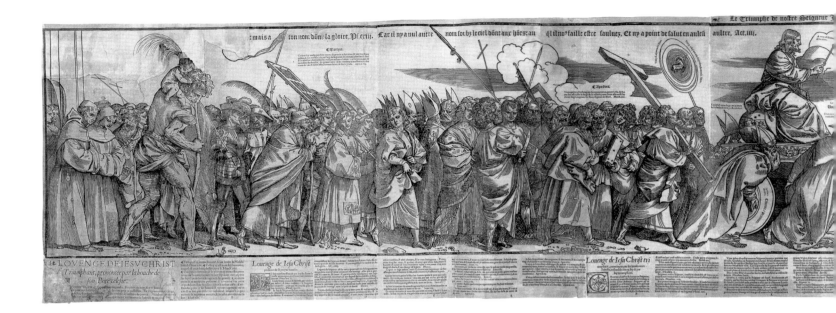

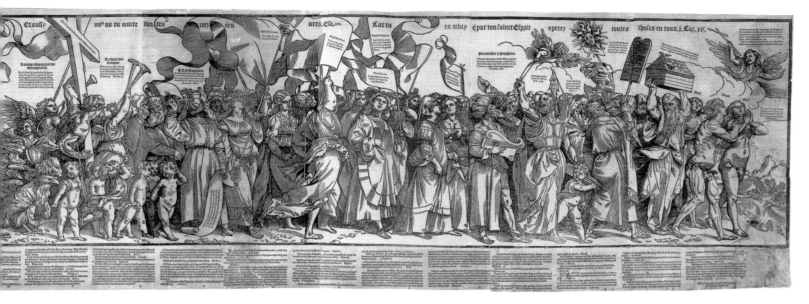

19

19 | Anonymous Italian
after Titian (*c.*1485/90–1576)
The Triumph of Christ, 1510–11

Woodcut
390 × 2705 mm
Dreyer, *c.*1972, no.1; Rosand and Muraro, 1976, pp. 37ff
The British Museum, 1930-4-14-40

This frieze of the *Triumph of Christ* is known in a number of editions, most of which were printed in fewer blocks than the ten mentioned in the Columbus inventory. The first edition was, however, printed on ten blocks but this edition no longer survives. That numerous editions were produced testifies to the popularity of the subject during the sixteenth century.

Christ triumphant is shown here seated upon a world on a chariot drawn by the four symbolic beasts of the Evangelists and pushed by the Doctors of the Church. Leading the procession are Adam and Eve. It seems that this was Titian's first design for a woodcut. Writing about this Triumph in 1550, the Italian art historian Giorgio Vasari described it as 'a work displaying vigour, style and knowledge', a resounding recommendation verifying its qualities.

This print is described in the Seville inventory at no. 2812 under the classification 'roll of many figures': *The triumph of Jesus Christ in ten sheets of paper, he sits on a world in a carriage, in the right he holds a stick, that index finger is outstretched, at the sides of the carriage are the four doctors of the church, two on each side, the evangelists carry it, in front are angels with trumpets, Eve is in front of them all, Adam touches her neck with the right, with the left knee her left shin, she has three vine leaves as a belt, but the beginning of the triumph is missing up to the part where it reads in the title eterna pace.*

19

Car tu ... es celuy q̃ par ton saĩct Esprit operez

Sibylla Delphica.
Les homes mortelz corrũperõt les idoles, a laduenement du grand Dieu.

Sibylla Samia.
Lesimaiges desdieux faictes à la main, seront brullees.

Sibyl.phrygia.
Faisant trãbler la terre, il ouurera enfer.

Patriarches ẓ Prophetes.
Chantez louenge a nostre Dieu, chantez louenge, chantez louenge a nostre Roy, chantez louẽge: Car Dieu est Roy de toute la terre: chantez louenge saigement. Pseaulme .xlvi.

Nestendz pas ta main sur lenfant Geñ . xxij.

toutes choſes en tous. j. Co2, rij.

Ioſue.

Le Soleil ſarreſta au milieu du ciel, & ne ſe haſta point de ſoy coucher par leſpace dung iour. Ioſue .x.

Quant leaue deſtruyſoit la terre, la Sapience lea de rechief guerie, gouuernant le luſte par vng bois contemptible. Sapi.x.

Abel' Adam Eua

Venez, montons a la montaigne du Seigneur, & a la maiſon du Dieu de Iacob: & il nous enſeignera ſes voyes, & cheminerons en ſes ſentiers. Venez, cheminõs en la lumiere de noſtre Dieu. Eſaie. ij. & Michee. iij.

Ceſte ✝ eſt la voye, cheminez en icelle: & ne declinez ne a la dextre, ne a la ſeneſtre. Eſa.xxx.

Toy, par le ſang de ton teſtament, as mene hors tes priſonniers de la foſſe ou il ny a point de aue. Zacharie. ix.

19 detail

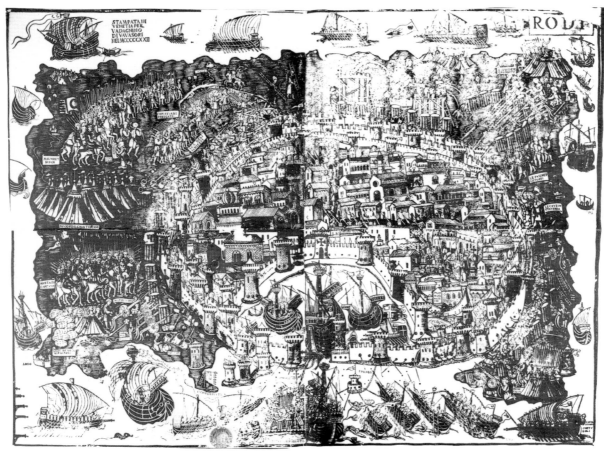

20

20 | Giovan Andrea Vavassore (*fl. c.*1510–*c.*1570)
The Siege of Rhodes, 1522

Woodcut
775 × 568 mm
Rivoli and Euphrussi, 1891, p. 228
The British Library, Maps 15.c.26(3)

The print reproduced here is a slightly reduced facsimile in the British Library, London. It represents the Turkish siege of Rhodes which ended with a Turkish victory and the expulsion of the Knights of St John on 20 December 1522. The print must have been produced immediately after the siege and was made specifically as a report and a record of the event. Very few of this sort of large-scale topical print have survived. It shows an amalgamation of narrative events (soldiers on horseback, cannons firing) with a geographical representation (the bay and the island).

Little is known about Vavassore except that he worked in Venice in the first part of the sixteenth century. Throughout his long career, he seems mainly to have been a copyist. The only known impression of this print in Berlin was destroyed during the Second World War.

This print is described in the Seville inventory at no. 3152 under the classification 'roll of maps': *Rhodes in four sheets, two long by two wide, coloured, in the lower middle between other boats are two small galleons, to the right of the mainsail is a rudder, the left is moored, one takes the sail, in the left corner is a boat with three men and three flags, one on the stern and one on the prow.*

21 | Anonymous German
The Relics, Vestments and Insignia of the Holy Roman Empire, c.1480–90

Hand-coloured woodcut
434 × 298 mm
Dodgson, 1934-35, II, no.246; Schreiber, 1942a
The British Museum, 1933-1-2-1

The dominant and most ancient relic in the middle of the composition is the lance of St Maurice; its head has been perforated and a nail from the Holy Cross has been inserted. To the left and right of the spear are other relics, which include Christ's crib, the arm of St Anne and the table-cloth used at the Last Supper. Until 1796, some of the relics depicted here were preserved in Nuremberg, but they were then removed to Vienna because of the French threat. With the exception of the lance, the other relics are conventional representations of what they depict. The colouring was applied at around the time the print was made.

> This print is described in the Seville inventory at no. 2959 under the classification '*pliego-size sheet of 2 animals*': *Many reliquaries, a helmet, a lance with fourteen small circles, to our right are two crosses, above are a belt and spurs, above are three worlds, two sceptres, seven cups, two swords, three links of a chain, a crown of an emperor and a garment in which are two lions.*

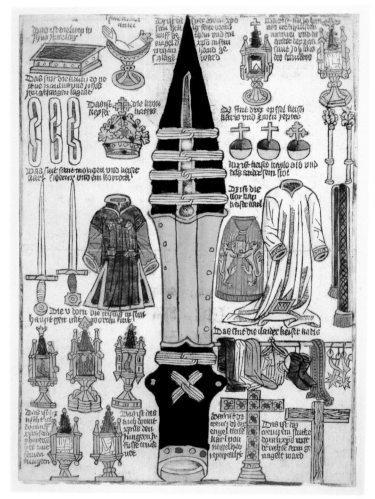

21

Woodcut (modern impression)
270 × 420 mm
Schreiber, 1961
The British Museum, 1857-5-20-29

The print described in the Columbus inventory is very slightly different from the impression exhibited here. One was evidently copied from the other. From the characteristic hats that the men wear, the attempt at Hebrew lettering and the content of the German banderole inscriptions, it is clear that they are meant to be Jews. It is an early example of anti-Semitic imagery and the inscriptions are virulent. The one running along the lower border reads: 'Because we do not eat pork that is why we are pale and our breath stinks.'

This print is described in the Seville inventory at no. 2110 under the classification '*pliego*-size sheet of 6 dressed men': *A naked man seated on a cushion suckling a sow, another man is kissing her snout, another is on top, with both hands raising the tail to kiss it, another touches the left hock with the left hand, there are banderoles in Flemish type.*

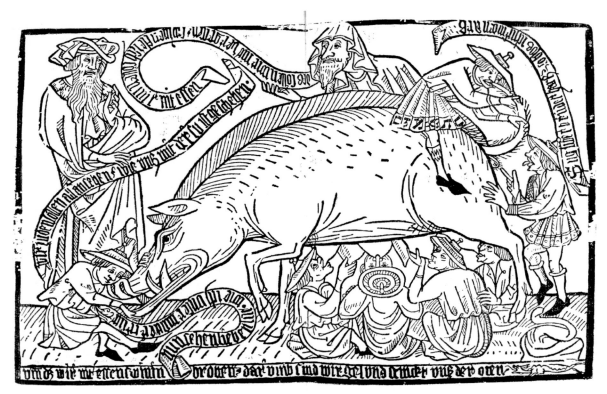

22

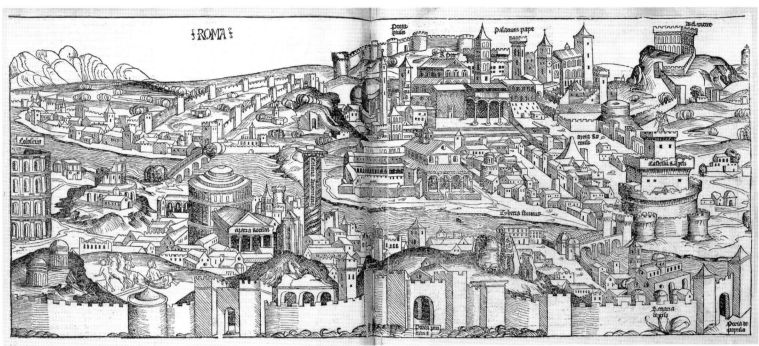

23 Michael Wolgemut (1434/7–1519) and Wilhelm
Pleydenwurff (*c.*1460–1494)
*View of Rome, c.*1493

Woodcut
231 × 453 mm
The British Museum, 1870-10-8-1938

Hartmann Schedel's *Nuremberg Chronicle* (1493) was the best-seller of its day.
It pretended to contain in one volume the entire 'history of the world' from
creation onwards and had many illustrations. The town views were evidently
sold as single-leaf impressions and this is how Ferdinand bought his. The *View
of Rome* is one of many views of cities that occur throughout the *Chronicle*. It
is a west-facing aspect that includes St Peter's in the background, Santa Maria
del Popolo in the north and the Coliseum to the south. Some of the single-leaf
impressions were hand-coloured.

Michael Wolgemut was Nuremberg's chief painter and pioneer of the print
industry and Albrecht Dürer was his apprentice from 1486 to 1489. The
Nuremberg Chronicle was published by Dürer's godfather, Anton Koberger.

> This print is described in the Seville inventory at no. 3138 under the classifica-
> tion '*marca*-size map': *Rome, in the lower left corner is a big tower, at its foot are
> two cube towers, in the lower right corner between two towers is a door, below it
> reads porta del populo and the pp of the word popolo touch the lower edge of the
> composition, on the encircling wall it reads Santa Maria de PPopulo, two tips of a
> bush touch the word populo.*

24

24 | Israhel van Meckenem (*c*.1440/45–1503)
Samson Slaying the Lion, second half of 15th century

Engraving
137 × 106 mm
B.vi.3[203]; H.xxiv.5
The British Museum, E.1-95

Israhel van Meckenem was the most productive engraver from the fifteenth century; around twenty per cent of all German copperplate engravings of the early period originate from his hand. He copied avidly from earlier and contemporary artists such as Martin Schongauer and Monogrammmist FvB [see cat. nos 31, 95] and produced his own designs of considerable originality. His productivity was matched by the popularity of his engravings, which resulted in the copper plates wearing out and becoming too weak to produce further impressions. An astute businessman, Meckenem constantly reworked his plates to produce new impressions and maximise their financial return. There are so many different states of Meckenem prints that it is sometimes difficult to ascertain their sequence. It is also very hard to date his engravings, but he worked from around 1465 until 1500.

Although small, the present print is a powerful representation of Samson overcoming the lion. Samson's stylised hair and the lion's mane reflect Meckenem's training as a goldsmith. The print does not seem to be a copy, and like most of his work it is signed with his prominent monogram.

> This print is described in the Seville inventory at no. 261 under the classification
> '*quarto*-size sheet of 1 dressed man': *Hercules on the lion, a cloth binds his hair which
> is tousled, with his right and left hands he opens its mouth, we can see only three
> fingers of each hand, the lion has its tail between its legs and round its left foot, behind
> on a peak is a castle with a round tower, a corridor in the middle, in the upper part
> are windows and below others, two long and narrow I.M.*

25 | Israhel van Meckenem (*c*.1440/45–1503)
Head of an Old Man (an Oriental), *c*.1480–90

Engraving
208 × 131 mm
H.xxiv.515; Shestack, 1969, n.210
The British Museum, 1845-8-9-312

This is the only print by Meckenem in which his full name is included followed by the word 'goltsmit'. His father had the same name and was a goldsmith and it has been suggested that the sitter represents his father. The entry in the Columbus inventory, however, describes the man as 'tocada a la turquesca', indicating that the turbaned figure was characteristic of oriental types. It is possible that Israhel used his father as a model to represent the oriental type.

> This print is described in the Seville inventory at no. 268 under the classification
> '*quarto*-size sheet of 1 dressed man': *A head of an old man with a big beard, he has
> a Turkish-style headdress, at our right side are thick locks of hair that touch his left
> ear and the cheek, to our left half the ear shows, between that and the eye is a lock
> of hair forming a circular twist like an 'O', at the foot is text that reads Ysrahel van
> ḋᷤᷓd .*

25

26

26

26 | Israhel van Meckenem (*c.*1440/45–1503)
Sts Quirinus and Antony, c.1475

Engraving
162 × 142 mm
Gugenbauer, 1911, pp. 65–6; H.xxiv.309(a & b)
The British Museum, 1993-10-3-10 and 1845-8-9-106

All existing impressions of this engraving are printed on separate sheets; originally, both figures were intended to form the one image as indicated by the continuous details running along the centre cut. Quirinus is the patron saint of Neuss near Düsseldorf and Antony was a popular saint who in the same region was called upon in times of need. In 1474/5, Neuss was attacked by troops of Charles the Bold. This print might well have been produced in response to that event, to invoke the protection of these saints.

> This print is described in the Seville inventory at no. 1592 under the classification '*medio*-size sheet of 2 dressed male saints': *An armed saint who is St Quirinus, has a banner with nine small circles in his right, in his left he has a shield with nine small circles, above is script that reads sancte quirium, the middle parts of the arms are covered by a protector, on his head is a hat with three plumes, next to him is a man, we can see neither the right nor the left thumb.*

27 | Israhel van Meckenem (*c.*1440/45–1503)
Christ Being Crowned with Thorns (The Large Passion),
*c.*1480

Engraving
208 × 145 mm
B.vi.14[207]; H.xxiv.146
The British Museum, 1842-8-6-76

This print is one of twelve that make up Meckenem's *Large Passion* produced around 1480; all appear to be Meckenem's own inventions. Like many prints from the period, the various elements of the story are shown at separate moments. Here, in the background, Christ is being blindfolded and beaten, whereas in the foreground he is being crowned with thorns. The sophisticated spatial arrangement and rational perspective evident throughout this series may be due to Meckenem's exposure to Flemish art.

> This print is described in the Seville inventory at no. 301 under the classification '*quarto*-size sheet of many dressed male saints': *Christ seated on a pillar with a cane in his right hand being passed to him by a Jew in his left hand, his right raised a little like a greeting, the other three are above fixing the crown of thorns on his head with sticks, one of them has his back turned, below are two dogs, one is hairy and the other, a greyhound, is lying down. I.M.f.*

27

28

28 | Israhel van Meckenem (*c.*1440/45–1503)
*St George and the Dragon, c.*1470–80

Engraving
170 mm diam.
B.vi.98[234]; H.xxiv.344
The British Museum, E.1-120

The circular composition of this engraving beautifully complements the movements of the main figures. The damsel sways backwards away from the moment the determined St George lances the dragon. St George wears the armour of a medieval knight and the sash upon which he sits provides Meckenem with the perfect opportunity to articulate its sculptural folds; their movement underscores the dramatic moment.

> This print is described in the Seville inventory at no. 1318 under the classification *'quarto-size sheet of 2 dressed male saints': St George in a circle, armed, fighting with a serpent, who has a lance thrust through its mouth, in front is the king's daughter kneeling close to a house, almost touching a sheep with her robe, the horse's tail is divided into five strands.*

29 | Israhel van Meckenem (*c.*1440/45–1503)
*The Mass of St Gregory, c.*1490

Engraving
416 × 294 mm
B.vi.102[236]; H.xxiv.354
The British Museum, 1845-8-9-348

This is the largest and most ambitious of Meckenem's numerous engravings of the Mass of St Gregory. It is thought to be a copy of a lost painting by Hans Holbein I. The legend relates how the saint, after finding a non-believer in his congregation, prayed for a sign, whereupon Christ appeared on the altar. The image demonstrated that those present at the Mass could perceive the bodily presence of Christ after the consecration. It was one of the most popular devotional images of the fifteenth and early sixteenth centuries. Meckenem's monogram appears twice in this image, directly beneath St Gregory who is turned from the viewer and also at the two ends of the altar cloth.

> This print is described in the Seville inventory at no. 2632 under the classification *'marca-size sheet of many dressed male saints': St Gregory who is saying Mass, above is the naked Christ half-length in the tomb, hands crossed, at the sides of his halo are many people standing and on horseback, at the sides of the tomb are two candlesticks with two burning candles, at the sides are many men and two cardinals, the one to our left has the crown of St Gregory in his hands, above Christ is the cross and other arms, further above is the sudarium and a woman holding it, in the altar it reads Jesus Maria.*

30

30 | Master ES (active second half of 15th century)
The Judgement of Solomon, c.1450–67

Engraving
219 × 147 mm
Lehrs.ii.7; B.vi.7[6]
The British Museum, 1884-7-26-30

There have been many attempts to construct an historical personality for the Master ES but he remains elusive. It is highly likely that he was a goldsmith, evidenced mainly by the sharp outlines of his figures and his use of stamps and punches to decorate his prints. His principal contribution to printmaking was developing the cross-hatching technique to build areas and define shadow. This can be seen in this print in the folds and shadows of the canopy.

The subject is from the Book of Kings (3:16–28) and depicts the wisdom of King Solomon who was to decide the fate of a new-born child being claimed by two women; a child of one of the women had died. In order to determine who was the rightful mother Solomon suggested cutting the child into two, upon which the true mother renounced her claim, thus proving her legitimacy.

> This print is described in the Seville inventory at no. 340 under the classification 'quarto-size sheet of many dressed men': *A seated king in a chair, to his right are five men, in his left he has a sceptre, his left foot touches the head of a dead boy, at the edge is a woman kneeling, her hands are joined, upon her belt are six pleats, there is a window in which is a young man whose head touches the glove upon which is a falcon.*

31 | Martin Schongauer (*c*.1435/50–1491)
The Death of the Virgin, after 1470

Engraving
255 × 169 mm
B.vi.33[134]; H.xlix.16
The British Museum, 1910-2-12-295

Like many printmakers of his generation, Martin Schongauer came from a family of goldsmiths, reflected perhaps in this engraving by the extraordinary detail on the candlestick at the foot of the Virgin's bed.

According to a legend, upon the Virgin's death the twelve apostles miraculously appeared at her bedside. This is the moment Schongauer has chosen to depict so powerfully. The Virgin is feeble and John the Apostle helps her to hold the candle. The print was copied many times and has become a cornerstone of fifteenth-century art. Part of its success is how we view the Virgin from an oblique angle that takes in the entire length of the bed as if we were looking through a window. This method of spectatorship was very popular during the late fifteenth century as a way of directly engaging the viewer.

> This print is described in the Seville inventory at no. 2415 under the classification 'pliego-size sheet of many dressed male saints': *The Death of the Virgin, a saint gives her a candle in the left that she takes with the left hand, behind is a saint who has a shaker in the left hand, thumb hidden, another holds a holy water container with both hands, below is a big candlestick with a burning candle, at the foot of the candlestick are three lions.*

32 | Wenzel von Olmütz (*fl.* 1475–1500)
| *The Last Supper, c.*1500

Engraving
168 × 142 mm
Lehrs.vi.5[196]; B.vi.16[324]
The British Museum, 1879-1-11-19

Almost nothing is known of this engraver except that he probably came from the city of Olmütz east of Prague. Most of his prints are copies of the work of other masters, especially Martin Schongauer [see cat. no. 31]. According to some authorities, this print was possibly copied from a painting from the circle of Stephan Lochner (*fl. c.*1440–after 1453). This engraving is striking for the delicacy of its execution, which is especially noticeable in the faces and hair of the Apostles.

This print is described in the Seville inventory at no. 293 under the classification '*quarto-size sheet of 14 dressed male saints*': *The Last Supper of Christ with his disciples, on the table are two chalices, the plate touches the head of a disciple of whom we cannot see the left, the other who is to our right touches bread with the middle finger, with the left index finger a knife, at the upper left of Christ is a dog and a man who has the right foot on the left and a sword, he holds a plate in his hands with which he touches his face.*

32

33

33 | Anonymous German
*St Antony, c.*1500

Woodcut
295 × 230 mm
TIB supp., 164.1217-3; Schreiber, 1217
The Ashmolean Museum, Oxford

Judging by the large number of fifteenth-century woodcuts depicting St Antony, he was one of the most popular devotional saints [see cat. no. 26]. This is one of the most impressive examples to have survived. Antony is shown holding a bell and accompanied by two pigs. The bell was thought to ward off evil, alluding to Antony's temptation [see cat. no. 78] and the pigs were bred by Antonine monks in the middle ages; the lard was used as a remedy for various skin diseases.

The design of this print, its clear cutting with open spaces, suggests that it might have been intended to be coloured, like many devotional prints from this period.

This print is described in the Seville inventory at no. 2127 under the classification 'pliego-size sheet of 7 dressed male saints': *St Antony in the left has a book, from the little finger hangs a small bell on which it reads annor, he has seventeen beads and a cross, above on a stick are many feet and hands, there are two pigs hanging, below are two men and two women kneeling looking to St Antony.*

CATALOGUE | 135

34

34 | Albrecht Dürer (1471–1528)
The Large Horse, 1505

Engraving
167 × 119 mm
B.vii.97[106]; Meder, 94
The British Museum, 1868-8-22-197

In this engraving, Dürer has concentrated on the form and the posture of the horse and that is why it takes up so much of the composition. The animal is foreshortened and shown from behind with its hind legs raised on a step, thus accentuating the muscularity of the flanks. The soldier in the background is a secondary detail providing balance and the column and the wall are additional points of interest.

The Italian printmaker Benedetto Montagna (*c*.1480–1555/8) engraved a copy of Dürer's *Large Horse*, which carried the monogram BM that is recorded in the Seville inventory entry alongside Dürer's monogram. Ferdinand obviously also owned an impression of Montagna's print.

This print is described in the Seville inventory at no. 253 under the classification '*quarto*-size sheet of 1 dressed man': *An armed man who wears boots and a halberd is behind a horse very swollen and looking bad with no saddle, it has a knot in its tail, there are two small trees, the head is near a very big pillar that is to our left* [BM] [尔 *1505*].

35a Albrecht Dürer (1471–1528)
The Betrayal of Christ (The Engraved Passion), 1508

Engraving
118 × 75 mm
B.vii.5[34]; Meder, 5

35b *The Lamentation over Christ (The Engraved Passion)*,
1507
Engraving
115 × 71 mm
B.vii.14[37]; Meder, 14
The British Museum, E.2-45 and E.2-54

Dürer's *Engraved Passion* comprises fifteen plates, all dated between 1507 and 1512. Unlike his other print series, these engravings were sold separately before the cycle was completed. In Dürer's Netherlands diary, written during 1520–21, he often refers to these prints being sold or given away as gifts. The impressions Ferdinand Columbus owned were possibly given to him by Dürer (see chapter

1). The prints in the series became immensely popular and were widely copied from the time of their creation. The engraving technique allowed Dürer to achieve subtle gradations of light and dark that, with the small format, create a compelling sense of intimacy.

No. 35a. This print is described in the Seville inventory at no. 151 under the classification '*octavo*-size sheet of 8 dressed male saints': *The arrest of Christ in a square, there are many armed people, in the middle of them is Judas who is kissing Christ on the mouth, we cannot see Christ's right hand nor his left thumb, nor Judas's right thumb, his left is on Christ's shoulder, behind him is a man who wants to place a rope over Christ's head, behind Judas is St Peter standing, he holds a knife in the right hand, that thumb hidden, 1508* 🅐 [*this is truly by Albrecht*].

No. 35b. This print is described in the Seville inventory at no. 146 under the classification '*octavo*-size sheet of 7 dressed male saints': *Christ taken down from the cross, the Virgin has his left arm, his right rests on the ground, only the little finger showing, above is a female saint who has her hands crossed on her head which is uncovered, to his left are two old men, one has an Albanian hat, the other a Moorish-type headdress.*

35a

35b

36 | Albrecht Dürer (1471–1528)
Samson Rending the Lion, 1497–8

Woodcut
382 × 280 mm
B.vii.2[116]; Meder, 107
The British Museum, 1895-1-22-663

Whereas for engraving Dürer had predecessors in the work of Martin Schongauer in the north [see cat. no. 31] and Mantegna in Italy [see fig. 2], in woodcut he had no precursors against whom to match his inventiveness and skill. Dürer revolutionised the woodcut technique by using it to produce extremely ambitious, large and detailed compositions. This print belongs to his earliest group of woodcuts, made before 1500. It must have been produced as a pendant to *Hercules* [cat. no. 37]; Samson is the Christian counterpart of Hercules.

> This print is described in the Seville inventory at no. 1710 under the classification '*pliego*-size sheet of 1 dressed man': *Hercules fighting a lion, his thumbs inside its mouth pulling it open, we can see only three fingers, right foot hidden, around his head is a tie, the lion has its tail raised, in the background is a city and a fort, many trees, a galleon, a boat, a barge, next to his right arm is a man on horseback, the other on foot is in front,* 🝔 .

37 | Albrecht Dürer (1471–1528)
Hercules Conquering the Molionide Twins, c.1496

Woodcut
390 × 283 mm
B.vii.127[143]; Meder, 238
The British Museum, 1895-1-22-708

The subject of this print is not immediately clear because it does not depict any of the familiar episodes from the life of Hercules. It was probably made as a pendant to *Samson* [cat. no. 36] and seems to represent Hercules slaying the twins Eurytus and Kteatus who, because of their great strength, overwhelmed all who came in their path. Their mother Molione, accompanied by a Fury, is shown discovering their death. Dürer sometimes recycled his figures and Molione with her hands raised over her head occurs in his engraved *Lamentation* [see cat. no. 35b].

The woodblock for this print survives in the British Museum.

> This print is described in the Seville inventory at no. 2074 under the classification '*pliego*-size sheet of 5 dressed men': *Hercules who is fighting with two armed men, he is dressed in an animal skin, he has placed the left foot on the belly of a man, his beard touches the arrows, behind is a naked woman, in the right she has a horse's jawbone with which she strikes a woman who places her hands over her head, above it reads Ercules and below is* 牙 .

37

38 | Albrecht Dürer (1471–1528)
The Men's Bath House, c.1496

Woodcut
387 × 282 mm
B.vii.128[144]; Meder, 266
The British Museum, 1895-1-22-709*

This is one of Dürer's best-known prints and belongs to the group of large wood-cuts designed before 1500 which had a remarkable influence on the subsequent development of the woodcut medium [see cat. nos 36–37]. This print demonstrates his extraordinary skills of design and imagination. An ordinary subject, it provided a chance to depict men of all ages in different positions in an outdoor setting. The subject, however, may not be as innocent as it first appears. A fully dressed man in the background looks past those in the bath house towards the viewer, and a tap in the same shape as a penis is carefully positioned in front of another man's genitals. A cock surmounts the tap. The German *Hahn* has the same phallic sense that the English *cock* retains.

This print is described in the Seville inventory at no. 2145 under the classification 'pliego-size sheet of 7 naked men': *Six naked men in a square, one plays a pipe with both hands, we cannot see the left thumb, the other plays a violin, we cannot see the left or the right thumb, next to him is another who is drinking from a mug with the right, we cannot see the left, below are two men in half-length, of one we cannot see the left or the other's right or left, below is a vase and a pear, there is a city, a fort, trees, all of the men are in a hut close to a beam,* 丂 .

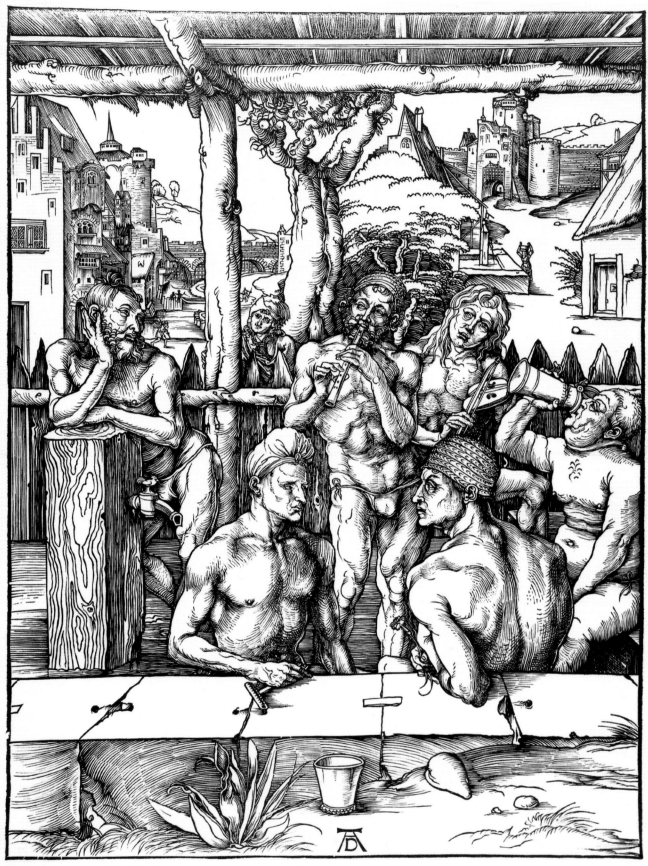

39 | Albrecht Dürer (1471–1528)
The Martyrdom of the Ten Thousand Christians, c.1496

Woodcut
387 × 284 mm
B.vii.117[140]; Meder, 218
The British Museum, 1895-1-22-698

Dürer tells the story of the Martyrdom in different sections of this print. In the middle, Christians tied to a tree are being flogged; in the upper section they are being forced off the precipice of Mount Ararat, and in the lower right a bishop is having his eye drilled out. On the command of the Roman emperors Hadrian and Antoninus, the Persian king Saporat (shown at the left) perpetrated the massacre. Ten years after this print, around 1508, Dürer represented the scene in a painting for Frederick the Wise who owned relics from the massacre [see cat. no. 79]. The block for the print survives in the British Museum.

> This print is described in the Seville inventory at no. 2455 under the classification '*pliego*-size sheet of many naked saints': *The ten thousand martyrs, above they fall off, below is the scourging, in the lower right is a bishop who drills the right eye with a drill, the driller has the right foot on the chest, next to him is another who with the right touches his left elbow, with the left he points below,* 丙 .

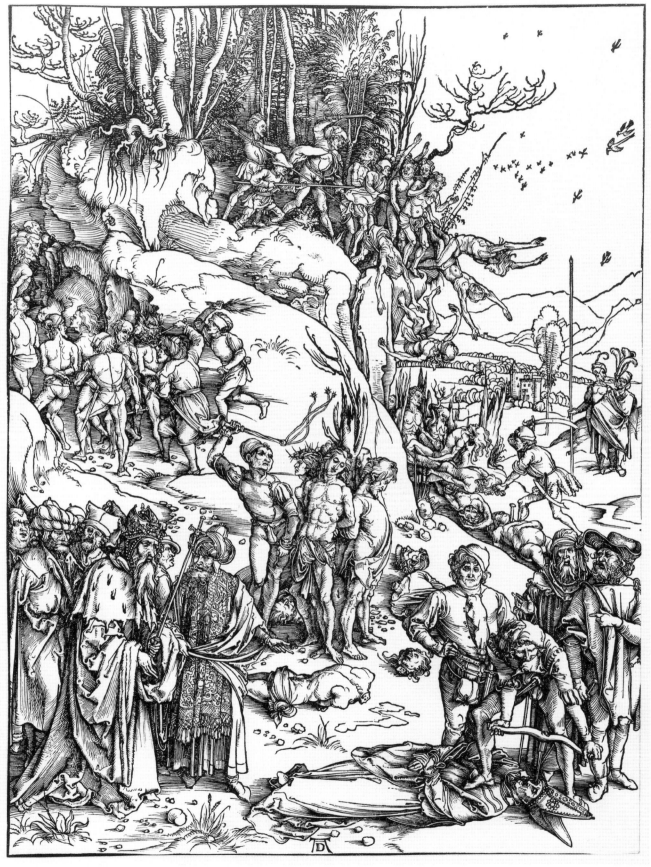

39

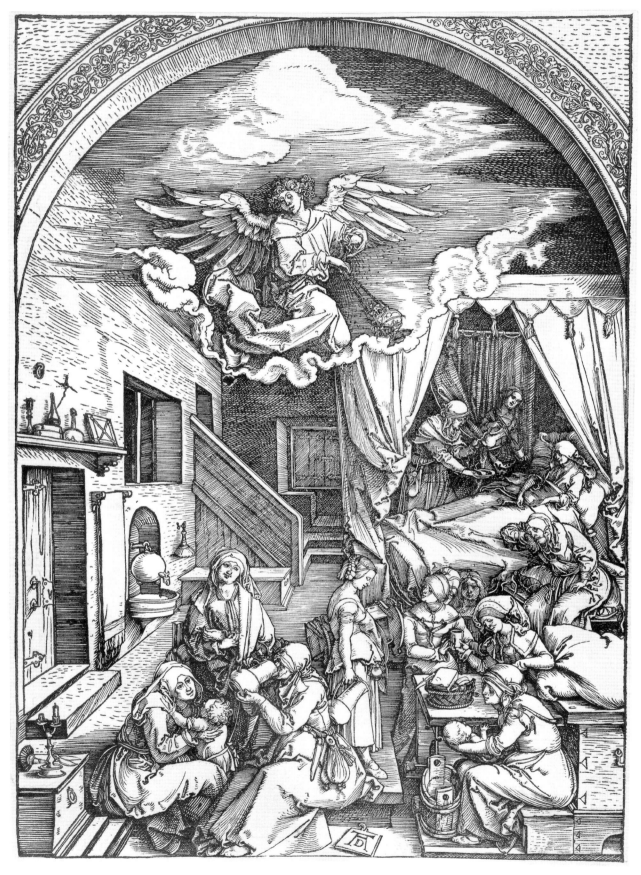

40a

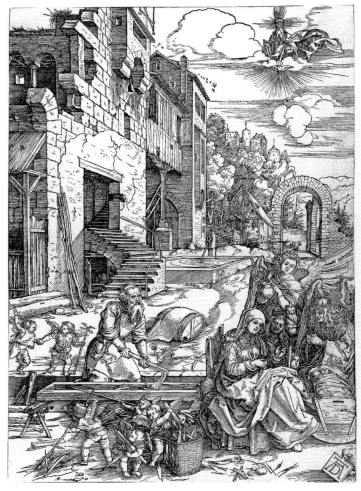

40a | Albrecht Dürer (1471–1528)
The Birth of the Virgin (The Life of the Virgin), 1503–5

Woodcut
297 × 210 mm
B.vii.80[131]; Meder, 192

40b | *The Holy Family in Egypt*

Woodcut
298 × 209 mm
B.vii.90[132]; Meder, 202
The British Museum, 1895-1-22-625 and 1895-1-22-635

Between 1503 and 1505 Dürer designed seventeen woodcuts for his *Life of the Virgin* series. He added two more prints in 1510 and the entire series was published with a Latin text and a frontispiece in 1511. Both of the prints shown here demonstrate Dürer's great facility at integrating numerous figures within complex architectural settings. The story of the Virgin's life is made more interesting because of the way Dürer relegates the main action off-centre and involves many other figures performing different tasks. The cast of characters humanises the scene, thus making it more accessible for the viewer.

No. 40a. This print is described in the Seville inventory at no. 2313 under the classification '*pliego*-size sheet of 15 dressed female saints': *The Virgin in a bed, to our left next to the bed is a female saint pouring water, next to her is a woman who has a plate in the right, above in the upper section is an angel who has a censer in the hands, below is a woman drinking, next to her is a woman who has a child, to the right is placed a table, and a basket is on it below a small tablet* 𝕬 .

No. 40b. This print is described in the Seville inventory at no. 2309 under the classification '*pliego*-size sheet of 15 dressed male saints': *The Virgin seated spinning, in the right she holds the spindle, the distaff is by the head of an angel, next to the Virgin is an angel who is playing a harp, below the left arm is a child in a bed, to our left one [St Joseph] is cutting wood, below are many angels who are carrying firewood, above are God the Father and the Holy Spirit, in the background are houses, below is a small tablet* 𝕬 .

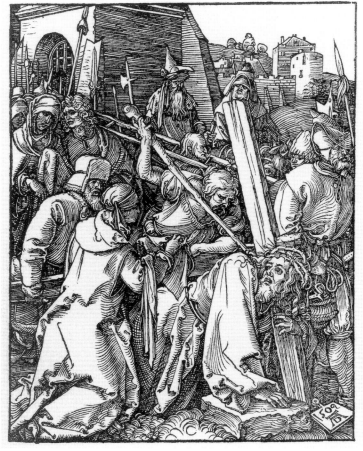

41a

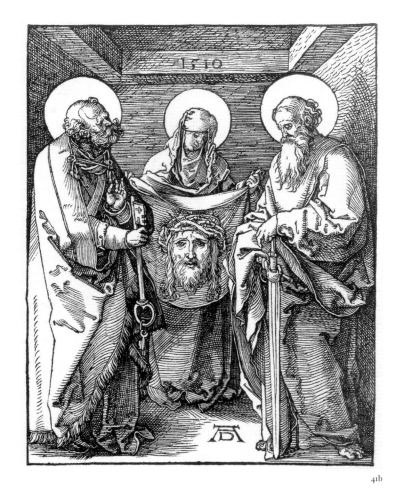

41b

41a | Albrecht Dürer (1471–1528)
Christ Carrying the Cross (The Small Passion), 1509

Woodcut
127 × 97 mm
B.vii.37[120]; Meder, 146

41b | *Sts Veronica, Peter and Paul with the Sudarium*, 1510

B.vii.38[120]; Meder, 147

41c | *Christ Being Nailed to the Cross*, c.1509–11

B.vii.39[120]; Meder, 148

41d | *Christ Crucified*, c.1509–11

B.vii.40[120]; Meder, 149
The British Museum, 1895-1-22-526, 1895-1-22-527, 1895-1-22-528 and 1895-1-22-529

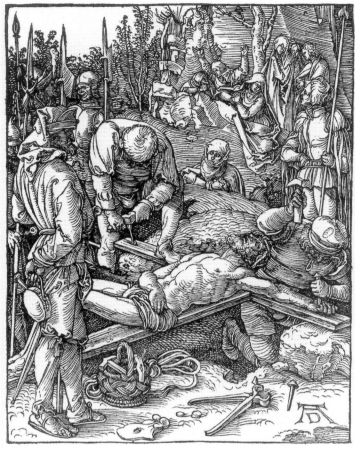

41c

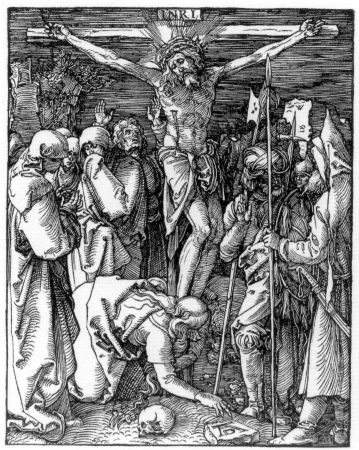

41d

Comprising thirty-seven prints, Dürer's *Small Passion* is his longest series and, judging by the many reprints, the best known during the sixteenth century. The series was also issued in book form in 1511. Dürer took only two years to produce the *Passion*, which probably accounts for the uniformity of its style. Today, thirty-five woodblocks from the series survive in the British Museum. Ferdinand Columbus owned the entire series except for the 1511 title-page.

No. 41a. This print is described in the Seville inventory at no. 1216 under the classification 'octavo-size sheet of 12 dressed male saints': *Christ when he fell with the cross, one is stabbing him in his neck with a stake, Christ has the right on the ground, thumb hidden, he looks back, another is helping him raise the cross, behind are the Virgin and St John, others come on horseback, others arrive by the gate of the city, the high arm of the cross touches the face of a fat Jew who has a cap, there is background* 🔲 .

No. 41b. This print is described in the Seville inventory at no. 998 under the classification 'octavo-size sheet of 3 dressed male saints': *The Virgin in the middle of Sts Peter and Paul, she has the sudarium in her hands stretched out, we can see only the right fingers, St Peter has his face raised a little, in the left he holds the keys, his*

garments are trimmed with tassels, we cannot see either leg, St Paul has a slightly larger beard, the left arm uncovered, the left of which is upon the pommel of a sword, we cannot see his right arm, the right foot is more uncovered than the left, from Peter's great key hangs a smaller one 1510 🔲 .

No. 41c. This print is described in the Seville inventory at no. 1222 under the classification 'octavo-size sheet of 13 dressed male saints': *Christ stretched out on the cross to be crucified, has the left nailed, the right is upon his belly, at the same side is a Jew with a drill, drilling the wood, we cannot see Christ's feet hidden by the body of a standing Jew, at his back he has a water bottle, his feet are in tied sandals, next is a basket with a coiled rope and two hammers, on the ground are pincers and two nails* 🔲 .

No. 41d. This print is described in the Seville inventory at no. 1191 under the classification 'octavo-size sheet of 9 dressed male saints': *Christ placed on the cross, to his right side are the Virgin and St John and the three Maries, one kisses his feet, in the other part are all the armed people, on the ground is a skull, no horsemen, the one kissing the feet has her right set on the ground, we cannot see that thumb, she touches the tip of a halberd belonging to one who seems to be blessing* 🔲 .

42b

42a | Albrecht Dürer (1471–1528)
The Flagellation of Christ (The Large Passion), 1497–1500

Woodcut
385 × 272 mm
B.vii.8[117]; Meder, 117

42b | *Christ in Limbo*, 1510

Woodcut
392 × 280 mm
B.vii.14[118]; Meder, 121
The British Museum, 1895-1-22-599 and 1895-1-22-605

Dürer produced twelve woodcuts for the *Large Passion* between the years 1497 and 1500 and four more much later, in 1510. In the following year, he published the series in book form, which is how Ferdinand Columbus bought his set (see chapter 4). There are remarkable differences between the early and late prints from the series. *Christ in Limbo*, made in 1510, demonstrates Dürer's far greater understanding of spatial recession and the effective deployment of figures to heighten the drama.

No. 42a. This print is described in the Seville inventory at no. 2332 under the classification '*pliego*-size sheet of many dressed male saints': *Christ standing naked, hands tied behind to the column, a Jew has his hair with the right, with the left he seems to want to beat him, next is another who has a scourge in the left hand, we cannot see the right leg, to the left of Christ is a seated Jew pulling with both hands a rope to which he is tied, his left foot touches the left foot of Christ, to his left is a hairy dog, further behind is a crown of thorns, a thorn of which touches the right foot of a young man* 🖉 *[this is truly by Albrecht].*

No. 42b. This print is described in the Seville inventory at no. 2251 under the classification '*pliego*-size sheet of 12 naked male saints': *Christ takes the holy fathers from limbo, the right knee is withdrawn, the right side is uncovered, with the right he takes a man by his right hand which is joined to another, behind him is Adam standing naked, in the right he has an apple, in the left a cross, there are many devils* 🖉 *this is truly by Albrecht.*

43a

43a Albrecht Dürer (1471–1528)
The Four Horsemen of the Apocalypse (The Apocalypse),
1498

Woodcut
394 × 281 mm
B.vii.64[128]; Meder, 167

43b *The Whore of Babylon*

Woodcut
392 × 282 mm
B.vii.73[129]; Meder, 177
The British Museum, 1895-1-22-576 and 1895-1-22-572

Early on in his career, Dürer decided that prints would provide the main source of his income. This partly explains his interest in great series of woodcuts. The *Apocalypse* was first published as fifteen woodcuts in 1498 and a second edition in 1511 with a Latin text – the edition Ferdinand owned. The approaching half-millennium must have inspired Dürer's choice of subject when apocalyptic prophecies were commonplace. So powerful was Dürer's interpretation that from the moment they appeared, the prints established the standard on which all future versions were based.

The *Four Horsemen* is one of the great images in the history of printmaking. It is based on the Book of Revelation (6:1–8). The first rider in the background represents the Conqueror; the second, brandishing a sword, War; the third, holding scales, Famine; and the fourth Death, closely followed by Hell devouring an emperor. People stumble and fall as the riders trample all in their path. *The Whore of Babylon* (Rev. 17, 18, 19) is seated upon a seven-headed beast. The cup she holds is full of 'abominations and filthiness of her fornication'. She is dressed in fine garments and decked with jewellery that reinforces the debauched nature of her character.

No. 43a. This print is described in the Seville inventory at no. 2218 under the classification '*pliego*-size sheet of many dressed male saints': *An image of the Apocalypse in which are four men on horseback, below appears ___ [Death?] who carries a fork of three prongs, below to the left of the horse next to the inferno is a king, another carries scales in his right, in his left the reins, the other in the right has a sword drawn that an angel touches with his left, the other goes to fire a bow and arrow, there are five men fallen to the ground and a woman,* 𐤠 *[this is truly by Albrecht].*

No. 43b. This print is described in the Seville inventory at no. 2331 under the classification 'pliego size sheet of 11 dressed male saints': *A representation of the Apocalypse in which are two angels, one has a wheel, in which figures a cross, in front is a man at arms on horseback who has a sword in his hand, we cannot see the left, below are the seven Deadly Sins, behind them is a woman dressed up who in the right has an ornate cup, we cannot see the thumb, the cup touches a boat, behind is a boat with two men* 𐤠 *[this is truly by Albrecht].*

43b

Nach Chiſtus gepurt.1513. Jar.Adi.5.May. Hat man dem groſ mechtigen Kunig von Poꝛtugall Emanuell gen Lyſabona pꝛacht auſ Jndia/ein ſollich lebendig Thier. Das nennen ſie Rhinocerus.Das iſt hye mit aller ſeiner geſtalt Abconderſet.Es hat ein farb wie ein geſpꝛeckelte Schildtkro t. Vnd iſt võ dicken Schalen vberlegt faſt feſt. Vnd iſt in der gꝛöſ als der Helfandt Aber nydertrechtiger von paynen/vnd faſt werhafftig. Es hat ein ſcharff ſtarck Hoꝛn voꝛn auff der naſen/ Das begyndt es albeg zu weꜩen wo es bey ſtaynen iſt.Das doſig Thier iſt des Helff fanꜩ todt feyndt.Der Helffandt fürcht es faſt vbel/dann wo es Jn ankumbt/ſo laufft Jm das Thier mit d em kopff zwiſchen dye foꝛdern payn/vnd reyſt den Helffandt vnden am pauch auff vñ erwürgt Jn/des mag er ſich nit erwern.Dann das Thier iſt alſo gewapent/das Jm der Helffandt nich ts kan thũn.Sie ſagen auch das der Rhynocerus Schnell/ Fraydig vnd Liſtig ſey.

1515
RHINOCERVS

44 | Albrecht Dürer (1471–1528)
| *The Rhinoceros*, 1515

Woodcut
212 × 298 mm
B.vii.136[147]; Meder, 273
The British Museum, 1895-1-22-714

The Rhinoceros is one of Dürer's best-known and most loved prints. The text running along the top relates that this great creature was brought from India by Emmanuel the King of Portugal to Lisbon: 'it has the colour of a speckled tortoise and it is covered with thick scales … it has a strong sharp horn on its nose, which it sharpens on stones … the stupid animal is the elephant's deadly enemy.' Dürer himself never saw the animal but probably relied on a description in a Portuguese newsletter and a sketch that he transformed into his own version. Only one edition of this print was produced during his lifetime, but it was repeatedly copied.

This print is described in the Seville inventory at no. 2954 under the classification '*pliego*-size sheet of 1 animal': *An animal called a rhinoceros, it has a horn on its nose that touches the edge of the circle, on its shoulders is another small one, it almost touches the end of its name which is above, we cannot see the left eye, above its ears is 𝕬 , above is 1515 and text in German type.*

45 Albrecht Dürer (1471–1528)
Map of the Northern Sky, 1515

Woodcut
430 × 430 mm
B.vii.151[161]; Meder, 260
The British Museum, 1895-1-22-734

This print was commissioned by Johann Stabius, the court historian, astronomer and mathematician to Emperor Maximilian. This and a map of the southern sky were the first celestial maps to be printed in the West and they give the positions of the stars for the years 1499–1500. In the four corners are the early astronomers: Aratus Cilix, Ptolomeus Aegyptius, M. Manlius Romanus and Azophi Arabus.

This print is described in the Seville inventory at no. 2647 under the classification '*marca-size sheet of many naked men*': *Images of the stars of the northern sky in a circle, outside each corner is a man from the waist up, the one in the upper left is called aratus celix, he has a stick in the left in which is a world, he touches the world with the right index finger, in the upper right is Ptolemy Aegyptus, in the left he has a stick that goes through a world, in the right a compass that touches the world, inside the circle is a horse, its head touches the right shoulder of a man who goes through the circle, in the right arm he has a jar with which he pours water.*

46a Dürer Workshop
*The Birth of Christ, c.*1503

Woodcut
63 × 50 mm
TIB comment.10.527a; H.vii.1

This print is described in the Seville inventory at no. 589 under the classification '*sezavo*-size sheet of 3 dressed male saints'

46b *The Dispatch of the Disciple to John the Baptist in Prison, c.*1503

TIB comment.10.527m; H.vii.13

This print is described in the Seville inventory at no. 808 under the classification '*sezavo*-size sheet of 7 dressed male saints'

46c *The Parable of the Weed, c.*1503

TIB comment.10.527o; H.vii.15

46d *Christ Feeding the Five Thousand, c.*1503

TIB comment.10.527s; H.vii.19

This print is described in the Seville inventory at no. 846 under the classification '*sezavo*-size sheet of 10 dressed male saints'

46e *Christ Speaking to his Persecutors Wanting to Stone Him, c.*1503

TIB comment.10.527x; H.vii.24

This print is described in the Seville inventory at no. 763 under the classification '*sezavo*-size sheet of 6 dressed male saints'

46f *The Parable of the Repast without Guests, c.*1503

TIB comment.10.527z; H.vii.26

This print is described in the Seville inventory at no. 554 under the classification '*sezavo*-size sheet of 2 dressed men'

46g *The Parable of the Rich Man and his Steward, c.*1503

TIB comment.10.527aa; H.vii.27

This print is described in the Seville inventory at no. 552 under the classification '*sezavo* size sheet of 2 dressed men'

46h *The Parable of the Rich Man and Poor Lazarus, c.*1503

TIB comment.10.527bb; H.vii.28

This print is described in the Seville inventory at no. 757 under the classification '*sezavo*-size sheet of 5 dressed men'

46i *The Prophecy of Jerusalem's Destruction, c.*1503

TIB comment.10.527ff; H.vii.32

46j *Christ Showing His Disciples the Signs from Heaven, c.*1503

TIB comment.10.527hh; H.vii.34

46k *The Incredulity of St Thomas, c.*1503

TIB comment.10.527kk; H.vii.37

46l *Christ at Emmaus, c.*1503

TIB comment.10.527jj; H.vii.36

This print is described in the Seville inventory at no. 590 under the classification '*sezavo*-size sheet of 3 dressed male saints'

The British Museum, 1909-4-3-19; 1909-4-3-23; 1909-4-3-21; 1909-4-3-22; 1909-4-3-9; 1909-4-3-12; 1909-4-3-18; 1909-4-3-11; 1909-4-3-13; 1909-4-3-26; 1909-4-3-10; 1971-6-19-3 (although 1909-4-3-16 and 1909-4-3-20 are included on the mount, Ferdinand Columbus did not own impressions of these prints)

The composition of Dürer's workshop is little understood but many prints were produced there by a number of cutters presumably working under Dürer's direction. Some of the prints shown here were made as illustrations for the *Salus Animae* (*The Salvation of the Soul*, Nuremberg, 1503). Others were probably made for an unpublished *Postilla* or *Plenarium* around 1503. They also exist as single-leaf impressions and this is how Ferdinand bought them.

No. 46c. This print is described in the Seville inventory at no. 651 under the classification '*sezavo*-size sheet of 3 dressed men': *A man sowing has the hem of an apron in his left hand, with the right he appears to be sowing, the sombrero on his head almost touches a villa, two men are sleeping near some oaks, one has his hands on his face, the other the left hand on his head.*

No. 46 i. This print is described in the Seville inventory at no. 668 under the classification '*sezavo*-size sheet of 4 dressed male saints': *Christ standing with his apostles, the right raising his left sleeve, his left touching a villa above which is another villa, his crown touches the hair of one who is next to St Peter, we can see neither feet nor hands, the crown touches the right eye of the same person who touches Christ.*

No. 46j. This print is described in the Seville inventory at no. 669 under the classification '*sezavo*-size sheet of 4 dressed male saints': *Christ standing with his apostles, he is between St Peter and St John, his right index is raised up, we cannot see the thumb, the left index finger is open and points below, he appears to be speaking with St John of whom neither the hand nor left foot can be seen, above are the sun, the moon and the stars.*

No. 46k. This print is described in the Seville inventory at no. 764 under the classification '*sezavo*-size sheet of 6 dressed male saints': *Christ in the right holds a cross with a flag, with the left he has a saint by the left, we cannot see the thumb or the saint's right, the banner touches an old man's head and the face, the other who is upon Christ's shoulder has the right eye covered by the flag.*

46c

46i

46j

46k

47 | Dürer Workshop
The Women's Bath, c.1496

Woodcut
226 × 240 mm
Röver-Kann, 2001; G.1347 (as Springinklee)
The British Museum, 1927-6-14-2

This print was made after a drawing by Dürer dated 1496 and now in Bremen. The theme of the bath house seems to have particularly interested Dürer around this time and occurs in his print of the *Men's Bath House* [see cat. no. 38].

> This print is described in the Seville inventory at no. 2194 under the classification '*pliego*-size sheet of 9 naked women': *Naked women who are washing themselves, one is seated, behind her another is kneeling, her left hand is placed in a small tub, her left toes touch a pan, another woman has whips in the left, another is brushing her hair, another with the right knee touches the face of a young boy.*

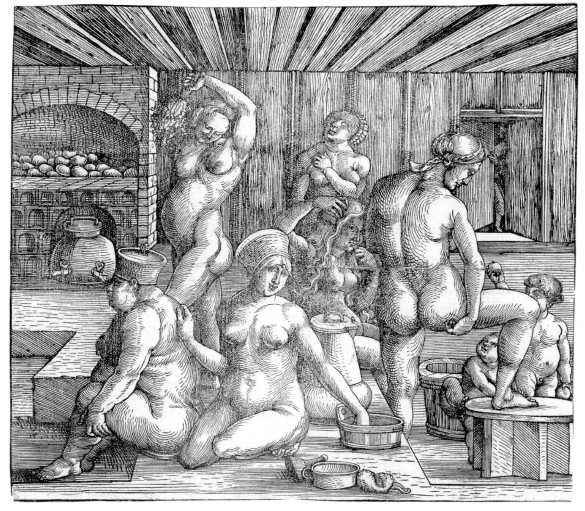

47

48 | Hans Baldung (Grien) (1484/5–1545)
| *The Conversion of St Paul*, 1514

Woodcut
295 × 195 mm
H.ii.125; Marrow and Shestack, 1981, no.52.
The British Museum, 1834-7-12-72

In 1503, at the age of eighteen, Baldung entered Dürer's workshop and when the master embarked on his second trip to Venice in 1505 he left the shop in his care. Dürer's influence on Baldung was not long-lived. They both had very different sensibilities; Baldung for example was very interested in erotic themes, which rarely occur in Dürer's work.

This print depicts the dramatic conversion of St Paul, taken from the Acts of the Apostles (9:1–25). Paul had been a persecutor of Christians and here his conversion is shown at the moment he was on his way to torment the small Christian community at the upper right. Christ appears to Paul and he is blinded. The rendition of the subject is dramatic and contrasts the might of celestial power with the impotent reaction of the earthly realm. At the lower left appears Baldung's monogram HGB. Grien was his nickname, the origin of which is unclear. It was possibly coined by Dürer, referring to his preference for the colour green or the word 'Grienhans', meaning devil, referring to the demonic themes that occur throughout his works.

> This print is described in the Seville inventory at no. 1941 under the classification *'pliego-size sheet of 3 dressed male saints'*: *St Paul on horseback, next are another two fallen riders, in the left corner is Christ who has a cross in the right, the horse has fallen, in its false reins are four circles, the man who is riding it has his right raised, he has the left on the horse's rump, the other man is embracing its neck, below is* HGB .

49

49 | Hans Baldung (Grien) (1484/5– 1545)
St Catherine, c.1505–7

Woodcut
235 × 161 mm
H.ii.135; Marrow and Shestack, 1981, no.5.
The British Museum, E.3-163

Baldung possibly intended this print to form a triptych or a small portable altar with two other prints, *St Barbara* and the *Virgin and Child*. The imposing and dignified St Catherine is shown holding a book, a symbol of her erudition that contrasts with the sword by her side and the wheel below – instruments of her martyrdom. The AD monogram in the upper right refers to Albrecht Dürer. It is possible that Baldung left some woodblocks in Dürer's studio and the master, or perhaps Dürer's widow, sanctioned the use of the monogram as a sign that they were authorised productions of the Dürer workshop, thereby increasing their market value.

> This print is described in the Seville inventory at no. 1553 under the classification '*medio-size sheet of 1 dressed female saint*': *St Catherine seated in a chair, holds a book in her hand, we can see only the left thumb, below is a half-wheel that touches the two feet of the chair, there is a sword that touches a wall, behind the saint is a door.*

50 | Hans Baldung (Grien) (1484/5–1545)
Adam and Eve: The Fall of Man, 1511

Woodcut
372 × 255 mm
H.ii.3; Marrow and Shestack, 1981, no.19
The British Museum, 1852-6-12-106

In this woodcut Baldung was the first to allude to the erotic nature of the fall of man while imparting to the figures a palpable sense of their vulnerability. Wearing a seductive smile, Eve looks directly towards the viewer, engaging us in the scene. The rabbits below allude to their sexual laxity and the serpent, no longer tame, hisses at them. Also unusual is Eve's position in front of Adam, whereas in traditional representations they are shown side by side, equally responsible for their condition. The bold inscription on the tablet, *Lapsus Humani Generis* ('the Fall of Mankind'), hangs directly above their heads.

> This print is described in the Seville inventory at no. 1838 under the classification '*pliego-size sheet of 2 naked male saints*': *Adam and Eve standing naked, showing neither thumb, he has the right raised, he appears to want to take an apple, to our left are two rabbits, to the right is a big tree in which is a serpent with its mouth open, above is a tablet that reads lapsus humani generis, in the lower left corner is another in which is ᴋᴇʙ 1511.*

50

51

51 | Hans Wechtlin (*c.*1480/85–1526)
| *A Skull in a Renaissance Frame, c.*1515

Colour woodcut
270 × 182 mm
B.vii.6[451]; G.1492
The British Museum, 1834-8-4-38

Hans Wechtlin was primarily a book illustrator who produced a handful of colour woodcuts depicting esoteric subjects aimed at an educated élite. During the early sixteenth century, prints with challenging themes greatly appealed to the Humanist sensibility.

This woodcut is possibly his most impressive and one of the outstanding prints of the Renaissance. Wechtlin builds the image through contrasting light and shade. The skull is set in a darkened niche and is thrust towards the viewer in a menacing way. Its powerful confrontation reinforces the meaning of the Latin inscription underneath: 'the glory of worldly happiness' (MVNDANAE FOELICITATIS GL[OR]IA).

> This print is described in the Seville inventory at no. 1638 under the classification '*medio-size sheet of 2 naked men*': *A skull has six teeth on our right side, eight on our left, below the face are letters in Latin that begin mundanae, above in the two corners are two children with wings, the one at our right has a stick in the left with a paper windmill, the one to our left has his right on his cheek, the left on his head, in the middle is a jar from which flames rise, to our left is a small tablet in which are two crossed staffs.*

52 | Hans Wechtlin (*c.*1480/85–1526)
| *A Knight and a Lansquenet, c.*1518

Colour woodcut
271 × 182 mm
B.vii.10[452]; G.1497
The British Museum, 1895-1-22-204

On account of his monogram 'Io V with the crossed pilgrim's staves' visible on the tablet in the lower left, Wechtlin was for a long time given the fictitious name Johann Ulrich Pilgrim.

This print demonstrates Wechtlin's command of the woodcut medium. It is printed from two blocks; the line block provided the outline and the tone block the colour. The plumes on the soldier's head and the garments worn by the lansquenet are brilliant demonstrations of unprinted areas of paper being used to maximum effect to define the figures and separate them from the wooded landscape.

> This print is described in the Seville inventory at no. 1848 under the classification '*pliego-size sheet of 2 dressed men*': *An armed man on horseback, in the right has a lance placed on the shoulder, with the left he has the reins of the horse, in the helmet are seven plumes, on the head of the horse there are three, the horse has the right raised, almost touching the tablet, which is on the ground, on which is a merchant's mark, an I and a D, a young man has a halberd on his shoulder with his right hand, the sword is sheathed, we can see only its cross and handle, the pommel is broad, his left foot is hidden.*

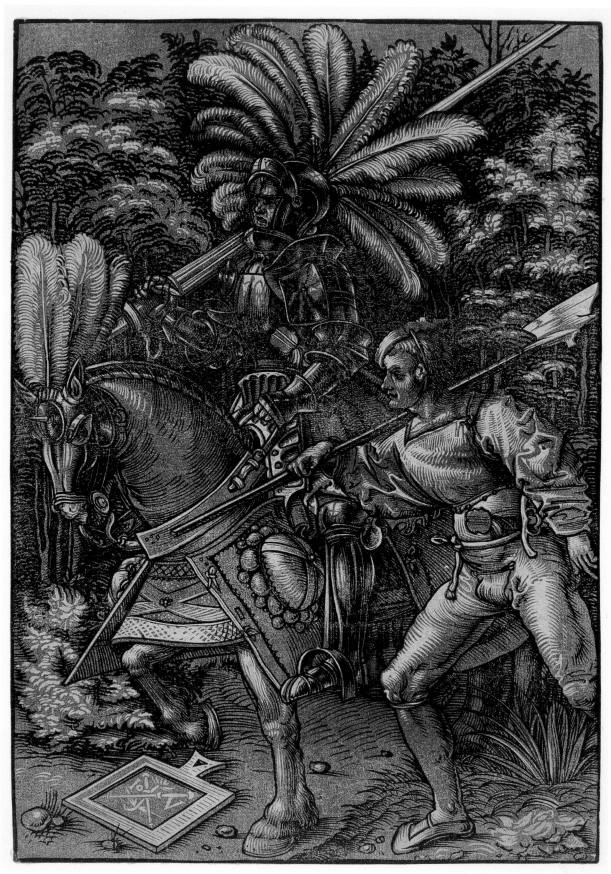

53

53 | Daniel Hopfer (*c.*1470–1536)
Design for Ornament Strips in Form of Dagger Sheaths,
*c.*1515–20

Etching
135 × 83 mm
B.viii.131[505];H.xv.141
The British Museum, 1845-8-9-1418

Daniel Hopfer's first profession was as an armourer and his ornament prints, such as the one shown here, reflect the sort of detail that could be found decorating armour. This print has a repeated pattern in the form of dagger sheaths. The strips were probably intended to be cut up and the decoration incised on to a sheath.

> This print is described in the Seville inventory at no. 155 under the classification *'octavo*-size sheet of 8 dressed male saints': *Seven pointed strips, in the upper one in the middle is a child shooting an arrow, we cannot see his right thumb, at the sides is D.H., below is the Virgin with the naked Christ Child in her arms, at the other side is a female saint with two children in her arms, the naked one with the right thumb touches the left ring finger of the little girl.*

54 | Daniel Hopfer (*c.*1470–1536)
*Medallion with the Bust of Nero, c.*1520

Etching
223 × 156 mm
B.viii.76[491]; H.xv.85
The British Museum, 1845-8-9-1362

Hopfer was the earliest artist to adapt the practice of etching on iron to print-making, probably around 1500. The etching technique allowed for softer effects, more akin to drawing than engraving. In this print, for example, Nero's hair resembles a pen and ink drawing. The decorative motifs surrounding the portrait are Italianate, the taste for which was greatly appreciated in Renaissance Augsburg during the early sixteenth century. Hopfer includes whimsical touches such as the foliage flying from the decorative vase at the lower right. The monogram resembling a fir cone by the letters DH is the emblem of the city of Augsburg.

> This print is described in the Seville inventory at no. 1708 under the classification '*pliego*-size sheet of 1 dressed man': *The head of the emperor Nero from the chest up, his hair is in sections, a wreath is placed on his head, below is his name on a black ground with white points, he shows only the left side of the face, the wreath has eight leaves.*

54

55 Hans Burgkmair (1473–1531)
*Madonna and Child in a Bower, c.*1508

Woodcut
221 × 151 mm
B.vii.7[202]; H.v.66
The British Museum, 1904-5-19-2

The elegant device of the bower of vines framing the Virgin and Child derives from northern Italian art. Burgkmair made a number of devotional prints with this subject. Here the Virgin holds the Bible and the Child touches it, reinforcing the importance of the Holy Scripture. The neck of her garment is inscribed AVE REGINA CELOR ('Hail, O Queen of Heaven') and her celestial associations are further suggested by the stars forming her halo. Burgkmair's monogram HB can be seen on the banderole at the right.

> This print is described in the Seville inventory at no. 1604 under the classification '*medio*-size sheet of 2 dressed male saints': *The Virgin seated, Christ upon the left knee, his right touches a book the Virgin has in her right, we can see only her three fingers, in her halo are sixteen stars, above is an arch of vines, to our right is a banderole in which is HB.*

55

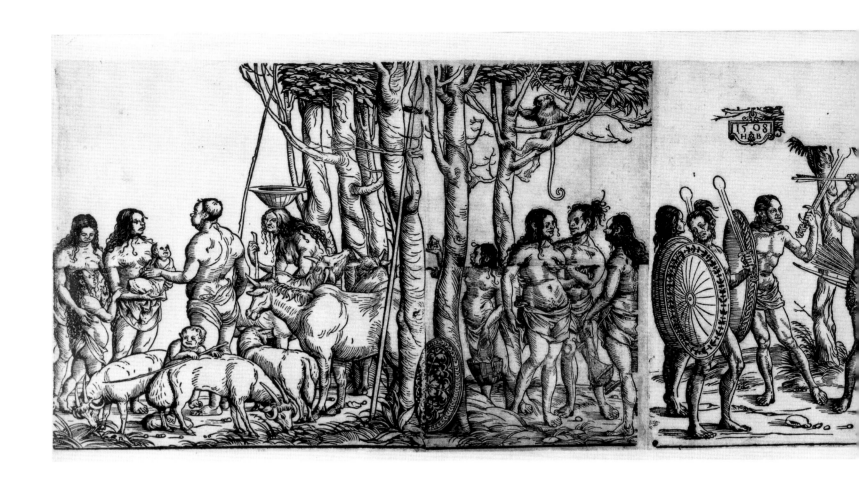

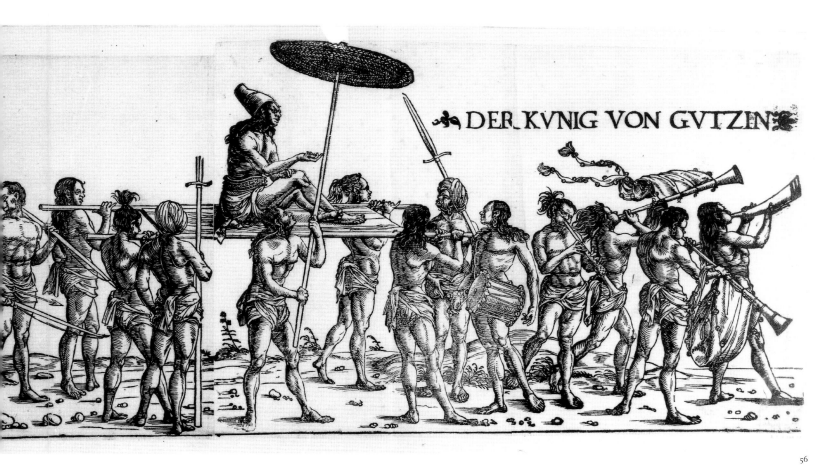

DER KVNIG VON GVTZIN

56 | Hans Burgkmair (1473–1531)
 | *The Peoples of Africa and India*, 1508

Woodcut
255 × c.2300 mm
B.vii.77[223]; H.v.731-36; McDonald, 2003a
The British Museum, 1895-1-22-405…407

The woodcut frieze of *The Peoples of Africa and India* was based on a short report by Balthasar Springer, published in 1508, of the voyage made by German traders to Africa, Arabia and the East Indies. It is likely that Springer returned with sketches of the peoples he had seen, which provided the source for Burgkmair. It is the first multi-block frieze of native peoples ever made in northern Europe and was enormously influential. It reveals an ethnographic fascination with native peoples at a time when the boundaries of the known world were expanding. The figures are arranged individually and in groups, showing the type of garments they wore as well as their natural environment. These prints are part of a much longer frieze that, originally printed, was around two metres long.

This print is described in the Seville inventory at no. 2795 under the classification 'roll of many figures': *The people of India in six sheets pasted lengthways, in the first sheet is a person with five bracelets on each arm, in the right he has two large arrows, in the left one raised above his head, behind him is a child with two strings of beads around his neck, the left leg is raised, in the fifth sheet is the Caciby [King] seated on a table that is carried by four Indians, one with both hands holds a long stick on which is a sunshade, the king with the right index finger almost touches the stick, in the fourth sheet are three with three shields and swords, one of these with his sword touches a tree from which hangs a tablet that reads 1508 H.B.*

57 | Hans Burgkmair (1473–1531)
The Head of Christ Crowned with Thorns, c.1508–15

Woodcut
195 × 159 mm
B.vii.22[207]; H.v.54-II
The British Museum, 1924-6-17-13

According to the legend, Saint Veronica wiped the face of Christ with her veil as he climbed Calvary carrying the cross, and the veil retained an imprint of his likeness. The subject was represented often during the Renaissance as a reminder of Christ's suffering. Burgkmair emphasises the immediacy of his suffering; tears roll down his cheeks from half-closed and swollen eyes. The texture of the cloth is suggested and the illusionistic holes in the corners may have prompted the owner to pin it on to a wall. The extensive passages of white paper showing through the hair and crown probably allowed for the print to be coloured.

This print is described in the Seville inventory at no. 1531 under the classification '*medio*-size sheet of 1 naked male saint': *The sudarium in a square, it has two thorns thrust through it in the front and another two behind not thrust, from the right eye fall three tears and on the right another two and from the four corners is a small circle, a little below is a phylactery in Flemish type.*

57

58 | Hans Burgkmair
Jacob Fugger the Rich, 1511

Colour woodcut
208 × 140 mm
H.v.315; G.506
Kupferstichkabinett, Staatliche Museen zu Berlin, 17-3

Jacob Fugger (1459–1525), a merchant and banker of Augsburg, was the most powerful and successful businessman of his age. His entire fortune was built on the monopoly of mining and trading silver, copper, other metals and spices. He lent vast sums of money to the Emperor Maximilian I [see cat. no. 59] and helped to secure the election in 1519 of Charles V as Holy Roman Emperor through bribing the electors [see cat. no. 60]. Fugger also built an extensive commercial network in the service of the Pope and collected payments due to the Vatican on its members' behalf.

This is one of the first printed portraits of a private individual, prompted no doubt by Fugger's extraordinary wealth and position. The title after his name, 'CIVIS AVGVSTÆ', refers to his pride at being a citizen of the city of Augsburg. Fashioning the sitter in profile like a Roman portrait reinforces his associations with greatness.

This print is described in the Seville inventory at no. 1272 under the classification '*quarto*-size sheet of 1 dressed man': A *man from the shoulders up, he is coiffed, in his hair are six ties, we cannot see the left half of his face, above are letters that read Jacobus Fuggor civis angustae, at the tip of the headdress is a conch-like thing, coloured.*

IACOBVS·FVGGER·CIVIS·AVGVSTÆ

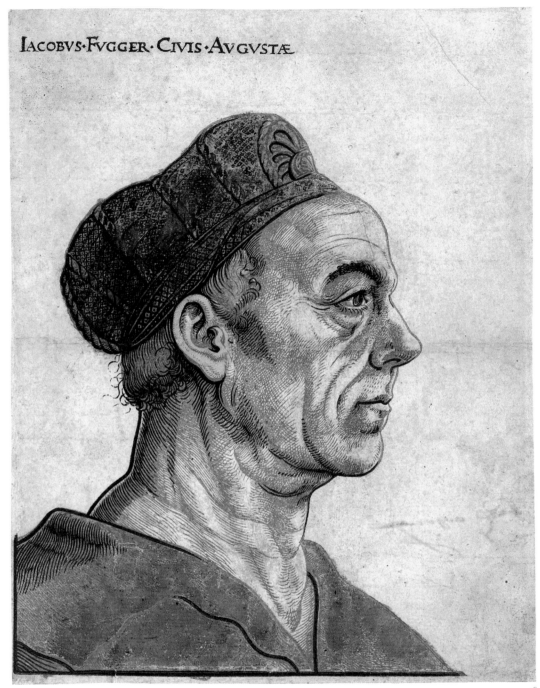

58

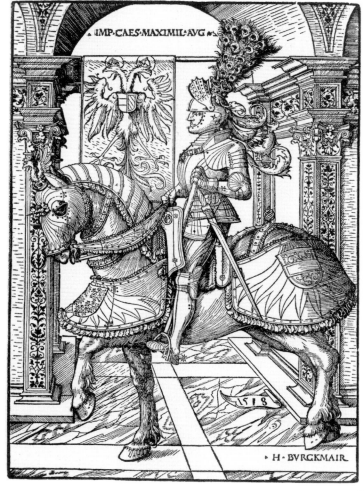

59

59 | Hans Burgkmair (1473–1531)
Emperor Maximilian I on Horseback, 1518

Woodcut
324 × 227 mm
B.vii.32[211]; H.v.323
The British Museum, 1868-8-22-203

Emperor Maximilian was Burgkmair's main patron from around 1508 until 1519. During that time, he became the chief designer of most of his print projects. This print was no doubt inspired by the Emperor's political ambitions. Equestrian portraits were an effective way of propagating his image as a defender of church and state. It was first issued in 1508 as one of the earliest examples of colour printing, probably as a special edition for the court, and was paired with another print depicting St George. The impression Ferdinand owned was produced in 1518 as the line-cut shown here.

> This print is described in the Seville inventory at no. 1748 under the classification '*pliego*-size sheet of 1 dressed man': *An armed man on horseback, in the left has the end of a stick which he leans on, he has many peacock plumes on his head, on his left arm are four circles, his vizor is raised, in the horse's chest is a shield in which are four eagles, he has the left raised, below is 1518 and a small banderole.*

60 | Hans Weiditz (before 1500–*c*.1536)
Emperor Charles V, 1519

Coloured woodcut on vellum
356 × 203 mm
G.1528; CD.II.169.54
The British Museum, 1862-2-8-55

Printed portraiture developed only in the first decades of the sixteenth century, at a time when the ruling classes became increasingly aware of the value of producing and distributing images of themselves. The present example depicts the young Charles V in the year he was crowned Holy Roman Emperor. It is printed on vellum, presumably as a deluxe coloured edition for wealthy clients. The lengthy inscription below describes the extent of Charles's office and his territories, and the name in the lower right, Jost de Negker, is that of the highly skilled cutter who played a very important part in the development of the fine woodcut in Europe [see cat. no. 105].

> This print is described in the Seville inventory at no. 2116 under the classification '*pliego*-size sheet of 6 dressed men': *King Charles, we cannot see below his belt, has an apple in the right, above are two columns in one part, in the other are letters in Flemish type, above is a shield that has an eagle, to our left are three pomegranates, to our right four.*

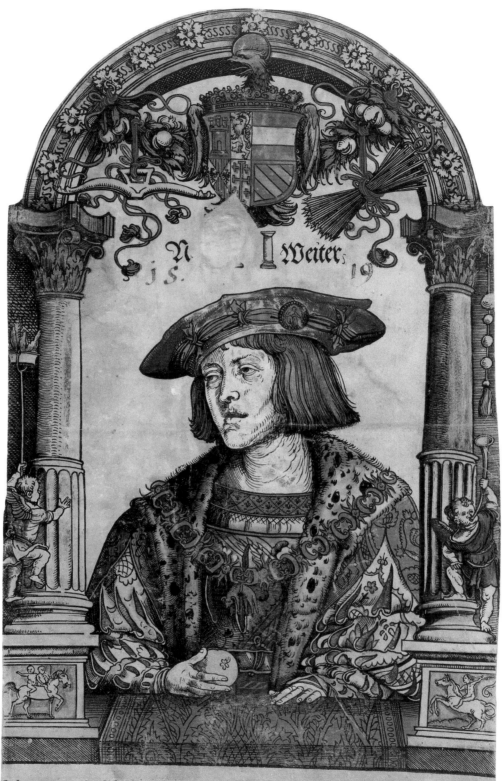

60

61 Hans Weiditz (before 1500–c.1536)
Grotesque Woman with Two Children
Carrying Toy Windmills, 1521

Woodcut
303 × 217 mm
G.1508
The British Museum, 1880-6-12-212

Weiditz appears to have been something of a specialist in comical and satirical prints. He produced large numbers of them, most of which have completely vanished. Those that do survive exist in very few impressions, a fact that attests to the popularity they enjoyed at the time they were made. Another impression of this print carries two columns of verse that explain how the writer had read a poem about an island with women whose breasts were so large that a 'monk's cloak could be made out of them'.

> This print is described in the Seville inventory at no. 1972 under the classification 'pliego-size sheet of 3 dressed men': *A monstrous woman with huge breasts, a cord passes between them which touches the left foot, the left breast touches a child whose right is hidden, in the left he has a spinning toy, in the other part is another child, in the right she has another, below is a banderole in German type.*

62 Hans Weiditz (before 1500–c.1536)
Winebag and Wheelbarrow, c.1521

Woodcut
277 × 212 mm
Röttinger, 1911, n.12, p. 50; G.1511
The British Museum, 1880-6-12-211

In this highly amusing image, a man who has drunk too much wine vomits while carrying his enormous paunch in a wheelbarrow. This type of satire sometimes warned against the excesses of drinking, but in this print the effect is intended to be purely comical.

> This print is described in the Seville inventory at no. 1743 under the classification 'pliego-size sheet of 1 dressed man': *A man with both hands pushes a wheelbarrow, in which he carries his belly which is huge, it has two fasteners, in his belt is a gourd, he spits above, his hat has eight plumes, left hand and right thumb hidden, below is a text in German type.*

61

62

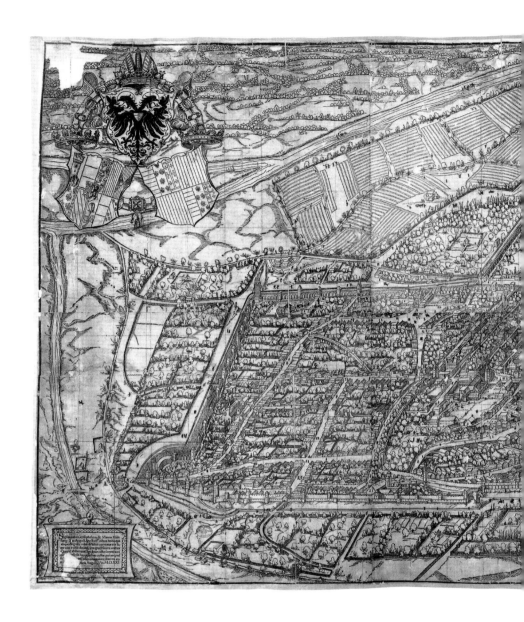

63 | Hans Weiditz (before 1500–*c*.1536)
Bird's-Eye View of the City of Augsburg, 1521

Woodcut
807 × 1920 mm
Röttinger, 1904, n.38; G.1530-41
The British Library, Map* 30415[6]

As a printmaker, Weiditz was remarkably versatile, turning his hand to portraiture, satirical prints [see cat. nos 61 and 62] and in this case a large topographical view, designed by Jörg Seld (*c*.1450–1527). Only two impressions of it survive. This print was the first plan-view of a town based on geometry and mathematical measurement to be executed north of the Alps and only the second overall (the earliest being Jacopo de' Barbari's *View of Venice* of 1500, fig. 53). So proud was Seld of his achievement that he devoted a text panel to emphasising its mathematical basis. This plan-view is primarily an expression of civic pride in the wealth, power and loyalty to the emperor of the City of Augsburg.

This print is described in the Seville inventory at no. 3181 under the classification 'roll of maps': *A city called Augusta Vindelicorum in eight sheets of marca-size, in the upper middle is a banderole that reads Sacri Ro. imp. civitas augusta vindelicorum, to our right is a tablet encircled by foliage that reads Sacri Romani etc etc, in the foliage are two men with horns who in both hands have a cup with six balloon shapes, in each lower corner is a tablet with text in Latin, above each two foliage leaves, to our left at the upper edge of the city is a very elaborate tower upon the spire of which is one standing [?] who almost touches a house outside the city.*

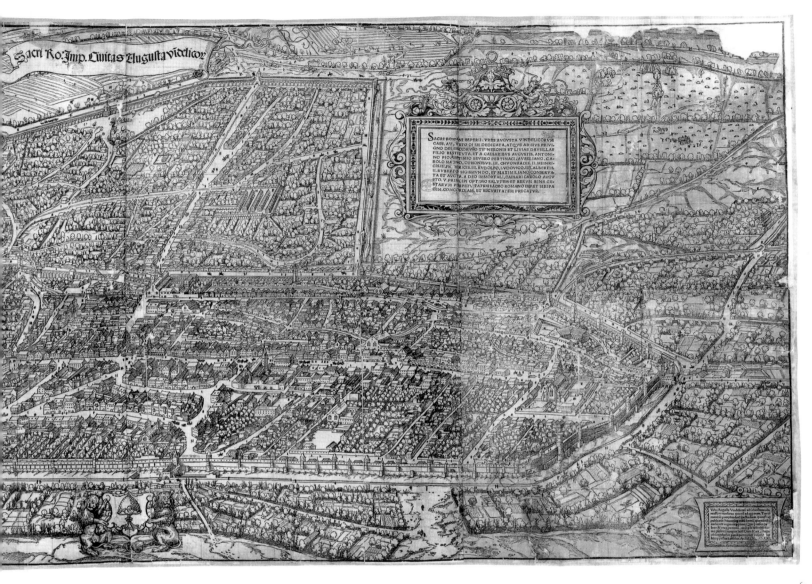

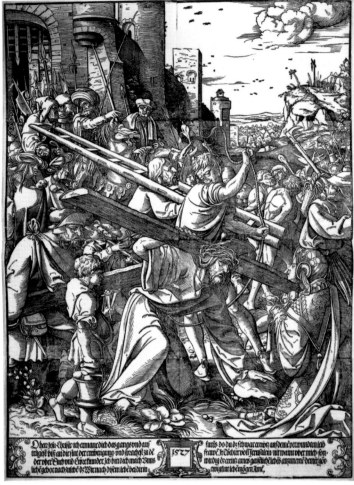

64

64 | Heinrich Vogtherr the Elder (1490–1556)
Christ Carrying the Cross, 1527

Woodcut
958 × 668 mm
Muller, 1997, n.185; G.1424-25
The British Museum, 1839-10-12-2[5]

One of the least understood aspects of Renaissance printmaking is the production of large-format prints, which by virtue of their size and fragility have mostly vanished. These large prints were made to be stuck on to walls as temporary decoration for holy feast days and other occasions such as town carnivals. Vogtherr's print is made from eight separate sheets of paper. Its size would have increased the effect of Christ's suffering; he stumbles under the weight of the cross and is whipped by his persecutor.

> This print is described in the Seville inventory at no. 2604 under the classification '*marca*-size sheet of many dressed male saints': *Christ with the cross across him, behind is a Jew who in the left has a rope with which he wants to beat him, we cannot see that thumb, nor the face, a man has a stick in the left placed on his left shoulder on which is a basket, in front of Christ is a kneeling woman who gives him a cloth with which he washes, we cannot see the left.*

65a | Hans Schäufelein (c.1482–1539/40)
The Legend of St Christopher, c.1505

Woodcut
238 × 360 mm
G.1052-53; H.xlii.31-38

65b | *The Legend of St Christopher*, c.1505

Woodcut
247 × 355 mm
G.1052-53; H.xlii.39-46
The British Museum, 1949-4-11-4052 and 1949-4-11-4053

Depicting the lives of saints in compartments originated in manuscripts and painted panels and developed in prints during the fifteenth century as an effective way of relating significant narrative episodes of the person's life. The prints were used as didactic storyboards, possibly to teach children and as a simple reminder of the lives of the saints. In the examples shown here each scene is accompanied by a brief textual explanation.

> No. 65a. This print is described in the Seville inventory at no. 2396 under the classification '*pliego*-size sheet of many dressed male saints': *The life of St Christopher in eight squares, in the upper one to our left is a king eating, his right hand is upon bread that is on the table along with two cups, in the lower corner it is as if he passes pilgrims, one is kneeling on his shoulders, another on the armpit, right hidden, the left foot touches the left elbow of a hermit, each square has a text box in Flemish type.*

> No. 65b. This print is described in the Seville inventory at no. 2397 under the classification '*pliego*-size sheet of many dressed male saints': *The Passion of St Christopher in eight squares, in the lower right corner it is as if someone is cutting the head, a man is kneeling on the right knee, with the left hand he raises the head of the saint, in another square is where he is being shot by arrows, an arrow is in a tree, in front is a king who has an arrow in the left eye, there are text boxes in Flemish type.*

Suadentis sequitur monitus, portatq; reportat
Trans flumen cunctos, pondera nulla timens

Forte quiescentem puer hunc speciosior astris
Se ferat in humeris nomine saepe uocat

Imponit puerum dorso, fert cuncta ferentem
Mox stupet, & ualido robore fractus erat

Deponit fessus puerum stans aspicit, inquit
Et puer & deus es filius atq; dei

65a

Ceditur hinc captus sed fronduit arida uirga
Credere sic christo millia multa facit

Protinus ad regis uinctus deducitur aedes
Et christum esse deum terq; quaterq; refert

Carcere conclusum nequeunt aquilina, Nicea
Flectere, sed credunt ad sacra uerba uiri

Ad regis iussum ambae intrant in templa deoq;
Fune ligant, sternunt, pulueris instar erunt

Arboris in trunco suspensa aquilina Nicea
Post flammas gladio coelica regna capit

Insidet ardenti scamno, flagris uapulatq;
Et caput ignita casside discruciant

Nec potuit sancti corpus penetrare sagitta
Sed iaculo regis lumen utrunq; necant

Martyris en pugnam capitis truncatio claudit
Cumq; fide uisum sanguinis unda dedit

65b

66

66 | Hans Schäufelein (*c.*1482–1539/40)
*A Standard-Bearer with a Banner, c.*1515

Woodcut
209 × 133 mm
B.vii.100[266]; H.xlii.64
The British Museum, E.8-85

Like many of his contemporaries, Schäufelein made prints of military figures. The *lansquenet* in particular was a popular subject [see cat. nos 10, 52] and Schäufelein's design is one of the most impressive. The banner furls behind the soldier, providing a dramatic backdrop as he leans into the wind. The high quality of the print is due in particular to the skill of the cutter Jost de Negker, whose monogram appears at the lower left [see cat. no. 104]. Schäufelein's own monogram, which occurs at the right, comprises the letters HS; the small shovel is a pun on his name, *Schäufel*.

> This print is described in the Seville inventory at no. 1260 under the classification '*quarto*-size sheet of 1 dressed man': *A standard-bearer holds a banner in the left, the right is placed on his right thigh, he wears many plumes, he wears pantaloons cut at the thighs, on the right shoulder is a hole, a city to our right, he has a close-cropped beard, the tips of each shoe have four slashes.*

67 | Monogrammist IS with a Shovel
(active 1st half of 16th century)
*Allegory of the Deliverance of Original Sin, c.*1515

Woodcut
324 × 243 mm
B.vii.54[260] (as Schäufelein); CD.II.37.114 (as Schäufelein)
The British Museum, 1856-2-9-253

The print represents an allegory of the Fall and Redemption of Man. An intertwined apple and olive tree grow in the centre of the composition, where a serpent holds an apple containing Death's head in its mouth. Eve is about to take the fruit that is held by the serpent while Adam passes a similar death-apple to an emperor. At the other side, the crowned Virgin passes a host (symbolising redemption) to a group of ecclesiastics. Above her, an angel holds a similar host. For a long time, this print was thought to be by Hans Schäufelein but the different monogram indicates the hand of another.

> This print is described in the Seville inventory at no. 2186 under the classification '*pliego*-size sheet of 9 dressed male saints': *Adam and Eve standing naked, to our right is an emperor, in the right Adam gives him an apple in which is a face, Eve takes another that a serpent has in its mouth, in the tree is an angel who in the right has a host, below is a female saint who gives another host to a pope, the pope has his hands joined.*

67

68 | Albrecht Altdorfer (1482/5–1538)
The Massacre of the Innocents, 1511

Woodcut
193 × 146 mm
B.viii.46[77]; Winzinger, 1963, no.15
The British Museum, 1895-1-22-356

Early in his career Altdorfer was strongly influenced by his contemporaries Lucas Cranach and Albrecht Dürer but he also turned to Italian printmakers for inspiration. A collection of Italian engravings is recorded in his will. As a printmaker, Altdorfer developed a highly idiosyncratic style in which he paid as much attention to the emotional resonance of the subject as to its execution. The *Massacre* was made at the beginning of his printmaking career. Typical of many of his prints, extraneous structures dominate the composition; here, the overgrown edifice at the right demands our attention and overshadows the events below. It is a strange rendition of the subject; the elaborately dressed soldier with his back turned in the foreground obscures much of our view. Only the child impaled on a sword held aloft boldly announces the subject.

This print is described in the Seville inventory at no. 1487 under the classification '*quarto*-size sheet of 13 dressed male saints': *The innocents, a man turned away, in the left he has a sword, the right at his side, behind is a head like a lion, a woman has a naked child in her arms, another one comes from behind, in the right he has a sword that seems to stab the head of a child, another man in the right has a raised sword on which is a naked child, to our right is another who in the right has a sword that is thrust into the left shoulder of another naked child, in a place is 1511, in the lower left corner is* 𝕬 .

69 | Albrecht Altdorfer (1482/5–1538)
St Christopher Bearing the Christ Child, 1513

Woodcut
168 × 120 mm
B.viii.53[79]; Winzinger, 1963, no.24
The British Museum, 1895-1-22-363

Because large areas of the paper have been left untouched, it has been suggested that Altdorfer designed this print with a tone block (for adding another colour) in mind. But it is more likely that the sparse calligraphy of the design was aimed at emulating the effects of a pen and ink drawing. The simplicity of this print belies its emotional power. Christopher doubles over as he fords the river, his billowing cape emphasising the tremendous effort he is making.

> This print is described in the Seville inventory at no. 1324 under the classification '*quarto-size sheet of 2 dressed male saints*': *St Christopher carrying on his shoulders Christ who has his left hand on St Christopher's head, he blesses with the right, St Christopher is very bent, in both hands he holds a staff, from his belt hangs a knife, in front is a small cottage and a tree from which hangs ⚐ 1513.*

70 | Albrecht Altdorfer (1482/5–1538)
The Large Crucifixion, 1515–17

Engraving
144 × 99 mm
B.viii.8[44]; Winzinger, 1963, no.134
The British Museum, 1842-8-6-94

Altdorfer's production of engravings (seventy-eight) almost equals that of his woodcuts (ninety-three). In both techniques he is concerned with rendering the visible in minute detail, and nowhere is this more evident than in the *Large Crucifixion*. Through the combination of stippling, cross-hatching and closely spaced parallel lines Altdorfer conveys the sense that an extraordinary event has taken place. The sky seems to be closing in and the white mountain and ghostly trees encircle the scene. Some of the trees are curved, as if they are paying attention to the events below. In the centre, Christ's head is set against a penumbra of light as he gazes towards his collapsed mother. This print is a perfect demonstration of how much emotional power can be conveyed through such a small image.

> This print is described in the Seville inventory at no. 163 under the classification '*octavo-size sheet of 9 dressed male saints*': *Christ crucified, left hidden, a woman with her elbow almost touches the face of a woman who is across from her, next is a man with a hat, the left arm almost touches the head of an old woman whose head touches St John's head, he has his left arm on the Virgin's left shoulder.*

69

70

71a Albrecht Altdorfer (1482/5–1538)
The Entry into Jerusalem (The Fall and Redemption of Man), c.1513

Woodcut
72 × 48 mm
B.viii.17[74]; Winzinger, 1963, no.42

71b *The Last Supper*

B.viii.18[74]; Winzinger, 1963, no.43

71c *The Agony in the Garden*

B.viii.19[74]; Winzinger, 1963, no.44

This print is described in the Seville inventory at no. 727 under the classification '*sezavo*-size sheet of 5 dressed male saints'

71d *The Betrayal of Christ*

B.viii.20[74]; Winzinger, 1963, no.45

71e *Christ before Caiaphas*

B.viii.21[74]; Winzinger, 1963, no.46

This print is described in the Seville inventory at no. 772 under the classification '*sezavo*-size sheet of 6 dressed male saints'

71f *Christ Presented before Pilate*

B.viii.22[74]; Winzinger, 1963, no.47

This print is described in the Seville inventory at no. 792 under the classification '*sezavo*-size sheet of 6 dressed male saints'

71g *The Flagellation of Christ*

B.viii.23[74]; Winzinger, 1963, no.48

71h *Christ Crowned with Thorns*

B.viii.24[74]; Winzinger, 1963, no.49

This print is described in the Seville inventory at no. 698 under the classification '*sezavo*-size sheet of 4 dressed male saints'

The British Museum, 1895-1-22-324; 1895-1-22-325; 1895-1-22-326; 1895-1-22-327; 1895-1-22-328; 1895-1-22-329; 1895-1-22-330; 1895-1-22-331

Altdorfer's series of the Fall and Redemption of Man comprises forty woodcuts. Ferdinand Columbus owned the complete set. By the time Altdorfer embarked on the series, he had made a number of small, finely detailed engravings [cat. no. 70] and in the woodcuts he has attempted to translate that same sense of intimacy. The cuts illustrated reveal Altdorfer's tendency to turn the protagonists away from the viewer, effecting more of an internal narrative than one of outward expression. Their intimacy compels the viewer to look closely and these prints are a technical *tour de force*.

Altdorfer probably produced the series in response to Dürer's 1511 publication of the *Small Passion* [cat. nos 41a–d], *Large Passion* [cat. nos 42a–b] and the *Life of the Virgin* series [cat. nos 40a–b]. However, it is important to recognise that Altdorfer's narratives are entirely his own interpretations and might even have been a challenge or alternative reading of the Passion to those of Dürer.

No. 71a. This print is described in the Seville inventory at no. 749 under the classification '*sezavo*-size sheet of 5 dressed male saints': *Christ on a donkey when entering Jerusalem, we cannot see the right, with the left he holds the reins of the donkey, in front are three men with palms to lay down, one of them is below, with the right leg he leans into the right corner, to our left is a 𐅀𐅀.*

No. 71b. This print is described in the Seville inventory at no. 860 under the classification '*sezavo*-size sheet of 13 dressed male saints': *When Christ ate with his disciples, Christ leans on the table with the left arm, with the right he gives Judas a robe, who leans on the table, he has a bag in his left, below to our left is a cushion, an apostle who is to our right points with the left to Judas, below is a pail with a jar inside and 𐅀𐅀.*

No. 71d. This print is described in the Seville inventory at no. 845 under the classification '*sezavo*-size sheet of 9 dressed male saints': *The arrest of Christ, to our right is a Jew who has Christ's left arm, he has four small circles in the right ear, three plumes on the head, his left foot touches a lantern, to our left is St Peter who in the right has a raised dagger, with the left he holds a stick that a Jew has with the left, there are many lances and burning candles, above is 𐅀𐅀.*

No. 71g. This print is described in the Seville inventory at no. 641 under the classification '*sezavo*-size sheet of 3 dressed male saints': *Christ and St Lazarus who is whipped by two men, one of them has a scourge in the right, the lower one has another of olive branches, around the body is a rope, the arms are raised, one touches the edge of the square, below there is a double A 𐅀𐅀.*

71a

71b

71d

71g

72

73

72 | Albrecht Altdorfer (1482/5–1538)
Jael and Sisera, 1513

Woodcut
121 × 94 mm
B.viii.43[76]; Winzinger, 1963, no.23
The British Museum, 1895-1-22-350

Sisera was a cruel Canaanite leader who in an attack by the Israelites was defeated. He escaped, seeking refuge in the tent of Jael, the wife of Heber the Kenite who belonged to a tribe at peace with the Canaanites. Jael gave Sisera nourishment and when he was sleeping drove a tent peg through his skull. This is the moment depicted by Altdorfer but, strangely, the setting is an open yard and not a tent.

> This print is described in the Seville inventory at no. 991 under the classification *'octavo-size sheet of 2 dressed men'*: *A woman seated, a man in front, with her left she has placed a nail in his right eye, in the right a hammer, she is banging it, his arms are extended, to our left is a door with four battlements above, his sleeves are slashed, in the lower left corner is* 𐆊.

73 | Albrecht Altdorfer (1482/5–1538)
St Christopher Seated on the Bank, c.1515–17

Woodcut
121 × 94 mm
B.viii.54[79]; Winzinger, 1963, no.85
The British Museum, 1895-1-22-362

The moment from the legend of St Christopher that Altdorfer has chosen to depict is highly unusual. Normally St Christopher is shown carrying the Christ Child on his shoulders [see cat. nos 69, 104] but here they are shown before they cross the river. The Child steps on to a stone, about to climb on to Christopher's back. Choosing an unusual moment of a well-known narrative is typical of Altdorfer.

> This print is described in the Seville inventory at no. 972 under the classification *'octavo-size sheet of 2 dressed male saints'*: *St Christopher seated on the ground because he wanted to take Christ on his shoulder, has his right hand set on the ground upon which he leans, he has the left leg withdrawn, Christ's left knee touches the right arm of the saint, Christ holds a stick in his right hand, near a big tree above which is* 𐆊.

74

75

<table>
<tr><td>74</td><td>Albrecht Altdorfer (1482/5 – 1538)
<i>Joshua and Caleb</i>, 1520–25</td><td>75</td><td>Albrecht Altdorfer (1482/5–1538)
<i>The Sacrifice of Isaac</i>, 1520–25</td></tr>
</table>

74 | Albrecht Altdorfer (1482/5 – 1538)
 | *Joshua and Caleb*, 1520–25

Woodcut
121 × 94 mm
B.viii.42[76]; Winzinger, 1963, no.92
The British Museum, 1895-1-22-349

Joshua and Caleb were two of the twelve men sent by Moses to explore lands available for conquest and they alone brought back an encouraging report, which led to the subsequent settlement of Canaan, the Promised Land. The scene depicted is their return after forty days bearing the fruits of the lands they had surveyed (Numbers 13:16–26).

> This print is described in the Seville inventory at no. 1114 under the classification 'octavo-size sheet of 5 dressed men': *Men, one of them to our left has in the left hand a basket-like thing in which are apples, in the right he has a stick, he is in a shirt, another is armed, in the left he holds a plate on which are apples and on top a melon, behind are two men who hold a wreath, each one has a pole, in the first the point touches his left foot, below are letters* 𝐀.

75 | Albrecht Altdorfer (1482/5–1538)
 | *The Sacrifice of Isaac*, 1520–25

Woodcut
121 × 94 mm
B.viii.41[76]; Winzinger, 1963, no.91
The British Museum, 1895-1-22-348

The tremendous smoke issuing from the fire at the right frames the composition, enclosing the central figures while foreshadowing what is to come. As a test of Abraham's faith, God instructed him to sacrifice his son but at the moment he was about to deliver the mortal blow an angel appeared and stayed his hand. Abraham saw a ram caught in the thicket and sacrificed it instead. Altdorfer captures the dramatic tension of the story in his typical somewhat recondite way. Abraham is turned from the viewer whereas, normally, the impending sacrifice is shown facing the viewer [see.cat. no. 15].

> This print is described in the Seville inventory at no. 1021 under the classification 'octavo-size sheet of 3 dressed male saints': *Abraham sacrificing his son, has placed the left on his neck, in the right hand has a blade, looks back, above is an angel, its right wing almost touches a* 𝐀, *in the corner below to our left is a jar and a staff, he shows his right ear.*

76

76 | Wolf Huber (*c*.1485–1553)
Pyramus and Thisbe, 1513–15

Woodcut
119 × 92 mm
B.vii.9[486]; H.xvA.12
The British Museum, 1895-1-22-440

Huber's small body of prints (thirteen in total) shows knowledge of Altdorfer's work. Similar foliage, minute cutting and striking atmospheric effects occur in the work of both.

This print depicts Pyramus and Thisbe, the hero and heroine from the classical love-story from Ovid (*Metamorphoses* 4.55ff). Their parents refused to consent to their marriage and they were forced to talk through a crack in the wall separating their houses. Finally, they arranged to meet near the tomb of Ninius. Thisbe, the first to arrive, took flight upon seeing a lion and dropped her cloak, which the lion mauled. Pyramus, finding the bloodstained cloak, stabbed himself. Thisbe returned and, finding her lover mortally wounded, took her own life.

> This print is described in the Seville inventory at no. 992 under the classification '*octavo*-size sheet of 2 dressed men': *A man who is lying down, has the right knee raised, the left withdrawn, in his chest is a dagger, with the right he seems to be making a gesture of contempt, his left cheek touches the door of a house, his left knee touches a tree, to our right is a woman standing touching the head of a lion with the left, a tree with her head, her left heel touches her right heel, her left foot touches a house.*

77 | Wolf Huber (*c*.1485–1553)
St George Fighting the Dragon, 1520

Woodcut
202 × 151 mm
B.vii.7[486]; H.xvA.10
The British Museum, E.7-228

This woodcut is the latest dated print by Huber and his most successful. St George is depicted at the moment he is about to slay the dragon, his sword raised high. As in other prints by Huber, the landscape and sky play a part in the unfolding drama. The birds dramatically taking flight in the middle ground seem to anticipate the calamity.

> This print is described in the Seville inventory at no. 1327 under the classification '*quarto*-size sheet of 2 dressed male saints': *St George armed on horseback, in the right has a two-handed sword, his vizor is raised, below the horse is a lance, in front is a serpent with its mouth open, above is a girl, hands closed, at her left is a sheep, to our right is a big tree, there are very big mountains.*

77

78 | Lucas Cranach the Elder (1472–1553)
The Temptation of St Antony, 1506

Woodcut
405 × 270 mm
B.vii.56[282]; H.vi.76
The British Museum, 1895-1-22-255

Lucas Cranach's patron, Elector Frederick the Wise, greatly encouraged his activity as a printmaker and as a result he enjoyed considerable success in this area. Cranach entered Frederick's employ around 1505, and from then his print production increased dramatically. In many of Cranach's woodcuts, including this *Temptation*, the Saxon coat of arms is prominently displayed, acknowledging the house of his protector.

Antony, like other hermits, suffered hallucinations because of his ascetic life in the desert. The temptations assumed two forms, attack by demons or assault by erotic visions. Cranach has chosen the demonic temptation, probably because it allowed him free rein to depict the fantastic hybrid creatures shown here. Schongauer's engraving of *c.*1475 inspired the group of figures attacking St Antony but the landscape below is completely Cranach's own invention.

> This print is described in the Seville inventory at no. 1685 under the classification '*pliego*-size sheet of 1 dressed male saint': *St Antony raised by the devils, one to our left pulls his mantle with both hands, above the mantle is one who pulls his beard with the right, in the left he has a stick that he wants to beat him with, to our right is another devil who has a stone in the right, next is a big tree in which are two shields, in one are two crossed swords, in the lower left corner is LC 1506.*

78

79 | Lucas Cranach the Elder (1472–1553)
The First Tournament, 1506

Woodcut
256 × 368 mm
B.vii.124[293]; H.vi.116
The British Museum, 1895-1-22-275

This print is one of a group of woodcuts depicting tournaments enacted in the market-place at Wittenberg where Cranach lived and worked. The events were organised by Frederick the Wise [see cat. no. 78] in association with the Feast of All Saints (1 November), when his remarkable collection of relics was put on display (19,000 objects by 1520).

Depicting a somewhat chaotic tournament, this woodcut was probably made with the intention of being hand coloured. One partly coloured impression survives in Dresden, which greatly clarifies the composition. Colours and insignia defined particular households. The Saxon coat of arms can be seen on the tapestry draped over the balcony in the upper section.

> This print is described in the Seville inventory at no. 2473 under the classification '*pliego*-size sheet of many dressed men': *A tournament of many people on horseback, in the lower left corner is a soldier who has a sword behind touching the right shin, the point of the lance of the second jouster is on the right eye of a trumpeter, to our right is a little dog that has its feet on a step, touching the nose of a horse, whose left foot we cannot see.*

80 | Lucas Cranach the Elder (1472–1553)
Four Saints Adoring Christ Crucified on the Sacred Heart, 1505

Woodcut
380 × 284 mm
B.vii.76[287]; H.vi.69
The British Museum, 1895-1-22-267

An image of unrelentingly orthodox character, this print is one of Cranach's most elaborate religious images. It is the first devotional print to which Cranach paid special care in its execution. The composition is well balanced and the details beautifully cut. Cranach often locates his religious subjects in terrestrial settings that give the appearance of topographical accuracy. The buildings shown here cannot be identified but were possibly a significant residence or monastery near Wittenberg where he worked.

> This print is described in the Seville inventory at no. 2184 under the classification '*pliego*-size sheet of 9 dressed male saints': *Christ crucified in a shield, in which is a heart held by four angels, on the cross is a crown between many tongues of fire, below is the kneeling Virgin, behind her is a saint who has arrows in his hand, right arm naked, in front of the Virgin is St John on his left knee, the left foot touches the other foot of a saint, below is a shield in which are two crossed swords, in the middle is 1505* .

81

81 | Lucas Cranach the Elder (1472–1553)
A Wild Man with a Child, c.1512

Woodcut
161 × 126 mm
B.vii.115[291]; H.vi.107
The British Museum, 1854-11-13-160

The meaning of this print and the reason for its being produced are not known, but it depicts a wild man stealing a baby after he has wrought death and destruction on its household. Dismembered bodies lie scattered and a woman in the background throws up her hands in horror. The subject is like none other in Cranach's work. It might be connected with the fascination for wild men from distant lands who were the subject of many prints during the period.

Cranach's monogram of the little serpent, which so often appears on his works, occurs here above the window embrasure near the woman.

> This print is described in the Seville inventory at no. 1444 under the classification '*quarto*-size sheet of 6 dressed men': *A savage man who walks like a cat, in his mouth carries a naked child, in the door of a house is a woman with her hands raised, across is a running child, in the house is a man who seems to be feeding some oxen, to our right is a duck in the water, above the house are two shields.*

82 | Lucas Cranach the Elder (1472–1553)
The Beheading of St John the Baptist, c.1514

Woodcut
330 × 231 mm
B.vii.62[284]; H.vi.87
The British Museum, 1895-1-22-259

Cranach presents the bloody moment immediately following the decapitation of John the Baptist. In many representations of this subject, Herod and Herodias look on. They may be among those in the upper balcony but because the men there are dressed in contemporary costume it is difficult to distinguish them. At the right, Salome descends the stairs to collect the head and present it to her stepfather, Herod. Cranach's serpent monogram appears prominently at the lower right.

> This print is described in the Seville inventory at no. 2401 under the classification '*pliego*-size sheet of many dressed male saints': *The death of St John the Baptist who is beheaded, below is an armed man who raises the head with the left, in the right he has a halberd, thumb hidden, above are another three armed men, one has a hat lying behind with many plumes, the pants are slashed, we can see neither thumb, in the right corner is a serpent with wings.*

82

83 | Monogrammist MV (first half of 16th century)
after Lucas Cranach the Elder
The Martyrdom of St Matthew, c.1515

Engraving
164 × 124 mm
B.viii.7[23]
The British Museum, 1853-7-9-27

This monogrammist is known only by the initials MV and the print is one of a series of twelve copies in reverse of woodcuts by Lucas Cranach the Elder. In all the prints, the artist substituted his own monogram for the Saxon coat of arms and in some he added extra details. No other prints by this printmaker are known.

This print is described in the Seville inventory at no. 335 under the classification 'quarto-size sheet of many dressed male saints': *A saint who has been decapitated, many people about, some on horseback, to our right the head touches the left foot of the armed footsoldier who puts his sword in its sheath, a horse touches another horse's nostrils, its right hoof touches the left ear of a dog* ⊠ .

83

84 | Wolf(gang) Traut (*c.*1480–1520)
 | *Christ Taking Leave of his Mother*, 1516

Woodcut
299 × 258 mm
G.1406
The British Museum, 1895-1-22-124

As a printmaker, Traut mainly produced woodcuts for book illustration. This is his most important signed single-leaf woodcut. He was very influenced by Dürer, who between 1512 and 1515 employed him to make woodcuts for the Triumphal Arch for the Emperor Maximilian. The buildings in the background of this print derive from those in Dürer's woodcut *Christ Taking Leave of His Mother* from the *Life of the Virgin* series [see cat. nos 40a–b].

This print is described in the Seville inventory at no. 2185 under the classification '*pliego*-size sheet of 9 dressed male saints': *Christ who takes the Virgin's right hand with his right, the Virgin with her left takes his sleeve, Christ's mantle is tied at the chest, behind is a saint who has a stick, both thumbs hidden, in the middle of Christ and the Virgin is a huge tree, below is 1516* XXꟼⱯ , *behind the Virgin are three women, below are three couplets in Flemish type.*

85

85 | Hans Springinklee (*c.*1495–1522)
| *St Jerome at his Desk*, 1522

Woodcut
235 × 182 mm
B.vii.57[329]; CD.I.412.81
The British Museum, 1895-1-22-417

Hans Springinklee was a prolific printmaker who worked closely with Albrecht Dürer in Nuremberg, producing mainly book illustrations. Through Dürer, he became involved in print projects for the Emperor Maximilian [see cat. nos 59, 84].

Outside book illustration, this print is one of the very few of his signed prints; his monogram occurs at the lower right. It is one of his most successful images. The architecture is effectively designed to create a powerful sense of spatial recession. The print was also used as an illustration to an edition of the Vulgate (Lyons, 1522).

> This print is described in the Seville inventory at no. 1608 under the classification '*medio*-size sheet of 2 dressed male saints': *St Jerome seated at a table writing with the right in an open book, on the table fringe are fifteen circles, below on a beam are two doves, on the table is a _ [crucifix?] the tip of which touches a house that has two trees, below is ISK.*

86 | Thomas Anshelm (*fl. c.*1488–*c.*1523)
| *The Martyrdom of St Sebastian*, 1501

Woodcut
338 × 226 mm
H.ii.5; G.55
The British Museum, 1930-7-16-4

Little is known about Thomas Anshelm except that he worked as a printer and cutter first in Basel and later in Strasbourg, Tübingen and several other towns in Germany. This information comes from inscriptions beneath his prints. The *Martyrdom of St Sebastian* was made in Pforzheim. Anshelm is known to have made only five woodcuts, all of which are striking for their quality. The type of rocky landscape looks back to the fifteenth-century work of Schongauer and his contemporaries.

> This print is described in the Seville inventory at no. 2059 under the classification 'pliego size sheet of 5 dressed male saints': *St Sebastian standing, hands tied, the left above, he has five arrows, in front of him are two men who are hitting him with arrows, one is arming a crossbow, the other firing with a bow, the saint does not show the right, across is another man who has a stick in the left.*

O heilger herr sebastian
ein mertler groß des ich dich man
Vor allem übel bschirm du mich
das ich dich bitt gantz innigklich
Besunder auch die mein behuet
vor der pestilentz grim vnd wüet
Du warst ein burger zů meilant
yn welschem land auch wol bekant

Du magst erwerben wol von got
das wir nit sterben an der not
Dyn nam vor got ist groß geacht
da von dem sünder trost ist gmacht
Sölchs zoe macht wissen vnd kunt
an der stumkeit sie ward gesunt
Ein gmahel nicostrati was
vnd vß dynr hilff vnd fürbit gnaß

Die mertler tröst du auch mit lon
verheissen yn des hymels tron
Sie yn got gab zů aller frist
nach all yr pein on argenlist
Darum du heilger mertler groß
by vns wölst sein on vnderlaß
Des bitt wir durch die marter dein
begern alzeit in dym dienst sein

Erlang vns die barmhertzigkeit
vnd bschaung der trifaltigkeit
Nach dem zergencklichen leben
wölst vns die ewig freud geben
Amen.
Gedruckt zů Pfortzheym.
·1501·

87 | Thomas Anshelm (*fl. c.1488–c.1523*)
The Virgin and Christ Child with St Dorothea, c.1512

Woodcut
300 × 226 mm
B.vii.1[487]; H.ii.4
The British Museum, 1912-5-13-55

Dorothea was a Christian saint and virgin martyr who was condemned to death around the year 303 because of her refusal to renounce her faith. The scribe Theophilus, who stopped Dorothea on the way to her execution, mockingly asked her to send a basket of apples and roses from the garden of heaven. After her death, a child appeared to Theophilus and presented him with these objects. In this print the Christ Child has taken the roses and basket offered by Dorothea in recognition of her faith and sacrifice.

Another impression of the *Virgin and Christ Child with St Dorothea* carries text beneath the image like that on the print of *St Sebastian* [see cat. no. 86].

> This print is described in the Seville inventory at no. 1935 under the classification '*pliego*-size sheet of 3 dressed male saints': *The Virgin has her Son on her knees who in the right has two branches in which are three apples, in the left he has a basket of apples and flowers, he gives the branch to a female saint who is in front of him, in the halo of each saint is a banderole, Christ's halo almost touches a large banderole, he has six stars on his robes and three on his right sleeve, below is ♄.*

88 | Anonymous German
View of Nuremberg, 1502

Engraving
194 × 290 mm
The British Museum, 1888-4-10-1

This engraved *View of Nuremberg* is closely copied from a woodcut in the *Nuremberg Chronicle* [see cat. no. 23] but for the addition of several flying male figures ringing bells in the towers of the city's churches. These, however, and the use of Greek for the cardinal points, transform a topographic view into a mysterious image that was predominantly moralistic and patriotic. Nuremberg was one of the most important early centres of printmaking in Germany and the city where Albrecht Dürer lived and worked.

> This print is described in the Seville inventory at no. 3134 under the classification 'medio-size map': *Nuremberg, in the right corner is a river entering the city, at the edge of the river is a dead tree, above is a bell tower in which is a man in the air with a hammer in the right, there are three others, each with hammers, one with his left foot touches a round tower, there are five rolls, above the door of the city that is to our left is a shield in which is an eagle.*

ÁPKTOΣ

ΔΥΣΜΉ

ΑΝΑΤΟΛΉ

ΜΕΣΗΜΒΡΊΑ

VRBS NORINBERGA QVADRIFINIA. ANNO M D II.

88

89 | Martinus (Martin) Waldseemüller (*c.*1475–1518/22)
Map of Europe, 1520

Woodcut
1066 × 1407 mm
Van der Heijden, 1992, no.1, p. 29
The map shown here is a (British Library) facsimile.
The original is in the Tiroler Landesmuseum Ferdinandeum, Innsbruck

It was only in 1511 that the first recorded printed map of Europe was published. Designed by Waldseemüller, it was cut and published in Strasbourg; no example of the first edition is known. That shown here is the second edition, published in 1520, of which only this unique impression survives. The map, lacking any indication of political borders, is surrounded by the arms of the ruling dynasties and of the provinces of Germany, possibly to commemorate the coronation of Charles V as Holy Roman Emperor in Aachen [see cat. no. 60]. Its primary purpose was utilitarian. It was, as the title states, intended to show the principal routes and distances within Europe (each dot on a route representing a mile). An earlier map by Waldseemüller, made in 1507, showed part of America for the first time.

> This print is described in the Seville inventory at no. 3185 under the classification 'roll of maps': *Europe surrounded by shields, in the upper left is writing that begins per hoc mare, at the right there is a tablet with two shields and a banderole that begins quod lucidius, in the middle above is Neptune riding a fish, the last at the lower right is ynsula de Brasill hizola Martin y Laconillo.*

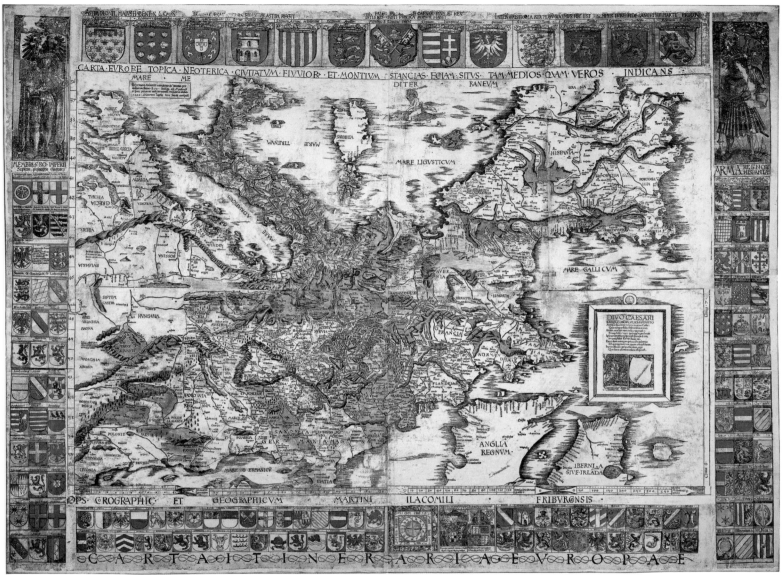

89

90a | **Niklaus Manuel Deutsch (?1484–1530)**
The Wise Virgin, 1518

Woodcut
185 × 105 mm
B.vii.5[469]; H.vi.4

90b | *The Wise Virgin*

B.vii.9[469]; H.vi.5

This print is described in the Seville inventory at no. 1296 under the classification 'quarto-size sheet of 1 dressed woman'.

90c | *The Foolish Virgin*

B.vii.10[469]; H.vi.6
The British Museum, 1877-6-9-61; 1877-6-9-62; 1877-6-9-69

The series of ten wise and foolish virgins represents the only prints that can be securely attributed to Manuel. He was primarily a painter and one of the most important of the Swiss Reformation. For this print series, Manuel was inspired by the engravings of the same subject made by Martin Schongauer in the 1470s, and as for him the religious subject provided the pretext for showing fashionably dressed women in various poses. Manuel's *Virgins* were immediately popular and were copied many times. Today impressions are very rare.

No. 90a. This print is described in the Seville inventory at no. 1290 under the classification 'quarto-size sheet of 1 dressed woman': *A standing woman, holding a burning lamp in the left, almost touches the letters and 1518, with her right raises her mantle, the sleeve is very loose, her mantle almost touches the tip of a post, she has slippers on her feet, in front a dagger, above which are letters* MD.

No. 90c. This print is described in the Seville inventory at no. 1286 under the classification 'quarto-size sheet of 1 dressed woman': *A woman standing with a lamp in her left hand, we cannot see the thumb, in the upper left corner are clouds that almost touch her right arm in which is a slash, her sleeve is tied with two strings, the tip of her belt almost touches a tree trunk, below is a dagger and letters* MD.

90a

90c

91 | Urs Graf (*c*.1485–1529/30)
Young Woman with an Old Man and a Youth
(*Mercenary Love*), *c*.1511

Woodcut
325 × 225 mm
H.xi.26
The British Museum, 1875-7-10-1455

Urs Graf was a prolific printmaker, producing mainly designs for book illustrations. His single-leaf prints are remarkable for their inventive treatment of various subjects often to do with the relations between the sexes. During his life, Graf was frequently in trouble with the authorities in Basel for various offences, includ-

ing beating his wife. His drawings are often satirical attacks against women. The theme of mercenary love, where young women marry or exchange sexual favours for money, was very popular during the fifteenth and sixteenth centuries. Here an old man gropes a young girl and as payment she takes money from his sack to give to the young man at her side. This is the only known impression of this print.

This print is described in the Seville inventory at no. 1965 under the classification '*pliego*-size sheet of 3 dressed men': A *woman between two men, we cannot see more than above the belt, the one at the right places his right hand on her right breast, the left on the right shoulder, a knife hangs from the belt showing three holes, the other man has four plumes in his hat, he holds the woman's waist with his right hand, with the left hand takes money that she gives him.*

92 | Urs Graf (*c*.1485–1529/30)
The Holy Land and Scenes from the Passion of Christ,
c.1510

Woodcut
381 × 534 mm
B.vii.7[462]; H.xi.14
The British Museum, 1856-2-9-182

Made from two blocks, this is the largest print Graf ever made and the only surviving impression. Set within a hilly landscape, each scene represents moments in the Passion of Christ. Although the Passion was often represented as a segmented narrative, Graf's particular approach is unusual. He leaves out the Crucifixion but includes the Transfiguration. The blank boxes above each scene were designed to contain text, either letterpress or possibly to be written in by the owner.

> This print is described in the Seville inventory at no. 2600 under the classification '*marca*-size sheet of many dressed male saints': *The holy land of Jerusalem, Christ praying in the garden, hands placed, an angel is on a crag holding a chalice, on it is a cross, the Jews bring Christ with his hands tied, one carries a candle to light the way, the sun is upon a curtain, on the tomb of the Virgin [Christ?] are five stones in a cross.*

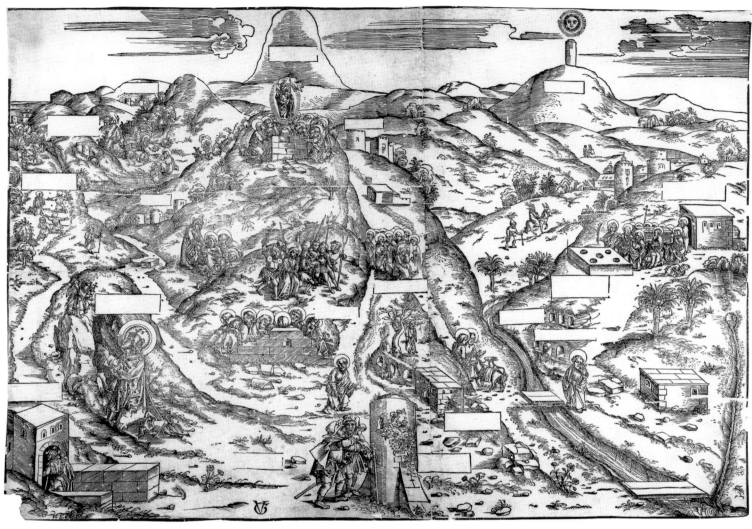

93 | Master IAM of Zwolle (c.1440–1504)
The Large Calvary with Horsemen, 1475

Engraving
352 × 348 mm
B.vi.6-I [93]; H.xii.p. 261
The British Museum, 1845-8-9-231

The Master IAM of Zwolle has tentatively been identified as Johan van den Mynnesten (active in Zwolle from 1462 until his death in 1504) but this cannot be verified. The drill as part of his monogram suggests that he might have been a goldsmith by profession [see cat. no. 94]. Almost nothing else is known about this artist. His prints, however, show an usually high level of refinement. The elegantly modelled forms, attention to meaningful perspective and clear separation of the figures are hallmarks of his manner. The figures in this print are typical of Dutch fifteenth-century art; they have crude peasant features and large hands.

This print is described in the Seville inventory at no. 2360 under the classification '*pliego*-size sheet of many dressed male saints': *Christ crucified, at his sides are the two thieves, one is bent, the other turns his head to a Jew who is on horseback with a lance in which is a banner touching a tower, below is the Virgin fainting, St John takes her right arm, Longinus touches the lance with the middle right finger, the little finger touches the left of one who offers his [below runs a dog whose tail almost touches a horse with the right foot].*

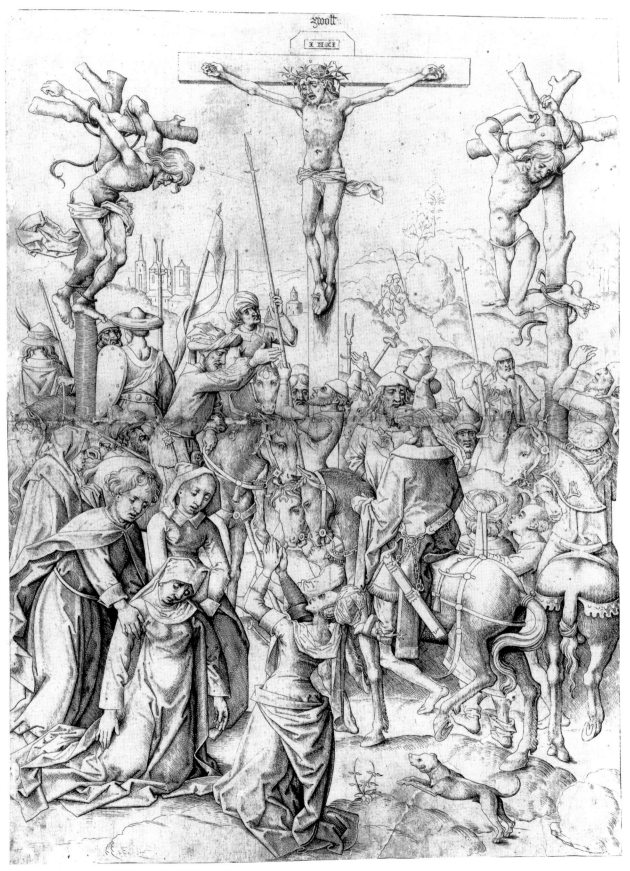

93

94

94 | Master IAM of Zwolle (*c*.1440–1504)
Allegory of the Transience of Life, *c*.1480–90

Coloured engraving on vellum
322 × 225 mm
B.vi.17[101]; H.xii.p. 276
The British Museum, 1845-8-9-232

Meditations on the transience of life were common subjects for printmakers during the fifteenth century. They reminded the viewer that all earthly glories and ambitions are futile, that Death is the final arbiter and one's actions on earth have repercussions for the afterlife. This engraving is a particularly confronting treatment of the subject. In the centre, Moses holds the Tablets of the Law to emphasise that the Ten Commandments are the only true guide to salvation. Below, in a tomb, a corpse decomposes and turns into a skeleton. All of the inscribed banderoles reinforce the central theme.

This print is described in the Seville inventory at no. 2001 under the classification '*pliego*-size sheet of 3 dressed male saints': *A skeleton that has its innards exposed in which is a toad, a snake enters by the mouth and leaves by the eye to our right, all of his members are complete, another three skulls and each one has a banderole in Latin.*

95	Monogrammist FvB	96	Master W+ (*fl. c.1465–c.1485*)
	St Philip, 1475–90		*A Cavalry Unit of Thirty Men, c.1465–c.1485*

Engraving
180 × 98 mm
Lehrs.vii.32[140]; B.vi.10[83]
The British Museum, 1845-8-9-222

Monogrammist FvB was perhaps the most talented Flemish engraver of the fifteenth century. His delicate modelling of forms through the use of small strokes creates broad tonal effects that suggest flickering light and differentiate between textures. Technically, he owes a lot to Martin Schongauer [cat. no. 31]. *St Philip* is one of a series of thirteen prints of Christ and the Apostles.

This print is described in the Seville inventory at no. 225 under the classification '*quarto*-size sheet of 1 dressed male saint': *A saint who holds a cross in the right hand, the tip of which touches his right foot, we cannot see the left foot, in his left he has an open book that to our right has seven lines F.V.B. we cannot see the left ear [and on the chest are two buttons].*

Engraving
140 × 183 mm
Lehrs.vii.27[57]; B.vi.26[64]
The British Museum, 1845-8-9-211

This print is one of a set of nine engravings depicting the battles and encampments of Duke Philip the Good of Burgundy (1396–1467). Military subjects were very popular during the fifteenth and sixteenth centuries but these prints stand out for the delicacy of their execution. The soldiers on horseback are arranged in a strict order but the engraver also indicates the untamed nature of the horses, which impatiently stomp their hooves, and the soldiers who seem eager for action. During Philip's reign – through inheritance, conquest and purchase – the territory of his duchy was doubled. His court was also the most splendid of his time in Western Europe. These prints were probably made as a commemorative record of his power.

This print is described in the Seville inventory at no. 336 under the classification '*quarto*-size sheet of many dressed men': *An army of soldiers on horseback placed in order, the first one does not have a lance, he has the right in the side, the left hidden, next is one who has a lance on the right shoulder, the left next to the ___ of the seat, the horse has its right hoof raised between two stakes, another man almost in the middle has the right raised, in the left he has a crossbow, we cannot see that thumb, no background, the lance of the second one crosses the other and touches the banner on the helmet of another* ⚐⚇ .

95

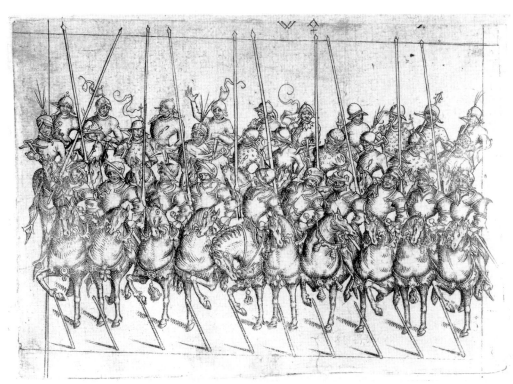

96

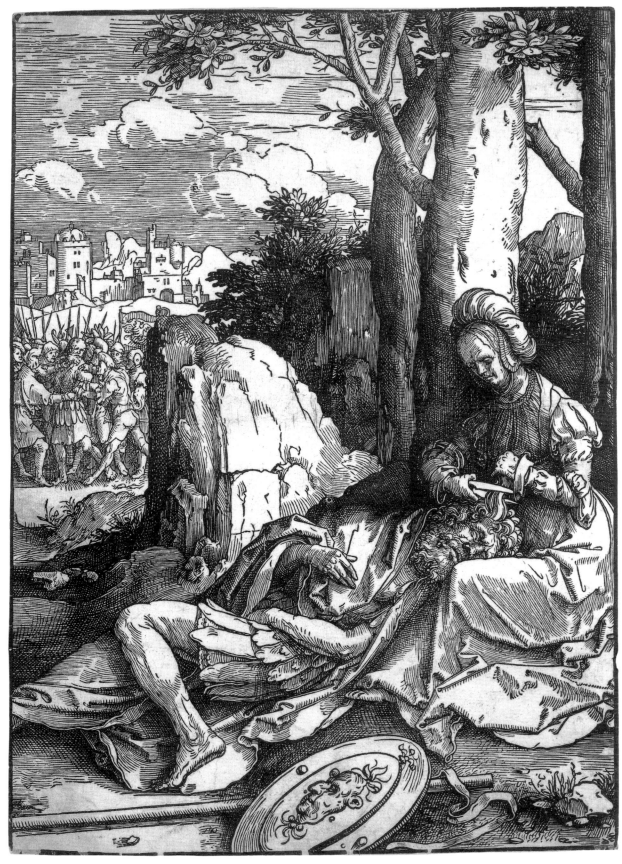

97 | Lucas van Leyden (*c.*1494–1533)
| *Delilah Cutting the Hair of Samson*
| (*The Large Power of Women*), *c.*1514

Woodcut
415 × 290 mm
B.viii.6[440]; NH.176
The British Museum, 1895-1-22-1160

Lucas was the first Dutch artist to establish an international reputation as a printmaker while he was still alive. His output was prolific and around 200 prints from his hand are known. This print is one of a series of six woodcuts depicting the subject of woman's power over man, a theme Lucas treated more than any other artist of his time.

The mood of this print (and of the entire series) is pensive. The moment Lucas has chosen is not one of confrontation but of furtive deception. As Samson sleeps, Delilah cautiously cuts his hair, the source of all his strength. Despite the solemnity of the occasion, Lucas could not resist adding a note of irony to the composition: the head on Samson's shield has double knots of hair.

> This print is described in the Seville inventory at no. 2208 under the classification '*pliego*-size sheet of 10 dressed men': *Samson between the legs of a woman who is cutting his hair with the scissors that she has in her right, with the left she has the strands of the hair, little finger outstretched, she has the right hand on his chest, the left set by her pudenda, the left leg uncovered, we cannot see her foot, there are many armed people.*

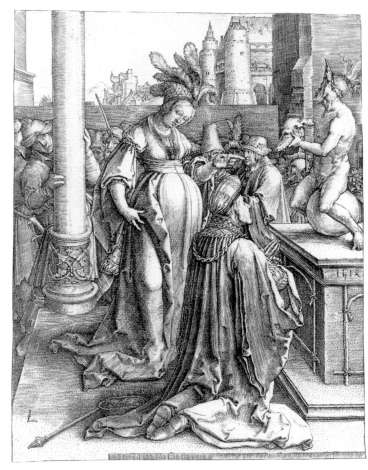

98 | Lucas van Leyden (*c.*1494–1533)
| *Solomon's Idolatry*, 1514

Engraving
168 × 128 mm
B.viii.30[354]; NH.30
The British Museum, K.k.6-81

Before the sixteenth century, representations of this subject were rare. Here, Solomon's sensual pagan wife leads him to idolatry. Her protruding belly suggests her pregnant state. She points to the idol, a satyr-like man with a flame on his head holding a skull and seated on a ball. The flame and satyr's ears seem to refer to lust and the skull is a reminder that life is transitory. The biblical story (I Kings 11:1–13) emphasises how Solomon was beguiled by love, which led to irrational and indeed dangerous behaviour. Love's power over Solomon is witnessed by spectators, placing it in the public rather than private realm.

> This print is described in the Seville inventory at no. 288 under the classification '*quarto*-size sheet of 12 dressed men': *A man kneeling with his hair dressed, he has the clothes of a sheik, a chain around the neck, hands together, eyes raised to a naked figure who is seated on a round stone, holding half a pig's head in his left hand, we can see only the right thumb and the index finger which holds a sceptre, next is a pregnant woman standing, with her right hand she raises the robes, with the left index finger points to the head, she has seven plumes, at her feet is a bonnet and a sceptre, next to the one kneeling there is a little of a city in the background. L.*

99 | Lucas van Leyden (*c.*1494–1533)
 | *A Young Man Holding a Skull, c.*1519

Engraving
184 × 145 mm
B.viii.174[433]; NH.174
The British Museum, 1849-10-27-82

Lucas constantly experimented with engraving to differentiate between surfaces and materials. In this print the cross-hatching and long parallel lines beautifully describe the young man's garments and headgear. The uniformity of the background heightens the richness of his attire. Although there is no direct evidence, some early commentators thought this engraving might be a self-portrait. It is clear, however, that its subject is a meditation on death. The young man points to the skull, a reminder of the transitory nature of life. His elegant garments and elaborate hat also underline the *vanitas* theme.

This print is described in the Seville inventory at no. 267 under the classification '*quarto*-size sheet of 1 dressed man': *A man in half-length holding a skull in the right under his robes, we cannot see the fingers of the left hand, the right sleeve has four slashes and a button, in the left three, in the opening of the vest are five slashes, he has an embroidered shirt with a button, the bonnet has three slashes with six plumes and a jewel with four pearls.*

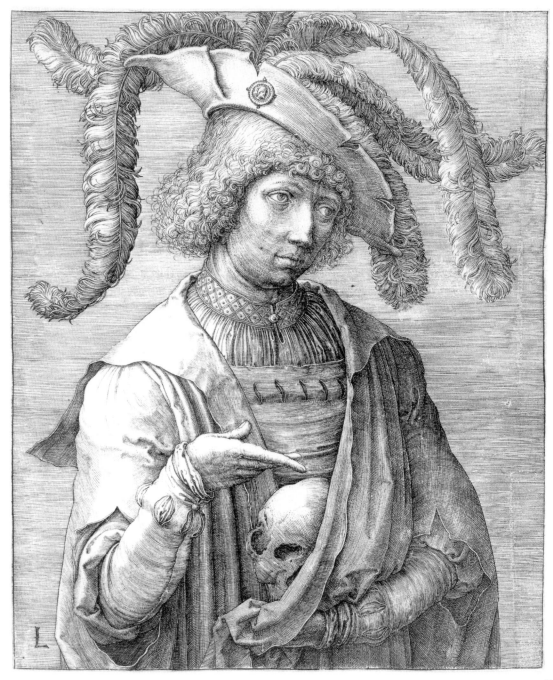

99

100 | Lucas van Leyden (*c.*1494–1533)
| *The Nine Worthies*, *c.*1520

Woodcut
317 × 1522 mm
B.viii.15a-c[442]; NH.190
The British Museum, 1849-10-27-95; E.6-8; 1849-10-27-97

The Nine Worthies were a group of heroes embodying courage and virtue. The subject was frequently depicted during the fifteenth and sixteenth centuries. In this print, the heroes are divided into three groups: pagan heroes of antiquity, Hebrew heroes from the Old Testament, and the Christian heroes of modern history. Lucas's treatment of them as a continuous frieze seems to be one of the earliest; normally they were depicted separately in niches.

This print is described in the Seville inventory at no. 2688 under the classification 'roll of 9 figures': *The nine famous horsemen in six sheets pasted lengthways, each has the letters in Latin below, all on horseback except Alexander who is on an elephant with a hammer in the left, the elephant's left tusk touches Hector's left calf whose false reins have four holes, the point of David's left elbow touches the snout of Judas Maccabeus's horse.*

101a | Monogrammist S (active first half of 16th century)
The Last Supper (The Passion), c.1520

Engraving
155 × 115 mm
Pass.iii.109; H.xiii.125

101b | *The Agony in the Garden*

Pass.iii.110; H.xiii.126

101c | *The Betrayal of Christ*

Pass.iii.111; H.xiii.127

This print is described in the Seville inventory at no. 281 under the classification '*quarto*-size sheet of many dressed male saints'

101d | *Christ Taken Captive*

Pass.iii.112; H.xiii.128

This print is described in the Seville inventory at no. 314 under the classification '*quarto*-size sheet of many dressed male saints'

The British Museum, 1846-5-9-119; 1846-5-9-120; 1846-5-9-134; 1846-5-9-135

The name Monogrammist S most probably refers to the production of an entire workshop rather than one engraver. There are over four hundred prints attributed to his hand, most of which are small and probably made for craftsmen to use to design metalwork and religious items. These four engravings are part of a series of twenty-one that depicted the Passion of Christ. Ferdinand owned the entire series except for the *Resurrection*.

No. 101a. This print is described in the Seville inventory at no. 316 under the classification '*quarto*-size sheet of many dressed male saints': *The Last Supper of Christ with his disciples, Christ has a chalice in his left hand, we can see only that index finger and thumb that touches St John's face, the disciple below to our left has a plate in his hands in which is a lamb, below a knife, Judas has a bag in the right that touches bread, below is a jug that almost touches the right foot of a man and the right foot of Judas.*

No. 101b. This print is described in the Seville inventory at no. 282 under the classification '*quarto*-size sheet of many dressed male saints': *Christ in a small circle kneeling with his hands together, above are two angels, one holds a cross, the other a chalice, a man has a lance that almost touches the right of an apostle, the man in the middle of his chest has four slashes, in the upper right corner a child stabs a serpent with a lance.*

101a

101b

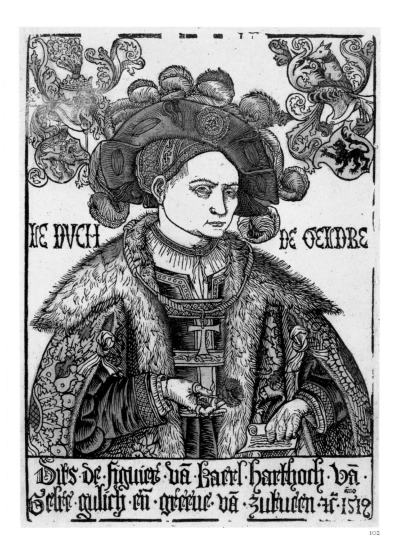

102

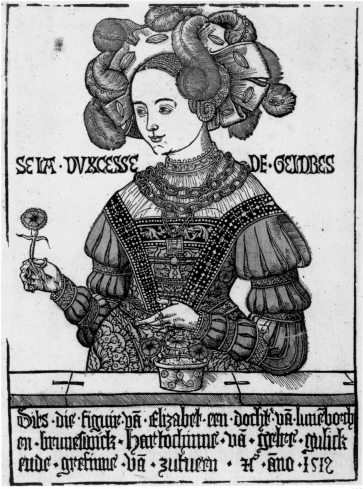

103

102 | Anonymous Netherlandish
Portrait of the Duke of Gelders, 1519

Colour woodcut
370 × 255 mm
Hind, 1932, pp. 34–5.
The British Museum, 1932-6-11-3

These twin portraits [see also cat. no. 103] are unique impressions and were published on the occasion of the marriage of Charles of Egmont (1467–1536), Duke of Gelders, and his wife Elizabeth (1494–1572), daughter of Henry, Duke of Brunswick, in February 1519. Both are holding carnations, symbols of friendship and their betrothal.

> This print is described in the Seville inventory at no. 1718 under the classification '*pliego*-size sheet of 1 dressed man': *A man from the waist up who is the Duke of Gelders, in the right holds a rose, we cannot see that little finger, in the hem of the right sleeve are eight circles, in the left nine, on his garment is a cross, around the neck hangs a chain with a cross of gold, he shows the right ear, has an elaborate headdress, the bonnet is full of plumes which have five twists and a jewel in the middle.*

103 | Anonymous Netherlandish
Portrait of the Duchess of Gelders, 1519

Colour woodcut
363 × 255 mm
Hind, 1932, pp. 34–5.
The British Museum, 1932-6-11-4

See cat. no. 102.

> This print is described in the Seville inventory at no. 1775 under the classification '*pliego*-size sheet of 1 dressed woman': *A woman in half-length, with nine plumes on her head, above her left ear is silver embroidery, in her right hand between her index finger and her thumb is a flower and on that hand are three rings, on the small finger, middle finger, thumb, and on that one is a stone, there are no stones on the other fingers, on the left hand are rings on each finger, the hand is above three carnations.*

104

104 | Jost de Negker (*c.*1485–*c.*1544)
after an unknown artist
St Christopher Bearing the Christ Child, 1506–8

Woodcut
383 × 268 mm
Jacobowitz and Loeb, 1983, n.133, p. 311
The British Museum, 1910-4-9-5

Jost de Negker was a professional woodblock cutter who was an important figure in the early history and development of the woodcut [see also cat. nos 60, 66]. This print is one of the first works he made before he went to Germany in 1508. The image is notable for the superb cutting and the elegant yet dynamic treatment of the subject. The saint's fluttering mantle twists around his staff and falls to his left side, effectively framing and balancing his figure. It is not known who provided the design but Negker probably filled in the landscape details.

> This print is described in the Seville inventory at no. 1923 under the classification '*pliego*-size sheet of 3 dressed male saints': *St Christopher with Christ on the shoulder, the right resting on the world on the head of St Christopher, we can see only three fingers, St Christopher has his right foot outside the water, it touches the crags, his robes wind around his staff and the right arm, there are four ducks in pairs at either side of the staff.*

105 | Jacob Cornelisz. van Oostsanen (*c.*1472/7–1533)
St Michael, 1510

Woodcut
371 × 247 mm
Steinbart, 1937, 11; H.v.135
The British Museum, 1890-1-18-3

This print is one of a series depicting saints on horseback. Although St Michael is the only saint not shown on a horse, he was part of the series. The image is filled with drama: St Michael jumps high above the dragon which recoils in fear as he raises the sword to kill it. Oostsanen's career parallels that of Lucas van Leyden and they may on occasion have collaborated. The woodcut of the *Nine Worthies* [cat. no. 100] was formerly attributed to Oostsanen but is now thought to be by Lucas van Leyden.

> This print is described in the Seville inventory at no. 2484 under the classification '*marca*-size sheet of 1 dressed male saint': *St Michael has a sword in the right hand, in the left he has a shield with which he wants to hit a devil who is below, that hand is hidden, his left foot touches the robes of St Michael, IMA, he has only a fingernail on the right thumb which touches the head [or its tip/end].*

105

106 Jan Wellens de Cock (*c.*1480–*c.*1526/7)
The Ship of St Reynuit (The Ship of Mismanagement),
*c.*1520–30

Woodcut
760 × 1160 mm
Nijhoff, 1931–9, 13–20; Jacobowitz and Loeb Stepanek, 1983, no.108
The Ashmolean Museum, Oxford

The Amsterdam publisher Doen Pietersz. issued this large woodcut printed on
eight sheets of paper in two editions, one with a French letterpress and one with
the text in Dutch, which is shown here. It depicts the story of St Reynuit, the
patron saint of all wastrels and spendthrifts who have no money to their names,
having lost it in the usual, predictable ways – especially by excessive drinking.
St Reynuit enjoyed considerable popularity in the Netherlands throughout the
first half of the sixteenth century. In this print the ship's figurehead is an upturned,
crowned tankard, symbolising one of the ways in which the voyagers have been
impoverished; similarly the coats of arms displayed around the side and stern of
the ship bear playing-cards and dice. At the bottom left of the print is a makeshift
tavern-cum-brothel, another familiar road to ruin.

> This print is described in the Seville inventory at no. 2808 under the classifica-
> tion 'roll of many figures': *A big ship suspending its sails in four sheets of marca-*
> *size, in the rigging of the great mast is a man with open arms, next are the steps, we*
> *can see neither foot, in the topsail of the prow is another man resting and with the*
> *right above, we cannot see either foot, to our right is a great palace upon which is a*
> *spire that has four pillars, in the middle is a bell whose chime a man holds with the*
> *right hand and with the left raises the hammer of the clock, in the upper middle is*
> *a text box of four lines, below are many people and eight text boxes in French type.*

107 | Jan Wellens de Cock (*c.*1480–*c.*1526/7)
*Six Musician Footsoldiers, c.*1520–30

Woodcut
250 × 375 mm
Nijhoff, 1931–9, n.174, pp. 35–6 (as unknown master)
The Ashmolean Museum, Oxford

Attempts fully to resolve the identity and define the career of this printmaker have not been successful, but he is known to have been strongly influenced by Lucas van Leyden. This print is related to the *Ship of St Reynuit* [cat. no. 106]. It seems to have formed part of a procession of musicians and soldiers intended to be part of the Reynuit composition.

This print is described in the Seville inventory at no. 2112 under the classification '*pliego*-size sheet of 6 dressed men': *Six soldiers standing, the three to our left have their own banners, the one in the middle has it in the left, the right is on the pommel of his sword, to our right is one who plays a pipe, he is bareheaded, he seems to be armed, another next to him has the other, he has a hat on his head with six plumes.*

107

108 | Anonymous Netherlandish
The Siege of Aden, 1513

Woodcut
420 × 1160 mm
Nijhoff, 1931–9, pls 21–4; Delen, 1935, p. 35
The British Museum, 1950-3-6-1

In 1513, Alphonso d'Albuquerque (1453–1515) led an unsuccessful attack by Portuguese forces against the Turkish at Aden (now on the south coast of Yemen). The text in the upper right relates details of the battle, how many men were involved and the difficulties they encountered.

> This print is described in the Seville inventory at no. 3177 under the classification 'roll of maps': *Aden, a city in six sheets, three long by two wide, there are many castles on cliffs, there are four boats with men, others without, in another are four men whose prow touches the ground, in this one is the flag of Portugal, further to our left is a halberdier in a door who has the right lower than the left, the tip of the halberd touches his right foot, at the extreme right by the border is an elephant carrying two barrels*

Oese machteghe en grote stat Ade genoemt die gelegé es int conincrijc vā prest indē werc
vā mecha was bestormt en beuochté vā Alfonso dalburkerke capitein generael vande hoge en
machtege edele conic vā portegael here Emanuel ms breebruist voshōder volre die welke noch
is die vrs ide siege die ide stat marc. dese kataelge gesiede vp de heiligé paesschaunt int iaer so
here Ihu cristiaus ms seres. M. cccc. riii. en so dese edele en wel genaedde capiteinins sine
volcke ald' warc verste de siege die ongrlouige hondé en viende ons here Ihu cristi wies den
hoop der mot so seere i grot getale die binné der stat warc dat dese edele capitein in ms der
ke moeste vit sine sept waert ms groter last en sorce al verseede en doorstat de seer vel vā die
majen die hem not grot seade dede onder sin volc als elkerstē mensche wel beclaghen mach

108

109 | Robert Peril (active 1st half of 16th century)
The Genealogical Tree of the House of Hapsburg, 1540

Colour woodcut
7.34m × 470 mm
Nijhoff, 1931–9, pls 231–6; H.xvii.2
The British Museum, 1904-7-23-1

One of the most outstanding, yet little-known, woodcuts produced during the Renaissance, this print commemorates the genealogy of the House of Hapsburg. The tree comprises twenty sheets that were meant to be joined together and hung from a height, or rolled up and spread on a flat surface. The tree begins with King Pharamundo and ends with Emperor Charles V. Editions in French (1535), Latin (1540) and Spanish (1540) are known. The impression shown here is from the 1540 edition. Ferdinand died in 1538 so he would have owned an earlier impression, probably the one with French letterpress.

Little is known about Peril except that he worked in Antwerp, and around 1530 Margaret of Austria commissioned him to produce a similar frieze depicting the procession through Bologna following the coronation of Charles V as emperor.

> This print is described in the Seville inventory at no. 2804 under the classification 'roll of many figures': *The genealogy of King Charles, in a tree at the trunk is a seated emperor who has a sword in his right hand, the index finger of which is set a little apart from the others, his left foot is on a lion, the tree has eight lines of circles in each of which is a man or a woman whose name is inscribed encircling, below is his/her coat of arms, the highest line has six circles and the other four and the last circle on the highest line to our left reads Barberina, it is very beautifully coloured and the colour is applied very well.*

109

109 detail

109 detail

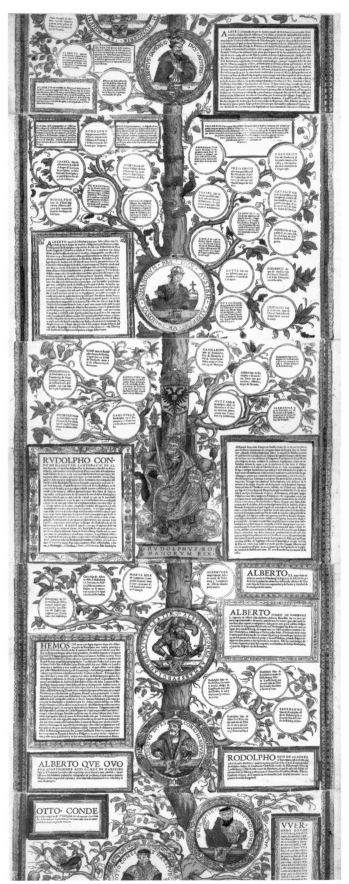

109 detail

109 detail

109 detail

Bibliography

A

Airaldi, *et al.*, 1985
Airaldi, G., *et al.*, *Cristoforo Colombo nella Genova del suo tempo*, Turin, 1985.

Alberti, 1972
Alberti, L.B., *On Painting and On Sculpture: the Latin texts of De Pictura and De Statua*, trans. C. Grayson, London, 1972.

Aldea Vaquero, 1972–5
Aldea Vaquero, Q., T. Marín Martínez *et al.*, *Diccionario de historia eclesiástica de España*, 4 vols, Madrid, 1972–5.

Alizeri, 1870–80
Alizeri, F., *Notizie dei Professori del disegno in Liguria dalle origini al secolo XVI*, 6 vols, Genoa, 1870–80.

Allen, 1933
Allen, P.S., *Opus epistolarum des. Erasmi Roterodami*, 12 vols, Oxford, 1933.

Alvarez, 1998
Alvarez, M.-T., 'Artistic Enterprise and Spanish Patronage: The Art Market during the Reign of Isabel of Castile (1474–1504),' in *Art Markets in Europe 1400–1800*, ed. M. North and D. Ormrod, Aldershot, 1998, pp. 45–59.

Alvarez Márquez, 1992
Alvarez Márquez, M. del Carmen, *El mundo del libro en la Iglesia Catedral de Sevilla en el Siglo XVI*, Seville, 1992.

Alvarez Márquez, 1987
Alvarez Márquez, M. del Carmen, 'La biblioteca de Don Fadrique Enríquez de Ribera, I Marqués de Tarifa (1532)', in *Historia, Instituciones, Documentos*, Seville, 1987, pp. 1–39.

Anzelewsky, 1982
Anzelewsky, F., 'Quelques considérations sur les prix et les formats des gravures à l'époque de Dürer', *Nouvelles de l'estampe*, no.64–5, 1982, p. 11.

Appuhn, and Heusinger, 1976
Appuhn, H., and C.v. Heusinger, *Riesenholzschnitte und Papiertapeten der Renaissance*, Unterschneidheim, 1976.

Aranda Bernal and Quiles, 2001
Aranda Bernal, A. and F. Quiles, 'El medio artístico en la Sevilla imperial', in *Orto Hispalensis. Arte y Cultura en la Sevilla del Emperador*, ed. A. Moreno Mendoza, Seville, 2001, pp. 48–57.

Arranz Márquez, 1991
Arranz Márquez, L., *Repartimientos y encomiendas en la Isla Española*, Madrid, 1991.

B

Babelon, 1913
Babelon, J., *La bibliothèque française de Fernand Colomb*, Paris, 1913.

Bakelants and Hoven, 1981
Bakelants, L., and R. Hoven, *Bibliographie des oeuvres de Nicolas Clénard 1529–1700*, Verviers, 1981.

Bambach, 1999
Bambach, C.C., *Drawing and Painting in the Italian Renaissance Workshop – Theory and Practice, 1300–1600*, Cambridge, 1999.

Bartrum, 2002
Bartrum, G., *Albrecht Dürer and his Legacy: the Graphic Work of a Renaissance Artist*, exh.cat., London, The British Museum, 2002.

Bartrum, 1995
Bartrum, G., *German Renaissance Prints 1490–1550*, exh.cat., London, The British Museum, 1995.

Bartsch, 1971–
Bartsch, A., *The Illustrated Bartsch*, ed. W.L. Strauss, University Park, PA, and New York, 1971–.

Bartsch, 1803–21
Bartsch, A., *Le Peintre-graveur*, 21 vols, Vienna, 1803–21.

Baxandall, 1988
Baxandall, M., *Painting and Experience in Fifteenth Century Italy (A primer in the social history of pictorial style)*, Oxford, 1988.

Beaujouan, 1987
Beaujouan, G., 'Fernand Colomb et la marché du livre scientifique à Lyon en 1535–1536', in *Histoire des Sciences des Techniques*, 1987, pp. 55–63.

Beaujouan, 1960
Beaujouan, G., 'Fernand Colomb et l'europe intellectuelle de son temps', *Journal des Savants*, 1960, pp. 145–59.

Beceiro Pita and Franco Silva, 1985
Beceiro Pita, I., and A. Franco Silva, 'Cultura nobilar y bibliotecas. Cinco ejemplos, de las postrimerías del siglo XIV a mediados del XVI', *Historia, Instituciones, Documentos*, no. 12, 1985, pp. 277–350.

Beceiro Pita, 1982
Beceiro Pita, I., 'La biblioteca del conde de Benavente a mediados del siglo XV y su relación con las mentalidades y usos nobilarios de la época', in *En la españa medieval. Estudios en memoria del Profesor D. Salvador de Moxó*, Madrid, 1982, pp. 135–45.

Bedini, 1998
Bedini, S.A. (ed.), *Christopher Columbus and the Age of Exploration. An Encyclopedia*, New York, 1998.

Bermúdez Plata, 1940
Bermúdez Plata, C., 'Algunas consideraciones sobre

Don Fernando Colón como bibliófilo', *Boletín de la Real Academia Sevillana de Buenas Letras*, lxiv, 1940, pp. 32–41.

Borges, 1987
Borges, J.L., *Labyrinths*, London, 1987.

British Museum, 1958
British Museum, *Short-Title Catalogue of Books Printed in Italy and of Italian Books Printed in Other Countries from 1465 to 1600 now in the British Museum*, London, 1958.

Brown, 1991
Brown, J., 'Spain in the Age of Exploration: Cross-roads of Artistic Cultures', in *Circa 1492. Art in the Age of Exploration*, ed. J.A. Levenson, exh.cat., Washington DC, National Gallery of Art, 1991, pp. 41–9.

Burke, 2000
Burke, P., *A Social History of Knowledge: from Gutenberg to Diderot*, Cambridge, 2000.

Bury, 1985
Bury, M., 'The Taste for Prints in Italy to *c.*1600', *Print Quarterly*, ii, 1985, pp. 12–26.

C

Cadenas y Vicent, 1992
Cadenas y Vicent, V. de, *Diario del emperador Carlos V: Itinerarios, permanencias, despacho, sucesos y efemérides relevantes de su vida*, Madrid, 1992.

Canellas, 1978
Canellas, A., 'Bibliotecas medievales hispanas', *Jerónimo Zurita. Cuadernos de Historia*, no.31–2, 1978, pp. 259–68.

Chartier, 1994
Chartier, R., *The Order of Books. Readers, Authors, and Libraries in Europe between the Fourteenth and Eighteenth Centuries*, trans. L.G. Cochrane, Cambridge, 1994.

Colón, 1992
Colón, F., *Abecedarium B y Supplementum (Ed. facsímil de los manuscritos conservados en la Biblioteca Colombina de Sevilla)*, Madrid, 1992.

Colón, 1984
Colón, H., *Historia del Almirante (Historia 16)*, Madrid, 1984.

Columbus, 1992
Columbus, F., *The Life of the Admiral Christopher Columbus*, trans. B. Keen with introduction, New Jersey, 1992.

Columbus, 1992a
Columbus, C., *The 'Libro de las profecías' of Christopher Columbus*, trans. D.C. West and A. Kling with commentary, Gainesville, 1992.

Conway, 1889
Conway, W.M., *Literary Remains of Albrecht Dürer*, Cambridge, 1889.

Coppel, 1996
Coppel, S., 'William Mitchell (1820–1908) and John Malcolm of Poltalloch (1805–93)', in *Landmarks in Print Collecting*, ed. A. Griffiths, London, 1996, pp. 159–88.

Cotarelo y Valledor, 1905
Cotarelo y Valledor, A., *Fray Diego de Deza. Ensayo biográfico*, Madrid, 1905.

Cuartero Huerta, 1950–54
Cuartero Huerta, B., *Historia de la Cartuja de Santa Maria de las Cuevas de Sevilla y de su filial de Cazalla de la Sierra*, 2 vols, Madrid, 1950–54.

D

Delen, 1934–5
Delen, A.J.J., *Histoire de la gravure dans les anciens Pays-Bas et dans les provinces belges, des origines jusqu'à la fin du XVIIIᵉ siècle* (part 2, 1934 and part 3, 1935), Paris, 1934–5.

Dodgson, 1980
Dodgson, C., *Catalogue of Early German and Flemish Woodcuts Preserved in the Department of Prints and Drawings in the British Museum*, 2 vols, London, 1903 (reprinted 1980).

Dodgson, 1934 and 1935
Dodgson, C., *Woodcuts of the XV Century in the Department of Prints and Drawings, British Museum*, 2 vols, London, 1934 (vol.1), 1935 (vol.2).

Dodgson, 1935
Dodgson, C., 'The Earliest Works of Jost de Negker', *The Print Collector's Quarterly*, xxii, 1935, pp. 9–17.

Domínguez Bordona, 1935
Domínguez Bordona, J., 'Manuscritos de América', in *Catálogos de la Biblioteca de Palacio*, Madrid, 1935.

Domínguez Casas, 1993
Domínguez Casas, R., *Arte y etiqueta de los Reyes Católicos. Artistas, residencias, jardines y bosques*, Madrid, 1993.

Dreyer, 1972
Dreyer, P., *Tizian und sein Kreis, 50 venezianische Holzschnitte aus dem Berliner Kupferstichkabinett Staatliche Museen Preussischer Kulturbesitz*, Berlin, c.1972.

Duque de Maura, 1944
Duque de Maura (G. Maura Gamazo), *El príncipe que murió de amor. Don Juan, primogénito de los reyes católicos*, Madrid, 1944.

E

Eisenstein, 1979
Eisenstein, E., *The Printing Press as an Agent of Change. Commentaries and Cultural Transformations in Early-Modern Europe*, 2 vols, Cambridge, 1979.

Espinosa y Quesada, 1892
Espinosa y Quesada, 'Catálogo de estampas de Don Fernando Colón', *El Centenario*, ii, 1892, pp. 171–5.

Esteban Romero, 1939
Esteban Romero, A.A., *Don Fernando Colón. Su personalidad literaria. Repertorios, bibliográficos y manuscritos*, Seville, 1939.

F

Faietti, and Scaglietti Kelescian, 1995
Faietti, M., and D. Scaglietti Kelescian, *Amico Aspertini*, Modena, 1995.

Fernández Armesto, 1975
Fernández Armesto, F., *Ferdinand and Isabella*, London, 1975.

Fernández de Navarrete, 1850
Fernández de Navarrete, E., 'Noticias para la vida de don Hernando Colón', in *Colección de documentos inéditos para la Historia de España*, Madrid, 1850.

Fernández de Oviedo, 1870
Fernández de Oviedo, G., *Libro de la Cámara Real del Príncipe Don Juan, é oficios de su casa é servicio ordinario*, Madrid, 1870.

Floyd, 1973
Floyd, T.S., *The Columbus Dynasty in the Caribbean, 1492–1526*, Albuquerque, 1973.

G

Gallego, 1990
Gallego, A., *Historia del grabado en España*, Madrid, 1990.

Gaskell, 1995
Gaskell, P., *A New Introduction to Bibliography*, New Castle, Delaware, 1995.

Geisberg, 1974
Geisberg, M., *The German Single-Leaf Woodcut: 1500–1550*, ed. and rev. Walter L. Strauss, 4 vols, New York, 1974.

Gestoso y Pérez, 1910
Gestoso y Pérez, J., *Curiosidades antiguas sevillanas*, Seville, 1910.

Gil, 1989
Gil, J., *Las joyas de la Colombina: las lecturas de Hernando Colón*, Seville, 1989.

Gómez Piñol, 1966
Gómez Piñol, E., *Catálogo de las estampas de Hernando Colón. Edición y estudio*, Seville (Facultad de Filosofía y Letras, Universidad de Sevilla), 1966 (thesis defended).

Goodhart Gordon, 1974
Goodhart Gordon, P.W. (trans. and annot.), *Two Renaissance Book Hunters. The Letters of Poggius Bracciolini to Nicolaus de Niccolis*, New York and London, 1974.

Goris and Marlier, 1971
Goris, J.-A., and G. Marlier, *Albrecht Dürer. Diary of His Journey to the Netherlands, 1520–1521*, New York, 1971.

Grigg, 1986
Grigg, R., 'Studies on Dürer's Diary of his Journey to the Netherlands: The Distribution of the *Melencolia I*', *Zeitschrift für Kunstgeschichte*, xlix, 1986, pp. 398–409.

Gugenbauer, 1911
Gugenbauer, G., 'Zu Israhel von Meckenem', *Mitteilungen der Gesellschaft für vervielfältigende Kunst*, no. 4, 1911, pp. 65–66.

Guillén Torralba, 1990
Guillén Torralba, J., 'Las bibliotecas de la catedral. La Colombina', in *La Biblioteca Colombina y Capitular*, Seville, 1990, pp. 5–42.

Guillén Torralba, 1992
Guillén Torralba, J., 'Hernando Colón', *Isidorianum*, ii, 1992, pp. 185–221.

H

Hajós, 1958
Hajós, E.M., 'The Concept of an Engravings Collec-

tion in the Year 1565: Quiccheberg, *Inscriptiones vel tituli Theatri Amplissimi*', *The Art Bulletin*, xl, 1958, pp. 151–6.

Harrisse, 1887
Harrisse, H., *Excerpta Colombiniana. Bibliographie de quatre cents pièces gothiques ... précédée d'une histoire de la Bibliothèque Colombine et de son fondateur*, Paris, 1887.

Harrisse, 1884
Harrisse, H., *Christophe Colomb: son origine, sa vie, ses voyages, sa famille et ses descendants, d'après des documents inédits...*, 2 vols, Paris, 1884.

Harrisse, 1871
Harrisse, H., *D. Fernando Colón, historiador de su padre. Ensayo crítico*, Seville, 1871.

Hazañas y la Rúa, 1909
Hazañas y la Rúa, J., *Maese Rodrigo: 1444–1509*, Seville, 1909.

Heitz, 1899–1942
Heitz, P. (ed.), *Einblattdrucke des Fünfzehnten Jahrhunderts*, 100 vols, Strasbourg, 1899–1942.

Hernad, 1990
Hernad, B., *Die Graphiksammlung des Humanisten Hartmann Schedel*, Munich, 1990.

Hernández Díaz and Muro Orejón, 1941
Hernández Díaz, J., and A. Muro Orejón, *El testamento de Don Hernando Colón y otros documentos para su biografía*, Seville, 1941.

Hind, 1963
Hind, A.M., *Introduction to a History of Woodcut, With a Detailed Survey of Work Done in the Fifteenth Century*, 2 vols, New York, 1935 (repr. 1963).

Hind, 1938–48
Hind, A.M., *Early Italian Engraving. A Critical Catalogue with Complete Reproduction of all the Prints Described*, 7 vols, London, 1938–48.

Hind, 1932
Hind, A.M., 'Rare Woodcuts and Engravings from the Boerner Sale', *British Museum Quarterly*, vii, 1932, pp. 34–5.

Hobson, 1999
Hobson, A., *Renaissance Book Collecting. Jean Grolier and Diego Hurtado de Mendoza, their Books and Bindings*, Cambridge, 1999.

Hollstein, 1954–
Hollstein, F.W.H., *German Engravings, Etchings and Woodcuts 1400–1700*, Amsterdam/Rotterdam, 1954–.

Hollstein, 1949–
Hollstein, F.W.H., *Dutch and Flemish Etchings, Engravings and Woodcuts, ca. 1450–1700*, Amsterdam, 1949–.

Huarte y Echenique, 1919
Huarte y Echenique, A., 'Apuntes para la biografía del maestro Juan Vaseo', *Revista de Archivos, Bibliotecas y Museos*, xl, 1919, pp. 519–35.

Huizinga, 1952
Huizinga, J., *Erasmus of Rotterdam*, New York, 1952.

Huntington, 1967
Huntington, A.M., *Catalogue of the Library of Ferdinand Columbus. Reproduced in Facsimile from the Unique Manuscript in the Columbine Library of Seville*, New York, 1905 (repr. 1967).

I

The Illustrated Bartsch
A. Bartsch, *The Illustrated Bartsch*, ed. de W. L. Strauss, University Park (Pennsylvania) and New York, 1971–.

J

Jacob, 1996
Jacob, C., 'Lire pour écrire: navigations alexandrines', in *Le Pouvoir des bibliothèques. Les mémoires des livres en Occident*, ed. M. Baratin and C. Jacobs, 1996, pp. 47ff.

Jacobowitz and Stepanek, 1983
Jacobowitz, E.S., and S.L. Stepanek, *The Prints of Lucas van Leyden and His Contemporaries*, exh.cat., Washington DC, National Gallery of Art; Boston, Museum of Fine Arts, 1983.

Jardine, 1993
Jardine, L., *Erasmus, Man of Letters*, Princeton, 1993.

Johnson, 1982
Johnson, J., 'Ugo da Carpi's Chiaroscuro Woodcuts', *Print Collector*, no. 57–8, 1982, pp. 2–87.

Jos, 1944
Jos, E., 'Investigaciónes sobre la vida y obras iniciales de Don Fernando Colón', *Anuario de Estudios Americanos*, i, 1944, pp. 1–174 (double sequence 527–698).

Jos, 1941
Jos, E., 'En las postrimerías de un centenario colombino poco celebrado', *Estudios Geográficos*, no. 4, 1941, pp. 513–65.

K

Kamen, 1991

Kamen, H., *Spain 1469–1714: A Society in Conflict*, London and New York, 1991.

Koch, 1951

Koch, R.A., 'Two Engravings by Monogrammist "S" (Alexander van Bruessele?)', *Record of the Art Museum of Princeton University*, x, 1951, pp. 12–19.

Kristeller, 1896

Kristeller, P., *Engravings and Woodcuts by Jacopo de' Barbari*, Berlin, 1896.

Künast, 2001

Künast, H.-J., 'Die Graphiksammlung des Augsburger Stadtschreibers Konrad Peutinger', in *Augsburg, die Bilderfabrik Europas. Essays zur Augsburger Druckgraphik der Frühen Neuzeit*, edited by J.R. Paas, Augsburg, Schwäbische Geschichtsquellen und Forschungen, Schriftenreihe des Historisches Vereins für Schwaben, Bd. 21, 2001, pp. 11–19.

Kwakkelstein, 1998

Kwakkelstein, M.W., 'Botticelli, Leonardo and a Morris Dance', *Print Quarterly*, xv, 1998, pp. 3–14.

L

Landau, 2003

Landau, D., 'The Print Collection of Ferdinand Columbus (1488–1539)', in *Collecting Prints and Drawings in Europe, c.1500–1750*, ed. C. Baker, C. Elam and G. Warwick, Aldershot, 2003, pp. 29–36.

Landau and Parshall, 1994

Landau, D., and P. Parshall, *The Renaissance Print: 1470–1550*, New Haven and London, 1994.

Lehrs, 1908–34

Lehrs, M., *Geschichte und kritischer Katalog des deutschen, niederländischen und französischen Kupferstichs im XV. Jahrhundert*, 16 vols, Vienna, 1908–34.

Levenson, Oberhuber, *et al.*, 1973

Levenson, J.A., K. Oberhuber *et al.*, *Early Italian Engravings from the National Gallery of Art*, Washington, 1973.

Lleó Cañal, 1979

Lleó Cañal, V., *Nueva Roma: Mitología y humanismo en el renacimiento sevillano*, Seville, 1979.

Lleó Cañal, 1998

Lleó Cañal, V., *La Casa de Pilatos de Sevilla*, Madrid, 1998.

M

Madrid, 2002

Madrid, *'Del Amor y la muerte'. Dibujos y grabados de la Biblioteca Nacional*, exh.cat., Madrid, Biblioteca Nacional; Barcelona, Fudació Caixa Catalunya la Pedrera, 2002.

Mal Lara, 1992

Mal Lara, J. de, *Recibimiento que hizo la Muy Noble y Muy Leal ciudad de Sevilla a la C.R.M. del Rey D. Philipe II*, ed. Manuel Bernal Rodríguez, Seville, 1570 (repr. 1992).

Manguel, 1997

Manguel, A., *A History of Reading*, London, 1997.

Manzano, 1960

Manzano, J., 'La legitimación de Hernando Colón', *Anales de la Universidad Hispalense*, 1960, pp. 85–106.

Manzano Manzano, 1964

Manzano Manzano, J., *Cristóbal Colón: seite años desisivos de su vida, 1485–1492*, Madrid, 1964.

Marín, 1952 & 1954

Marín, T., 'La biblioteca del obispo Juan Bernal Díaz de Luco (1495–1556)', *Hispania Sacra*, v & vii, 1952 & 1954, pp. 263–326 (v) and 47–84 (vii).

Marín Martínez, 1993

Marín Martínez, T., J.M. Ruiz Asencio *et al.*, *Catálogo Concordado de la Biblioteca de Hernando Colón*, 2 vols, Madrid, 1993.

Marín Martínez, 1970

Marín Martínez, T., *(Memoria de las) Obras y libros de don Hernando Colón*, Madrid, 1970.

Marrow and Shestack, 1981

Marrow, J.H., and A. Shestack, *Hans Baldung Grien. Prints and Drawings*, exh.cat., Washington DC, National Gallery of Art; New Haven, Yale University Art Gallery, 1981.

Massing, 1977

Massing, J.M., 'Jacobus Argentoratensis. Etude préliminaire', *Arte Veneta*, xxxi, 1977, pp. 42–52.

Matute, 1896

Matute, J., 'Adiciones y correcciones al tomo IX del viaje de España de D. Antonio Pons', *Archivo Hispalense*, ii, 1896, p.n.a.

McDonald, 2004

McDonald, M.P., *The Print Collection of Ferdinand Columbus (1488–1539): a Renaissance collector in Seville*, 2 vols (with CD-ROM), London, 2004.

McDonald, 2003

McDonald, M.P., '"Extremely curious and important!": Reconstructing the Print Collection of Ferdinand Columbus,' in *Collecting Prints and Drawings in Europe, c.1500–1750*, ed. C. Baker, C. Elam and G. Warwick, Aldershot, 2003, pp. 37–54.

McDonald, 2003a

McDonald, M.P., 'Burgkmair's Woodcut Frieze of Natives of Africa and India', *Print Quarterly*, xx, 2003, pp. 227–44.

McDonald, 2001

McDonald, M.P., 'Coleccionismo en la era del descubrimiento: La colección de estampas de Hernando Colón', *Goya*, no. 283–4, 2001, pp. 299–307.

McDonald, 2000

McDonald, M.P., 'The Print Collection of Ferdinand Columbus', *Print Quarterly*, xvii, 2000, pp. 43–6.

McDonald, 2000a

McDonald, M.P., 'Database Design and Management for the Columbus Print Collection Project', *Print Quarterly*, xvii, 2000, pp. 374–80.

McDonald, 1998

McDonald, M.P., 'The Print Collection of Philip II at the Escorial', *Print Quarterly*, xv, 1998, pp. 15–35.

Meder, 1932

Meder, J., *Dürer-Katalog: Ein Handbuch über Albrecht Dürers Stiche, Radierungen, Holzschnitte, deren Zustände, Ausgaben und Wasserzeichen*, Vienna, 1932.

Mexia, 1989–90

Mexia (Mejía), P., *Silva de varia lección*, Seville, 1543 (repr. 1989–90).

Mora Mérida, 1988

Mora Mérida, J.L., 'Un hombre, una historia y una mentalidad: Don Hernando Colón (1488–1539)', in *Descripción y Cosmografía de España*, Seville, 1988, pp. ix–lii.

Morales Padrón, 1989

Morales Padrón, F., *Historia de Sevilla: La ciudad de Quinientos*, Seville, 1989.

Moreno Mendoza, 2001

Moreno Mendoza A., ed. *Orto Hispalensis. Arte y Cultura en la Sevilla del Emperador*, Seville, 2001.

Muller, 1997
Muller, F., *Heinrich Vogtherr l'Ancien: un artiste entre Renaissance et Réforme*, Wiesbaden, 1997.

Muro Orejón, 1964–84
Muro Orejón, A., ed. *Pleitos Colombinos*, 8 vols, Seville, 1964–84.

Muro Orejón, 1940
Muro Orejón, A., 'Don Hernando Colón: protector de las Bellas Artes', *Boletín de la Real Academia Sevillana de Buenas Letras*, lxiv, 1940, pp. 25–31.

N
Nijhoff, 1931–9
Nijhoff, W., *Nederlandsche Houtsneden 1500–1550. Reproducties van oude Noord- en Zuid Nederlandsche Houtsneden op losse Bladen met en zonder tekst in de oorspronkelijke Grootte*, 's-Gravenhage, 1931–9.

O
Obregon, 1992
Obregon, E. de, 'Beatriz Enríquez, la amante de Cristóbal Colón', *Historia y vida*, xxv, 1992, pp. 38–46.

Oliva Alonso, 1982
Oliva Alonso, D., 'De arquitectura doméstica sevillana en el siglo xvi', in *Homenaje al Profesor Dr Hernández Díaz*, Seville, 1982, pp. 231–41.

Ostos and Pardo, 1997
Ostos, P., M.L. Pardo *et al.*, *Vocabulario de codicología*, Madrid, 1997.

P
Panofsky, 1955
Panofsky, E., 'The History of the Theory of Human Proportions as a Reflection of the History of Styles', in *Meaning in the Visual Arts*, London, 1955, pp. 55–107.

Parshall, 1982
Parshall, P., 'The Print Collection of Ferdinand, Archduke of Tyrol', *Jahrbuch der Kunsthistorischen Sammlungen in Wien*, lxxviii, 1982, pp. 139–84.

Parsons, 1952
Parsons, E.A., *The Alexandrian Library, Glory of the Hellenic World*, London, 1952.

Passavant, 1860–64
Passavant, J.D., *Le Peintre-graveur*, 6 vols, Leipzig, 1860–64.

Provost, 1991
Provost, F., *Columbus: An Annotated Guide to the Scholarship on His Life and Writings, 1750 to 1988*, Detroit, 1991.

R
Ravà, 1920
Ravà, A., 'Il "Camerino delle antigaglie" di Gabriele Vendramin', *Nuovo Archivio Veneto*, xxxix (new series, year xxii), 1920, pp. 155–81.

Recio Mir, 2001
Recio Mir, Á., 'Realidad y proyecto en la arquitectura de la *imperial Seville*', in *Orto Hispalensis. Arte y Cultura en la Sevilla del Emperador*, ed. A. Moreno Mendoza, Seville, 2001, pp. 58–79.

Rhodes, 1958
Rhodes, D.E., 'Don Fernando Colón and his London Book Purchases, June 1522', *The Papers of the Bibliographical Society of America*, lii, 1958, pp. 231–48.

Richardson, 1999
Richardson, B., *Printing, Writers and Readers in Renaissance Italy*, Cambridge, 1999.

Rivoli and Ephrussi, 1891
Rivoli, Duc de, and C. Ephrussi, 'Zoan Andrea et ses homonymes', *Gazette des Beaux-Arts*, v & vi, 1891, pp. 401–15 (v), 225–44 (vi).

Roca y Ponsa and Maldonado, 1971
Roca y Ponsa, J., and J.M. Maldonado, *Biblioteca Colombina. Catálogo de sus libros impresos publicado... bajo la... dirección de su bibliotecario... Dr D. Servando Arbolí y Farando*, with notes by Simón de la Rosa y López, 7 vols, Seville, 1888–1948 (repr. 1971).

Roersch, 1933
Roersch, A., *L'Humanisme belge à l'époque de la Renaissance. Études et Portraits*, Louvain, 1933.

Rosa y López, 1906
Rosa y López, S. de la, 'El itinerario de Don Hernando Colón y su vocabulario topográfico de España', *Revista de Archivos, Biblioteca y Museos*, year x, 1906, pp. 106–18, 260–74.

Rosand and Muraro, 1976
Rosand, D., and M. Muraro, *Titian and the Venetian Wood-cut*, exh.cat., Washington DC, National Gallery of Art; Dallas Museum of Fine Arts; Detroit Institute of Arts, 1976.

Roth, 2000
Roth, H., *Der Anfang der Museumslehre in Deutsch-land: das Traktat 'Inscriptiones vel tituli theatri amplissimi' von Samuel Quiccheberg*, Berlin, 2000.

Röttinger, 1942
Röttinger, H., 'Hans Wechtlin und der Hell-dunkelschnitt', *Gutenberg Jahrbuch*, xvii–xviii, 1942, pp. 107–13.

Röttinger, 1911
Röttinger, H., 'Neues zum Werke Hans Weiditz,' *Mitteilungen der Gesellschaft für vervielfältigende Kunst*, no. 3, 1911, pp. 46–52.

Röttinger, 1904
Röttinger, H., *Hans Weiditz der Petrarkameister*, Strasbourg, 1904.

Röver-Kann, 2001
Röver-Kann, A., *Albrecht Dürer: Das Frauenbad von 1496*, exh.cat., Kunsthalle, Bremen, 2001.

Ruffini, 1960
Ruffini, M., *Fernando Colombo e i libri italiani della Biblioteca Colombina di Siviglia*, Turin, 1960.

Ruiz Asencio, 1995
Ruiz Asencio, J.M., *Testamento de Hernando Colón (estudio critico y transcripción)*, Madrid, 1995.

S
Sáez Guillén, 2002
Sáez Guillén, J.F., *Catálogo de manuscritos de la Biblioteca Colombina de Sevilla (Elaboración de índices. P. Jiménez de Cisneros Vencelá)*, 2 vols, Seville, 2002.

Sánchez Cantón, 1950
Sánchez Cantón, F.J., *Libros, tapices y cuadros que coleccionó Isabel la Católica*, Madrid, 1950.

Schiffauer
Schiffauer, G., 'Hernando Colón en Flandes y en Alemania (1520–1522)', in *Homenaje a Elías Serra Ráfols*, Universidad de la Laguna, n.d., pp. 317–30.

Schilling, 1999
Schilling, H., 'Charles V and Religion. The Struggle for the Integrity and Unity of Christendom', in *Charles V 1500–1558 and his Time*, ed. H. Soly, Antwerp and Cambridge, 1999, pp. 285–364.

Schoenrich, 1949–50
Schoenrich, O., *The Legacy of Christopher Columbus: The Historic Litigations Involving his Discoveries, his Will, his Family, and his Descendants*, 2 vols, Glendale, 1949–50.

Schreiber, 1969
Schreiber, W.L., *Handbuch der Holz- und Metal-schnitte des XV. Jahrhunderts*, 8 vols, Stuttgart, 1969.

Schuppisser, 1989
Schuppisser, F.O., 'Copper Engraving of the "Mass Production" Illustrating Netherlandish Prayer Manuscripts', Paper presented at the Masters and Miniatures Congress (Medieval Manuscript Illumination in the Northern Netherlands), Utrecht, 10–13 December 1989.

Sebastián y Bandarán, 1940
Sebastián y Bandarán, J., 'La casa, los libros y la biblioteca de Don Fernando Colón,' *Boletín de la Real Academia Sevillana de Buenas Letras*, lxiv, 1940, pp. 16–24.

Segura Morera and Vallejo Orellana, 2001
Segura Morera, A., and P. Vallejo Orellana, *Catálogo de los impresos del siglo xvi de la Biblioteca Colombina de Sevilla (Vol.1: A–B)*, Seville, 2001.

Segura Morera and Vallejo Orellana *et al.*, 1999
Segura Morera, A., P. Vallejo Orellana *et al.*, *Catálogo de incunables de la biblioteca capitular y colombina de Sevilla*, Seville, 1999.

Serrano y Sanz, 1932
Serrano y Sanz, M., '*Proemio*' to the Historia del almirante don Cristóbal Colón by his son Don Hernando, Madrid, 1932.

Shaw, 1933
Shaw, J. Byam, 'The Master I.B. with the Bird. Part II', *The Print Collector's Quarterly*, xx, 1933, pp. 9–33 and 169–78.

Shaw, 1932
Shaw, J. Byam, 'The Master I.B. with the Bird. Part I', *The Print Collector's Quarterly*, xix, 1932, pp. 273–97.

Shestack, 1969
Shestack, A., *The Complete Engravings of Martin Schongauer*, New York, 1969.

Shestack and Talbot, 1969
Shestack, A., and C. Talbot, *Prints and Drawings of the Danube School*, exh.cat., New Haven, Yale University Art Gallery; Philadelphia Museum of Art, 1969.

Siurot, 1940
Siurot, M., 'Algo de Fernando Colón', *Boletín de la Real Academia Sevillana de Buenas Letras*, lxiv, 1940, pp. 1–8.

Staikos, 2000
Staikos, K.Sp., *The Great Libraries from Antiquity to the Renaissance (3000 B.C. to A.D. 1600)*, Delaware and London, 2000.

Steinbart, 1937
Steinbart, K., *Das Holzschnittwerk des Jakob Cornelisz. von Amsterdam*, Burg, 1937.

T
Taviani, 1985
Taviani, P.E., *Christopher Columbus: the Grand Design*, London, 1985.

Torre, 1956
Torre, A. de la, 'Maestros de los hijos de los Reyes Católicos', *Hispania. Revista Española de Historia*, xvi, 1956, pp. 256–66.

Torre Revello, 1945
Torre Revello, J., 'Don Hernando Colón: su vida, su biblioteca, sus obras', *Revista de Historia de América*, no.19, 1945, pp. 1–59.

Torre y del Cerro, 1933
Torre y del Cerro, J. de la, *Beatriz Enríquez de Harana y Cristóbal Colón, estudio y documentos*, Madrid, 1933.

Treen, 1989
Treen, M. de Freitas, *The Admiral and his Lady: Columbus and Filipa of Portugal*, New York, 1989.

V
van der Hejden, 1992
van der Hejden, H.A.M., *De Oudste Gedrukte Kaarten van Europa*, Alphen aan den Rijn, 1992.

Van Os, 1994
Van Os, H., *The Art of Devotion in the Late Middle Ages in Europe 1300–1500*, trans. M. Hoyle, exh.cat., Amsterdam, Rijksprentenkabinet, Rijksmuseum, 1994.

Vega, 1992
Vega, J., 'Impresores y libros en el origen del Renacimiento en España', in *Reyes y Mecenas: Los reyes católicos – Maximiliano I y los inicios de la Casa de Austria en España*, Toledo, Museo de Santa Cruz, 1992, pp. 199–232.

Vocht, 1934
Vocht, H. de, *Monumenta Humanistica Lovaniensia: Texts and Studies about Louvain Humanists in the First Half of the XVI Century*, Louvain, 1934.

W
Wagner, 2000
Wagner, K., 'Fernando Colombo, Genova e i genovesi', *La Berio*, no. 2, 2000, pp. 5–13.

Wagner, 2000a
Wagner, K., 'La "locura" de don Hernando Colón': Discourse read before the Real Academia Sevillana de Buenas Letras – 13 February 2000.

Wagner, 1995
Wagner, K., '"Ego Arabicomanés" Andazas del humanista Nicolás Clenardo en España y Portugal', *Archivo Hispalense*, 237, 1995, pp. 95–102.

Wagner, 1992
Wagner, K., 'La Biblioteca Colombina en tiempos de Hernando Colón', *Historia, Instituciones, Documentos*, 19, 1992, pp. 485–95.

Wagner, 1992a
Wagner, K., 'Hernando Colón: semblanza de un bibliófilo y de su biblioteca en el quinientos aniversario de su nacimiento', in *El libro antiguo español. Actas del segundo Coloquio Internacional (Madrid)*, ed. M.L. López Vidriero and P.M. Cátedra, Salamanca, 1992, pp. 475–92.

Wagner, 1992b
Wagner, K., 'Hernando Colón y la formación de su biblioteca', in *Actas del primer encuentro internacional colombino*, ed. C. Varela, 1992, pp. 175–83.

Wagner, 1991
Wagner, K., 'Hernando Colón en Italia', *Archivo Hispalense*, 225, 1991, pp. 51–61.

Wagner, 1990
Wagner, K., 'Hernando Colón: el hombre y su biblioteca', in *La Biblioteca Colombina y Capitular*, Seville, 1990, pp. 43–67.

Wagner, 1988
Wagner, K., 'Libros de la Biblioteca Colombina perdidos y hallados', *Journal of Hispanic Philology*, xiii, 1988, pp. 7–11.

Wagner, 1986
Wagner, K., 'Libros obsequiados a Hernando Colón y otras curiosidades de su biblioteca', in *Homenaje a Pedro Sáinz Rodríguez*, Madrid, 1986, pp. 713–24.

Wagner, 1986a
Wagner, K., 'Bibliotecas antiguas en la Biblioteca Universitaria de Sevilla', in *El libro antiguo español:*

Actas del primer Coloquio Internacional, ed. M.L. López–Vidriero and P.M. Cátedra, Madrid, 1986, pp. 403–8.

Wagner, 1984
Wagner, K., 'El itinerario de Hernando Colón según sus anotaciones. Datos para la biografía del bibliófilo sevillano', *Archivo Hispalense*, 203, 1984, pp. 81–99.

Wagner, 1981
Wagner, K., 'La reforma protestante en los fondos bibliográficos de la Biblioteca Colombina', *Revista Española de Teología*, xli, 1981, pp. 393–463.

Wagner, 1979
Wagner, K., *El doctor Constantino Ponce de la Fuente: El Hombre y su Biblioteca*, Seville, 1979.

Wagner, 1976
Wagner, K., 'La biblioteca del Dr. Francisco de Vargas, compañero de Egidio y Constantino', *Bulletin Hispanique*, lxxviii, 1976, pp. 314–23.

Wagner, 1973
Wagner, K., 'Las aldinas de la Biblioteca Colombina. Contribución al estudio de los precios de libros a comienzos el siglo XVI', *Archivo Hispalense*, 171–3, 1973, pp. 209–14.

Wagner, 1972
Wagner, K., 'Biblioteca Colombina: Las siglas relativas al pie de imprenta en los repertorios bibliográficos de Hernando Colón', *Cuadernos bibliográficos*, xxviii, 1972, pp. 41–9.

Wagner, 1972a
Wagner, K., 'Altre notizie sulla sorte dei libri di Marin Sanudo', *La Bibliofilia*, lxxiv, 1972, pp. 185–90.

Wagner, 1972b
Wagner, K., 'Apuntes para el coste de vida en Sevilla, agosto 1544 – febrero 1545', *Archivo Hispalense*, clxx, 1972, pp. 119–30.

Wagner, 1971
Wagner, K., 'Sulla sorte di alcuni codici manoscritti appartenuti a Marin Sanudo', *La Bibliofilia*, lxxiii, 1971, pp. 247–62.

Wagner, 1969
Wagner, K., 'Verzeichnis der in der 'Biblioteca Colombina' (Sevilla) vorhandenen Druckwerke in deutscher und niederländischer Sprache', *Börsenblatt für den Deutschen Buchhandel-Frankfurter Ausgabe*, 51, 1969, pp. 1529-40.

Wagner, 1967/9
Wagner, K., 'Ein Sohn des Kolumbus in Worms zur Zeit des Reichstages 1521', *Der Wormsgau. Zeitschrift der Kulturinstitute der Stadt Worms und des Altertumsvereins Worms*, viii, 1967/9, pp. 34–7.

Wagner, 1966
Wagner, K., 'Un hijo de Colón en Alemania', *Anales de la Universidad Hispalense*, xxvi, 1966, pp. 101–9.

Wagner and Carrera, 1991
Wagner, K. and M. Carrera, *Catalogo dei libri a stampa in lingua italiana della Biblioteca Colombina di Siviglia*, Ferrara, 1991.

Wagner and Guillén, 1991
Wagner, K., and J. Guillén, 'Pasado, presente y futuro de la Biblioteca Colombina', in *Hernando Colón y su Epoca*, Seville, 1991, pp. 61–77.

Winzinger, 1963
Winzinger, F., *Albrecht Altdorfer Graphik: Holzschnitte, Kupferstiche, Radierungen*, Munich, 1963.

Yarza, 1993
Yarza, J., *Los Reyes Católicos: paisaje artistico de una monarquia*, Madrid, 1993.

List of Works in the Catalogue

Altdorfer, Albrecht (1482/5–1538)
The Massacre of the Innocents, 1511
Woodcut
193 × 146 mm
The British Museum, 1895-1-22-356 (no. 68, p. 184)

St Christopher Bearing the Christ Child, 1513
Woodcut
168 × 120 mm
The British Museum, 1895-1-22-363 (no. 69, p. 185)

The Large Crucifixion, 1515–17
Engraving
144 × 99 mm
The British Museum, 1842-8-6-94 (no. 70, p. 185)

The Entry into Jerusalem (The Fall and Redemption of Man), c.1513
Woodcut
72 × 48 mm
The British Museum, 1895-1-22-324 (no. 71a, p. 186)

The Last Supper, c.1513
Woodcut
72 × 48 mm
The British Museum, 1895-1-22-325 (no. 71b, p. 186)

The Agony in the Garden, c.1513
Woodcut
72 × 48 mm
The British Museum, 1895-1-22-326 (no. 71c, p. 186)

The Betrayal of Christ, c.1513
Woodcut
72 × 48 mm
The British Museum, 1895-1-22-327 (no. 71d, p. 186)

Christ before Caiaphas
Woodcut
72 × 48 mm
The British Museum, 1895-1-22-328 (no. 71e, p. 186)

Christ Presented before Pilate
Woodcut
72 × 48 mm
The British Museum, 1895-1-22-329 (no. 71f, p. 186)

The Flagellation of Christ, c.1513
Woodcut
72 × 48 mm
The British Museum, 1895-1-22-330 (no. 71g, p. 186)

Christ Crowned with Thorns
Woodcut
72 × 48 mm
The British Museum, 1895-1-22-331 (no. 71h, p. 186)

Jael and Sisera, 1513
Woodcut
121 × 94 mm
The British Museum, 1895-1-22-350 (no. 72, p. 188)

St Christopher Seated on the Bank, c.1515–17
Woodcut
121 × 94 mm
The British Museum, 1895-1-22-362 (no. 73, p. 188)

Joshua and Caleb, 1520–25
Woodcut
121 × 94 mm
The British Museum, 1895-1-22-349 (no. 74, p. 189)

The Sacrifice of Isaac, 1520–25
Woodcut
121 × 94 mm
The British Museum, 1895-1-22-348 (no. 75, p. 189)

Anonymous German
The Relics, Vestments and Insignia of the Holy Roman Empire, c.1480–90
Hand-coloured woodcut
434 × 298 mm
The British Museum, 1933-1-2-1 (no. 21, p. 123)

Jewish Sow, c.1470–90
Woodcut (modern impression)
270 × 420 mm
The British Museum, 1857-5-20-29 (no. 22, p. 124)

St Antony, c.1500
Woodcut
295 × 230 mm
The Ashmolean Museum, Oxford (no. 33, p. 135)

View of Nuremberg, 1502
Engraving
194 × 290 mm
The British Museum, 1888-4-10-1 (no. 88, p. 206)

Anonymous Italian
Allegory of Pope Paul II and Emperor Frederick III, c.1495
Engraving
215 × 145 mm
The British Museum, 1845-8-25-264 (no. 2, p. 100)

The Battle of Zonchio (Navarino), c.1499
Woodcut coloured using stencils
548 × 800 mm
The British Museum, 1932-7-9-1 (no. 5, p. 104)
After Titian (c.1485/90–1576)
The Triumph of Christ, 1510–11
Woodcut
390 × 2705 mm
The British Museum, 1930-4-14-40 (no. 19, p. 119)

Anonymous Netherlandish
Portrait of the Duke of Gelders, 1519
Colour woodcut
370 × 255 mm
The British Museum, 1932-6-11-3 (no. 102, p. 227)

Portrait of the Duchess of Gelders, 1519
Colour woodcut
363 × 255 mm
The British Museum, 1932-6-11-4 (no. 103, p. 227)

The Siege of Aden, 1513
Woodcut
420 × 1160 mm
The British Museum, 1950-3-6-1 (no. 108, p. 234)

Anshelm, Thomas (fl. c.1488–c.1523)
The Martyrdom of St Sebastian, 1501
Woodcut
338 × 226 mm
The British Museum, 1930-7-16-4 (no. 86, p. 202)

The Virgin and Christ Child with St Dorothea, c.1512
Woodcut
300 × 226 mm
The British Museum, 1912-5-13-55 (no. 87, p. 204)

Argentoratensis, Jacobus (Jacob of Strasbourg) (fl. c.1500–c.1520)
designed by Benedetto Bordon
Istoria Romana, c.1500–25
Woodcut
291 × 397 mm
The British Museum, 1862-7-12-118 (no. 16, p. 115)

After Benedetto Bordon (fl. 1488–1530)
Madonna Enthroned between Sts Roch and Sebastian, c.150–25
Woodcut
542 × 292 mm
The British Museum, 1919-6-16-14 (no. 17, p. 116)

Aspertini, Amico (1474/5–1552)
Three Musician Soldiers, c.1510–20
Engraving (drypoint)
142 × 143 mm
The British Museum, 1870-6-25-1062 (no. 10, p. 109)

Baldung, Hans (Grien) (1484/5–1545)
The Conversion of St Paul, 1514
Woodcut
295 × 195 mm
The British Museum, 1834-7-12-72 (no. 48, p. 159)

St Catherine, c.1505–7
Woodcut
235 × 161 mm
The British Museum, E.3-163 (no. 49, p. 161)

Adam and Eve: The Fall of Man, 1511
Woodcut
372 × 255 mm
The British Museum, 1852-6-12-106 (no. 50, p. 161)

de' Barbari, Jacopo (*c.1460/70–c.1516*)
Battle Between Nude Men and Satyrs, 1490s
Woodcut
384 × 538 mm
The British Museum, 1849-9-10-600 (no. 3, p. 101)

Brescia, Giovanni Antonio da (*c.1460–c.1520*)
after Giovanni Pietro da Birago
A Nereid and Two Children Playing Musical Instruments,
c.1500
Engraving
536 × 78 mm
The British Museum, 1845-8-25-678 (no. 11, p. 110)

Burgkmair, Hans (*1473–1531*)
Madonna and Child in a Bower, c.1508
Woodcut
221 × 151 mm
The British Museum, 1904-5-19-2 (no. 55, p. 166)

The Peoples of Africa and India, 1508
Woodcut
255 × c.2300 mm
The British Museum, 1895-1-22-405...407 (no. 56,
p. 169)

The Head of Christ Crowned with Thorns, c.150–15
Woodcut
195 × 159 mm
The British Museum, 1924-6-17-13 (no. 57, p. 170)

Jacob Fugger the Rich, 1511
Colour woodcut
208 × 140 mm
Kupferstichkabinett, Staatliche Museen zu Berlin, 17-3
(no.58, p. 172)

Emperor Maximilian I on Horseback, 1518
Woodcut
324 × 227 mm
The British Museum, 1868-8-22-203 (no. 59, p. 174)

Campagnola, Domenico (*1500–64*)
The Massacre of the Innocents, 1517
Woodcut
532 × 822 mm
The British Museum, 1860-4-14-120 (no. 18, p. 117)

Carpi, Ugo da (*c.1502–1532*)
A Sibyl Reading, c.1515
Chiaroscuro woodcut
287 × 240 mm
The British Museum, W.4-18 (no. 14, p. 113)

After Titian? (*c.1485/90–1576*)
The Sacrifice of Abraham, 1515
Woodcut
790 × 1076 mm
Kupferstichkabinett, Staatliche Museen zu Berlin, 44-
1967 (no.15, p. 114)

Cock, Jan Wellens de (*c.1480–c.1526/7*)
The Ship of St Reynuit (*The Ship of Mismanagement*),
c.1520–30
Woodcut
760 × 1160 mm
The Ashmolean Museum, Oxford (no. 106, p. 230)

Six Musician Footsoldiers, c.1520–30
Woodcut
250 × 375 mm
The Ashmolean Museum, Oxford (no. 107, p. 232)

Cranach the Elder, Lucas (*1472–1553*)
The Temptation of St Antony, 1506
Woodcut
405 × 270 mm
The British Museum, 1895-1-22-255 (no. 78, p. 192)

The First Tournament, 1506
Woodcut
256 × 368 mm
The British Museum, 1895-1-22-275 (no. 79, p. 194)

Four Saints Adoring Christ Crucified on the Sacred Heart,
1505
Woodcut
380 × 284 mm
The British Museum, 1895-1-22-267 (no. 80, p. 197)

A Wild Man with a Child, c.1512
Woodcut
161 × 126 mm
The British Museum, 1854-11-13-160 (no. 81, p. 197)

The Beheading of St John the Baptist, c.1514
Woodcut
330 × 231 mm
The British Museum, 1895-1-22-259 (no. 82, p. 198)

Dürer, Albrecht (*1471–1528*)
The Large Horse, 1505
Engraving
167 × 119 mm
The British Museum, 1868-8-22-197 (no. 34, p. 136)

The Betrayal of Christ (*The Engraved Passion*), 1508
Engraving
118 × 75 mm
The British Museum, E.2-54 (nos. 35a, p. 137)

The Lamentation over Christ (*The Engraved Passion*),
1507
Engraving
115 × 71 mm
The British Museum, E.2-45 (no. 35b, p. 137)

Samson Rending the Lion, 1497–8
Woodcut
382 × 280 mm
The British Museum, 1895-1-22-663 (no. 36, p. 138)

Hercules Conquering the Molionide Twins, c.1496
Woodcut
390 × 283 mm
The British Museum, 1895-1-22-708 (no. 37, p. 140)

The Men's Bath House, c.1496
Woodcut
387 × 282 mm
The British Museum, 1895-1-22-709 (no. 38, p. 142)

The Martyrdom of the Ten Thousand Christians, c.1496
Woodcut
387 × 284 mm
The British Museum, 1895-1-22-698 (no. 39, p. 144)

The Birth of the Virgin (*The Life of the Virgin*), 1503–5
Woodcut
297 × 210 mm
The British Museum, 1895-1-22-625 (no. 40a, p. 147)

The Holy Family in Egypt, 1503–5
Woodcut
298 × 209 mm
The British Museum, 1895-1-22-635 (no. 40b, p. 147)

Christ Carrying the Cross (*The Small Passion*), 1509
Woodcut
127 × 97 mm
The British Museum, 1895-1-22-526 (no. 41a, p. 148)

Sts Veronica, Peter and Paul with the Sudarium, 1510
Woodcut
127 × 97 mm
The British Museum, 1895-1-22-527 (no. 41b, p. 148)

Christ Being Nailed to the Cross, c.1509–11
Woodcut
127 × 97 mm
The British Museum, 1895-1-22-528 (no. 41c, p. 148)

Christ Crucified, c.1509–11
Woodcut
127 × 97 mm
The British Museum, 1895-1-22-529 (no. 41d, p. 148)

The Flagellation of Christ (*The Large Passion*), 1497–1500
Woodcut
385 × 272 mm
The British Museum, 1895-1-22-599 (no. 42a, p. 151)

Christ in Limbo, 1510
Woodcut
392 × 280 mm
The British Museum, 1895-1-22-605 (no. 42b, p. 151)

The Four Horsemen of the Apocalypse (*The Apocalypse*),
1498
Woodcut
394 × 281 mm
The British Museum, 1895-1-22-576 (no. 43a, p. 152)

The Whore of Babylon, 1498
Woodcut
392 × 282 mm
The British Museum, 1895-1-22-572 (no. 43b, p. 152)

The Rhinoceros, 1515
Woodcut
212 × 298 mm
The British Museum, 1895-1-22-714 (no. 44, p. 154)

Map of the Northern Sky, 1515
Woodcut
430 × 430 mm
The British Museum, 1895-1-22-734 (no. 45, p. 155)

Dürer Workshop
The Birth of Christ, c.1503
Woodcut
63 × 50 mm
The British Museum, 1909-4-3-19 (no. 46a, p. 156)

The Dispatch of the Disciple to John the Baptist in Prison,
c.1503
Woodcut
63 × 50 mm
The British Museum, 1909-4-3-23 (no. 46b, p. 156)

The Parable of the Weed, c.1503
Woodcut
63 × 50 mm
The British Museum, 1909-4-3-21 (no. 46c, p. 156)

Christ Feeding the Five Thousand, c.1503
Woodcut
63 × 50 mm
The British Museum, 1909-4-3-22 (no. 46d, p. 156)

Christ Speaking to his Persecutors Wanting to Stone Him,
c.1503
Woodcut
63 × 50 mm
The British Museum, 1909-4-3-9 (no. 46e, p. 156)

The Parable of the Repast without Guests, c.1503
Woodcut
63 × 50 mm
The British Museum, 1909-4-3-12 (no. 46f, p. 156)

The Parable of the Rich Man and his Steward, c.1503
Woodcut
63 × 50 mm
The British Museum, 1909-4-3-18 (no. 46g, p. 156)

The Parable of the Rich Man and Poor Lazarus, c.1503
Woodcut
63 × 50 mm
The British Museum, 1909-4-3-11 (no. 46h, p. 156)

The Prophecy of Jerusalem's Destruction, c.1503
Woodcut
63 × 50 mm
The British Museum, 1909-4-3-13 (no. 46i, p. 156)

Christ Showing His Disciples the Signs from Heaven,
c.1503
Woodcut
63 × 50 mm
The British Museum, 1909-4-3-26 (no. 46j, p. 156)

The Incredulity of St Thomas, c.1503
Woodcut
63 × 50 mm
The British Museum, 1909-4-3-10 (no. 46k, p. 156)

The Women's Bath, c.1496
Woodcut
226 × 240 mm
The British Museum, 1927-6-14-2 (no. 47, p. 158)

Graf, Urs (c.1485–1529/30)
*Young Woman with an Old Man and a Youth (Mercenary
Love)*, c.1511
Woodcut
325 × 225 mm
The British Museum, 1875-7-10-1455 (no. 91, p. 211)

The Holy Land and Scenes from the Passion of Christ,
c.1510
Woodcut
381 × 534 mm
The British Museum, 1856-2-9-182 (no. 92, p. 212)

Hopfer, Daniel (c.1470–1536)
Design for Ornament Strips in Form of Dagger Sheaths,
c.1515–20
Etching
135 × 83 mm
The British Museum, 1845-8-9-1418 (no. 53, p. 164)

Medallion with the Bust of Nero, c.1520
Etching
223 × 156 mm
The British Museum, 1845-8-9-1362 (no. 54, p. 164)

Huber, Wolf (c.1485–1553)
Pyramus and Thisbe, 1513–15
Woodcut
119 × 92 mm
The British Museum, 1895-1-22-440 (no. 76, p. 190)

St George Fighting the Dragon, 1520
Woodcut
202 × 151 mm
The British Museum, E.7-228 (no. 77, p. 190)

Leyden, Lucas van (c.1494–1533)
*Delilah Cutting the Hair of Samson (The Large Power of
Women)*, c.1514
Woodcut
415 × 290 mm
The British Museum, 1895-1-22-1160 (no. 97, p. 219)

Solomon's Idolatry, 1514
Engraving
168 × 128 mm
The British Museum, K.k.6-81 (no. 98, p. 219)

A Young Man Holding a Skull, c.1519
Engraving
184 × 145 mm
The British Museum, 1849-10-27-82 (no. 99, p. 220)

The Nine Worthies, c.1520
Woodcut
317 × 1522 mm
The British Museum, 1849-10-27-95; E.6-8; 1849-10-27-97
(no.100, p. 223)

Manuel Deutsch, Niklaus (?1484–1530)
The Wise Virgin, 1518
Woodcut
185 × 105 mm
The British Museum, 1877-6-9-61 (no. 90a, p. 210)

The Wise Virgin, 1518
Woodcut
185 × 105 mm
The British Museum, 1877-6-9-62 (no. 90b, p. 210)

The Foolish Virgin, 1518
Woodcut
185 × 105 mm
The British Museum, 1877-6-9-69 (no. 90c, p. 210)

Master ES (active 2nd half of 15th century)
The Judgement of Solomon, c.1450–67
Engraving
The British Museum, 1884-7-26-30 (no. 30, p. 132)

Master IAM of Zwolle (c.1440–1504)
The Large Calvary with Horsemen, 1475
Engraving
352 × 348 mm
The British Museum, 1845-8-9-231 (no. 93, p. 214)

Allegory of the Transience of Life, c.1480–90
Coloured engraving on vellum
322 × 225 mm
The British Museum, 1845-8-9-232 (no. 94, p. 216)

Master W+ (fl. c.1465–c.1485)
A Cavalry Unit of Thirty Men, c.1465–c.1485
Engraving
140 × 183 mm
The British Museum, 1845-8-9-211 (no. 96, p. 217)

Meckenem, Israhel van (c.1440/45–1503)
Samson Slaying the Lion, 2nd half of 15th century
Engraving
137 × 106 mm
The British Museum, E.1-95 (no. 24, p. 126)

Head of an Old Man (an Oriental), c.1480–90
Engraving
208 × 131 mm
The British Museum, 1845-8-9-312 (no. 25, p. 126)

Sts Quirinus and Antony, c.1475
Engraving
162 × 142 mm
The British Museum, 1993-10-3-10 and 1845-8-9-106
(no. 26, p. 128)

Christ Being Crowned with Thorns (The Large Passion),
c.1480
Engraving
208 × 145 mm
The British Museum, 1842-8-6-76 (no. 27, p. 128)

St George and the Dragon, c.1470–80
Engraving
170 mm diam.
The British Museum, E.1-120 (no. 28, p. 130)

The Mass of St Gregory, c.1490
Engraving
416 × 294 mm
The British Museum, 1845-8-9-348 (no. 29, p. 130)

Modena, Nicoletto da (fl. c.1500–c.1520)
St Bernardino of Siena, c.1510–15
Engraving
146 × 103 mm
The British Museum, 1853-6-11-245 (no. 8, p. 108)

St George and the Dragon, c.1510–15
Engraving
149 × 103 mm
The British Museum, 1846-5-9-16 (no. 9, p. 108)

Monogrammist FvB
St Philip, 1475–90
Engraving
180 × 98 mm
The British Museum, 1845-8-9-222 (no. 95, p. 217)

**Monogrammist IS with a Shovel (active 1st half of 16th
century)**
Allegory of the Deliverance of Original Sin, c.1515
Woodcut
324 × 243 mm
The British Museum, 1856-2-9-253 (no. 67, p. 183)

Monogrammist MV (active 1st half of 16th century)
after Lucas Cranach the Elder
The Martyrdom of St Matthew, c.1515
Engraving
164 × 124 mm
The British Museum, 1853-7-9-27 (no. 83, p. 200)

Monogrammist S (active 1st half of 16th century)
The Last Supper (The Passion), c.1520
Engraving
155 × 115 mm
The British Museum, 1846-5-9-119 (no. 101a, p. 226)

The Agony in the Garden, c.1520
Engraving
155 × 115 mm
The British Museum, 1846-5-9-120 (no. 101b, p. 226)

The Betrayal of Christ, c.1520
Engraving
155 × 115 mm
The British Museum, 1846-5-9-134 (no. 101c, p. 226)

Christ Taken Captive, c.1520
Engraving
155 × 115 mm
The British Museum, 1846-5-9-135 (no. 101d, p. 226)

Monogrammist SE
after Botticelli?
Carnival Dance: The Sausage Woman, 1475–90.
Engraving
382 × 565 mm
Kupferstichkabinett, Staatliche Museen zu Berlin, 102-1908 (no. 4, p. 102)

Negker, Jost de (c.1485–c.1544)
after an unknown artist
St Christopher Bearing the Christ Child, 1506–8
Woodcut
383 × 268 mm
The British Museum, 1910-4-9-5 (no. 104, p. 228)

Olmütz, Wenzel von (fl.1475–1500)
The Last Supper, c.1500
Engraving
168 × 142 mm
The British Museum, 1879-1-11-19 (no. 32, p. 228)

Oostsanen, Jacob Cornelisz. van (c.1472/7–1533)
St Michael, 1510
Woodcut
371 × 247 mm
The British Museum, 1890-1-18-3 (no. 105, p. 228)

Palumba, Giovanni Battista (active 1st quarter of 16th century)
Mars, Venus and Vulcan (Vulcan Forging the Arms of Achilles), c.1505
Woodcut
298 × 213 mm
The British Museum, 1854-11-13-167 (no. 12, p. 110)

The Calydonian Boar Hunt, c.1505–12
Woodcut
270 × 445 mm
The British Museum, 1895-1-22-1215 (no. 13, p. 112)

Peril, Robert (active 1st half of 16th century)
The Genealogical Tree of the House of Hapsburg, 1540
Colour woodcut
7.34m × 470 mm
The British Museum, 1904-7-23-1 (no. 109, p. 236)

Pollaiuolo, Antonio (c.1432–1498)
Battle of the Nude Men, c.1460–75
Engraving
398 × 594 mm
The British Museum, V.1-33 (no. 1, p. 99)

Raimondi, Marcantonio (c.1470/82–1527/34)
after Titian (c.1485/90–1576)
St Jerome in the Desert, c.1510
Engraving
144 × 189 mm
The British Museum, 1867-10-12-644 (no. 6, p. 106)

Portrait of Raphael, c.1518
Engraving
139 × 106 mm
The British Museum, 1973 U.82 (no. 7, p. 107)

Schäufelein, Hans (c.1482–1539/40)
The Legend of St Christopher, c.1505
Woodcut
238 × 360 mm
The British Museum, 1949-4-11-4052 (no. 65a, p. 180)

The Legend of St Christopher, c.1505
Woodcut
247 × 355 mm
The British Museum, 1949-4-11-4053 (no. 65b, p. 180)

A Standard-Bearer with a Banner, c.1515
Woodcut
209 × 133 mm
The British Museum, E.8-85 (no. 66, p. 183)

Schongauer, Martin (c.1435/50–1491)
The Death of the Virgin, after 1470
Engraving
255 × 169 mm
The British Museum, 1910-2-12-295 (no. 31, p. 132)

Springinklee, Hans (c.1495–1522)
St Jerome at his Desk, 1522
Woodcut
235 × 182 mm
The British Museum, 1895-1-22-417 (no. 85, p. 202)

Traut, Wolf(gang) (c.1480–1520)
Christ Taking Leave of his Mother, 1516
Woodcut
299 × 258 mm
The British Museum, 1895-1-22-124 (no. 84, p. 201)

Vavassore, Giovan Andrea (fl. c.1510–c.1570)
The Siege of Rhodes, 1522
Woodcut
775 × 568 mm
The British Library, Maps 15.c.26(3) (no. 20, p. 122)

Vogtherr the Elder, Heinrich (1490–1556)
Christ Carrying the Cross, 1527
Woodcut
958 × 668 mm
The British Museum, 1839-10-12-2[5] (no. 64, p. 180)

Waldseemüller, Martinus (Martin) (c.1475–1518/22)
Map of Europe, 1520
Woodcut
1066 × 1407 mm
Tiroler Landesmuseum Ferdinandeum, Innsbruck (no.89, p. 208)

Wechtlin, Hans (c.1480/85–1526)
A Skull in a Renaissance Frame, c.1515
Colour woodcut
270 × 182 mm
The British Museum, 1834-8-4-38 (no. 51, p. 162)

A Knight and a Lansquenet, c.1518
Colour woodcut
271 × 182 mm
The British Museum, 1895-1-22-204 (no. 52, p. 162)

Weiditz, Hans (before 1500–c.1536)
Emperor Charles V, 1519
Coloured woodcut on vellum
356 × 203 mm
The British Museum, 1862-2-8-55 (no. 60, p. 174)

Grotesque Woman with Two Children Carrying Toy Windmills, 1521
Woodcut
303 × 217 mm
The British Museum, 1880-6-12-212 (no. 61, p. 176)

Winebag and Wheelbarrow, c.1521
Woodcut
277 × 212 mm
The British Museum, 1880-6-12-211 (no. 62, p. 176)

Bird's-Eye View of the City of Augsburg, 1521
Woodcut
807 × 1920 mm
The British Library, Map* 30415[6] (no. 63, p. 178)

Wolgemut, Michael (1434/7–1519) and Wilhelm Pleydenwurff (c.1460–1494)
View of Rome, c.1493
Woodcut
231 × 453 mm
The British Museum, 1870-10-8-1938 (no. 23, p. 125)

Index

Occasionally in this index, titles of prints and books are shortened. Only those that are discussed to support an argument – not those cited in a list form – are indexed. For the prints in the catalogue, see 'List of Works in the Catalogue', pp. 251–4.